The
VISUAL
DIALOGUE

The VISUAL DIALOGUE

An Introduction to the Appreciation of Art / *second edition*

Nathan Knobler

University of Connecticut

HOLT, RINEHART AND WINSTON, INC.

New York Chicago San Francisco Atlanta
Dallas Montreal Toronto London Sydney

To S.H.K., who was a gentle man

Editor Dan W. Wheeler
Production Editor Rita Gilbert
Picture Editor Joan Curtis
Designer Marlene Rothkin Vine

Library of Congress Catalogue Card Number: 70-153954
College SBN: 03-081342-5
*A Helvetica Press production: Printed in black-and-white gravure
by the Presses Centrales, Lausanne, Switzerland;
color offset by the Imprimeries Réunies, Lausanne, Switzerland;
bound by Mayer & Soutter S.A., Renens, Switzerland.
First printing, 1971.*

Preface

This book is the attempt of an artist and teacher to provide information, ideas, and arguments—as well as a beginning vocabulary and syntax—through which those eager to find significance and satisfaction in art may have the ability to hold a meaningful, constructive discourse with it. Four years ago, when I wrote the preface to the first edition of *The Visual Dialogue*, my principal concern was for the alienation felt both by a large portion of the lay public confronted with and unable to comprehend the "difficult" expressions of contemporary art and by many artists who were convinced of the public's "visual illiteracy," of its ignorance of the concepts basic to the arts. Though museum attendance was indeed booming, the representative viewer seemed not to perceive the historical ties between present-day art and the arts of the past; he appeared generally incapable of "reading " the current languages of painting and sculpture and often extremely limited in his ability to "read" the visual languages of the past. Today, the puzzlement, distrust, and hostility may still exist, on the part of artists and their audience alike, but the atmosphere in which we all find ourselves has changed, and whatever the failures of our culture we seem intent on redefining the good, the useful life, and, in the process, on accepting the arts as fundamental in their importance for the lives of all people. It has been in this spirit, therefore, that I have reapproached the nomenclature of the eternally vital exchange that occurs between the artist and his work, between the produce of the creative endeavor and its beholders, and, ultimately, between the artistic community and the society that it nourishes and is nourished by. My purpose remains the preparation of informed, aware, and responsive participants in a dialogue whose subject is the fulfillment of the human need for esthetic satisfaction.

It is not only record-breaking museum attendance that confirms the very real desire felt by many members of the educated public to come to grips with

the challenge of the arts, but, now, a much enlarged population of patrons collecting the works of professional artists and of people interested in developing their own ability to produce art objects. Often, however, this desire is thwarted by a kind of cultural barrier which isolates the observer from a response to the work of art. It is a barrier constructed in three parts. Part one is formed by the assumption made by many that they can differentiate between a work of art and an object which does not fit this category. They establish a narrow conceptualization of the nature and the form of the legitimate painting, piece of sculpture, and well-designed building, and they tend to reject as illegitimate those products of artists which do not conform to the acceptable pattern.

Another section of the wall exists because of the extremely limited contact between most people and actual examples of painting, sculpture, or buildings that would fit the description of architectural works of art. Though it is true that the museums are crowded, the amount of exposure to the visual arts does not compare with the exposure to music or literature. Many reproductions of paintings and sculptures are to be found in books and magazines, but the availability of these references is a mixed blessing, for it gives the illusion of contact with the arts when, in fact, even the most carefully printed publications are unsatisfactory substitutes for painting, and are, of course, misleading in the representation of the three-dimensional art forms. Some might argue that reproduction of music by tape and phonograph is comparable to the color reproduction of works in the visual arts. But the reproduction of sound is much closer to the original source than is the reproduction of the texture, the scale, and the precise color in painting or the material and the actual three-dimensionality of a statue.

Related to the two parts of the barrier already mentioned is a third element, which is perhaps the most crucial component in the whole matrix. It is the feeling of confusion, the sense of inadequacy, and frequently the feeling of frustration and antagonism toward objects identified as works of art which cannot be confined within the limits of the conceptualization acceptable to the observer.

In my view, an introduction to the appreciation of art must begin by attempting to eliminate the barrier of misunderstanding and prejudice found in the untrained viewer. He must find the continuity between the arts of the past and those of the present. He must be offered a sound, logical exposition of the nature of the visual arts that will help to remove the doubt he may feel about the work of the contemporary painter, sculptor, and architect. Finally, the interested layman must be given a sense of his ability to deal with works of art without the necessity of a third party to tell him what to look at, why he should look at it, and what it should mean.

The concern that I feel for the need to establish a basis for the understanding and the acceptance of the visual arts requires that the first chapters of this book deal with somewhat abstract problems at a length which is unusual in texts concerned with the appreciation of art. My experience in teaching this material has convinced me that it is an illusion to believe it possible to involve

students in individual works of art before resolving in a preliminary but thorough way their doubts about the nature and validity of the arts in general. This introduction prepares the way for further study by presenting arguments which suggest that there is meaning to be found in forms of art which are at present beyond the understanding of the interested individual.

The book continues with a middle section, divided into two parts, on the two- and three-dimensional forms, devoted to the exposition of the language of the visual arts. Here, I have tried to introduce the reader to the diversity which exists in both the content and the form of the visual arts throughout their history. This portion of the book has been written on the assumption that the observer must recognize the interdependence between means and ends in painting, drawing, printmaking, sculpture, and architecture. If he is to understand what a painting means, a viewer must also comprehend how that meaning is communicated.

Concluding the narrative is a brief section, consisting of two chapters, on expression in art, on the capacity of the visual arts to bear the weight of powerful feelings and to convey an intensity of conviction that other modes of communication could not support. Here, as elsewhere in the book, the depth and maturity of the viewer's response is considered imperative to the realization of the full artistic communication possible in visual expression.

Such, then, is the procedure devised for the book, and it has been followed in all awareness of the increased involvement many people now have with the arts, the increase due, I believe, to these factors: the dependence of modern society on advanced knowledge of the world it lives in and the dependence upon the visual media of film and television for the communication of knowledge; the enhanced worth of activities conducive to personal fulfillment in an age of such complexity and specialization that much human endeavor is rendered meaningless; and, finally, the emergence of a significant segment of our society with the resources of time and energy for release, after the satisfaction of economic need, to productive use in the arts.

The change from an essentially consumer attitude toward the arts to that of a creative attitude on the part of the amateur suggests a function for art appreciation that did not seem so important when the first edition of this book was being prepared. Now, in addition to introducing the susceptible viewer to the special conditions an understanding of art requires, the sympathetic study of art can offer the novice image-maker a working knowledge of the mechanisms of media and the ways in which artists have managed the problems of esthetic order, expression, and representation.

Benefited by observations made by readers of the first edition, I have wanted this reconsideration of *The Visual Dialogue* to bring greater precision and clarity to the ideas I originally selected as thematic to the book. Since the first edition appeared, there has also been time to develop the materials and concepts for a section on urban planning and for entire chapters on drawing and printmaking. Too, the reader will find the treatment of color theory, photography, and kinetic forms greatly expanded beyond the consideration

they received in the earlier edition. My own professional development in sculpture has resulted in an enrichment of this aspect of the book.

In general, my guiding thesis has been that art appreciation derives from a visual dialogue between each observer and the work of art he confronts—a dialogue which requires a willing, perceptive, discriminating participant on one side and the work of art on the other. A third party, the critic, or the teacher, may function to introduce the participant to the work, to prepare him for the appreciation of it, but he can do no more, for art appreciation cannot be taught. It grows within the observer when he is ready for it, and it has an opportunity to develop only when there is a continuing contact between the perceiver and works of art. Even when he is in despair, the artist acts positively. To produce an object that is intended to speak to others implies a belief in the value of communication. To produce an object that is intended to last implies a belief in the continued existence of a society composed of people able to respond to the efforts of the creator. It is my hope that this book will help foster such a responsive community, for by accepting the challenge of the arts people may affirm their most human and humane qualities.

A combination of art and labor is required to transform a manuscript into a well-printed, carefully edited book. Many individual efforts and sacrifices are made before a volume as complex as this one can be issued, and an author who has had the good fortune to see his ideas and words shaped into richly illustrated, properly ordered pages knows he is indebted to skillful and committed professionals who have contributed to the final form of the book bearing his name. With the preparations that preceded the first edition of *The Visual Dialogue* I began my association with editor Dan Wheeler, who has carried the major responsibility for the production of both editions. His competence, deep concern for the maintenance of the highest standards of bookmaking, his astute and provocative criticism are in evidence throughout these pages. Theresa Brakeley edited the manuscript with intelligence and sensitivity, providing her expert knowledge and the encouragement of a concerned friend. The admirable design and layout of the book are the work of Marlene Rothkin Vine, and it is she who devised an appropriate, stimulating, and satisfying visual form for both words and pictures. Rita Gilbert bore much of the burden of holding all the elements in coherent order once production began, while Joan Curtis accomplished the seemingly endless task of locating and securing illustrations and permissions for almost 600 works of art and architecture and the 78 color plates from cooperating individuals and institutions throughout the world. Professors Jack Arends, with the assistance of his associates at Northern Illinois University, LeGrace G. Benson, of Cornell University, David Lauer, now chairman of the Art Department at the College of Alameda, California, and Don Murray, of the University of Florida, made welcome comments on this version of the book during its several stages of preparation. All have my thanks!

January 1971 N.K.
Mansfield Center, Conn.

Contents

THE NATURE
OF THE
VISUAL EXPERIENCE

chapter 1

ART APPRECIATION
AND THE
ESTHETIC EXPERIENCE

Man is an image maker. From the paintings on the cave walls of Paleolithic man a record of the visual arts has continued to our own time, and though the motivation for these images appears to change from era to era, there is ample evidence to affirm the need of men to transform their experiences into visual symbols (Figs. 1, 2).

In this span of time buildings and monuments have risen, some to fall quickly, others to remain as witnesses to man's efforts to protect himself and to glorify his heroes, societies, and gods.

The combination of visual symbols and architectural structures produced by man illuminates the past, and many of these artifacts continue to provide the present-day observer with insights and pleasures, rewarding in their own right without reference to their historical implications. The meaning of art does not lie exclusively in its function as a key to the lives of individuals and societies now gone or as a reflection of today's life; for some viewers art serves primarily as a source of sensuous and intellectual satisfaction that needs no external referent. In the form of a Greek kylix (Fig. 3), the color of a Matisse painting (Pl. 1, p. 15), or the structure of a great bridge (Fig. 4) there is a potential for awe and delight unrelated to practical value or cultural and historical background.

For those who produce the paintings, sculpture, and architecture of their time, the arts may have a variety of meanings. A work of art may serve as an

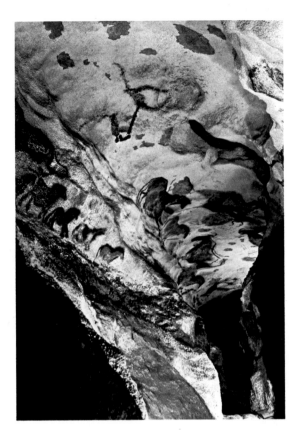

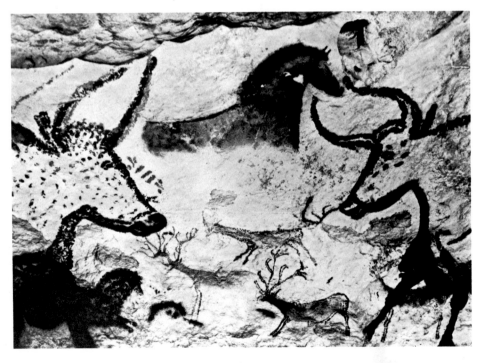

left: 1. Lascaux Cave, left gallery
of chamber A. Rock painting.
15,000–10,000 B.C.
Montignac (Dordogne), France.

below: 2. Rock painting, detail.
15,000–10,000 B.C.
Lascaux Cave (Dordogne), France.

exercise in skill and manual dexterity. Perhaps it is a comment on society and morality, wrenched out of the personal involvement of the artist. Perhaps it tells a simple story. Possibly it satisfies the need to create a mystical token or icon. Whatever the reason for creating it, the work of art has, for many artists, served its purpose when it is completed. Other rewards may come when the work has found a responsive audience, but the response of the public is so unpredictable that its acceptance can provide only a secondary level of satisfaction for the artist.

For the observers, the consumers of the arts, the meaning of art begins with the work itself. The observer begins where the artist has stopped. The meaning

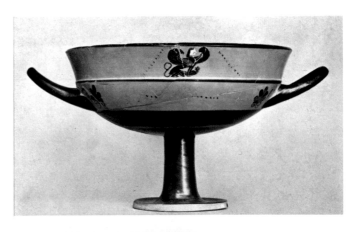

right: 3. Athenian black-figure kylix, "Little Master" type, with sphinx and dead man. 550–540 B.C. Painted earthenware, height 7⁷/₈". Metropolitan Museum of Art, New York (Rogers Fund, 1903).

below: 4. ROBERT MAILLART. Salginatobel Bridge, Graubunden, Switzerland. 1929–30.

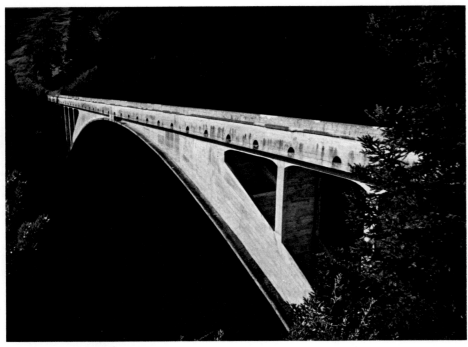

the layman finds in the art object is dependent upon the work of art, but it is also dependent on the viewer's own intellectual and emotional condition, as well as on his ability to perceive the work before him.

The artist fashions a visual statement which in turn becomes the subject matter for a response or reaction from the observer. In this sense the visual arts may be considered a language. As in other languages, there is a source for the communication, the artist; there is a medium that carries the information originating at the source, the work of art; and finally there is a receiver, the observer. Like the reader of a written text, the observer must recognize and decipher the symbols and the pattern of symbols before understanding can occur. Of course, reading and enjoyment are not synonymous. Just as no one reader will find pleasure in each book on a library shelf, so no beholder should expect to find pleasure in every art object or to understand each work of art he sees. Library shelves are filled with volumes beyond the comprehension even of highly educated individuals, and the walls of museums are hung with some paintings which have a similarly limited audience.

It is possible for a layman to have an immediate esthetic response to some works of art, but it is probable that many of the paintings, the pieces of sculpture, and the buildings he confronts will offer him little pleasure. In fact, there may be works of art which disturb and even anger or repel him. Esthetic satisfaction is the result of a complex combination of subjective attitudes and perceptual abilities. No one can state with certainty why certain objects elicit positive responses while others do not, but if the observer wishes to increase the number of art objects to which he can respond with satisfaction, he must alter the conditions that affect his response.

The philosopher Albert R. Chandler, in his book *Beauty and Human Nature,* discusses the satisfaction to be found in the arts. He calls this satisfaction "the esthetic experience."

> The esthetic experience may be defined as satisfaction in contemplation, or as a satisfying intuition. When I enjoy a beautiful sunset I am satisfied to contemplate it. My intellectual curiosity is put to sleep—I do not care just then about the physical causes of clouds and light. My practical interests are suspended— I do not care just then whether such a sky foretells dry weather, though my garden may need rain. I am satisfied to contemplate the sunset.
>
> .
>
> The word *satisfaction* may be defined indirectly as the state of mind which is indicated by the willingness to prolong or repeat the experience in question. . . . The term satisfaction is better than *pleasure,* because *satisfaction* is the broader term. The harrowing excitement aroused by a melodrama is scarcely a pleasure, but it is undoubtedly a satisfaction, since people seek to prolong or repeat it. The same might be said of pathos in music and poetry. It may reduce us to tears, but our experience is nevertheless a satisfying one.[1]

[1] All annotations can be found in a special section at the end of the text entitled "Bibliography and Notes," the notes themselves positioned on page 482.

It takes very little special training to react to the colors of a sunset or the forms of clouds or mountains, yet many people find it difficult to have a pleasurable experience from some works of art. Why? An examination of the factors which can lead to an esthetic experience may develop an understanding of this problem and provide a guide for the discovery of satisfaction in art objects that offered little to the observer before.

Initially, the esthetic experience is the result of an interaction between an art object and an observer. This interaction cannot take place unless the conditions for its occurrence are present. These conditions are *the ability of the observer to perceive and comprehend those aspects of the object or experience which contribute to esthetic satisfaction* and *a receptive attitude on the part of the observer.*

Before going on, let us limit the definition of the esthetic object. It has been suggested that the esthetic experience may be initiated by a response to both natural and man-made stimuli. The study of the esthetic response in all its forms is a formidable task and not the purpose of this text; we are dealing here with the response to a work of art, and we shall restrict our definition of the esthetic stimulus so that it becomes synonymous with works of the visual arts. Though this restriction eliminates many possible areas of discussion, it still leaves a large body of work for examination. Traditionally, the visual arts have been divided into the fine arts and the practical, or applied, arts, the major branches of the fine arts being generally categorized as painting, sculpture, and architecture. It is possible to argue that there is a potential for esthetic satisfaction in every man-made object, from a can opener to a skyscraper, from a postage stamp to the ceiling mural of a great church, but an attempt to cover the entire range of the visual arts would not permit us to focus on the essential problem that concerns us—the achievement of an esthetic response, an *appreciation* of art.

The basic problems which arise in the appreciation of sculpture, painting, and architecture have their counterparts in all the visual arts, and the exposition of these problems will apply to other areas of the visual arts which may become the concern of the reader.

THE RECEPTIVE ATTITUDE

What is the attitude essential for an esthetic experience? First, it is necessary that *the observer's attention be directed toward the object before him.* The person looking at a work of art must give it his full and undivided attention.

Some degree of interaction with a work of art is possible without the complete attention of the observer. Many people who live in rooms hung with paintings may rarely stop to contemplate them. Others listen to music while performing their household chores, combining concert attendance with cooking and dusting. In each instance there is contact with a work of art, but the experience is not one that engages the respondent in a direct, "face-to-face" relationship. Other examples are less obvious but produce similar results: the casual stroll through a museum or gallery without taking the time for a

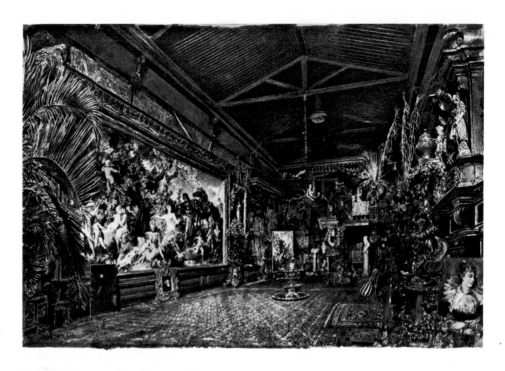

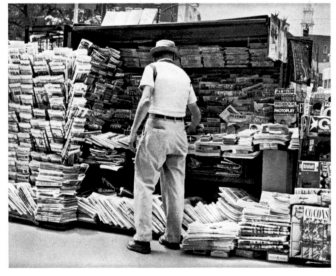

above: 5. RUDOLF VON ALT.
Studio of the Painter Hans Makart.
1885. Watercolor.
Historisches Museum der Stadt Wien, Vienna.

left: 6. Newsstand.

reflective pause; interference of noise and crowds, which hampers concentration; bad lighting; conflicting backgrounds—all these may create a partial barrier between the work of art and the viewer.

The photographically precise painting of the studio of the nineteenth-century artist Hans Makart, reproduced in Figure 5, gives a sense of the chaos that can result from the haphazard display of bric-a-brac, paintings, sculpture, furniture, and fabrics. Hidden within the confusion of this conglom-

eration are individual pieces which may have a high degree of artistic merit, but it is nearly impossible to isolate them from their surroundings. In total, a group of objects may create an atmosphere, set a mood, but as the group becomes more complex, the individual items lose their separate identities. Much the same condition exists in the photograph of a newspaper-and-magazine stand (Fig. 6). Desiring to display all his wares, the newsdealer has succeeded in hiding them, for they have become a part of an allover pattern.

The marginal contact produced by a limited interaction between art object and viewer may give a certain amount of satisfaction which can be called a form of esthetic experience. The sense of well-being and the pleasant atmosphere afforded by "background music," "background" interior decoration, or a casual glance around the galleries of a museum can be valuable. An environment which satisfies those who operate within it is important; so is the environmental change offered to the museum visitor as a contrast to the experience and surroundings that are a part of the daily routine. This form of response provides pleasure with a minimum of discomfort and tension.

When a workman applies himself to physical or mental problems, he seeks to avoid any condition of disturbance or interference that will increase the effort necessary to complete his primary task. The often-heard comment about some forms of art, "I wouldn't want to hang that in my livingroom," is an expression of the desire to provide a home environment without conflict and discomfort.

To what does the casual observer respond in a peripheral or partial interaction with an art object? It appears that he responds to the familiar, the obvious, the comfortable qualities in the work. Recent experiments in psychology confirm earlier theories indicating human and animal preference for experiences that are familiar and therefore cause a minimum of tension. The *familiar* is acceptable and comfortable; the *unfamiliar*, uncomfortable, often disagreeable. It is reasonable to assume that pleasurable responses to partial interaction with a work of art are produced by factors the respondent finds familiar, either because of previous exposure to the specific art object under contemplation or because of qualities in the work that recall other responses of pleasure. If the work contains unfamiliar elements, which tend to cause inner tension, those portions may be neglected, unperceived, and therefore comfortably passed over. Of course, some art works, because of their general exposure or similarity to other, well-known productions, may be so familiar they offer little or no possibility for discomfort and can therefore satisfy the limited requirement of "background" esthetics.

Most works of art contain elements that are now, or were at one time, both familiar and unfamiliar, innovative, or unexpected. The ratio of the familiar (F) and the innovative (I) differs for each object as perceived by each individual who interacts with it. What is familiar to one person may be unusual or even undecipherable to another. The $F:I$ ratio can vary with time, with differing social or cultural conditions, and with those personal experiences that contribute to the distinctions among individuals. Most viewers find the paintings

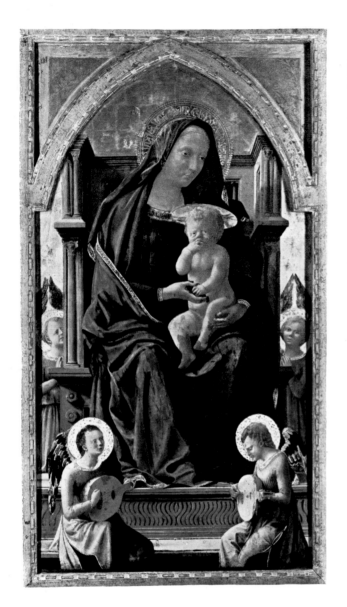

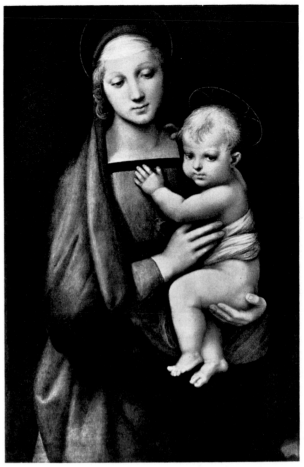

left: 7. MASACCIO. *Madonna and Child Enthroned.* 1426.
Tempera on panel, 4′ 5¹/₄″ × 2′ 4³/₄″. National Gallery, London.

above: 8. RAPHAEL. "*Madonna del Granduca.*" c. 1504–05.
Oil on panel, 33 × 21¹/₄″. Pitti Palace, Florence.

by Masaccio, Raphael, and Copley, reproduced in Figures 7, 8, and 9, to be consistent with a familiar and traditional form of representation in which little appears innovative. For many, Matisse's *Pink Nude* (Pl. 1, p. 15), though over 35 years old, is more heavily weighted on the experimental side of the *F:I* ratio than the three earlier figure paintings. Matisse has represented a reclining female figure within an interior, but the simplified drawing, the absence of the traditional use of shading, and the heightened colors applied in apparently flat, spontaneously formed areas of paint set this composition apart from the three older ones. To those who have seen other Matisse paintings, or works in a similar vein by other artists, the innovational values in the Matisse will seem

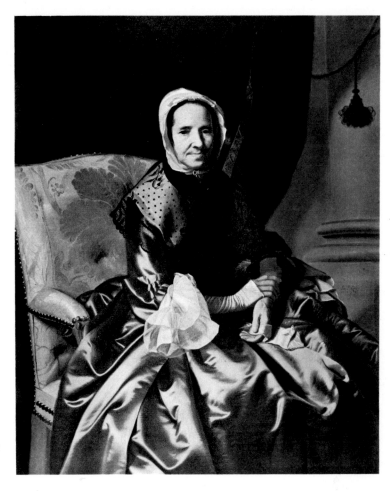

9. JOHN SINGLETON COPLEY.
Portrait of Mrs. Thomas Boylston. 1766.
Oil on canvas, 49 × 38″. Fogg Art Museum,
Harvard University, Cambridge, Mass.
(bequest of Ward N. Brown, 1828).

lower in the *F:I* ratio, or inventions, affecting the *F:I* balance but unnoticed by the more naïve spectator, may be perceived in some other aspect of the painting.

Similarly, to the knowledgeable and perceptive, the paintings of Masaccio, Raphael, and Copley may provide altogether imaginative and unpredictable solutions to the problem of figural depiction when considered in terms other than those of the traditional representational mode. The color and form relationships, the qualities of surface, the psychological suggestion of the subject in each work, and even the psychological relationship indicated between the subject and the observer may be seen as an extraordinary, unanticipated variant of a familiar approach to painting.

There is evidence that once exposed repeatedly to a work of art, the viewer will derive a more pleasurable response from the sheer familiarity of what he sees, even without a conscious effort to understand or like it. However, individuals are rarely forced to examine repeatedly art objects they do not care to experience, so that this gradual accommodation or adjustment happens infrequently. A person who desires to extend his response to complex and

demanding art objects will have to involve himself with the works as completely as he can. No doubt the unfamiliar aspects of the work will cause discomfort—even, on occasion, too much discomfort to permit continued involvement. Inevitably the motivation of the person seeking insight into the visual arts will be measured against the effort, emotional and intellectual, required to come to terms with demanding art objects. For some persons, motivation and capacity may be insufficient for sustained interest in a certain body of work, but this need not deter them from experiencing and enjoying such art as may satisfy their needs. Also, at another time that art now seen as too demanding or too disturbing may become familiar enough, in part, to permit a stimulating and satisfying interaction with the innovative portions.

Among the most important requirements for obtaining a satisfactory esthetic experience from unfamiliar art is the observer's willingness to take each work at its face value; that is, to accept it as a serious, rational effort of a serious, rational person. At one time this requirement would have seemed an unnecessary, and perhaps even bizarre, suggestion, because the public concept of the nature of serious art closely paralleled the appearance of the paintings and sculptures produced by artists. During the past century this condition has changed. The consistency between public expectation and artistic production no longer exists. We need only compare a group of paintings spanning the period from the fifteenth century to the beginning of the nineteenth with a group from the end of the nineteenth century to the present to see the evidence of the remarkable expansion of artists' concepts of the nature of a painting.

The three traditional works already cited—*Madonna and Child Enthroned* by Masaccio (Fig. 7), dated 1426, Raphael's *Madonna del Granduca* (Fig. 8), of about 1505, and John Singleton Copley's *Mrs. Thomas Boylston* (Fig. 9), painted in 1766—plus Edgar Degas' *Nieces of the Artist* (Fig. 10), from 1865, all share a common mode for the representation of form, space, and texture as found in nature. The methods of painting differ stylistically, but in each

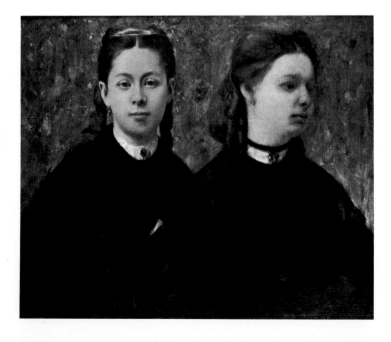

10. EDGAR DEGAS. *Double Portrait: The Nieces of the Artist.* c. 1865. Oil on canvas, 23⁵/₈ × 28³/₄″. Wadsworth Atheneum, Hartford.

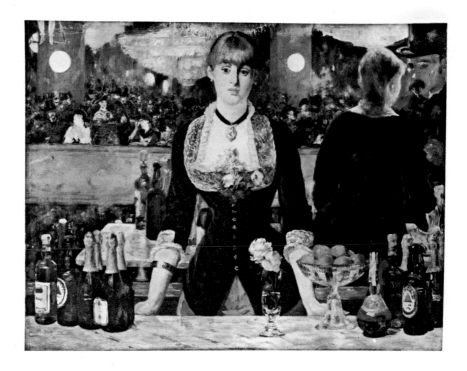

11. EDOUARD MANET.
A Bar at the Folies-Bergère.
1881–82. Oil on canvas,
3′ 1¹/₂″ × 4′ 3″.
Courtauld Institute
Galleries, London.

instance it seems that the artist wanted the viewer to be concerned with the representational image and not with the means employed to produce that image. For the materialization of all these works paint was applied to a surface, but the painting methods specific to each work remain unimportant relative to the significance of the subject matter illustrated.

Edouard Manet's *Bar at the Folies-Bergère* (Fig. 11), which dates from 1881–82, Paul Gauguin's *Poèmes Barbares* (Fig. 12), painted in 1896, *Girl*

12. PAUL GAUGUIN. *Poèmes Barbares.*
1896. Oil on canvas, 25¹/₂ × 19″.
Fogg Art Museum, Cambridge, Mass.
(Maurice Wertheim bequest).

13

Before a Mirror by Pablo Picasso (Pl. 2, p. 16), dated 1932, and Willem de Kooning's *Woman and Bicycle* (Pl. 3, p. 17), of 1952–53, are examples of paintings produced within a span of less than seventy years. Methods of representation and the application of paint differ markedly in these four works. It is possible to discuss stylistic differences in the paintings of Masaccio, Raphael, Copley, and Degas, but those differences seem slight when compared to the dramatic contrasts between one and another of the later works.

Comparison of the de Kooning with a 1967 canvas by Barnett Newman (Pl. 4, p. 18) reveals a distinction even greater than that existing between de Kooning's painting and the work of Picasso. Newman appears to reject every accepted attitude and method employed by the other artists. His large, unmodulated areas of flat color are an enigma to a major segment of the public, and though many of his contemporaries are working in a similar manner, others debate the validity and importance of this approach to painting, preferring their own concepts to his.

The reasons for these changes in the visual arts will be discussed elsewhere, but the fact does remain that works of art now being offered to the public, by serious artists, often leave the uninitiated confused and sometimes antagonistic. A contemporary observer, confronted with the profusion of approaches used by present-day artists, may question the values and the intentions that allow the wide range of styles and techniques. Questions such as, "Which approach is to be used as a standard for judgment?"; "Which technique demonstrates a skillful use of materials?"; perhaps even "Am I being hoaxed?" are typical expressions of the present division between the community of producing artists and potential consumers. A bridge over this chasm can be built, but it must be preceded by an attitude on the part of the observer that will allow the introduction of esthetic forms foreign to him. When faced with objects which at first glance may seem meaningless, the observer who seeks to understand contemporary art must give the artist the benefit of the doubt. The observer must grant the possibility that his inability to comprehend the works in question is due to an inadequacy in himself and not in them. He must assume, at least temporarily, a certain humility, a willingness to reserve judgment until he can be quite certain that his attitude is founded upon a clear understanding of what he sees. What has he to lose? Whatever his possible loss, it should be measured against the enrichment that can occur when the gap is closed and the observer finds in a work of art a meaning that once eluded him.

THE PERCEPTION OF THE OBSERVER

The deaf cannot react to the sounds of a Brahms symphony. The blind cannot know the sensation of a bright-red area juxtaposed to a green one of equal brilliance. Between the observer and the objects are the limitations imposed by the ability to perceive. Except for the blind, perception of the visual arts would seem to pose no difficult problems, but few persons of normal vision realize how limited their perception really is.

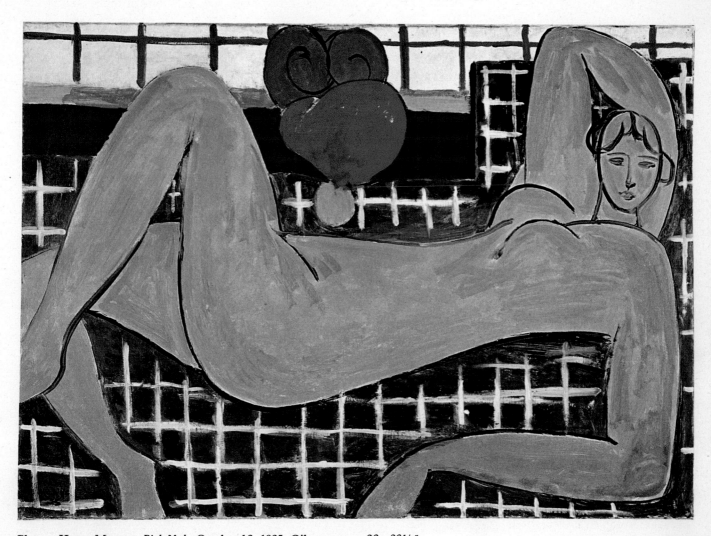

Plate 1. HENRI MATISSE. *Pink Nude*. October 16, 1935. Oil on canvas, $26 \times 36^{1}/_{2}''$.
Baltimore Museum of Art (Cone Collection). (See Figs. 209–214.)

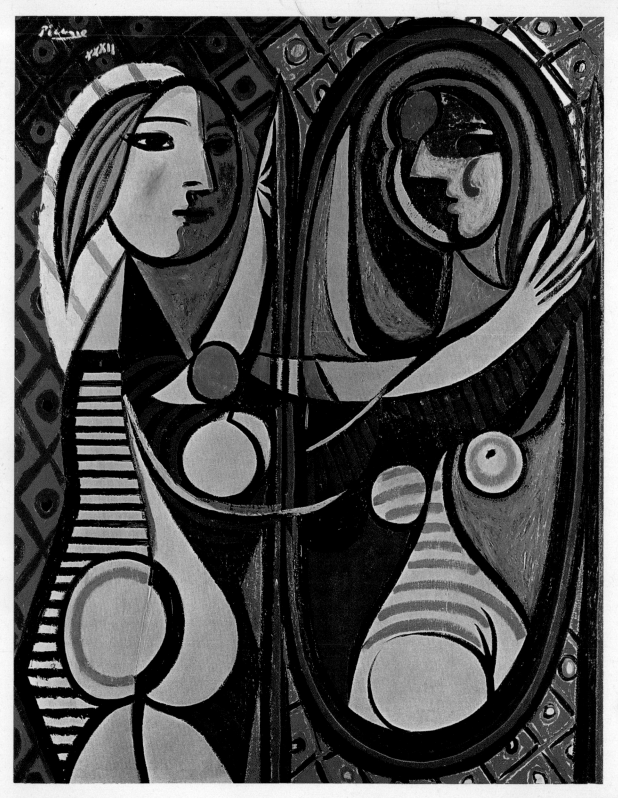

Plate 2. PABLO PICASSO. *Girl Before a Mirror*. 1932. Oil on canvas, 5′4″ × 4′3¹/₄″.
Museum of Modern Art, New York (gift of Mrs. Simon Guggenheim).

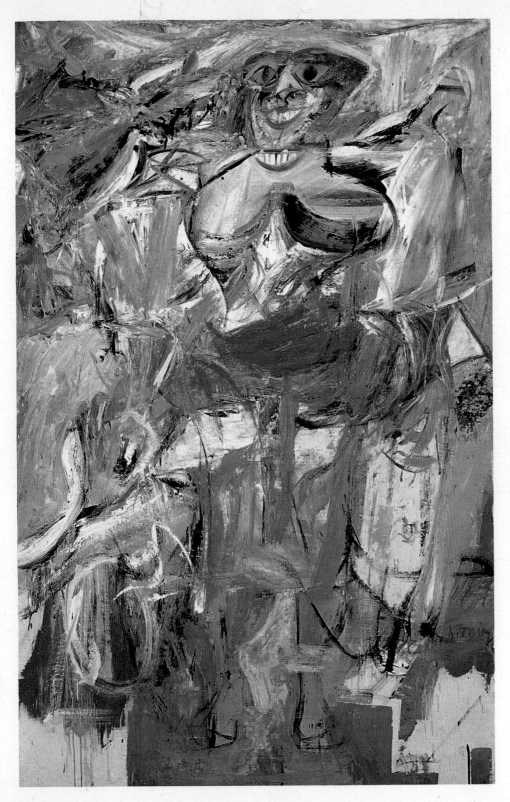

Plate 3. WILLEM DE KOONING. *Woman and Bicycle*. 1952–53. Oil on canvas, 6′ 4¹/₂″ × 4′ 1″.
Whitney Museum of American Art, New York.

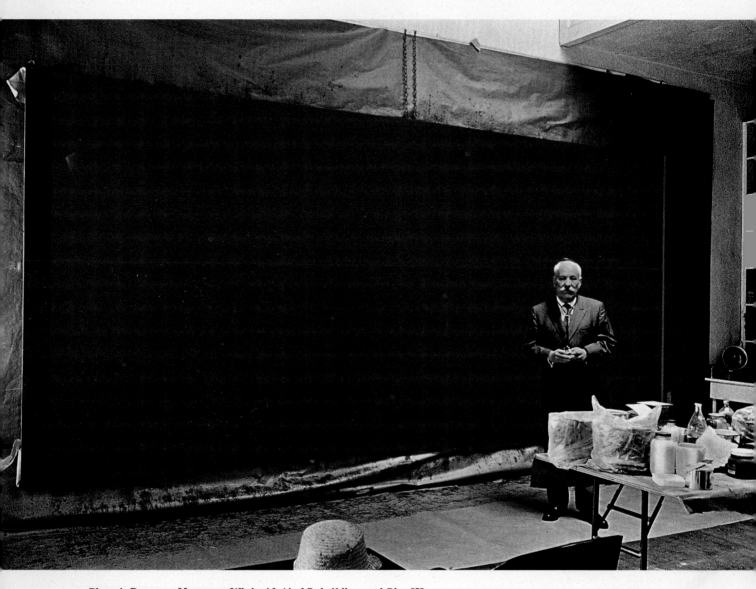

Plate 4. BARNETT NEWMAN. *Who's Afraid of Red, Yellow, and Blue III.*
1966–67. Oil on canvas, 8′ × 17′ 10″. Stedelijk Museum, Amsterdam.
The artist standing before his work.

18

Perception, our awareness of the world around us, based on the information that comes through the senses, is too often considered a natural, matter-of-fact attribute of the human being. The assumption is made that everyone sees the same things, that the world, as we know it through our sight, hearing, touch, and ability to smell, is the same for all. This is not so.

For some time psychologists and physiologists have known that there is a considerable difference between the raw information given to the brain by the senses (sensations) and our awareness of the world based on this information (perceptions). Professor J. Z. Young, an English physiologist, describes a number of experiments performed with individuals born blind who, in their later years, were enabled to see. Under these conditions the scientist has an opportunity to study the phases of visual training normally passed through by children, because the adult, unlike the child, can describe with accuracy what is happening to him. The once-blind person, now physiologically normal, does not "see" the world immediately.

> The patient on opening his eyes for the first time gets little or no enjoyment; indeed, he finds the experience painful. He reports only a spinning mass of lights and colours. He proves to be quite unable to pick out objects by sight, to recognize what they are, or to name them. He has no conception of a space with objects in it, although he knows all about objects and their names by touch. "Of course," you will say, "he must take a little time to learn to recognize them by sight." Not a *little* time, but a very, very long time, in fact, years. His brain has not been trained in the rules of seeing. We are not conscious that there are any such rules; we think that we see, as we say, "naturally." But we have in fact learned a whole set of rules during childhood.[2]

Young goes on to say that the once-blind man can learn to "see" only by training his brain. By expending a considerable amount of effort, he can gradually understand the visual experiences of color, form, space, and textures.

Some experimenters have expressed doubt concerning the use of the evidence given by adults who have gained their sight after being blind from birth. These psychologists believe that the experience of mature subjects cannot be assumed to parallel the perceptual development of infants because adults, in the process of aging, have had other sensory experiences that affected the development of their visual perception. Agreement does exist, however, that visual perception at all age levels is the result of a learning process; that man has the capacity to alter his perceptual ability and develop special forms of perception.[3] Therefore, what these experiments suggest is that the sensations we receive have no meaning for us until we know how to order them into a coherent perception. Sensation is only one part of perception. Also included in the construction of a percept is the past experience of the observer and his ability to combine sensations into a meaningful form. To perceive something requires that the observer make a selection of the numerous sensations transmitted to him at any one time. He must select those sensations which are significant for the construction of a particular experience and disregard those which are irrelevant.

It is not clear how much training and what kind of learning must go on, but many kinds of visual training take place in the normal course of growing up in a world already organized into a particular physical and cultural structure. The child learns to see objects that obstruct his movements. He learns, after falling numerous times, to step over his toys. He learns to recognize his parents and to interpret other visual experiences which are a part of living in his world. Visual information combines with other sensory data and interacts with emotional and intellectual functions of the brain to shape his perceptions. As he matures, the perceptual process appears to become automatic. Certainly the individual is unaware that it is taking place; only when special perceptual demands are made on him does he become conscious of an effort to develop abilities he does not possess. Biology students, who learn to interpret microscopic data, and medical students, who learn to perceive small changes in skin color and in the sound of the heart and lungs, have much in common with the

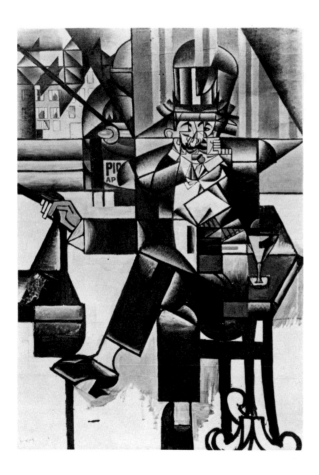

left: 13. JUAN GRIS. *The Man in the Café.* 1912.
Oil on canvas, 4′ 2 1/2″ × 2′ 10 5/8″.
Philadelphia Museum of Art
(Louise and Walter Arensberg Collection).

below: 14. GEORGES BRAQUE. *Man with a Guitar.*
1911. Oil on canvas, 45 3/4 × 31 7/8″.
Museum of Modern Art, New York
(Lillie P. Bliss bequest).

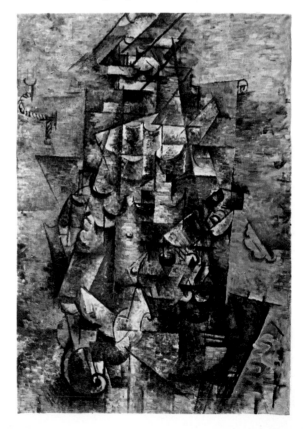

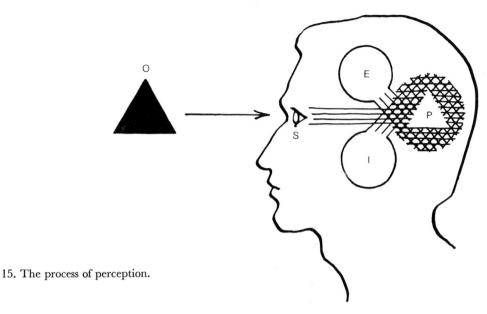

15. The process of perception.

novice in the visual arts, who must become aware of relationships that an untrained observer would pass over.

The perception of pictorial images which are a part of everyday activity, photographs and drawing of ordinary objects and their function in daily life, develops in the first years of childhood. But when the person trained to perceive the ordinary visual symbols is confronted by the paintings of the Cubists (Figs. 13, 14) the rules that apply to the perception of a photograph do not work to give meaning to the picture. Juan Gris and Georges Braque use different structural patterns from those which would appear in a photographic representation; their patterns cannot be understood if the observer's visual training has been limited to that required for the perception of photographs. The chaos that may appear to exist in Cubist painting can be seen as a coherent image by the viewer who has been taught to "read" Cubist art. Repeated exposure to this kind of painting may result in a form of understanding even without the benefit of formal training.

This process of perception can be diagramed in the following way (Fig. 15): *O* represents an object or experience existing in the world outside the observer. It may be a single work of art or a complex pattern of interrelated phenomena. Information about this object is gathered by the sense organs (*S*). In the case of the visual arts the organ would most often be the eyes of the observer, but it could also be the finger tips, which might move across the surface of a piece of sculpture. In the design of certain buildings the sounds of water or the rustle of the wind through the branches of trees have been considered important elements of the plan, requiring the use of the ears as information receivers.

The sensory input (*S*) is sent to the brain, where it is interpreted. The interpretation is affected by the past experience of the observer, which may be labeled *E*. This experience would include the accumulation of daily interactions with the environment in which the observer has lived, his geographical location, his economic and political background, his religious involvement, his

friends. Included also would be the formal training given to him in schools. It is important to note that past experience is not a static quantity or quality. It changes with time as the observer lives, reads, observes, and is taught. E is different for every person, for though there may be great similarities between the past experience of individuals within a common cultural environment, no two persons can ever have identical past experiences.

Interpretation of the sensory input is affected also by factors other than past experience. Intelligence (I) functions, as do the emotional attitude of the moment and the intensity of concentration. Even the observer's physical state may cause the input to be colored in one way or another. Thus, a combination of sensory input, past experience, intelligence, and attitude operate to produce the perception (P) that was initially stimulated by the object (O).

The value of this brief analysis is to be found in the steps indicated between the originating object and the final perception. Too often the assumption is made that object and perception are one, that individuals will perceive a single object or a single experience (which can be considered an object in our diagram) identically. Of course, this is just not so, and, in fact, it is possible that any one person may have different perceptions of the same object at different times. A change in experience or a more sympathetic attitude may change a perception so that a new vision or insight occurs. Like the subjects in the experiments described by Young, the observer, once "blind," may be given sight.

The perception of meaning in a work of art is not automatic, even though it appears to be so for some works. The training and effort required of the artist for the production of his work often requires a parallel preparation in the public which expects to respond to it. The creative artist begins the chain that leads to esthetic experience, but his responsibility ends in the studio. At this point the responsibility shifts, and it is the observer who bears the burden. If he is satisfied that his perceptual training is equal to the demands made by the artist, then he can question the content and the values implicit in the objects before him. If not, the serious observer can react only to what he finds meaningful; many paintings and pieces of sculpture will remain enigmatic to him until that time when he is prepared to respond to them.

APPRECIATION AND VALUES

We are continually making judgments—deciding which action is right, which article of clothing suits the demands of a social situation, whose opinion is valid. This concern for values finds its expression in the public response to the visual arts as it does in other areas of activity. The questions most frequently heard are: "How do you know it's good?" and "Who decides what is good or bad?" In a society that places a premium on making the *proper* choices there is a natural desire to establish a basis for choice in the area of the arts. Should art appreciation have as its goal the development of the ability to make esthetic judgments, to tell a bad painting from a good one, to recognize a poor building,

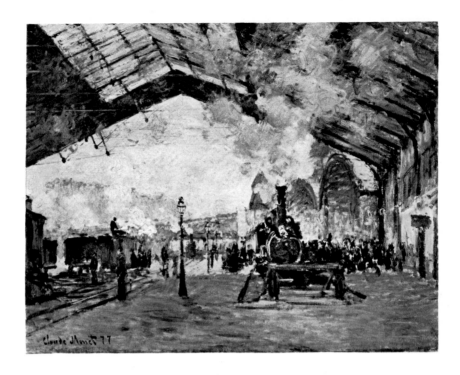

16. CLAUDE MONET.
Old St. Lazare Station, Paris.
1877. Oil on canvas,
$23^{1}/_{2} \times 31^{1}/_{2}''$.
Art Institute of Chicago.

a mediocre piece of sculpture? What do words that connote value—"great," "good," "bad," "poor," "mediocre"—mean when applied to the visual arts?

If it is assumed that there are universal, precise criteria which may be applied to the visual arts, then the application of value terms such as "good" and "bad" suggests that the critic who makes the evaluation is familiar with the terms, is capable of analyzing the work in question, and can apply the terms with objectivity. The question of absolute values in the area of esthetics has concerned philosophers for centuries. Many estheticians have attempted to construct value systems for the arts. None of them has proved adequate. Inevitably the judges are confronted with the application of the rules they have constructed, and it is at this point that major problems arise, for it is impossible to eliminate the personal responses of the viewer from his function as a judge.

Also difficult is the application of rules that were adequate in the past to new works of art, which appear to deny, or even to defy, tradition. The classic example of the confusion that can occur when traditional values are applied to new art forms is to be found in the general critical response given the works of the Impressionist painters in the latter half of the nineteenth century. The paintings of these artists were rejected by the large mass of the public, the critics, and museums because they introduced methods of paint application and color usage which were not consistent with previous practice. Paintings by Monet (Fig. 16), Renoir (Pl. 5, p. 35), Pissarro (Pl. 6, p. 36), and others, which now seem unquestionably fine works of art, were reviled and damned as the products of charlatans or madmen.

There are estheticians who deny the importance of external criteria. They insist on personal, subjective responses as the basis for judgment in the arts. Their judgment becomes a form of communion between the work and the observer. If the observer is moved—if he feels an emotional, an esthetic, or a moral response to a painting, a building, or a statue—it becomes good. Works which do not fulfill this expectation fail and are therefore placed in the lower levels of esthetic achievement. Here again the assignment of values to art objects has obvious difficulties. The very personal responses in one critic carry with them no assurance of similar reactions in others. Even if it is assumed that all those who examine the body of work to be found in the visual arts have a similar educational and social background, there must be differences of intellect, personality, and physical makeup which will affect attitudes and judgments.

Obviously, the assignment of values in art is a complex, often confusing business. Yet critics do operate in the visual arts, and though an examination of their writings reveals many areas of conflict, points of agreement actually exist. Certain works of art can be valued more highly than others as esthetic objects. The recognition given to such productions is achieved because, over an extended period of time, they have been considered by those with broad experience in art to be the exemplars of their kind. This judgment is not the expressed opinion of the general public but the evaluation of specialists, individuals who have made the study of art their life's work. Whatever the criteria employed by these judges, they have arrived at some common understanding of quality. They do say, as a body, "This work is good," and their opinions joined in a composite judgment constitute a significant comment upon the arts.

We must acknowledge, however, that these are opinions and no more than that. They represent individual, personal attitudes, whether taken singly or as a part of the judgment of history. These experts bring to their judgments a vast accumulation of experience. They have seen many works of art and can make comparisons between a specific work and thousands of other paintings and pieces of sculpture. When they say that a work of art is good or great, they are, in effect, saying that, compared to the many similar works they have seen before, this particular example communicates its message in a manner equal to or better than the others. Nevertheless, one must always remember that not even experienced critics can make absolute judgments, though their opinions may sometimes carry great weight. Their statements are subject to review, as are the opinions of all of us. The critical limitations of those who condemned the Impressionists can be demonstrated in many other instances. Tastes and values can change. All esthetic judgments may eventually be reexamined and reevaluated in terms of new cultural relationships. Yet the attitudes of the trained critics are valuable. The critics' contact with art is many times greater than that of the average museum visitor. They have studied the art of the past and are aware of current production. Because of their preparation and experience, they can guide the untrained observer to an understanding of art of the past and the present by enlightened comment and a cultivated choice of exhibition material. They can say to the novice, "Here are the works of art which

have given me an esthetic experience. In my considered opinion they are the best of their kind. Perhaps you, too, may find in them the satisfaction they have provided me."

"Should art appreciation have as its goal the development of the ability to make esthetic judgments?" The answer to this question must be in the negative. The confusion and uncertainty that surround the problem of values in the arts when specialists deal with it would be compounded when left to the nonspecialist. Of course, no one is barred from the game of awarding critical accolades to the particular works of art which strike his fancy, but the significance of the award is doubtful.

One should not confuse art appreciation with art evaluation. The goal of art appreciation should be the achievement of an esthetic experience. An individual may be guided toward this experience by the knowledge and sensitivity of others; he may help himself by learning the language of art; but in order to achieve this experience he should look at art to react to it, rather than to judge it. If he responds to works of art which are considered mediocre, or even bad, by the experts, the works can still have value for him. Given the opportunity to see a large number of paintings and pieces of sculpture, and given the training to perceive the significant relationships within them, the observer may eventually find that the objects once important to him no longer satisfy his esthetic needs. The forms, colors, and images that prompted his initial reactions may in time lose their impact. The familiar, comfortable portion of the work may, indeed, become commonplace and possibly boring. The strange, enigmatic aspects of some works may appear less formidable, no longer alien to his experience and now susceptible to examination and contemplation. At this point the example of the trained observers can prove valuable, for if their esthetic needs have been satisfied by certain art objects, it is possible that, in time, the less experienced observer will find satisfaction there too.

The importance of an evaluation depends on the experience and the ability of the judge. Intelligent evaluation may be a guide to appreciation of the visual arts, but it should not be considered the ultimate goal of the person who seeks meaning in the arts.

THE ART OBJECT

What is a work of art? In general usage the term "work of art" may include the manifestations of a wide range of human activity, from the use of the spoken and written word to the exploitation of the body in movement. It includes objects of minute size and delicate craftsmanship and constructions of huge proportions.

The objects in Figures 17 and 18 are both examples of the art of the ancient Greeks. One is a bronze figurine from the sixth century B.C., the other, a great temple of the goddess Athena, the Parthenon, built in the fifth century B.C. Both are considered works of art, and yet they display obvious differences in size, material, and function. Compare these two examples with a painting by Pablo Picasso (Fig. 19) and a piece of sculpture by David Weinrib (Pl. 61, p. 281; Fig. 20), both produced in the twentieth century, and the dissimilarity between works of art will appear even more striking.

A definition of *art object* requires a definition of *art*. Many usages of the term "art" can be found in the current editions of dictionaries and encyclopedias. In addition, there are numerous personal definitions and theories presented by individual writers and philosophers. Dictionary and encyclopedia definitions typically are neutral in their point of view, with little or no area for argument. On the other hand, estheticians tend to define their own personal concepts of art and its functions, often stressing some particular facet of the definition that seems important to them in the context of their own philosophical

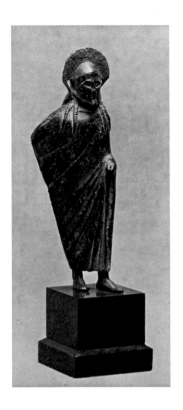

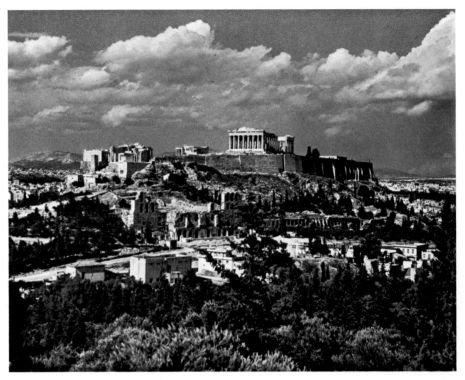

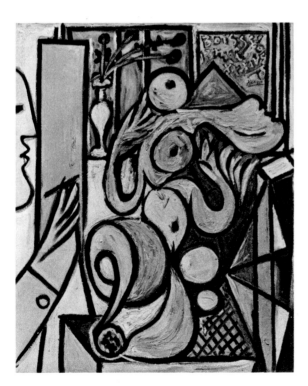

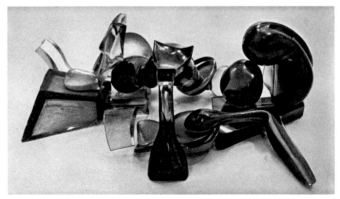

top left: 17. *Draped Warrior.* Greek. 6th century B.C.
Bronze, height 7 1/2". Wadsworth Atheneum, Hartford.

top right: 18. ICTINUS and CALLICRATES. The Parthenon,
on the height of the Acropolis, Athens. 448–432 B.C.

left: 19. PABLO PICASSO. *The Painter.* 1934.
Oil on canvas, 39 1/4 × 32". Wadsworth Atheneum, Hartford
(Ella Gallup Sumner and Mary Catlin Sumner Collection).

above: 20. DAVID WEINRIB. *Polychrome No. 1.* 1966.
Plastic, 18 × 36 × 36". Courtesy Royal Marks Gallery, New York.

preferences. The great variety of meanings attributed to the word "art" emphasizes the desire of men to explain what appears to be a universal human activity. Social groups throughout time, in every part of the earth, have channeled some of their energies into the production of esthetically satisfying objects. Why do they do this, and what qualities inherent in the objects formed separate them from purely utilitarian products? These questions and others intended to define the nature of the esthetic object and our response to it have yielded no absolute conclusions, but certain concepts do recur in most definitions, so that it may be possible to develop a single definition broad enough to include most of the individual concepts.

Differences in the definition of art are concentrated in two major conceptual positions: There are those who see the work of art primarily as a means of expressing and communicating ideas and emotions, and then those who look at the work of art as an object to be perceived as a thing in itself, with little or no reference to other areas of experience. The first group of writers considers the storytelling or imitative aspects of art to be its essential characteristic. "What is the artist saying?" "What sort of picture of the world does he present?" These are questions the writers ask. Often the estheticians in this group expect the message communicated by the artist to have special qualities, "moral" or "real." They expect to find a meaning in art with a reference to the life and experience of those exposed to the art object. Lev Tolstoi, a nineteenth-century Russian author, reflected this point of view in his book *What Is Art?* (1896) when he made the following statement: "To evoke in oneself a feeling one has experienced, and having evoked it in oneself, then by means of movements, lines, colors, sounds, or forms expressed in words, so to transmit that feeling that others may experience the same feeling, that is the activity of art."

In direct contrast to the position taken by Tolstoi and those who agree with him is that of Clive Bell, an English esthetician. Bell is known for his defense of the work of the young European artists of the early twentieth century who rejected the traditional, academic storytelling art that was then held in high regard. These artists deemphasized the importance of representational subject matter and placed a stress upon formal design. In effect, these artists were more concerned with the appearance of the object they were making than with what the object represented. In stating the position of his esthetic, Bell wrote:

> What quality is shared by all objects that provoke our esthetic emotions?... Only one answer seems possible—significant form. In each [object], line and colors combined in a particular way, certain forms and relations of forms, stir our esthetic emotions. These relations and combinations of lines and colors, these esthetically moving forms, I call "Significant Form"; and "Significant Form" is the one quality common to all works of visual art.
>
> .
>
> Let no one imagine that representation is bad in itself; a realistic form may be as significant, in its place as part of a design, as an abstract. But if a representative form has value, it is as form, not as representation. The representative element in a work of art may or may not be harmful; always it is irrelevant.[1]

In the painting *Starry Night* by Vincent van Gogh (Pl. 7, p. 37) Tolstoi might have emphasized the expression of emotion, which seems to have filled Van Gogh prior to or during the painting of this picture; the swirling movements of the sky, which pulsates with all the surging excitement of the imagination of a mystic who searches the heavens, aware of the invisible forces in the vastness of the universe; the sense of the contrast between this drama in the heavens and the peaceful unawareness of the sleeping village on earth. For Clive Bell the facts of the sky, the moon, the cypress tree, and the village would have been unimportant in comparison with his own excitement as he reacted to the spiral forms, the repeated curved movements, and the contrast of the rich blues and the yellows juxtaposed in agitated brush strokes.

Tolstoi's approach emphasizes the expressive or communicative side of art; Clive Bell's attitude emphasizes the formal side of art. Estheticians agree that these two points of view are not mutually incompatible.

It is possible, perhaps even necessary, to have both the formal and the expressive, or communicative, elements in a single work of art. There is growing evidence that the insistence on formal and expressive principles in art is based upon something more substantial than the personal intuition of philosophers. Psychological studies in recent years have given new insights into the human esthetic impulses, relating them to the human need to communicate and to structure experience. The growing catalogue of psychological studies of the creative expression of the human being suggests that all men have within them the potential seed of this formal communication which we have labeled "art." The difference between the artist and any other human being with this dormant potential is to be found in the ability of the artist to bring forth what the others are incapable of producing. The artist, for one reason or another, develops the manual facility and the intellectual and emotional capacity to make manifest that which in its essence is a part of all human beings. Henry Schæfer-Simmern, in *The Unfolding of Artistic Activity*, says:

> All normal children display this inner drive for pictorial creation. Drawings on walls, doors, pavements, are visible proofs of the child's inborn creativeness. But because, in the general education, attention is still mainly directed toward acquisition of conceptual knowledge, the child's spontaneous drive for genuine visual cognition is neglected. As he grows older, the creative urge diminishes. It is therefore understandable that in most persons visual conception and its pictorial realization are not developed beyond the stages of childhood. But the ability itself has not vanished. It is always latent and can be awakened.[2]

Schæfer-Simmern's comment on the child's need for pictorial expression is illustrated by the examples of children's spontaneous drawing found in the streets throughout the world (Figs. 21–24).

The visual arts may be considered as communication, as formal organization, or as a combination of both, but it is also possible to examine the products of the artist as the results of a skilled manipulation of materials. Artists find pleasure in the act of applying paint or cutting into the resistant surface

21–24. Children's street drawings. Chalk.

above left: 21. Exterior doorway, Cornelia Street, New York. 1956.

above right: 22. *La Sposa (The Bride)*. Pavement in Anguillara, Lazio, Italy. 1959.

far left: 23. Barred and shuttered window, Ronda, Andalusia, Spain. 1958.

left: 24. Sidewalk, Cornelia Street, New York. 1955.

of a granite block, and the viewer can also respond to or empathize with the manner in which materials have been controlled and combined in the process of forming the art object.

No art object can exist unless someone has formed it. The wood or stone which eventually becomes the statue, the paint and canvas which fuse to form the painting, and certainly the many materials which are combined to construct even the simplest building must be worked, manipulated, and managed to produce the forms that constitute the work of art. As a master of materials, the artist becomes the craftsman. He must know his materials and how to work them. The artisan or craftsman differs from the artist in that the craftsman's concern is almost exclusively the handling of the materials. He learns to control his media and to exploit their surfaces, structures, and forms. The artist requires these skills too, but they are only a part of his art. They must remain the means by which he achieves the end of his work, which is communication and/or esthetic organization.

How much skill is required? Obviously, enough to do the job. The measure of the skilled use of materials in a work of art is directly related to the intention of the work. When a limited skill in drawing, painting, or carving causes an artist to produce work that is obscure in its intent, when incomplete knowledge

of the structural and visual qualities of his materials limits the resolution of the architect's design, then the artist is not the craftsman he should be.

On the other hand, a viewer must recognize that the fulfillment of the artist's intention may require a use of materials that departs from tradition. The application of minute areas of paint to a smooth surface with almost invisible brush strokes may indicate a consummate craftsmanship on the part of the painter, but it does not set an absolute standard for the measurement of skill in painting. In another time, for another purpose, the skilled artist may require an application of paint in large, obvious splashes, or perhaps he will need the surfaces and textures of paint dripped or sprayed. The choice of the technical means to produce his work is the artist's.

The two drawings by Picasso illustrated here are examples of the extremes to which the manipulation of material can be carried. In the drawing *Girl with Necklace* (Fig. 25) the flowing, graceful line is carefully and accuretaly inscribed. The sensuous, curved forms are traced without a single misstep. No superfluous mark detracts from the continuity of the edge. In total, the quality of the line adds to the image of serenity and grace. The artist's virtuosity is obvious in the control of the line and in the accuracy of its placement in the space of the paper.

Contrast this figure drawing with the study *Head* (Fig. 26). The scrawled, crude areas are shocking in their apparently careless forms. Gone is the controlled, studied grace, and in its stead is an example of what appears to be a drawing produced in an undisciplined emotional frenzy. We know that Picasso has the ability to draw with grace and accuracy. Can both drawings be the result

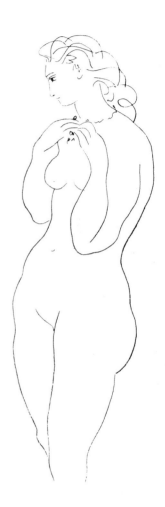

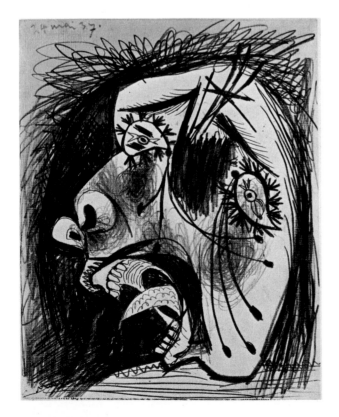

above: 25. PABLO PICASSO. *Girl with Necklace.* 1944. Pen drawing. Private collection.

left: 26. PABLO PICASSO. *Head* (study for *Guernica*). May 24, 1937. Pencil and gouache on white paper, $11\frac{1}{2} \times 9\frac{1}{4}''$. Museum of Modern Art, New York (on loan from the artist).

of a skillful use of the materials? The answer is to be sought in the intent of the artist. What is Picasso attempting to do in the second drawing? Could he have produced the anguish he wished to communicate by drawing his forms with a graceful, flowing line? The drawn line has the potential of being used in many ways. The choice Picasso made in each of the two drawings was based upon his awareness of the material he was using. The employment of that material in one drawing is no more skillful than its use in the other. It is the intention that controls the technique, and it is difficult to separate intention from technique in the appreciation of any work of art.

Another somewhat provocative definition of art is offered by the American painter and teacher Robert Henri, who wrote in *The Art Spirit* (1923):

Art Is the Attainment of a State of Feeling: The object of painting a picture is not to make a picture—however unreasonable this may sound. The picture, if a picture results, is a by-product and may be useful, valuable, interesting as a sign of what has passed. The object, which is back of every true work of art, is the attainment of a state of being, a state of high functioning, a more than ordinary moment of existence. In such moments activity is inevitable, and whether this activity is with brush, pen, chisel, or tongue, its result is but a by-product of the state, a trace, the footprint of the state.

These results, however crude, become dear to the artist who made them because they are records of states of being which he has enjoyed and which he would regain. They are likewise interesting to others because they are to some extent readable and reveal the possibilities of greater existence.[3]

Henri's statement is that of the artist who says, "Art is what I produce when I am performing my function as an artist, an activity I can distinguish from the many other activities I engage in because it causes me to feel fulfilled and elated." This highly subjective definition is in accord with the thought of the eighteenth-century German Romantic poet-dramatist Friedrich Schiller as well as that of Herbert Spencer, the late-nineteenth-century English philosopher of the theory of evolution. It regards art as the result of play, which is conceived of as activity pursued for itself, not intended for direct application.

The artist's definition of his own art has particular relevance when we consider the work of those innovators who reject the traditional art forms of their time as a basis for new expression. If an artist is motivated to create objects or experiences that fulfill and satisfy him and yet appear to have no precedents, he cannot use established criteria for justifying the esthetic value of his work (Pl. 8, p. 38). It does not matter that at some later date the artist, or someone else, may find significant connections or parallels between the new work and earlier art forms, for the avant-garde artist, at the time of his creative activity, must act as his inner necessity directs.

Mike Heizer is an artist who digs giant trenches on the flatlands of Nevada and California, using a variety of excavation tools. Some of these trenches (Fig. 27) stretch intermittently for distances in excess of 600 miles. Heizer has been described as being at odds with an art world that is impos-

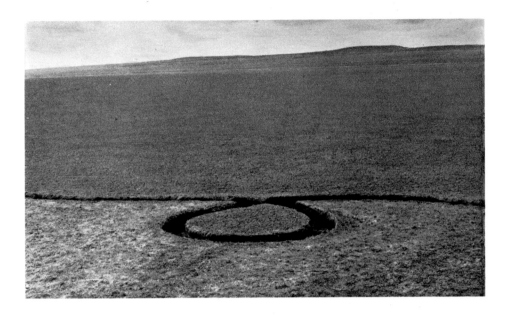

sibly "full of objects already." He is quoted as saying, "Artists have been misled into thinking that you have to create something in order to contribute to art. . . . I want to create without creating a thing. I want to create without mass and volume." Of his work he says, "I make it for myself and for art but for no one else. . . . Art is only memory anyway."[4]

It is interesting to note that Heizer's pursuits have parallels in earlier human activity. Of course, it cannot be suggested that prehistoric peoples were motivated by the same subjective needs that energize this contemporary artist, but in a purely physical way his efforts present a comparison with earthworks constructed at various sites throughout the world by societies that gave an esthetic order to large topographic compositions. One such example, in Adams County, Ohio, is a construction in the form of a serpent (Fig. 28), the

above: 27. MICHAEL HEIZER.
Circumflex. 1969.
Earthwork, length 120′.
Massacre Dry Creek Lake, Vya, Nev.

right: 28. Great Snake Mound,
Adams County, Ohio.
Prehistoric period. Length 1,254′.

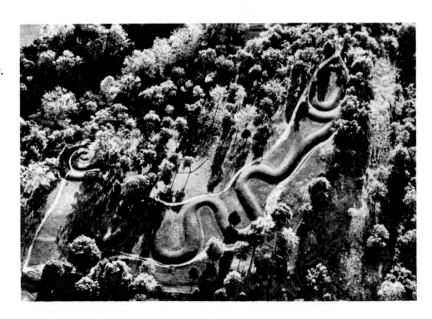

work of a people identified with the Adena culture. Measuring 1,254 feet in length, the mound has an average width of 20 feet and a height that varies from 4 to 5 feet. The two crescent walls that form the open jaws are 17 feet wide and 75 feet across. The Adena people are thought to have lived over two thousand years ago and are believed to have used the mound as a ritual object, for it does not seem to serve any practical purpose. At a great expenditure of time and energy this people shaped the earth into a monument. Their motivation must have been strong, for their effort certainly was prodigious. Once completed, the serpent could not have been seen as a whole, for there was no high ground from which to observe it. Today, visitors to the site are required to climb a tower constructed for this purpose, and they can see what the builders could know only in their minds.

When Mike Heizer says, "I want to create without creating a thing; I want to create without mass and volume," he goes beyond the art forms he has produced in the desert. His trenches are, in fact, material entities. They do exist, they have measurable dimensions. Heizer is not alone in his desire to achieve a nonmaterial art. He is one of a group of artists who believe that the creation of art is possible without the production of an object or an event. Identified as *conceptual artists*, these members of the avant-garde are challenging the primary traditional assumption that artists are object makers. They deny the importance of the work of art except as it exists in the mind of the creator.

The conceptual artist insists that all art objects are essentially information systems; a painting, a building, a statue, or a photograph are physical equivalents for a conception or a state of mind. Conceptualist Joseph Kosuth says, "Physical things deteriorate, art is strength of idea, not material." The idea is the form. After the conception, any form of communication—pictorial, diagrammatic, symbolic, or verbal—expressive of the idea is legitimate.

Douglas Huebler, who began as a sculptor, conceived of the following project. He drew a line across a United States map on the 42nd parallel (Fig. 29).

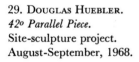

29. Douglas Huebler.
42º Parallel Piece.
Site-sculpture project.
August-September, 1968.

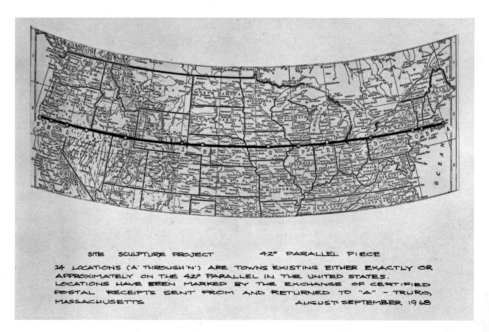

SITE SCULPTURE PROJECT 42° PARALLEL PIECE
14 LOCATIONS ('A' THROUGH 'N') ARE TOWNS EXISTING EITHER EXACTLY OR APPROXIMATELY ON THE 42° PARALLEL IN THE UNITED STATES. LOCATIONS HAVE BEEN MARKED BY THE EXCHANGE OF CERTIFIED POSTAL RECEIPTS SENT FROM AND RETURNED TO "A" - TRURO, MASSACHUSETTS AUGUST-SEPTEMBER 1968

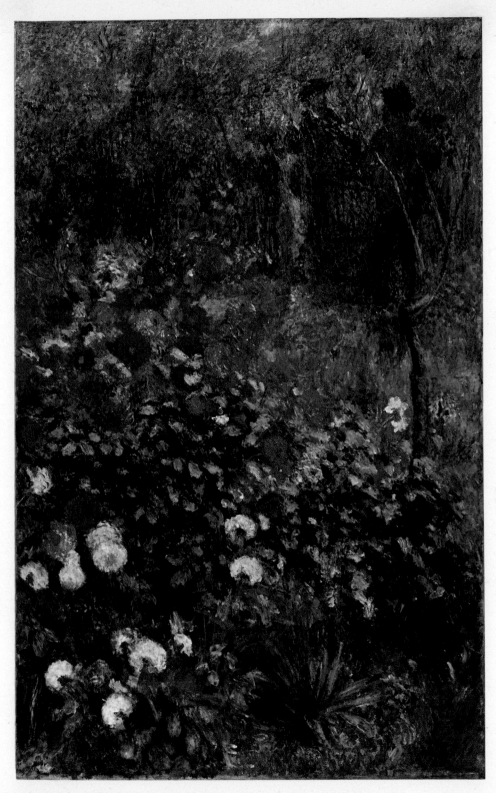

Plate 5. AUGUSTE RENOIR. *The Garden in the Rue Cortot, Montmartre.* 1876.
Oil on canvas, 5′1/2″×3′ 2¹/2″. Museum of Art, Carnegie Institute, Pittsburgh.

35

Plate 6. CAMILLE PISSARRO. *The Meadow and the Great Walnut Tree in Winter, Eragny.* 1885.
Oil on canvas, 23¹/₄ × 38¹/₂". Philadelphia Museum of Art (W. P. Wilstach Collection).

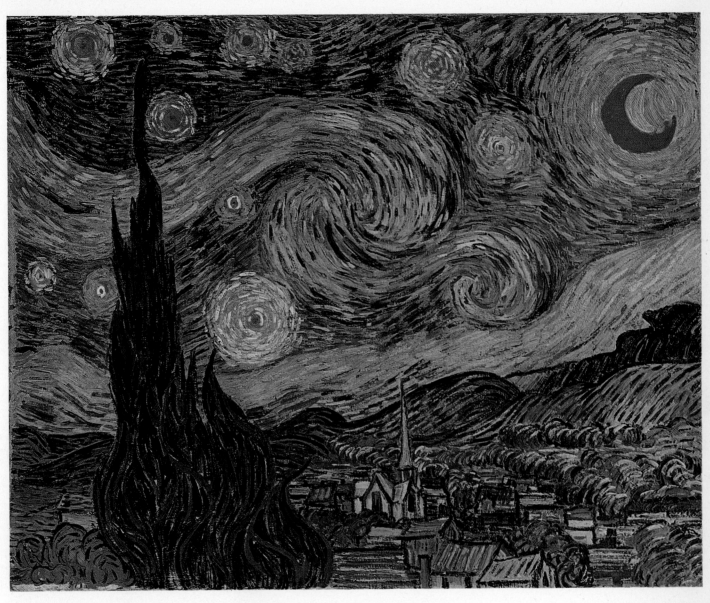

Plate 7. Vincent van Gogh. *Starry Night*. 1889. Oil on canvas, $29 \times 36 \frac{1}{4}''$.
Museum of Modern Art, New York (acquired through the Lillie P. Bliss Bequest).

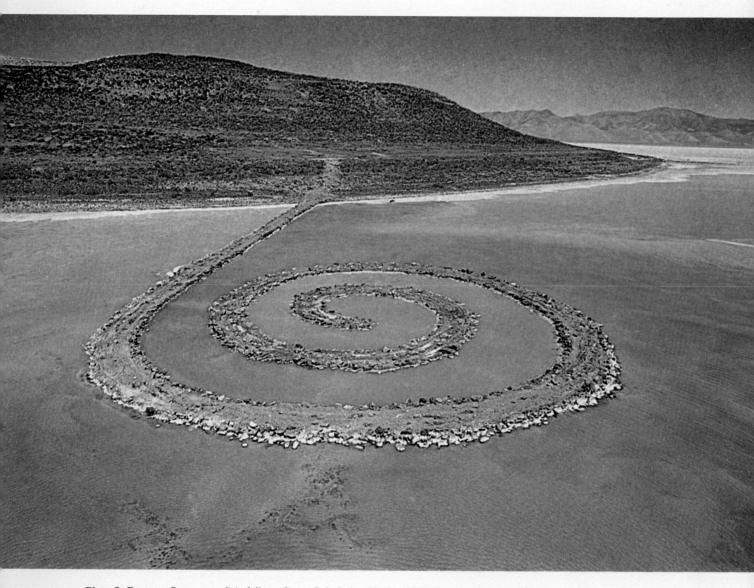

Plate 8. ROBERT SMITHSON. *Spiral Jetty*, Great Salt Lake, Utah. 1970. Length 1500′, width 15′.

On this line he identified fourteen towns between the east and west coasts. He visited the towns, sent certified postal receipts from each location to a central collection point. After completing his tour he made a report of the experience, including in it written and photographic descriptions. For Huebler the complete work of art embraces the conception of the trip, the experience of making the trip, and the graphic representation of that experience. The artist has had an adventure in time and space which followed an experience that occurred within him.

Without equivocation, it is possible to say that Huebler's experience conforms to the basic proposition put forward by Robert Henri, though it is probable that Henri could not have anticipated this extension of his ideas.

There are those who contend that much is lost in the arts if the production of real objects is not a direct result of the creative process. The argument is made that the transformation of physical material into esthetic structures stimulates ideas and actions that could not have been anticipated before the actual process began. From this more traditional point of view the art object is not simply a symbolic expression of an idea previously conceptualized in total. It is a participant in an activity whose final form is the result of the artist's motivating conception and the interaction that occurs between the artist and his material as he struggles to give it form.

Summarizing then, we may say that a work of art can be described as *a product of man which has a defined form or order and communicates human experience.* To this may be added that it is *affected by the skilled control of the materials used in its construction to project the formal and communicative concepts that the artist wishes to present.*

Such a definition is broad enough to include, within its limits, a great many man-made objects and creative activities. Commercial advertising design, interior decoration, industrial design of commercial and personal objects, sewing, pottery making and other crafts—even the writing of a letter—can fall within the definition suggested. It is also broad enough to allow for the attitude of the highly subjective artist who argues that art is the product of his activity as an artist, requiring no additional modification.

In addition, every work of art has physical limitations, though these do not necessarily comprise a part of the definition. Two-dimensional and three-dimensional objects can be measured, whether they be miniatures or great building complexes; works that include time as a part of their construct have a beginning and an end. To comprehend an art object as a physical entity is to be aware of these dimensions.

Equally important is a comprehension of the difficulty that exists in defining the limits of the symbolic or metaphoric content in a single art object. Because the symbolic and/or metaphoric meaning is, in large part, dependent upon the response of each observer, there is an infinite number of possible responses and interpretations for any one painting or piece of sculpture. The work of art can therefore be said to have limited physical dimensions that can create an unlimited variety of metaphysical responses in those who interact with it.

The inclusiveness of our definition recognizes the potential for esthetic experience in many products of human activity, but no attempt is made in the definition to provide a guide for the establishment of value in the visual arts. It does not separate great art from the mediocre. Each of the art forms within the definition has the potential for a superior esthetic achievement. Some forms may seem more limited in possibilities for full exploitation of one or more of the facets of the definition. Sewing and weaving for instance, would appear to have greater limitations in communication than does painting (Figs. 30, 31); pottery, too, would seem to be less effective than sculpture as a means of expressing ideas and emotions; and yet in the hands of a sensitive artist these art

30. Friendship quilt, from Baltimore. 1844. Cotton appliqué on muslin, 6′ 2 ¹/₂″ square. City Art Museum of St. Louis (gift of Mrs. Eugenie Papin Thomas).

forms do affect a viewer, and certain examples rise above the level of craft object to become important works of art (Fig. 32).

The definition of a work of art suggested here will be that understood throughout this book. Though it will be applied only to the arts of painting, sculpture, and architecture, the reader should remember that the statements made in reference to these particular art forms will have application to all the visual arts.

BEAUTY

Nowhere in this definition is the idea of beauty included. This may seem a strange oversight, for the word "beauty" is almost always found in conjunction with art in casual discussions of the subject. The concept of beauty is one of those silent attendants to be expected alongside the person who looks at a work of art.

For many people a work of art must be beautiful, but, faced with some contemporary paintings, buildings, or sculpture characterized as works of art, these people feel confused and disturbed, for what they see before them they consider not beautiful, but ugly. Since it is ugliness they recognize, how can they reconcile this disturbing conflict between art and the absence of beauty?

The questions that must be asked are: "What is meant by the words 'ugly' and 'beautiful'?" and "Must these qualities be present in a definition of a work of art?"

There are two basic concepts of the meaning of beauty. In one point of view beauty lies in the subjective response of a person upon contact with an external stimulus: the sense of the beautiful lies within us. Something outside ourselves can make us feel this sense of beauty, but the feeling is not a part of the object that triggered this response; it is solely and completely within the onlooker. In the second point of view beauty is an inherent characteristic of an object or an experience. It is the relationship of the individual parts in their combination that the viewer recognizes as beauty.

These two definitions appear to approach beauty from two opposite poles. Those who think of beauty as existing solely in the unique responses of the

above: 31. Nazca fabric in tapestry weave (detail), from Peru. Pre-Columbian, A.D. 400–1000. University Museum, University of Pennsylvania, Philadelphia.

below: 32. Chinese vase. Han Dynasty, 206 B.C.–A.D. 229. Porcelaneous stoneware, height 16¹/₂″. Metropolitan Museum of Art, New York (bequest of Mrs. H. O. Havemeyer, 1929; H. O. Havemeyer Collection).

individual are examining the experience from an observer's point of view. Those who think of beauty as inherent in an object or experience are seeing it from the point of view of the creator, the person who must decide how to make his work beautiful.

The first attitude was expressed by the English esthetician Edgar Carritt, about 1914: "We cannot reflectively think of beauty as an intrinsic quality in physical objects or even in human actions or dispositions, but only as a relation of them to the sensibilities of this or that person." Following in the tradition of Immanuel Kant and George Santayana, Carritt considers beauty a response to a visual, aural, or tactile sensation that gives pleasure.

What of the person who is trying to produce a beautiful object, sound, or movement? For him it is not enough to know that beauty is a subjective reaction within the observer. Such a definition leaves him helpless when he wishes to create something beautiful. The choreographer who must plan a ballet finds it necessary to decide how to group his dancers so that the ensemble will arouse a feeling of delight in the members of the audience. The composer must select, from the resources of orchestral sound, those particular tones and rhythms which can give the listener the satisfaction of an esthetic experience. The painter, within limits of the edges of his canvas, must place color and textures so that the viewer will feel within himself a surge of delight, which in turn will cause him to exclaim, "Beautiful!" To recognize beauty is one thing, but to produce it is another.

"I shall define Beauty to be a harmony of all the parts, in whatsoever subject it appears, fitted together with such proportion and connection, that nothing could be added, diminished or altered, but for the worse."[5] Leon Battista Alberti, an Italian architect, wrote this definition of beauty in the fifteenth century. Today, the same attitude prevails within a large group of the working artists and many of the foremost writers on art. They believe that beauty is the result of a controlled relationship among the separate parts of a work. This definition does not tell the artist how to create beauty, but it does direct his energies toward that goal. It can also direct the observer to the essential elements in a work of art, which in turn may give him that experience of beauty which is called the "esthetic experience."

Both points of view noted above seem valid. It is difficult to refute the argument that beauty, for the observer, is a personal, subjective response, but it can be maintained, on the other hand, that the response requires an initial stimulus with the potential to trigger the esthetic experience.

Formerly, the esthetic experience was almost always equated with a reaction to beauty. In discussing the sources of esthetic sensation, writers were interested in the aspects of beauty and in what produced it. Since the turn of the century, under the influence of psychology, the term "esthetic experience" has more often been interpreted to mean something more than a response to the beautiful.

As noted in Chapter 1, Chandler and others feel that an esthetic experience can be, at the same time, unpleasant and disagreeable—that it can

include the ugly, the repulsive, and the painful. In effect, many contemporary estheticians and psychologists say that our reaction, pleasant or unpleasant, to art, a reaction we may wish to repeat over and over again because it gives us emotional satisfaction, need not be limited to a recognition of beauty in the work; it may also encompass whole realms of human sensibility and response that are almost the polar opposite of what generally would be thought of as beautiful.

With reference to the two questions, "What is meant by the words 'ugly' and 'beautiful'?" and "Do these qualities belong in a definition of a work of art?" it can be stated that the identification of the ugly and the beautiful is recognized as a personal, subjective response to outside stimuli. Therefore, the recognition of the beautiful by different persons may be motivated by different experiences. Experience, effective at one particular time as an esthetic stimulus for a particular person, may, in time, lose its efficacy for him, to be supplanted by other esthetic stimuli. This evolution affects both the observer and the creating artist who attempts to produce something beautiful by controlling the relationships among the parts of his work in progress. However, the creation of beauty in the usual sense is not the sole consideration of the artist. He may sometimes relate the parts of his work to produce something that is not beautiful. It may be an image more expressive than those created before; it may be a combination of forms or colors in an unexpected and startling composition. The word "beautiful" is tied to the past. It harks back to the established and accepted images and esthetic orders. The new, the startling, the disturbing is rarely seen as beautiful. When the observer approaches a work of art with the attitude that beauty and art are one, he may be imposing upon that work a restrictive demand, forged by tradition, which cannot be fulfilled. In consequence, he may be cutting himself off from an esthetic experience which could offer rich rewards.

The conclusion of philosophers that the identification of beauty varies from person to person has been reinforced by psychological studies showing that the esthetic reaction is similar to other emotional reactions and that the individual reactions differ considerably. From infancy on, each person receives innumerable sensations which form within him a potential response to certain stimuli. Some of these responses will be identified as a perception of beauty. Because these emotional reactions are so varied, because there are so many unknown quantities in the creation of the sense of beauty within all people, it is impossible to establish absolute criteria for the identification of the beautiful. The questions always arise: "Beautiful to whom?" "Beautiful when?" To demand that art be beautiful is to reduce the definition of the word to such a personal level as to render it meaningles.

We return, therefore, to our original definition: *Art is a product of man in which materials are skillfully ordered to communicate a human experience.* Within these limitations it is possible for some observers to find beauty, for others to find intellectual and emotional satisfaction, and for still others to discover a disturbing enigma.

chapter 3

ART AS COMMUNICATION

Communication between persons of wholly dissimilar backgrounds can occur only on an elementary level; separated by the barriers of language and by the absence of common customs and attitudes, the participants in the dialogue may find that their only basis for communication exists in their common experience of the immediate physical world.

Even between individuals who share a common heritage the exchange of ideas, information, and feelings is often difficult. How many arguments are the result of a confused transfer of information? Who has not felt the frustration of trying to express the taste of food, the scent of a garden, or the love of a child? Often, the inadequacy of communication is the result of a limited ability to use the available language, but it is also possible that the language itself is incapable of transmitting the information desired.

Nevertheless, communication does take place. The complex process of living in social groups requires a continuing interaction among the members of a group. We seem always to be telling someone something or listening to someone. To keep a society functioning, its members must exchange a great deal of practical information, but it is just as important for each member of the group to be able to express those intimate, personal reactions to life which give him a sense of his own humanity. Wilbur Urban, in *Language and Reality* (1939), expressed the same idea as follows:

Life as it is merely lived is senseless. It is perhaps conceivable that we may have a direct apprehension or intuition of life, but the meaning of life can neither be apprehended nor expressed except in language of some kind. Such expression or communication is part of the life process itself.[1]

To point or to scream is to communicate, but the need for more complex communication requires a process or method which is itself more complex.

Communication is a transfer of information or ideas from a source to a receiver. Some vehicle or medium is required for this exchange. We usually refer to this vehicle as a "language." Two persons, looking at the same object, share the consciousness of it. By a series of manual signals they may refer to that object and exchange a limited amount of information about it. Once these individuals are separated, or the object of their reference is removed, some systematic combination of sounds or marks must be formulated to span the distance between them. This more complicated "language" requires the development of equivalents which stand for the object, or the information about it, so that the message may be carried from the speaker to the listener. In communication these equivalents are called "symbols." All those persons who wish to take part in the process of communication, to speak together or read the same paper, must have a knowledge of the language and the symbols that are a part of it. As the communication becomes more complex, as the descriptions become more precise, the language must be developed to represent the specific information and express it. This process requires a language of many individual symbols and a systematic means for combining them into significant and understandable relationships.

To understand a system of language it is necessary to know the specific sounds that have been assigned a definite meaning in it. When it becomes necessary to communicate these sounds beyond the limits of hearing, written symbols, a combination of lines or marks, must be used; and these, too, require a common understanding on the part of the communicators. Thus, the sound

33.

34.

represented by the word **CAT** refers to a particular species of four-legged animal. The sound itself is not an attempt to imitate the noise made by the animal. The word that identifies this particular animal in the English language differs from the one used in Swedish or Hindustani. It acquires its significance only because we, who speak English, agree to its meaning.

When we wish to express the sound that stands for this quadruped, we combine the lines shown in Figure 33 to produce the symbol shown in Figure 34. Note that, just as the sound does not imitate the cry of the animal, the lines do

not portray it visually. Their meaning exists because it has been arbitrarily assigned and we have been taught to use it.

When a child learns to read, he goes through this process of combining separate elements into a single meaningful unit. At first the separate parts of a letter must be consciously combined to form its shape: a **T** is laboriously constructed with a horizontal mark placed rather precariously over a vertical mark. Then the separate letters are combined to form a word which carries another kind of meaning. In time, the elements that form the letters **C-A-T** and then the word **CAT** lose their separate identities and are seen as a pattern which is readily identified and associated with the animate object in the experience of the child. A good reader will rarely have to consider the separate letters that he combines to form words. Most often he will react to the pattern of the letters and recognize the entire word as a single unit. It is not unusual for rapid readers to identify whole groups of words as a unit, because of the pattern they create. Whether the size of the pattern is large or small, it is his ability to recognize it which allows the reader to understand the meaning of that particular combination of elements.

The sentence **THE CAT IS ON THE FENCE** is a grouping of separate elements that the reader has learned to combine in a particular way. If the accustomed pattern is broken, even though the individual elements are unchanged, confusion can result:

THEC ATIS ONTH EF ENCE

THE CAT FENCE ON IS THE

Both of the above letter groupings are confusion itself for they do not fall into a familiar pattern. To understand the meaning carried by these elements, a reader must stop the normal flow of his reading and attempt to puzzle out the proper relationships for the separate parts. He must, in effect, place them in a new order which makes sense to him.

35. ROBERT CAROLA.
Graphic word play. 1964.

A clever typographic designer can add levels of meaning to a word or sentence by a careful selection of the type face or by the arrangement of letters. In Figure 35 the letters **CENS** are separated from the letters **RED** by a solid black block. Taken at face value, the combination of the letters and the block is meaningless. It is only when the reader assumes that the block covers the capital letter **O** that the combination of letters is joined in the spelling of "censored." Once that assumption has been made, the black block no longer acts as a deterrent to legibility. It becomes a symbol for the censor's act and a

Plate 9. REMBRANDT. *Portrait of a Young Man.* 1655. Oil on canvas, $38 \times 32\frac{1}{2}''$.
Wadsworth Atheneum, Hartford (Ella Gallup Sumner and Mary Catlin Sumner Collection).

Plate 10. Detail of Plate 9, Rembrandt's *Portrait of a Young Man*.

self-fulfilling visual sign. Similarly, in the arts, the person confronted by a new experience must place it in an orderly context with the experiences he has had in the past. He looks for some form of meaning, and always he seeks it in those terms already familiar to him. In painting and sculpture the terms are frequently those of the representation of the physical world, the shape and color of a tree or the size and proportion of a house in its surrounding landscape. The question is often asked by untrained observers of a painting or sculpture, "What is it supposed to be?" These two art forms traditionally have been concerned with the physical appearance of things, and a viewer quite understandably may try to fit the several parts of a painting or piece of sculpture into a pattern based upon the appearance of objects he has seen. He has been trained to do this from childhood, just as he has been trained to read.

As in the case of reading a written language, an untrained observer is usually quite unaware of the separate elements which have been combined to form the symbol of the object he recognizes, nor is he conscious of the way in which they have been combined. Like the reader who has progressed from the tiresome process of consciously combining letters into words and words into sentences, the untrained person before a painting or a sculpture often assumes that "reading" a work of art should be a natural, automatic ability, a function of all who can see.

In actuality, the artist uses separate elements to construct pictorial symbols in much the same way as a writer combines parts of the written language to produce his method of communication. The diagrams reproduced above will demonstrate the similarity between these two processes.

The ten linear elements in Figure 36 are similar to those used to construct the word **CAT**. When they are combined as in Figure 37 their identities as separate parts give way to a group identity as a pictorial symbol, a house. As in the case of the word formed by separate elements, the new pattern takes on a meaning of its own, which does not normally require the viewer to go through the relatively laborious process of conscious organization.

Again, as in the instance of the word symbols, this pictorial symbol can be combined with others to form a larger unit, and this unit, too, has a meaning, because the viewer is able to sense a pattern, a set of relationships, which mean something to him (Fig. 38).

Like the jumbled sentence, this pattern, once broken, may result in confusion (Fig. 39). Because the parts are not arranged in a pattern which has a meaning for the viewer, communication is interrupted; and, as in the word

left: 40. REMBRANDT. *Dr. Faustus.* c. 1652. Etching, 8¹/₈ × 6¹/₄″. Metropolitan Museum of Art, New York (Sylmaris Collection; gift of George Coe Graves, 1920).

below: 41. Drapery detail of Figure 40.

puzzle, no communication can occur again until these elements find their place in a new pattern.

The example of the pictorial symbol used above is a simple demonstration of the organization of one of the artist's plastic elements, *line.* Every work of art, no matter how complex, which uses line as its sole or primary element derives its meaning from the way the lines have been combined. At times the patterns of lines are so complex that the viewer may not consider them as separate and distinct parts. The etching by Rembrandt in Figure 40 is a picture of Dr. Faustus. Within a darkened room the aging man turns from his desk to see a glowing inscription. He is dressed in heavy robes, his face modeled by the light

of the apparition. Form, light, the textures of cloth are all the result of the artist's use of the etching needle. In an enlarged detail of the etching (Fig. 41) the folds of cloth lose their identity and are seen for what they really are— groups of lines. Each of these lines was placed in its particular position by the artist so that it joined with others to create the desired effect. Just as the ten lines of the demonstration drawing were combined to form a house (Fig. 37), the lines of the etching are organized to produce their more complex meaning.

What holds true for line is equally true for other plastic elements, including *color, form,* and *texture.* Once again, the example of a work by Rembrandt can serve to demonstrate the creation of a symbol used to express the appearance of objects. The *Portrait of a Young Man* in Plate 9 (p. 47) is an oil painting. When seen from a short distance, the chain that circles the shoulders of the figure appears to be constructed of separate metal segments, glistening in the light. A detail of the painting (Pl. 10, p. 48) shows a portion of the chain as it has been formed by the artist, actually a number of rather broad strokes of a brush loaded with pigment, which combine to mean "metal chain." Both examples emphasize a basic fact of representation in the visual arts: *the representation of an object is not the object.* The artist did not glue a chain on the canvas when he wished one there. Like the writer, who uses words which are symbols for the things he wishes to communicate, the artist uses the elements of painting and sculpture for communication. The combination of these elements produces equivalents for the subject matter, but the equivalents are always just that— combinations of elements joined to produce an order which must be recognized by an observer before their significance is comprehended.

Consideration of the problems of equivalency will quickly make the following facts apparent. First, *there may be a number of equivalents for the same object in nature.* Line or color or form can be used to produce an equivalent. A change in the medium employed by the artist will inevitably change the appearance of the equivalent; that is, oil paint will produce forms, colors, and textures which differ considerably from those realized with watercolor or mosaic tile.

Second, *the appearance of an equivalent may be affected by factors which have nothing to do with the subject matter represented.* Just as there are many different languages in use throughout the world at the present time, each utilizing equivalent combinations of written symbols to represent the objects and experiences of the communicators, there are different visual equivalents in use for communication in art. Differences of time and tradition may affect both the written and the plastic languages. Even in the expression of persons who share the same language, the same traditions, and the same time in history there is a possibility that, wishing to say the same thing, they will say it in different ways.

Finally, it can be said that *each object of experience in nature can be understood or seen in a number of ways* and that *it is impossible for an artist to express simultaneously all the possible meanings potentially in his subject matter.* At some stage the expression of one aspect of reality will reduce, obscure, or contradict the expression of another point of view.

42. Façade, Rouen Cathedral. Begun 1210.

43. Side view, Rouen Cathedral.

44. Apse, Rouen Cathedral.

Figure 42 is a photograph of the façade of Rouen Cathedral. This image gives a great deal of information about the appearance of the building, but it cannot provide all the visual data available to a person visiting the site. The photograph does not show the sides and back of the exterior (Figs. 43, 44); neither does it reveal the interior (Figs. 45, 46). Details of the carved masonry surfaces can be recorded only by a set of separate close-up images (Fig. 47). Still other kinds of information not available to the visitor, but important to his understanding of the building and its structural systems, can be communicated by drawings of the plan and sections of the building (Figs. 48, 49). In addition, should it become desirable to know the location of the cathedral in the city of

left: 45. Nave, Rouen Cathedral. Begun 1210.

below left: 46. Vaulting, Rouen Cathedral.

right: 47. Exterior detail, Rouen Cathedral.

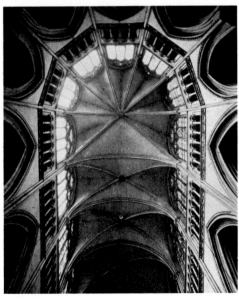

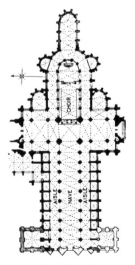

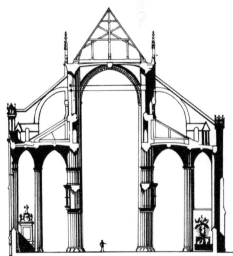

above: 48. Plan, Rouen Cathedral.

right: 49. Section through nave and aisles, Rouen Cathedral.

Rouen, or the location of the city in the country of France, yet other visual representations, such as general and detailed maps, would be necessary.

The French Impressionist Claude Monet saw the cathedral of Rouen in still another way. For him, and for the other Impressionists painting late in the nineteenth century, light reflected from the surfaces of buildings and landscape was a major factor in the perception of the real world. The physical objects might remain constant, but their appearance changed radically under different conditions of light and atmosphere. Monet took the façade of Rouen Cathedral as his subject in a series of paintings, two of which are reproduced as Plates 11 and 12 (p. 65). In each of them, using technical devices that helped to create a painted equivalent for the effects of light, the artist communicated information about the cathedral that could not have been comparably expressed in any of the other visual forms mentioned above.

It is not possible for a single work of art to furnish complete information about any three-dimensional object that the observer can view from all angles. This is especially true of two-dimensional art forms, but it holds equally true for three-dimensional forms that are not exact replicas in size and material of already existing objects in nature. The artist's representation of a real object or event must necessarily convey only a portion of the pertinent information.

Frequently the communication of one kind of data by a visual equivalent will prevent the transmission of other kinds of information. Monet's technique of applying paint to his canvas in small, distinctly separate brush strokes was employed to create a luminous surface of color more vibrant and evocative of the actual light he perceived than would have been possible if he had applied the paint in smooth, even surfaces. However, because he was concerned about the representation of light, he could not at the same time represent the detailed carving of the stone to be seen in the photograph (Fig. 42). The two kinds of information were mutually incompatible, given the limitations of the medium, the manner of applying the paint, and the artist's choice of light reflection, rather than the specifics of modeling, as the salient feature of his personal response to the building.

On the other hand, the photographer who shot the interior of Rouen Cathedral could not possibly have recorded a complete view of the nave with the full side walls and the vaults above. Here the limitation exists in the optical system of the camera, which did not include within the range of its lens as much area or detail as the artist's eye and experience can encompass and condense.

All the images discussed above, including Monet's paintings, are concerned with the physical appearance of the cathedral. Information related to the historical or the religious aspects of the structure could be the basis for many other visual statements. An artist may try to isolate those limited bits of information which he feels are most expressive of the object or experience he has perceived in his subject and then attempt to realize equivalents that will convey those essential qualities to his audience.

Three studies by the Dutch painter Piet Mondrian are examples of the response of this artist to a tree (Figs. 50–52). What is the tree to Mondrian?

50. PIET MONDRIAN. *Tree II*. 1912.
Black crayon on paper, $9^5/_8 \times 22^1/_4$".
Haags Gemeentemuseum, The Hague.

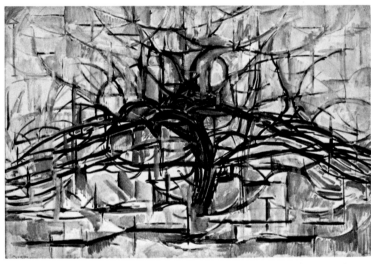

left: 51. PIET MONDRIAN. *Horizontal Tree*.
1911. Oil on canvas, $29^5/_8 \times 43^7/_8$".
Munson-Williams-Proctor Institute,
Utica, N. Y.

below: 52. PIET MONDRIAN.
Flowering Apple Tree. 1912.
Oil on canvas, $27^1/_2 \times 41^3/_4$".
Haags Gemeentemuseum, The Hague.

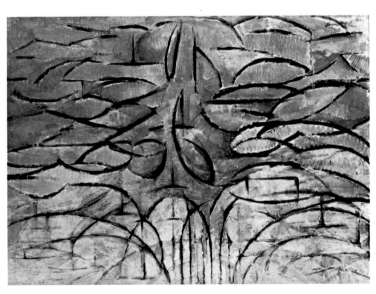

Is it a complex arabesque of silhouetted branches, stirring with the forces of life within it; or is it a logical series of rhythms, movement against counter-movement, an organic structure? Each painting isolates a portion of the many possibilities that the tree presents to a viewer. By selecting and emphasizing certain parts of the object before him, by reducing the importance of other parts, eliminating details that tend to obscure the statement he wished to make, Mondrian was able to form three different equivalents for the same object.

It is impossible to say that one of the renderings of the tree is more accurate than the other. Is the plan of a house more accurate than a photograph of its exterior? Does the painting of an animal by an aborigine of Australia (Fig. 53) tell more or less of the truth about that animal than could be shown by a detailed scientific drawing? The detailed drawing might delineate an exterior view of the animal, but the native has tried to combine what he sees of the outside with what he has seen within the animal.

Anyone wishing to produce a visual symbol for an experience must be selective. From his consciousness of color, light, form, texture, movement, and even the nonvisual experiences of sound, touch, and smell, he must choose those

53. Kangaroo-like animals,
tribal painting from Arnhemland,
Northern Territory, Australia.
19th century(?). Painted bark, height 40³/₄″.
Museum of Primitive Art, New York.

54. *Neb-Amun's Gratitude for His Wealth.* Egyptian wall painting, from the tomb of Neb-Amun, Thebes. 18th Dynasty, 16th–14th century B.C. Painted copy, tempera. Metropolitan Museum of Art, New York.

few characteristic qualities which suggest the essentials of the reality apparent to him at the time he begins to work. This choice may be complicated even further if the artist decides that his subjective responses to the world about him are important factors in the "real" world and that they, too, should be a major constituent of his work.

Selection of the pertinent aspects of reality is not always a matter of free choice. Enmeshed with his own time, the artist perceives and reacts in a manner controlled in part by the traditions and patterns of his cultural environment. The artist who composed the Egyptian wall painting in Figure 54 was part of a tradition that existed before he began his life and continued, essentially unchanged, for hundreds of years after his death. The medium he used, the symbols he employed to represent human forms, even the subject matter itself, all were given to him as part of a tradition. His counterpart in seventeenth-century Holland, the painter Vermeer van Delft, worked within quite a different tradition, one closer to present-day photographic forms of representation (Pl. 13, p. 66), but he, too, was faced with technical and symbolic precedents and passed them on with little alteration to those who followed him. Comparing the work of Vermeer with paintings by his contemporaries and with subsequent Western art, one can identify similarities in the representation of form and space that link these artists into a long, continuing tradition. This tradition has much in common with the visual equivalents made by a camera.

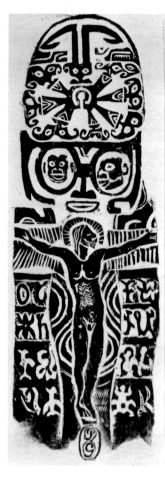

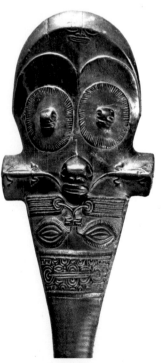

left: 55. PAUL GAUGUIN. *Crucifixion.* c. 1889. Woodcut, 15⁷/₈ × 5³/₈″.
Metropolitan Museum of Art, New York (Harris Brisbane Dick Fund, 1929).

below left: 56. Carved head of club, from the Marquesas Islands. 19th century (?).
Wood, full length 5′. University Museum, University of Pennsylvania, Philadelphia.

In Europe, for four hundred years prior to the nineteenth century, the methods for representing form and space in the visual arts had remained essentially unchanged. Though there were stylistic differences between artists and between national or cultural groups, the similarities between the methods of representation outweighed the differences. Linear perspective, aerial perspective, and shading were the prime methods for conveying a sense of natural space and three-dimensional form in two-dimensional works such as paintings and drawings. These methods (or conventions) had been used so long and so widely that they took on the value of absolutes. That is, they were assumed to be the standard by which all methods of representation were to be measured. Late in the eighteenth century, photography was invented, and it was subsequently developed in the nineteenth century into a practical and relatively simple method of creating a visual equivalent for the "real" world. The introduction of the photograph gave additional importance to perspective as the standard method for producing visual equivalents of the artist's perception of form and space in the physical world. That the camera recorded an image in linear perspective by an optical-chemical process seemed to be a scientific confirmation of the validity of the perspective system of representing space.

During this same period of time a minority of artists began to experiment with new methods of representation. Influenced by examples of art from the East, from Africa, and from the Americas, these painters and sculptors sought to extend the traditional equivalent forms beyond their familiar representational and expressive limits.

At the end of the nineteenth century Henri de Toulouse-Lautrec found in the flat color and the linear arabesques of Japanese prints a basis for the invention of compositions that seemed radical to his times. In his paintings and posters the influence of the East is clearly evident. Compare *Le Divan Japonais* (Pl. 14, p. 83) with the Japanese prints in Figure 177 and Pl. 42 (p. 180). Paul Gauguin's self-imposed exile to the islands of Tahiti and the Marquesas in the South Pacific came after his enthusiastic visit to a Javanese village exhibit at the Exposition Universelle in Paris in 1889. A reflection of the art of the islanders can be found in Gauguin's painting, sculpture, and prints. A very direct influence is revealed in the woodcut *Crucifixion* reproduced here as Figure 55. In style and composition it has a clear connection with the carved club head from the Marquesas Islands, illustrated in Figure 56.

European artists of the twentieth century have been continuously fascinated and influenced by non-Western art forms. Very early in their careers Pablo Picasso and Amedeo Modigliani (Figs. 57, 58) demonstrated a concern for the sculpture of West Africa (Figs. 59, 355), and a comparison of the work of the sculptor Henry Moore (Fig. 60) with pre-Columbian art (Fig. 61) suggests the

above left: 57. PABLO PICASSO. *Man's Head* (study for *Les Demoiselles d'Avignon*). 1907.
Watercolor, $23^3/_4 \times 18^1/_2$″. Museum of Modern Art, New York (A. Conger Goodyear Fund).

above center: 58. AMEDEO MODIGLIANI. *Head.* c. 1915. Stone, $22^1/_4 \times 5 \times 14^3/_4$″. Museum of Modern Art,
New York (gift of Abby Aldrich Rockefeller in memory of Mrs. Cornelius J. Sullivan).

above right: 59. Mask, from the Itumba region, border of Gabun and Congo.
Wood, height 14″. Museum of Modern Art, New York.

below left: 60. HENRY MOORE. *Mask.* 1929. Concrete, height $8^1/_2$″. Collection Lady Hendy, Oxford.

below right: 61. Mask of the god Xipe Totec. Mexican Aztec, 14th century.
Basalt, height $8^3/_4$″. British Museum, London.

debt the Englishman owes to the collections assembled by the British Museum from "primitive" cultures.

Other artists have found themselves stimulated by scientific and technological developments which evolved at a startling pace as the century progressed. New theories of light and color, a growing sense of change and movement in social orders, and studies in human psychology have affected the arts in ways both direct and indirect. The artists of this age have not seen the world differently, for the optical-neurological process of sight remains the same: Reflected light from forms positioned before the eye focuses on the retina, and this information is transmitted to the brain. Perceptions, however, have been differently interpreted, and these demand different visual equivalents.

If we imagine a scene, a boy flying a kite, what will the visual sense information tell about what there is before us? The wind is blowing; the sight of leaves trembling and being blown about indicates the presence of the wind. The boy runs across the field, the string of the kite clutched in his hand. The line leads up into a blue-violet sky to a glistening spot. The sun fills the sky with a luminous glow. Its light contrasts with strong shadows on the boy and turns the green of the field into a series of shifting planes—blue-green, yellow-green. The high grass moves with the wind, and its movement causes changes in the color of the field. There is a sense of connection between the figure in the field and the kite struggling to break the cord which ties it to the boy and to the earth, and yet both of them together, in and above the field, seem isolated from all the rest of the world.

In this imagined scene we are aware of color, light, movement, form, texture. We are aware of our own response to the scene and of the response of the boy. What portion of this reaction is to be selected as the essential portion—the luminosity of the sunlight; the movement of the wind, the boy, and the kite; the specific information about the boy, such as the color of his hair, his age, his weight, the nature of his clothing; pehaps the triangular shape made by the land, the boy, and the kite as they are seen against the horizon? Perhaps the most important part of the whole experience is our own response.

In the relatively short period from the middle of the nineteenth century to the first two decades of the twentieth there arose in succession the Impressionists (Pl. 5, p. 35; Pls. 11, 12, p. 65), the Pointillists (Pl. 15, p. 84), the Fauves (Pl. 16, p. 84), the Cubists (Fig. 62), the Futurists (Fig. 63), and others—groups of artists all attempting to find an adequate equivalent for the communication of the world they perceived about them. Each group found it necessary to construct a visual vocabulary and grammar which differed from those available to them. In their own time the equivalents produced by these painters and sculptors were, quite naturally, compared to the traditional standard, the perspective image, and found wanting. The differences in application of paint, in the use of color, in the representation of form and space were frequently attributed to inadequate ability or arbitrary idiosyncracies, even to madness.

Now, however, it is possible to see all these approaches, including that of the traditionalists, as legitimate attempts to reduce the experience of the three-

dimensional world of actual experience to the symbolic expression of paint, clay, and stone. The present-day viewer of art can no longer assume that the photographic image is a standard by which other images are to be judged, a language acting as the measure of other communication systems, for he finds himself in a multilingual visual world, a world in which all languages have value measured by their capacity to communicate a significant image of some part or portion of human experience. Both the artist and the viewing public are faced today with problems of communication which rarely affected their counterparts in the

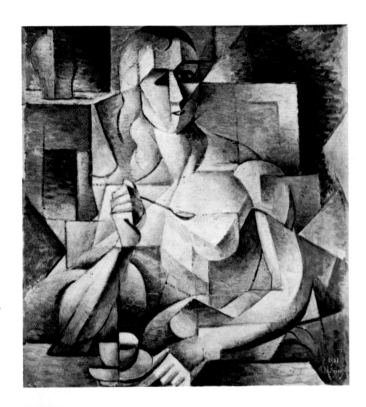

right: 62. JEAN METZINGER. *Tea Time.* 1911. Oil on panel, 29³/₄ × 27³/₈″. Philadelphia Museum of Art (Louise and Walter Arensberg Collection).

below: 63. GIACOMO BALLA. *Dog on Leash.* 1912. Oil on canvas, 25 × 42¹/₂″. George F. Goodyear and the Buffalo Fine Arts Academy.

past. Because they are aware of so much of the world, because they can perceive it historically, scientifically, psychologically, and because the personal perception has been given a value which it did not have in the past, the representation of that perception and the comprehension of what has been represented becomes a complex process. The artist who initiates the communication must use a system that is adequate to say what he has a need to say about experience, and if he cannot find an existing method of visual communication adequate for the job, he must devise one. The viewer comes to the work of art with the knowledge that there are many ways of looking at the world and many ways of communicating what has been experienced. If the artist has used a system of visual communication with which the viewer is familiar, an exchange of information will probably occur, but should the artist adopt a method of expression foreign to the viewer, confusion can be and often is the consequence.

THE SUBJECT MATTER

What can the artist communicate? This question is related to another: What does the artist wish to communicate? To judge by the evidence of the work of artists throughout history, the subject matter of the arts can be broken down into four categories: *the world of perceptual reality; the world of conceptual reality; the personal response to experience;* and, finally, *the communication of order.* These four areas are not mutually exclusive. Many works of art combine all of them, but there are art forms which appear to emphasize one to the exclusion of the others, and when confronted by a painting, a sculpture, even a building, the spectator should attempt to identify the initial artistic intention.

The World of Perceptual Reality

Human beings living on the earth in the present have certain basic similarities: the shape and function of their bodies, their primary human drives, and, within the limits of their geographical locations, those aspects of nature which have significance in their lives.

The seas, the land, the skies, and the creatures living in them are a large part of the common inheritance; they are physical aspects of the world around us. They can be seen, touched, heard, and smelled. Man has added to the physical world structures demonstrating his ingenuity and industry—buildings, bridges, roads, and machines—which seem to increase in numbers by the hour, until in some places they fill the land to the exclusion of grass and trees.

This physical world is known to each human being through his senses. The retina of the eye reacts to light energy reflected from objects. Vibrations of air on the drums of the ears are received as sound. The skin reacts to changes of temperature and to contacts with other surfaces. Odors are registered and responses are made to them. In total, this stimulation of the sensory organs provides the raw material that is synthesized within the mind into a personal perception of the external world. J. Z. Young explains the process:

The essence of the whole process is learning to conform to the conventions of the group in which the individual lives. When we ask a child to name something, we are teaching him to make a response that ensures communication. We are also passing on to him our own ways of observing. We have various means of rewarding him when he is right, punishing him when he is wrong. We can do it by feeding or beating him, but the first can only be infrequent and the second tends to cut off all connexion with him. We do it much more subtly by establishing a special behaviour sequence, that of communication. The child's most important lesson is that the fitting of stimuli into a communicable form produces "satisfactory" results. It is difficult to appreciate how deeply this first way of responding controls all the others, which are later learned through it. Once this is established it is not necessary to set up an elaborate apparatus of rewards and punishments to teach each new association. By giving the signs of approval or disapproval we can show the child instantly whether he has produced the right reactions or not. His whole brain system is trained so that it seeks to organize all the sensory input into some communicable output—to put it into words. From his earliest days cutting off means hunger and cold, whereas communication means satisfaction. The smile becomes the symbol of completion and satisfaction and the cry that of disorder and pain. By association with these signs that communication has or has not been achieved, the names that are "right" are built into the brain system; the child learns to select and observe "correctly."[2]

Coming into a new world, the child does not experience ordered sensations. He slowly learns to see as his forebears saw, so that he can get along in their world. For this he is in their debt. At the same time, by teaching him to see their world, they have restricted his vision. He is denied the freedom of ordering his own sensations (if this were possible) and seeing the world in his own way. His reactions to colors and sounds are limited, and, since the pattern of sensation to perception is set in a specific mold, it is difficult to change.

A thousand or even five hundred years ago, men were more isolated from one another than they are today. Separated by the miles and days of difficult travel, they lived their lives insulated from others who were alien to their culture. The world about them was a small place, and all those who were a part of it were much like themselves. When someone from "another world" did enter their own, he was recognized as different, but the differences did not suggest other worlds, with other ways of living and other ways of seeing; they were seen essentially as eccentricities, in contrast with the "normal" way of saying or doing things. Even the differences that had existed in the past history of the group were not generally understood. Books were available to only a few, and those which were in circulation could not accurately describe the world and manners of former times.

Changes in perception and its representation did occur as ideas and experiences interacted, but at a pace much slower than that of today. An example can be seen in the work of the German Renaissance artist Albrecht Dürer. Born in 1471, Dürer was an established artist by the year 1505. His paintings and woodcuts were highly regarded, and they remain so today. But

in that year Dürer went to Venice, which he had visited about a decade earlier, and there he worked until 1507, winning major commissions and achieving the esteem of Italian masters. Before his return to Germany, Dürer undertook a 100-mile trip to Bologna to receive instruction in "the secret art of perspective," for, despite his success, the artist recognized what he considered a deficiency in his work and sought to eliminate it. He was concerned about the method of representing space in the two dimensions of painting. This problem was of major interest to artists then as now.

An examination of an engraving entitled *The Nativity* (Fig. 64), completed by Dürer in 1504, will show that the edges of forms assumed to be parallel in nature—steps, the meeting of walls with floor and ceiling, window ledges, portions of the well in the courtyard—are drawn so that, if extended, the lines

left: 64. ALBRECHT DÜRER. *The Nativity.* 1504. Engraving, $7^1/_4 \times 4^3/_4''$. Metropolitan Museum of Art, New York (Fletcher Fund, 1919).

right: 65. Analysis of Figure 64.

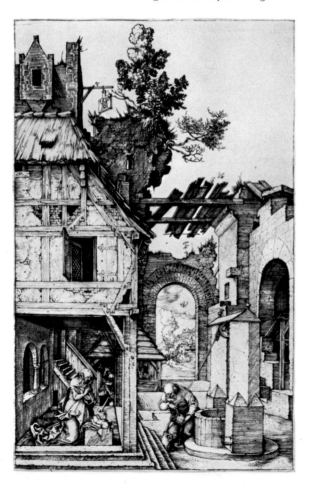 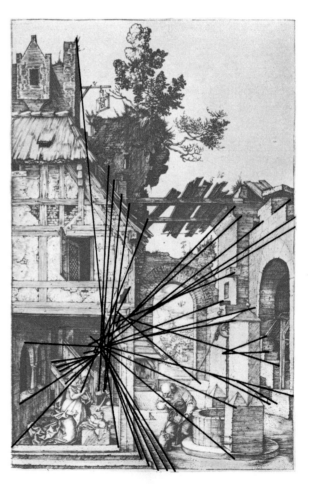

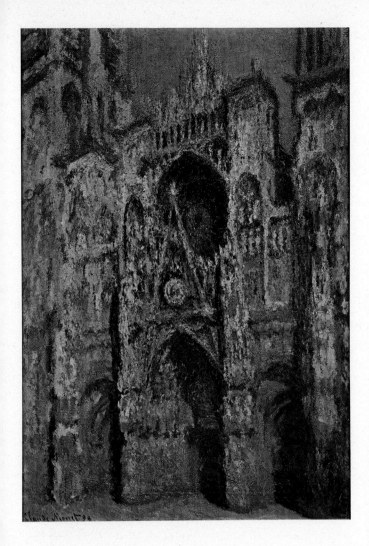

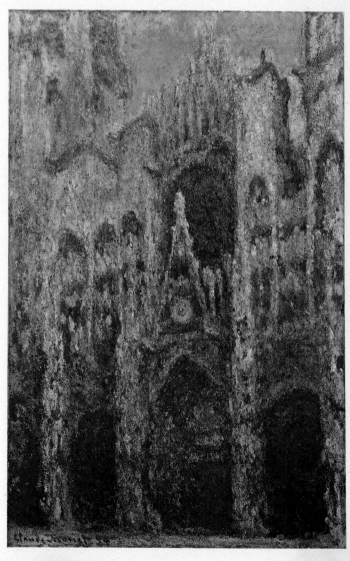

left: Plate 11. CLAUDE MONET. *Rouen Cathedral: Full Sunlight.* 1894. Oil on canvas, 36 × 24³/₄″. Louvre, Paris.

below: Plate 12. CLAUDE MONET. *Rouen Cathedral: Sunset.* 1894. Oil on canvas, 42 × 29″. Museum of Fine Arts, Boston (Juliana Cheney Edwards Collection; bequest of Hannah Marcy Edwards in memory of her mother).

Plate 13. Jan Vermeer van Delft. *Girl Asleep*. c.1656. Oil on canvas, 34¹/₂ × 30¹/₈″.
Metropolitan Museum of Art, New York (bequest of Benjamin Altman, 1913).

appear to converge. Such convergence is based, in part, on methods, then traditional in northern European art, of reproducing the illusion of three-dimensional form and space and, in part, on the empirical experience of the artist, who must have perceived that edges actually parallel with the horizontal axis appear to move back into space diagonally. As Dürer drew it, the print conveys a feeling of depth, but the artist must have sensed that the spatial representation worked out by Italian masters was superior to his own. Though not yet widely published, linear perspective had been employed for almost three-quarters of a century by the Italians, the originators of this method of simulating form and space. In linear perspective, converging lines were used as a device for expressing the recession of parallel rectangular forms into space away from the observer, but the system was organized around specific points of convergence related to the positions of the spectator and the objects that were to be represented.

When Figure 64 and its analysis, Figure 65, are compared with Figures 66 and 67, the effect of Dürer's studies in Bologna can be seen. In *The Adoration of the Magi*, the later print, the artist organized all the indicated parallels in the ruined courtyard so that they converge at a single point as they appear to recede. In the earlier print there is no such consistency. Points of convergence are created without any orderly relationship to one another. This difference

left: 66. ALBRECHT DÜRER.
The Adoration of the Magi. 1511.
Woodcut, $11\frac{1}{2} \times 8\frac{5}{8}''$.
Metropolitan Museum of Art,
New York
(gift of Junius S. Morgan, 1919).

right: 67. Analysis of Figure 66.

above: 68. Map from Pietro Coppo, *Portolano.*
Venice, 1528. Actual size.

left: 69. Electromicrograph,
section of the nerve ending
on an electric cell of a Narcine (torpedo fish).
Magnification 19,000 diameters.

may seem slight, but it was noticeable to the artist and was sufficient to
motivate Dürer to travel in quest of representational methods that would over-
come his dissatisfaction.

Today, there are few places on this earth which are hidden. Through the
media of mass communication—television, the movie camera, radio, news-
papers, and books—all so readily available, the world has become smaller and
smaller. Anthropologists, archaeologists, and explorers have roamed the earth
to examine man and his environment. The past as well as the present has been
opened to investigation. Man has been revealed as a creature of many faces,
with many ways of seeing the world. Concepts of morality, of social and eco-

nomic organization, and of the relationship of the human being to his habitat have been shown to differ widely. Art and the expression of beauty have been found to take many forms. Even the casual reader cannot fail to recognize the vast differences that typically separate one cultural group from another.

However, an awareness of the differing cultural forms of human life is not the only way in which the view of the world has been broadened. As late as the sixteenth century Western man's knowledge of the physical world he inhabited was confused, limited, and inaccurate. The crude, small woodcut map in Figure 68 was published in Venice in 1528. A sixteenth-century scholar studying this map could marvel at the extension of geographical knowledge. We see it as an indication of the naïveté of the Renaissance cartographer, an illustration of the limited view of the earth and its configurations held by men living only five centuries before our own. Today, developments in the sciences have extended the limits of the senses to a tremendous degree. The eye, aided by the microscope, can see into a world of complex and amazing forms (Fig. 69). The X-ray tube permits exploration of the intricate inner forms of familiar objects and creatures (Fig. 70). The oscilloscope reveals patterns of sound and other invisible energies (Fig. 71). The motion picture camera makes possible the capture of even the swiftest of movements for study at leisure. The telescope can reach into the heavens to examine the vast spaces among the stars and the patterns of the nebulae (Fig. 72). Satellites can photograph the earth, giving us

70. Radiograph
of the human body.

71. Photograph of an oscilloscope screen,
showing an electron-density contour map
of the primary unit of a crystal of *tris*
(thiourea) copper (I) chloride,
constructed with X-ray diffraction data
and the analogue computer X-RAC.
Department of Physics,
Pennsylvania State University,
University Park, Pa.

72. Great Nebula in Orion
(Messier 42). Photograph, 100".
Mount Wilson
and Palomar Observatories.

above left: 73. Satellite photograph of the planet earth.

above right: 74. Map of Mars according to Schiaparelli. 1877–86.

left: 75. Surface of Mars photographed from Mariner 6, July 30, 1969, from an altitude of 2,150 miles. NASA.

a view of our environment that has changed our attitude toward man and the space he inhabits (Fig. 73). What astronomers, beginning in 1877, formerly thought were canals, formed in fine straight lines (Fig. 74), on the surface of Mars have been discovered through satellite photography (Fig. 75) to be no more than distortions of reality conveyed by the limitations of even the largest existing telescopes. There is a psychological tendency for the eye to connect features whose separations are near the limit of resolution. This propensity of the eye to simplify and smooth out very fine, chaotic detail may have helped "produce" the narrow "canals" of Mars.

The landscape of today is not restricted to a view from a hilltop; it can be seen from a plane far above the earth (Fig. 76) or from a bathyscaph a mile beneath the surface of the sea. The dimensions of the perceptual world have been increased many times over in the last few years, and they now continue their expansion into outer space. Each day brings with it a new world to see.

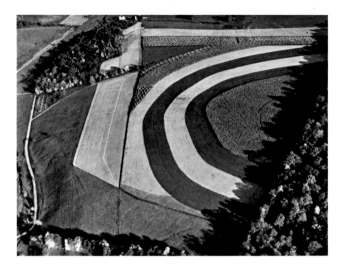

above: 76. Aerial view, contour farming, Nottingham, Pa.

right: 77. ALBRECHT ALTDORFER.
Danube Landscape near Regensburg.
c. 1522–25. Oil on panel, $11 \times 8\,{}^5/_8''$.
Alte Pinakothek, Munich.

For Renaissance man the forms of the outer world were restricted to what he could see with his unaided eye. When the painter of the fifteenth century conceived of a landscape, he saw it in terms of trees growing over him and mountains rising up over the fields in distant blues and violets (Fig. 77). Today, the world is a different place for the artist. His vision is no longer confined to the limits of the earth. He may paint what he sees, but now what he sees is extended to the microcosm and macrocosm revealed by science and technology.

The World of Conceptual Reality

A part of the traditional function of art has been the representation of perceptual reality, and it is important to note that our awareness of the nature of our physical environment is constantly changing. We must recognize also that the conception of this real world may differ with individuals and groups.

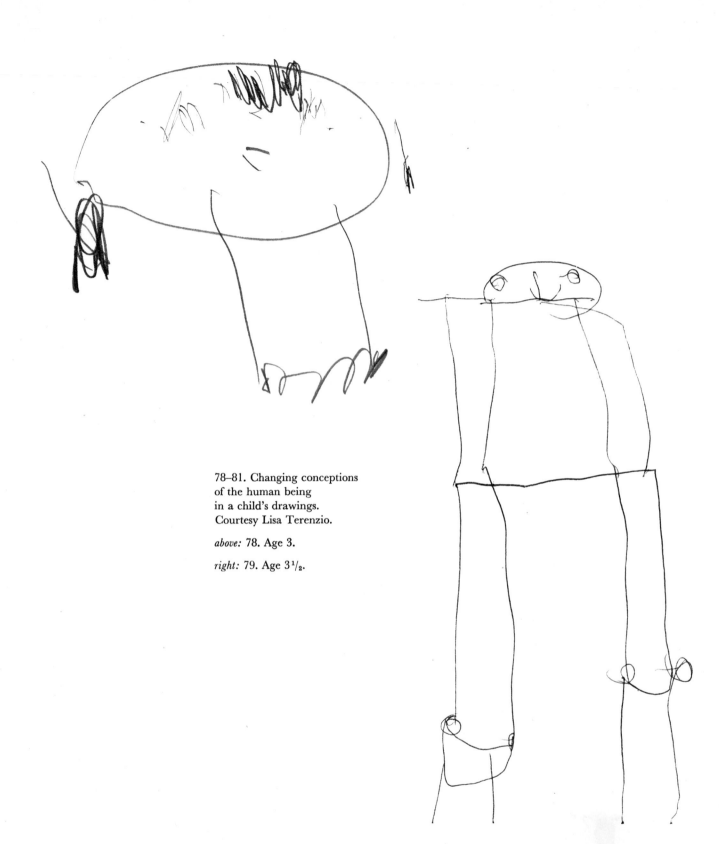

78–81. Changing conceptions
of the human being
in a child's drawings.
Courtesy Lisa Terenzio.

above: 78. Age 3.

right: 79. Age 3¹/₂.

There are many approaches to the representation of what we perceive. We all have conceptions of things. These conceptions may vary from time to time, but at any given time we can visualize images of a great many objects. Some of these images may be the result of careful study; some perhaps are the result of a careless, passing observation. Some conceptual images have been acquired without direct observations but, instead, by contact with images already conceived and produced by others. Photographs, paintings, sculpture, motion pictures, and other image-making media can create ready-made conceptions of objects and experiences for those who cannot create their own.

The world can be thought of as a series of limited conceptual realities, objects which exist only in certain defined and static shapes and positions. A person who conceives of the world in this way sees it in terms of stereotyped concepts. It is often quite difficult for him to recognize representations of physical reality unless they closely approximate his conceptual images. A tree is always *the* tree, a bird is *the* bird, grass is always green, and the sky is always blue.

Children conceive of the world in this way, and their art is an excellent example of *conceptual representation* (Figs. 78–81). As they grow and become aware of themselves and their social groups, their art changes to include the new concepts they develop. The preschool child's perceptions are strongly influenced by his home environment and are altered when he leaves home to spend a large portion of his waking hours in contact with teachers and other children in school.

Television viewing has changed our apprehension of the real world. Not only does it bring into the home information that was once unavailable, but it also provides moving images as equivalents for the real world rather than the still images that formerly served so often to shape concepts of the world about us. Consider the experience of the adult who saw still photographs of Niagara Falls, never having seen the falls with his own eyes. The photographs recorded the cascading water as though time had stopped and the motion and forms of the falls were frozen. It is possible that he could have had an empathic response to the static images, projecting onto the picture past experiences of the direct observation of large masses of falling water. But this is very different from the experience of the young child who sees television images of the moving flood of waters that spray into the air as they churn over the rocks of the Niagara bluffs. The movement, the patterns that change in time, the swirling mist shifting in continuous flux are represented on the surface of the television tube. The kinetics of reality are now as important as, or perhaps more important than, the static statement of the shape of the physical elements observed.

For the average child, exposed to thousands of hours of moving images, the motion of forms in space can become more significant than the appearance of the forms themselves. The growing interest of young people in motion pictures, reflected both in seeing and producing cinematic art, suggests the effect of exposure to the kinetic image at an early age. Nevertheless, it would be unreasonable to assume that cinematography will completely replace still images in the lives of children. So long as a paper and pencil are more readily available

above: 80. Age 5^1/$_2$.

below: 81. Age 5^1/$_2$.

than a camera and film the drawn image will remain important to the child and to the adult. Yet even the still image can be altered by the influence of our growing perception of motion as a significant factor in our *real* world, and changes in our conceptions and the equivalents for those conceptions must inevitably take place.

Much in the visual arts is based upon conceptual images. The artist represents what he *knows* about reality, rather than what he *sees*. Like the child, he records those aspects and segments of his world which are meaningful to him, putting together separate conceptual elements to form the entire representation of an experience. Early Egyptian art is conceptual (Fig. 82). To depict a man the Egyptian artist selected the most representative concepts of the separate parts of the body and then combined them to form the complete figure. He chose a profile view of a head and placed within it a front view of an eye. He usually indicated the shoulders in a frontal position and the hips and legs from the side view. The resulting image may not satisfy the demands of other cultures for the representation of a human figure, but its conventions were accepted by the artists and their patrons in Egypt, so that variations from it became the exception rather than the rule.

Contrasting with the conceptual representation of physical reality is a system intended to reproduce the perceptual experience derived from careful observation of the physical world. In this approach a bird is not always *the* bird. It may be a dot, or a flash of light, or perhaps even the path of a spiraling glider as seen in the sky. Physical experience is communicated in *perceptual representation* as a visual image which, under certain conditions, may be interpreted as a bird, or a man, or an ocean. The senses give the viewer the raw material of his concept. He sees the world in flux, and nothing in it appears twice in exactly the same way. The variables of distance, time, light, movement, and background affect the appearance of all objects, so that they may be represented differently at different times. Even the attitude of the observer at the time of the observation can make a difference in the image created. The resultant representation of this perception may be a three-dimensional replica of the subject or it may be as simplified as a single flashing piece of metal, in which the artist attempts to express the movement, the grace, and the speed of a bird in flight (Figs. 83, 84).

Neither conceptual nor perceptual representation of the physical world is in itself superior to the other; both exist and are to be found in the art of the past and the present.

The Personal Response to Experience

The physical environment comprising the world of actual experience is considered to be the *real* world. In this context the word "real" is used to differentiate that part of experience which seems to occur outside ourselves from that which is confined to our inner subjective being. But the separation of reality from what is unreal is often an artificial division, for there are many

above: 82. *Offering Bearers.* Egyptian wall painting,
from the tomb of Sebekhotpe, Thebes.
18th Dynasty, 16th–14th century B.C.
Tempera on mud plaster, width c. 30″.
Metropolitan Museum of Art, New York
(Rogers Fund, 1930).

left: 83. DOROTHY DOUGHTY. *Male Redstart.* 1935.
English Royal Worcester,
bone china; height 9″.
Metropolitan Museum of Art, New York
(gift of Mr. and Mrs. Thomas F. Staley, 1950).

right: 84. CONSTANTIN BRANCUSI. *Bird in Space.*
1928(?). Bronze, height 4′ 6″.
Museum of Modern Art, New York.

subjective attitudes, responses, and images which carry as great a sense of
reality as that part of life which is confined to external experience.

The world of subjective reality has been a major influence on much of the
visual arts. Constructed of the thoughts and feelings of men, it is shaped by
their social values, their emotions, their ideas on life, and their own existence.
As William James put it: "Every exciting thought in the natural man carries
credence with it. To conceive with passion is *eo ipso* to affirm." For many per-
sons their subjective consciousness is more vital, more meaningful, than their
contact with the perceptual environment about them, but the communication
of this consciousness, this inner reality, often creates problems which are not
associated with the communication of experience grounded in the physical

world. When a person wishes to say something about a tree, or a cloud, or perhaps even personal relationships, he knows that he is dealing with material common to the conscious experience of many within his society. When he wishes to communicate his own inner experiences, he can never be sure that the images he produces to represent his subjective reality will have meaning for others. In the attempt to express what is real but unseen, the lack of universal symbols creates problems of ambiguity and confusion of meaning and limits comprehension and acceptance.

Museums abound with examples of paintings and sculpture which communicate the forms and experiences of the physical world. The arts that the public generally associates with the communication of abstract realities are music, poetry, and some forms of prose; in these art forms it expects to find expression of intimate areas of human experience. That the visual arts may also serve this purpose is less easily recognized. For centuries painters and sculptors have tried to express their personal reactions to their subject matter; and in recent times the communication of the artist's subjective world has become more and more prevalent. There are constant efforts to find a means of communicating these unseen realities in visual terms. The drawings by Picasso discussed in Chapter 2 (Figs. 25, 26) may be used again to exemplify the differ-

opposite far left: 85. BRONZINO. *Portrait of a Young Man* (possibly Guidobaldo II, Duke of Urbino). 1530–32. Oil on panel, $37^5/_8 \times 29^1/_2''$. Metropolitan Museum of Art, New York (bequest of Mrs. H. O. Havemeyer, 1929; H. O. Havemeyer Collection).

opposite left: 86. BRONZINO. *Portrait of a Young Man.* c. 1537–38. Oil on panel, $33^7/_8 \times 26^3/_8''$. Staatliche Museen, Berlin.

right: 87. JEAN-AUGUSTE-DOMINIQUE INGRES. *Louis Bertin.* 1832. Oil on canvas, $46 \times 35^1/_2''$. Louvre, Paris.

ences between art which has a representational emphasis and art which emphasizes the expressive, subjective response of the artist. The differences in these drawings are dramatically obvious. The head for *Guernica* does more than describe; it involves the viewer in the passion that the artist must have felt at the moment he produced the drawing. One cannot imagine Picasso as an uninvolved observer when he began this study. It is much easier to assume a certain detachment on his part when he executed the nude study. Yet an argument could be made that here, too, the artist was emotionally involved and that the drawing is expressive of a quite different concern. Often, it is difficult to isolate the representation of perceptual reality from the subjective response of the person who records his perception. Complete objectivity is an impossible goal, and even in the art of such a courtly painter as Bronzino (Fig. 85), a Mannerist who worked in the sixteenth century, one can find a sense of the involvement of the artist.

Compare the Bronzino with Ingres' portrait of Louis Bertin (Fig. 87), a work of the nineteenth century that appears to be an attempt at objective representation. Though quite similar in style, there are stylistic differences between them which indicate that the two works are the products of different hands. Both artists created sharply focused studies of the form and texture of

the physical aspects of the subjects. Very little opportunity seems available for the expression of the artists' attitude toward the men they have portrayed. But what of the posture of the subjects? Their poses could have been reversed. Imagine the response of a viewer had Louis Bertin been posed, like Bronzino's aristocratic youth in Figure 85, standing with his hand on his hip and the other hand gracefully marking a place in a book, or if Bronzino's subject were seated, like Bertin, in a chair, legs apart, with his fingers resting on his thighs. Consider the absence of architectural environment behind the Ingres figure and the geometric division of the spaces that divide the area in the sixteenth-century work.

The second Bronzino *Portrait of a Young Man* (Fig. 86), from the Staatliche Museen in Berlin/Dahlem, offers an interesting comparison with the adjacent painting by the same artist, now in the collection of the Metropolitan Museum in New York. Though the hard-edged, precisely painted style in both attests that the paintings came from the same hand, the differences between them contribute to the sense of the artist's response to his subject. The New York portrait is angular and full of sharp contrasts of dark and light, with a strong, elegant emphasis on the vertical composition. The Berlin painting is much more even in tone, with a rounder, more harmonious linear structure, less elegant but contributing to the representation of a sitter who appears more humane and sensitive than the figure in the Metropolitan portrait.

The artist's personal response to experience can be demonstrated in a more obvious and direct manner. He can act the role of commentator on contemporary society. By the use of caricature or dramatic emphasis he can depict people and events in a way that indicates a political, moral, or ethical opinion.

In 1835, France was in a state of social unrest. Many of her citizens felt the lack of personal and political freedom that had been expected as a result of the French Revolution of 1789 and the Republic that was formed in 1792. The successive regimes of Napoleon Bonaparte, Louis XVIII, Charles X, and finally Louis-Philippe had left French citizens hungry for the economic and political rights to which they believed themselves entitled. The rule of Louis-Philippe saw continued conflicts between the government and various groups in the country. Honoré Daumier lived during this period. As an artist, he identified with the republican ideals of the Revolution and spent much of his life commenting, in visual images, on the social injustice and the hypocrisy he saw about him. Much of his commentary was published in a periodical called *Charivari*. The artist's intention was to stir responses in his viewers that would encourage them to resist governmental acts that Daumier despised. For instance, a drawing (Fig. 88), published in 1835, referred to a trial of Lyons workers who had struck the previous year. Its caption reads: "You have the floor, explain yourself." The scene and the caricatured faces, combined with the caption, leave no doubt about the artist's personal reaction to the condition of law in his country.

The contemporary draftsman who wishes to make a relevant social or political comment often employs images that are simpler and less pictorial than

those drawn by Daumier. Instead of producing a picture or a tableau, he may invent a symbol that communicates its meaning to the reader by distorting the recognizable features of a well-known subject so as to dramatize a salient characteristic or idiosyncrasy. The meaning can be amplified by the use of a drawing style that appears to express the emotions of the draftsman as he created the image. Robert Osborn's rapid, excited line in Figure 89 is a short-

above: 90. WeeGee (Arthur Fellig).
The Critic. 1943. Photograph.

right: 91. Dorothea Lange.
Migrant Mother, Nipomi, Calif. 1936.
Photograph for
the Farm Security Administration.
Oakland Museum, Calif.

hand pictorial note. In a succinct and simplified calligraphy the artist has drawn an easily apprehended symbolic statement, a social comment, and a personal declaration.

Photography lends itself admirably to the production of telling images that reveal social and political attitudes on the part of the photographer. By selecting his subject matter, or by isolating posture or action of the subject, a photographer can make a subjective comment on the world he perceives. An excellent example is to be found in the photograph by WeeGee entitled *The Critic* (Fig. 90). Though not caricatured in the manner of Daumier, the subjects in this picture are stopped, in time, by the photographer's camera in a moment of self-caricature that is both revealing and amusing.

A more poignant statement is made in the photograph taken by Dorothea Lange of a migrant woman and her children (Fig. 91). This intimate study can be seen as a sympathetic record of an isolated event in the life of one family, or it can become a commentary on the misery and moral fortitude of many people throughout the world, whose heavy burden leaves its evidence in their anonymous faces.

The Communication of Order

Many works of art present no parallels with the experience of an observer because they were produced in a period, geographical location, or culture remote from his own. What can they mean to the contemporary person who does not share the background of the artist responsible for the art works? A study of history may supply some of the meaning. The similarity of emotions which men have shared throughout time may reveal other meanings. The ability to recognize the representations of physical reality may seem to give another kind of understanding.

An examination of Plate 17 (p. 85) can give a revealing insight into this problem. This work is from the Herat school of painting in Persia, and it dates from the sixteenth century. What does it really mean to a contemporary Western museum visitor? Certainly it is possible to recognize the representation of figures, a paved court, and what appears to be a building with two figures dining within it, even though the form of representation does not conform to the style commonly seen in Western painting. Once this level of understanding is achieved, what other meaning is to be found in this work? The painting is titled *Bahram Gur in the Turquoise Palace on Wednesday*. Who is Bahram Gur? Who are the others in the courtyard? Is this a simple private meal between two friends, two lovers, two philosophers? The sixteenth-century Persian miniaturist wanted to convey some meaning to his coeval audience. Can the meaning derived by a contemporary viewer who passes the work in a gallery make this painting a significant artistic statement in the last half of the twentieth century? It may be suggested that much of the narrative meaning and the historical setting of this work can be gathered by research in libraries. Books can surely be found to explain the storytelling element, and this kind of information will offer the

92. Initials JVE, LL, and PNME,
from *The Universal Penman.* 1743.

viewer some satisfaction of a literary order. Yet even without such background
knowlege, the painting can give a high degree of esthetic satisfaction to present-
day persons. The differences of time, place, and culture have not markedly
affected the human response to color, form, and texture, which constitute
the primary reality of the object. The contemporary viewer can find pleasure
and meaning in these elements and in the recognition of the way they have
been organized.

It is just this sense of order to which Alberti referred in the definition of
beauty quoted in Chapter 2 (p. 42), and it can be, for the observer, a kind of
special communication bridging the gaps of time and geography and giving
him a sense of satisfaction and pleasure.

Rarely do we find a system of communication without provision within it
for an esthetic elaboration of the symbols which are used. In the spoken lan-
guage the choice of words for their euphonious character or for the rhythm of
a syllabic progression becomes a natural part of dramatic and poetic speech.
Decorative writing, the use of illuminated initials in manuscripts, and the
arrangement of type on a page (Pl. 18, p. 86; Figs. 92–94) are examples of the
union of symbolic function with esthetic function in written communication.

Plate 14. HENRI DE TOULOUSE-LAUTREC. *Le Divan Japonais*. 1892. Lithographic poster, 31⁵/₈ × 23⁷/₈″.
Museum of Modern Art, New York (Abby Aldrich Rockefeller Purchase Fund).

left: Plate 15. GEORGES SEURAT.
Entrance to the Harbor, Port-en-Bessin.
1888. Oil on canvas, $21^5/_8 \times 25^5/_8''$.
Museum of Modern Art, New York
(Lillie P. Bliss Collection).

below: Plate 16. ANDRÉ DERAIN.
London Bridge. 1906.
Oil on canvas, $26 \times 39''$.
Museum of Modern Art, New York
(gift of Mr. and Mrs. Charles Zadok).

opposite: Plate 17. *Bahram Gur
in the Turquoise Palace on Wednesday.*
Persian miniature, Herat school,
16th century. Metropolitan Museum
of Art, New York
(gift of Alexander Smith Cochran, 1913).

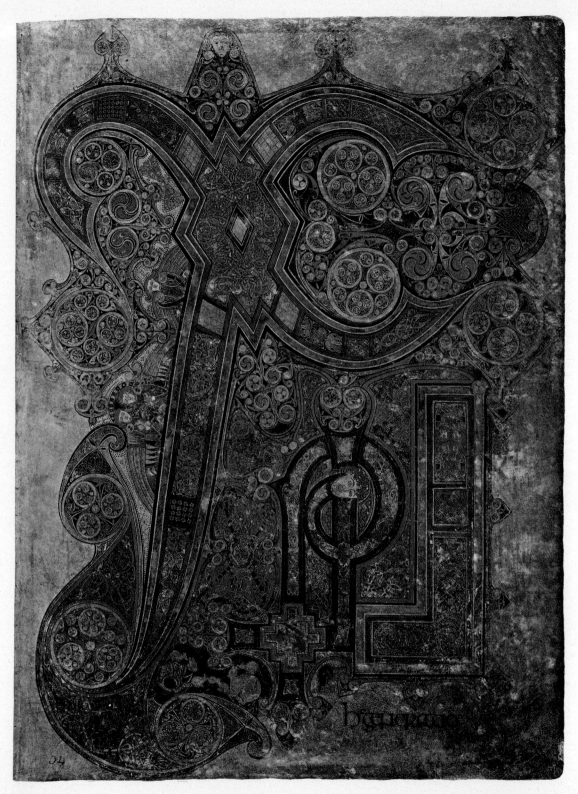

Plate 18. Chi rho monogram, from *The Book of Kells*. 7th–8th century. Trinity College Library, Dublin.

93, 94. Dennis Wheeler. Posters for *Life*, 1964.

above : 93. *Banner of Leadership.*

right: 94. *Fresh as Spring.*

Often, in the combination of these two functions, the concern for esthetic elaboration reduces the readability of the message. In the reproduction of illuminated initials from *The Book of Kells* (Pl. 18), an early Celtic Biblical manuscript, the Greek letters χ ρ ι, the first three letters of the name of Christ, have been used as the basis for an intricate design. The design is so complex that it all but eliminates the symbolic significance of the form. One aspect of communication gives way to another. Contemporary examples of the reduction of legibility to increase the decorative aspect of type are found in Figures 93 and 94, both posters for the magazine *Life*. In Figure 93 the well-known title

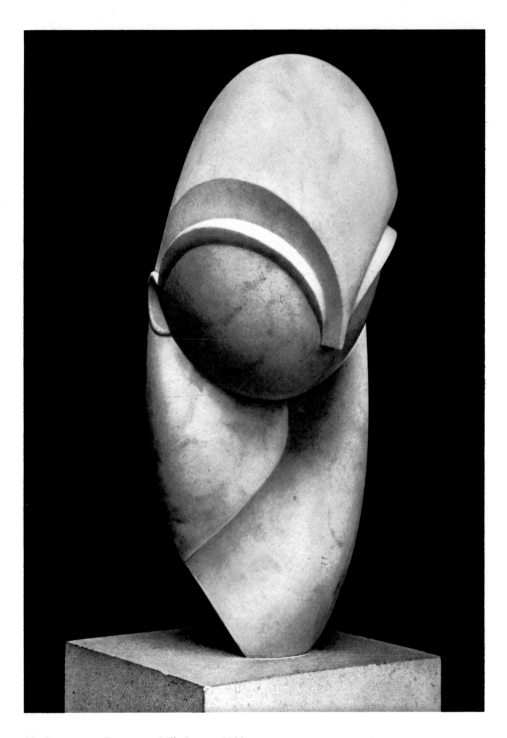

95. Constantin Brancusi. *Mlle Pogany*. 1931.
Marble on limestone base, height 17 1/2″.
Philadelphia Museum of Art
(Louise and Walter Arensberg Collection).

has been cut and shifted to assume the shape of a stylized flag. The letters here are out of their normal position, but still legible. In Figure 94 the letters L and I are shifted and F and E are almost totally obscured as the designer uses them to create the symbol of a flowering plant. Because the *Life* identification is so well known, the designer can alter it considerably without losing the recognition value of the symbol and its reference to the magazine.

Constantin Brancusi's marble head *Mlle Pogany* (Fig. 95) is an example of sculpture in which the esthetic relationships of the forms seem to dominate the symbolic function of these forms. The carved marble object represents a human female head, but because the repetition and continuity of flowing, curved lines was of major concern to Brancusi, the recognition of the object as a head becomes more difficult. In a manner similar to that employed by the designer of a beautifully written word the artist reduces symbolic meaning for what might be called an esthetic effect. Yet it should not be assumed that there is a dichotomy between the esthetic concern and the symbolic concern of an artist. The very simplification of the natural details of the head of his subject so as to produce an elegant marble object enabled Brancusi to make a statement about the subject through the use of the material and the esthetic relationship of the forms.

The portrait of Mlle Pogany can be "read" as a simplified human head; it can be "read" as an esthetically pleasing marble object, in which surface and form combine to produce a three-dimensional design; or, finally, it can be "read" as both symbol and object, the qualities of the object taking on a meaning directly related to the subject symbolized. Meaning in the visual arts may occur on any of these three levels or on all of them.

There are works of art which make no reference to subject matter of any sort. Often, these art objects are characterized by an extremely sensitive exploitation of the potentials of color, form, or texture. In the common use of the word "meaning" it might be argued that these works are meaningless, even though they may draw an esthetic response from the viewer, but it is possible to conceive of works of art in this group as their own subject matter. They "speak" *of* themselves. Their meaning lies in the complex formal relationships built into them. To understand them is to recognize the manner in which they have been constructed, to sense their order and the intellectual and emotional character of the person who produced them (Fig. 20; Pl. 19, p. 95).

This discussion began with the question: "What can the artist communicate?" To sum up, art as communication has much that is common to all sytems of communication; symbols and groups of symbols are combined in structured relationships to achieve equivalents for human experience. The symbols that are developed are separate and distinct from the actual objects and experiences they represent. Often, these symbols and their organization are based upon a previous tradition, but just as often they are the result of an individual artist's attempt to find the means of communicating those aspects of his experience he feels cannot be expressed with the visual language of his heritage. Because of the new breadth of subject matter now a part of the environment

in which men live, because of the relatively recent emphasis on one's subjective attitudes and responses to experience, there is a continuing search on the part of the artist for visual equivalents expressive of his inner world and of his consciousness of the world he perceives about him. Parallel with the artist's concern for the visual equivalent is his interest in the esthetic structure of his work. At times it is the symbolic meaning which dominates his art, at times the esthetic, but most often it is a fusion of the two.

As in the instance of verbal or written communication, there is a need for adequate preparation on the part of all parties to the intercourse; and for the observer of painting, sculpture, and architecture this means recognition of the problems of communication in the visual arts and active participation in the study of the new languages which appear as artists strive for an adequate expression of contemporary life.

THE LANGUAGE
AND VOCABULARY OF
THE VISUAL DIALOGUE
Two-dimensional Forms

chapter 4

PAINTING
The Plastic Elements

The visual arts are conveniently divided into two-dimensional and three-dimensional objects. Three-dimensional art forms, sculpture and architecture preeminently, occupy real space with real forms—measurable and having actual weight and substance. The two-dimensional arts of painting and drawing also require actual materials—paper, cloth, plastic surfaces that carry marks or areas of color produced by pigment-bearing substances—but generally the visual and esthetic meaning of these art forms depends upon the relationships and images that are created by the organization of the work in the dimensions of width and length. Often the artists working in two dimensions make use of three-dimensional illusions based upon optical and symbolic relationships established upon the flat surface of the drawing or painting.

Though it is possible to speak of these two categories as distinct polar art forms, many contemporary examples of art seem to straddle the two extremes, with three-dimensional elements occurring in essentially two-dimensional objects, or with flat, painted or engraved, two-dimensional areas or linear elements incorporated into predominately three-dimensional constructions.

Rembrandt's painting of an old woman cutting her nails (Fig. 96) is really a great many areas of colored paint applied to a canvas surface (Fig. 97). Each area was mixed by the artist and brushed, stroke by stroke, beside other areas to produce an image that represents an old woman. She appears to be three-dimensional, she appears to be in a lighted space, and the viewer has the

impression of seeing a living person engaged in a normal human activity. But, of course, Rembrandt, as he painted the picture, understood that he was creating an illusion, and the observer is aware that the woman is only an image. Rembrandt knew how to realize this image by making the appropriate decisions about the quality of the color, the size and shape of the color areas, and their relative positions so that the three-dimensional illusion appeared.

Similarly, Richard Anuszkiewicz made decisions that created the illusions which are the basis for his painting *All Things Do Live in the Three* (Pl. 19, p. 95).

left: 96. REMBRANDT. *Old Woman Cutting Her Nails.* 1648. Oil on canvas, $49^5/_8 \times 40^1/_8''$. Metropolitan Museum of Art, New York (bequest of Benjamin Altman, 1913).

below: 97. Detail of Figure 96.

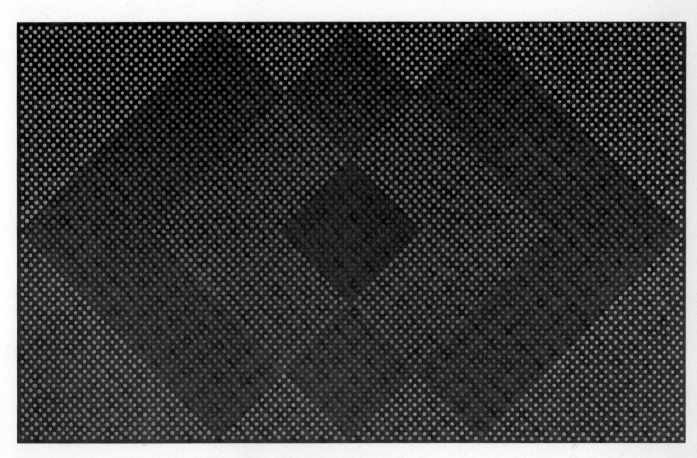

Plate 19. RICHARD ANUSZKIEWICZ. *All Things Do Live in the Three*. 1963.
Oil on canvas, 21⁷/₈ × 35⁷/₈". Collection Mrs. Robert M. Benjamin, New York.

Plate 20. Thomas Wilfred.
Lumia Suite, Opus 158 (two stages).
1963–64. Light composition projected
against a screen, 6 × 8′.
Museum of Modern Art, New York
(Mrs. Simon Guggenheim Fund, 1963).

HUE

VALUE

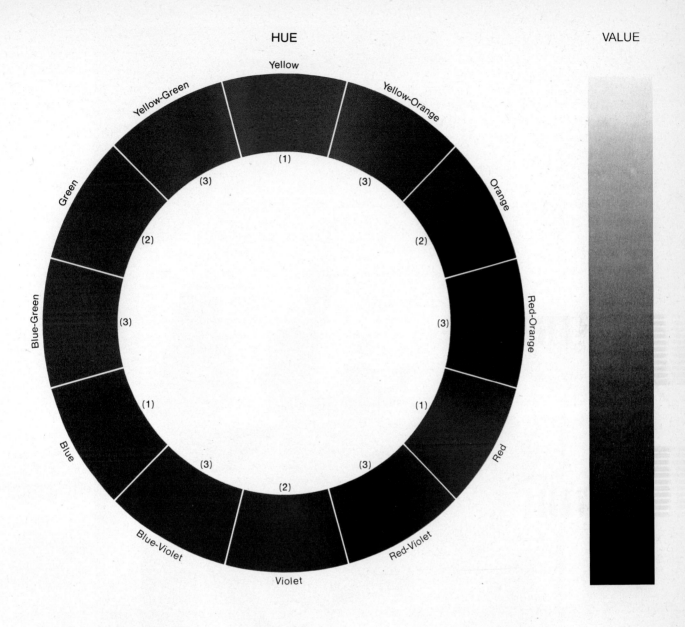

SATURATION

Plate 21. Charts showing the ranges in the three dimensions of color—hue, value, and saturation (intensity).

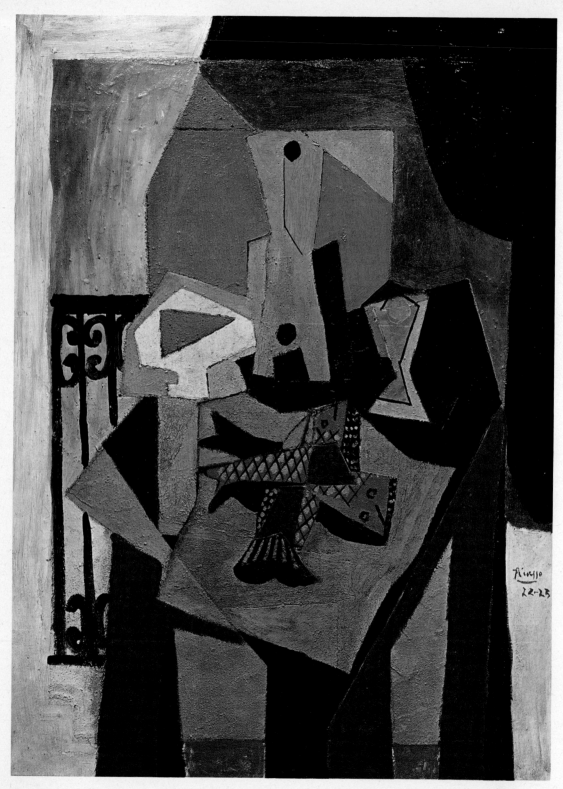

Plate 22. PABLO PICASSO. *Still Life with Fishes*. 1922–23.
Oil on canvas, 4′ 3″ × 3′ 2¹/₂″. Courtesy Marlborough Gallery, New York.

His intention differed from Rembrandt's, for the two artists were not attempting to produce similar illusions, but both had the ability to use color so as to create the appearance of space, motion, or objects that engage the perception of the beholder with a conviction of actuality. Anuszkiewicz used the optical effects of juxtaposed, contrasting color areas to generate a sense of vibration. Sections of the painting seem to float in front of other sections; then in some mysterious way the illusion changes, and the forms that seemed to advance now recede, and others take their place. This ambiguous back-and-forth effect occurs within the limits of an area that shimmers with a vibrant light so intense that for many it is difficult to look at for extended periods of time. Actually, no light exists in the painting, and the forms do not, in fact, undulate; the illusion is vivid and immediate, but the shifting of forms and spaces takes place only in the eye and mind of the beholder.

The Rembrandt painting is an illusionary representation of a light condition that the observer has experienced before. Anuskiewicz has devised an illusion of vibrating light and movement unrelated to any representational meaning dependent upon the perceptual mechanism of the observer in response to the interacting colors.

The observer can walk about and within a building. The material of a statue occupies actual space, casts shadows, and offers itself to be touched. A painting or drawing, on the other hand, exists in a world without physical depth. Two-dimensional art stops at the frame or edge of the paper or canvas and at the depth of the coloring or tonal agent on a flat surface. It is this difference which divides the plastic means of the painter from those of his counterparts in the three-dimensional arts.

The marks made by paint or drawing materials can be described in the following terms: the color of the marks, the areas they fill, the distances or space between them, and their texture or surface quality. These are the essential plastic elements of two-dimensional art: *color, form, space,* and *texture.* Often, the element of *line* is added to the other four. Line is a special aspect of form that is basic to many kinds of drawing and painting. We might say that a line is actually a form so long in proportion to its width that we tend to overlook the dimension of width and assume that the element has only the one dimension of length. It is also possible to consider line as the edge of a form. In either case—as the evidence of the gestural act of drawing or as the boundary of a form—line plays an important role in the two-dimensional arts, whether it is considered a separate plastic element or a particular component of the element of form.

COLOR

The painter, the draftsman, and the printmaker all begin with color as their basic plastic element. Color in the arts of two dimensions is the means for the development of all the other elements. Two-dimensional form cannot exist without differentiation of color; even a black form on a white background is dependent upon the *contrast* between white and black for its existence. No form

can be produced unless it is in some color. No form can be seen unless it is on some different color.

To understand why an artist makes specific color choices it will be necessary to consider the nature of the choices available to him.

Any discussion of color inevitably depends upon the ability of the communicators to identify and describe the particular qualities which give each color its distinctive appearance. In painting these qualities are a function of the source of illumination used to light the surface of the work and the coloring matter in or on that surface. Color theory, as applied to light from a direct source, is somewhat different from that applied to color as perceived from reflected surfaces. Most of the present-day use of color in the visual arts is reflected color, and this discussion will concentrate on a description of this theory. The reader should note that, as in sculpture and architecture, light has become an extension of color in the work of some artists concerned with two-dimensional art forms.

One of the pioneers in the use of projected lights is Thomas Wilfred. Wilfred's light painting experiments date from 1919. Since that time he has continued to produce automated light constructions called *Lumia* (Pl. 20, p. 96). They consist of translucent screens upon which are projected, from the rear, a continuously changing pattern of prismatic light effects. The slow variations and developments of the light forms have much in common with the changes occurring in the movements of clouds or the shimmering reflections that can be seen as light bounces off the surface of moving water and falls on a ceiling or wall. Other artists are using light to intensify the brilliance of the color painted on the surface of their work; still others use it as a contrast or complement to the painted areas.

Many systems have been developed for the description of color. Most of them employ a theoretical model of a three-dimensional solid as a graphic device for the representation of the three qualities in color which, it is generally agreed, affect the appearance of any individual color. These qualities are identified as *hue,* the visual distinction of, for instance, red from blue; *value,* the relative darkness or lightness of a color; and *saturation, intensity,* or *brilliance*— the vividness of the pure color progressively dimmed or dulled toward neutrality.

Hue

The *hue* of a color is a function of the wavelength of the light that is reflected from a surface to the retina of the eye. The spectrum of wavelengths and their corresponding hues varies from waves about 1/33000 inch long, which are seen as red, to those about 1/67000 inch long, which are seen as violet. At certain points along the spectrum most people with normal vision will identify narrow bands at which the change of wavelengths appears to produce a change in the quality of the color. These bands have been identified by the commonly used words "red," "orange," "yellow," "green," "blue," and "violet" (Pl. 21, p. 97). Actually, many people can identify intermediate bands which seem to differ enough from the bands juxtaposed to them to require separate identities, so

that "yellow-orange" and "red-orange," "yellow-green" and "blue-green," "blue-violet" and "red-violet" are also used to make distinctions of color quality. For the trained color observer, even more precise identifications of isolated wavelength bands are possible, and each identifiable band on the spectrum is called a "hue."

Color theorists have recognized that it is possible to obtain most of the colors in the spectrum from a combination of a limited number of hues, known as *primary hues* and identified as yellow, red, and blue (Pl. 21, p. 97). Different proportional mixtures of two of the primaries will produce the spectral range between them. Thus, combinations of red and yellow will include a great variety of yellow-reds and red-yellows. At a point along the scale the yellow-reds and red-yellows appear to take on an identity separate and distinct from the parent hues. This intermediate, or "secondary," hue is called "orange," which can appear to vary from a red emphasis (red-orange) to a yellow emphasis (yellow-orange). Blue and yellow can also be combined in varying proportions to produce a scale that includes green at some point in the progression, with modifications comparable to those on the red-yellow scale, ranging through blue-greens and yellow-greens, bluish yellows, and yellowish blues. On the scale made by combinations of blue and red we find violet, with variations of reddish blues, red-violets, blue-violets, and bluish reds.

Theoretical combinations of hues are used as guides by painters, but the mixtures are modified according to characteristics of the paints available. Most of the manufactured paints take their hues from the colored powder, the pigment, that is used in them. Such pigments are processed from raw materials of mineral and chemical origin. For example, a whole range of reds and yellows results from treatment of the metal cadmium, which changes color in this range as it is heated. Cadmium yellow, cadmium yellow light, cadmium yellow pale, cadmium orange, cadmium red light, cadmium red, and even cadmium purple are available from most paint manufacturers. Some of the pigment hues closely approximate spectrum colors, but few are identical to them. Painters learn to combine pigments so as to arrive at the hues they want, for theory does not always match reality, and they cannot mix from primary hues all the colors they want and need. For this reason paint is manufactured in a great number of hues combined from many different pigment materials and bearing color names not found in the description of the spectrum.

Value

On a scale beginning with black and progressively lightening to white, a hue such as yellow is seen to have a degree of lightness close to the white pole (Pl. 21, p. 97). Other hues in the blue or violet family match points on the scale nearer black. This measure of lightness in a color is called its *value*. As noted, not all hues have the same value; each of them may be altered in value to be lighter or darker. With opaque paint, it is possible for the artist to raise the value of a color by the direct addition of white. When transparent paints

are being used, the artist can add vehicle (that is, the liquid medium in which the pigment is mixed) and thin the paint, dispersing the particles of pigment so that more of the white ground shows through the paint film. This gives the optical effect of a lighter value. Similarly, hues can be darkened to a lower value through the admixture of black, or, in the case of transparent paint, by applying the thinned paint over a dark ground.

Saturation

It is possible to produce an area of color which is yellow in hue, very light in value, and extremely bright. This same light-hued yellow can also be made to appear dull and grayed. The difference in brilliance is said to be a difference in the degree of *saturation*, or *intensity*, in a color (Pl. 21, p. 97).

In paint, each hue has a different ultimate degree of saturation, for the pigments available to produce the color and the binding medium have limits in the brilliance of color they can produce. All hues, however, can be reduced in brilliance until they reach the lowest levels of saturation. At that point they become neutralized and appear as grays which cannot be identified with any hue family.

When two hues of paint are combined and their combination produces a neutral gray, the hues are said to be *complementary*. Some disagreement exists about the precise identification of complementary hues, but in broad terms red is complemented by a hue in the green or blue-green area, yellow by violet or blue-violet, and blue by orange. By varying the proportions of a complementary mixture of hues, it is possible to realize many different degrees of saturation.

The German physical chemist Wilhelm Ostwald suggested another basis for producing saturation changes. He established his color system upon the combination of hue, white, and/or black. That is, he used additions of white *or* black to change value, but he produced saturation changes by combining a hue with a porportional mixture of white *and* black.

Many of the colors produced by raising or lowering the value of a hue are known by names not used in color theories. Brown results from lowering the value of the hues in the red, orange, and yellow section of the spectrum. Navy blue and forest green are also low-value forms of the basic hue. Pastel colors such as pink, aquamarine, and lemon yellow are found at the high end of the value range.

The Color Solid

A theoretical model, similar to one developed in the early nineteenth century by the German artist Philipp Otto Runge—of the three color qualities, hue, value, and saturation—can be constructed so that the hues are represented as circling a vertical axis (Fig. 98). This axis represents a value scale with black at the bottom and white at the top. Changes in saturation are expressed across the

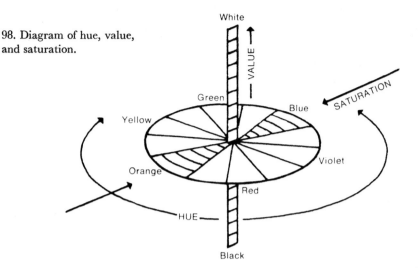

98. Diagram of hue, value,
and saturation.

circle, so that the blue-orange complementary group is shown with the most
brilliant color at the outer edge of the hue circle and neutrality is indicated at
the center point, a step on the vertical axis. The orange and blue segments
become progressively grayer as they move toward the center.

A horizontal slice through the color solid shows all the hues at a constant
value level with diminishing saturation indicated from outer edge to the center
(Fig. 99).

A vertical slice through the color solid shows two complementary hues
juxtaposed along the value axis. These hues vary in value along the vertical
axis and in saturation along the horizontal axis (Fig. 100).

The model described above is a simplified concept. It does not represent
the differences in value and saturation between pure hues. A more precise
model could be constructed, but it would not differ in essentials from that
drawn here.

left: 99. Diagram of variations
in saturation.

right: 100.
Diagram of hue variations
in value and saturation.

FORM

Form in two-dimensional art is the area containing color. Figure 101 represents a canvas bearing a painted color field. A change in the color of the area will not affect its size or proportion; the form remains the same, no matter what color it contains. A form as simple as the square in Figure 102 can be found in some contemporary paintings (Pls. 75, 76, p. 460), but usually forms are far more irregular in outline. The forms in Pablo Picasso's painting *Still Life with Fishes* (Pl. 22, p. 98) could be traced from the surface to a piece of paper and cut out to become a kind of jigsaw puzzle, each shape fitting into those adjacent to it. Every puzzle piece could be given a color different from that in the painting, and certainly the appearance of the work as a whole would change, but the forms would still communicate much of the original content (Fig. 103).

Sometimes, as in the paintings of Monet (Fig. 16) and Renoir (Pl. 5, p. 35), the edges of the forms are imprecise; it is difficult to say exactly where one form ends and the adjacent form begins. In cases like this the edges seem to exist within a loosely defined boundary area at the outer limits of a coherent color shape. One can sense where the forms seem to end without being able to point to a definite point of change.

In some paintings, comprehensive forms are created by groups of smaller forms. As in the square in Figure 104, areas of closely related color join to create larger forms. Close study of the Monet painting in Figure 16 will reveal

left: 101. Diagram of a canvas bearing a painted color field.

left: 102. Diagram of a canvas bearing a field painted in a single color.

right: 103. Analysis of Plate 22 (p. 98), Picasso's *Still Life with Fishes*.

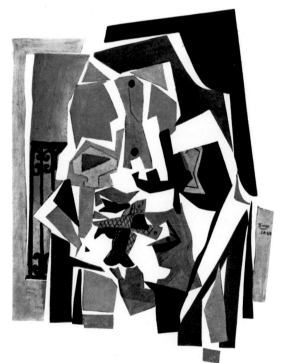

above: 104. Diagram of a canvas supporting a comprehensive form composed of groups of smaller forms.

right: 105. Analysis of Figure 85, Bronzino's *Portrait of a Young Man.*

a progression of form groupings that begins with the primary units, individual brush strokes organized into small areas, which then become parts of a larger compositional structure.

It is important to note that the forms referred to here are not the illusionistic representations which "read" as part of the factual content of the painting. In Bronzino's *Portrait of a Young Man* (Fig. 85) it is the central dark form composed of smaller light and dark color areas that we observe and not the young man's *clothed body* alone, which is an illusion created by the combined shapes of the subsidiary color areas. The dark form representing the costume is joined with a low-value form above that stands for the shaded side of the man's face and his hat. At the lower left the major central form is joined to a dark form that represents the side of the table. If the viewer squints his eyes so that the details of the painting are obscured, he will more clearly see the large dark, light, and intermediate values of the areas that divide the painting into several forms of varied size (Fig. 105).

SPACE

The artist who works in two dimensions begins by making marks on a flat surface. This surface is his *space*, the world in which he constructs the plastic order of his art. Limited by the size and proportions of the two-dimensional plane, the painter arranges his forms in this space to make them satisfy the esthetic, representational, and expressive needs of his concept.

The analogy of the jigsaw puzzle can serve here, too. If the space of the painting is taken to be a sheet of paper the size and shape of the completed puzzle, the forms, or parts of the puzzle, can be placed in their required positions on the paper. Imagine the paper partially covered by pieces of the puzzle.

106. JACK YOUNGERMAN. *Anajo*.
1962. Oil on canvas, 6′ 2″ × 6′.
Collection the artist, New York.

The paper shows through between the separated parts; that is, the *forms* are seen sitting in the *space*. The combination of forms and intervening spaces comprises a composition in which it is possible to distinguish forms from spaces and still find the organization satisfying. Also possible is a situation in which the entire paper, or space, is covered by interlocking forms, so that no void is revealed. The only space the observer is aware of is the total area of the paper, as indicated by the outer dimensions of the entire puzzle. In the first instance we are dealing with a composition that has positive, important elements of form set in measurable positions relative to one another on a limited ground or space. In the second example all the forms have a similar importance; they are interdependent. This compositional statement does not refer to the representational content of the painting. The parts of the puzzle can combine to create the illusion of any number of pictorial images, or they can be joined without a representational intent to produce a visual effect dependent solely upon the response of the observer to combinations of color areas.

In responding to a picture like Jack Youngerman's *Anajo* (Fig. 106), how does one know whether the composition is intended to be read as a group

Plate 23. HANS HOLBEIN THE YOUNGER. *Georg Giesze*. 1532.
Oil on panel, 37³/₄ × 33″. Gemäldegalerie, Staatliche Museen, Berlin.

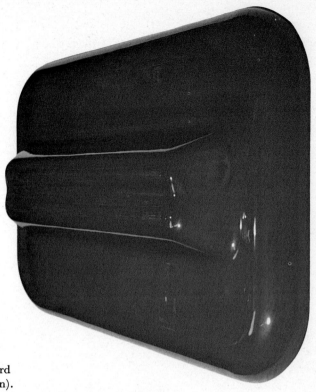

opposite: Plate 24. CARLO CRIVELLI.
St. Peter, detail of a wing panel
in *The Demidoff Altarpiece*. 1476.
Oil and gold leaf on lime, entire panel 4′ 6³/₄″ × 1′ 4″.
National Gallery, London
(reproduced by courtesy of the Trustees).

right: Plate 25. CRAIG KAUFFMAN. *Untitled*. 1967.
Vacuum-molded plexiglas, 4′ 8″ × 2′ 10¹/₄″.
Collection Julie and Don Judd, New York.

below: Plate 26. JOHN MARIN.
From the Bridge, New York City. 1933.
Watercolor, 21⁷/₈ × 26³/₄″. Wadsworth Atheneum, Hartford
(Ella Gallup Sumner and Mary Catlin Sumner Collection).

Plate 27. EL GRECO. *The Vision of St. John the Divine*. 1608–14. Oil on canvas, 7′ 2¹/₂″ × 6′ 4″. Metropolitan Museum of Art, New York (Rogers Fund, 1956).

of forms moving away from the observer or a group of forms locked together on a single plane? An observer who senses that certain forms in a painting seem more important than others may interpret them as the positive form components of the composition placed in a controlled relationship to one another on or in a space. Another observer may conclude that the relative importance of the forms in the painting is ambiguous. At one time one group seems to be most important; at another, a different group assumes primary value.

An untrained viewer may be disconcerted by the idea that it is possible to respond in a number of ways to ambiguous elements in a work of art. Judgments regarding the importance of form-space relationships or even regarding the point at which a soft-edge form ends and adjoins another form involve psychological and physiological states within each observer. For some works of art the judgments can be made with a high degree of certainty that other viewers will have similar responses, but other art objects are far less precise in their construction. There is no way to be assured that one's own reading of an ambiguous visual composition is the "right," the "true," relationship as intended by the artist. When a work of art requires imprecision to satisfy the artist's expressive, representational, or esthetic intention, the artist has no alternative; he must introduce ambiguity, knowing that this may elicit an unanticipated interpretation of his work by those whose perceptual, intellectual, and emotional sets differ from his own.

TEXTURE: THE THREE-DIMENSIONAL ASPECTS OF PAINTING

The illusionistic representation of tactile surfaces has long been a concern of painters and draftsmen. By the sixteenth century, European painters, particularly those in the north, had developed representational skills and techniques to extraordinary levels. No tactile surface was too difficult for them to simulate. There is a magical quality in the painted illusions of glistening silks, transparent and reflective glass, burnished metal, and the intricately woven patterns of Oriental rugs that are to be found in the paintings of artists like Hans Holbein (Pl. 23, p. 107). The artist's observation of these materials is as keen and insightful as the examination he has given the facial and figurative character of his subject.

The pictorial effects achieved by the artist in paintings that stress tactile illusions are the result of consistent and precise drawing, accurate perception and rendition of small differences in tonality, painting techniques that utilize opaque and transparent applications of pigment, and the ability of the painter to form sharp, hard contours, or edges that are blurred and atmospheric. The physical surface on which such a master as Holbein painted was conventionally flat, and his brush strokes smoothed to an even, glassy finish, for the artist concieved of his work as the creation of an illusion, and he did not wish to attract the viewer's attention to the medium, the paint, which is the real tactile surface of painting.

Though illusionistic painting still has its adherents, the contemporary interest in tactile surfaces is more frequently expressed by the use of actual three-dimensional elements bonded physically to the painting support.

Precedents for the enrichment of surface can be found in many periods throughout the history of art. Painters often have embossed the gold backgrounds and details of their panels. In Plate 24 (p. 108) is reproduced a detail from an altarpiece by Carlo Crivelli that includes three-dimensional relief elements with mounted jewels in the brooch and miter of St. Peter, as well as embossing of the surface at the back.

The works of many painters, among them Rembrandt (Figs. 96, 97), exhibit the use of thick paint that protrudes from the plane of the painting. Sometimes such *impasto* areas may function on both an illusionistic and a physical level, creating an equivalent for a real object and simultaneously acting as a three-dimensional surface variation in contrast to areas of flat paint. Vincent van Gogh (Pl. 7, p. 37; Fig. 107), and, later, Chaim Soutine (Pl. 29, p. 120), among others, also enriched the surfaces of their canvases with applications of thick paint and made impasto an integral part of their art.

Early in the twentieth century the elaboration of the surface was extended even further by combining paint with other materials—painted paper, cloth, wood—which were attached to the surface of the canvas, in works called *collages* (Figs. 108–110). Contemporary painters such as Alberto Burri (Fig. 111)

107. Vincent van Gogh. *Sunflowers.* 1887.
Oil on canvas, 17 × 24″.
Metropolitan Museum of Art, New York (Rogers Fund, 1949).

below left: 108. JUAN GRIS. *Breakfast.* 1914. Pasted paper, crayon, and oil on canvas, 31⁷/₈ × 23¹/₂″. Museum of Modern Art, New York (Lillie P. Bliss bequest).

below right: 109. GEORGES BRAQUE. *Le Courier.* 1913. Collage, 22 × 22¹/₂″. Philadelphia Museum of Art (A.E. Gallatin Collection).

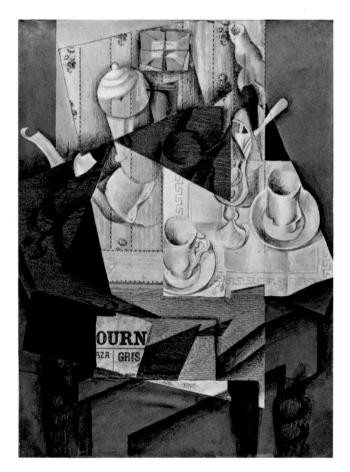

right: 110. KURT SCHWITTERS. *Cherry Picture.* 1921. Collage on painted cardboard, 36¹/₈ × 27³/₄″. Museum of Modern Art, New York (Mr. and Mrs. A. Atwater Kent, Jr., Fund).

left: 111. ALBERTO BURRI. *Grande Nero Plastica La-3.*
1963. Plastic with oil on canvas, 6′ 8″ × 6′ 5³/₈″.
Collection the artist, Rome.

below: 112. ROBERT RAUSCHENBERG. *Canyon.*
1959. Oil on canvas with assemblage,
7′ 2¹/₂″ × 5′ 10¹/₂″ × 1′ 11″.
Collection Mrs. Ileana Sonnabend, Paris.

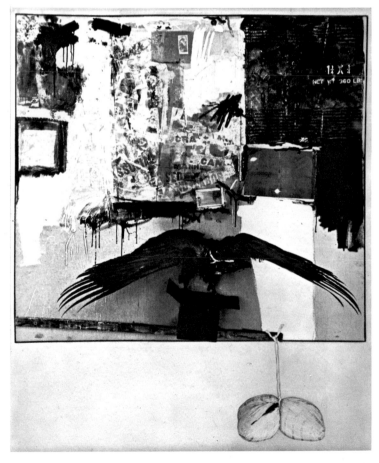

and Robert Rauschenberg (Fig. 112) have gone beyond even these innovations to produce works which approach the depth of sculpture.

In the plexiglas objects of Craig Kauffman (Pl. 25, p. 109) the distinction between painting and wall sculpture almost ceases to exist. Kauffman's pieces are produced by an industrial process called "vacuum forming" that shapes sheets of plastic to predetermined forms. The resulting lightweight, transparent shell is then painted on the back with intense color areas reinforcing the spatial effects of the actual three-dimensional forms projecting forward from the wall.

The examples given here all have physical and material three-dimensional elements. Much more common in the history of painting is the creation of an illusionistic third dimension by systems of perspective drawing, color values, light and shadow, overlapping of forms, placement of the forms within the picture area, and other devices calculated to produce a symbolic equivalent for actual objects existing in natural space and depth, as well as the textural illusions mentioned on page 111. Since these methods of representation apply also to other two-dimensional arts as well as to painting and require a rather extensive analysis and explanation, they have been treated as the subject matter of Chapter 6.

LINE

Figure 113 is a black mark that would be described as a *line* by almost anyone looking at it. When this same mark is enlarged to five times its original size (Fig. 114), it becomes a form. The difference is based upon our perception of the dimensions. In the first, the length of the mark and its undulating direction so dominate our perception that we tend to ignore the width. In the second, though identical in proportion and shape, the size is so greatly increased that the dimension of width becomes significant.

The artist produces his lines with instruments—pens, pencils, etching needles, crayons, brushes loaded with paint. The marks made by these instruments are measurable in two dimensions, but when they result in what we call "lines," one of the dimensions is disregarded. This is particularly true of a line that maintains a fairly constant thickness, as in Picasso's *Girl Before a Mirror*

above: 113. A "line."

below: 114. Figure 113 enlarged five times to make a "form."

(Pl. 2, p. 16). The linear elements in de Kooning's *Woman and Bicycle* (Pl. 3, p. 17) are more varied in size and have a kinetic character, a sense of the action on the part of the artist who produced them, especially when compared to the more restrained quality of the lines in the Picasso painting. The viewer should consider the linear elements in these two paintings as both lines and forms. As lines, they provide two-dimensional webs in each painting, forming an arabesque over much of the canvas surface; but they also act as slender forms of color, contributing to a complex, interdependent color-form composition.

The scale of linear elements in painting can be large and obvious, as they are in these two examples, or it can be fine-drawn in sharply focused detail, like that in the dark accents on the forms representing leaves in Van Gogh's *Sunflowers* (Fig. 107). Careful examination of this painting will reveal short linear forms that combine to make up the broader and larger forms. These smaller lines of color have both a cumulative effect—giving a directional character to the large forms and suggesting movement, growth—and a depth that would not be expressed by flat, undifferentiated areas.

As noted earlier in this chapter, another type of line perceivable in a work of art results not from a mark inscribed by a drawing instrument but from the division of two adjacent color forms along a clearly defined edge. Vertical, diagonal, and horizontal edges in Juan Gris' painting *Breakfast* (Fig. 108) can be seen as linear elements dividing the spatial composition of the painting, similar to a drawn grid like that in Figure 115.

In painting, then, the artist has at his disposal the plastic elements of color, form, space, texture, and line. Each element may be analyzed individ-

ually, but each can contribute to the effect of one or more of the others. Frequently the artist may utilize all of them in the expression of his intention. Thus, for most painters, form and space cannot be separated from color. Line and form are often the same thing. The impasto of the brush stroke can be texture, form, and color simultaneously.

The beginning student of painting and design is often given a specific problem intended to deal with one or two of these elements at a time, but before long he realizes that a work of art results from the interaction, from the interdependence of these means, rather than from their operation as independent parts of the whole.

MEDIUM AND PROCESS

In the visual arts, as in all the arts, the artist must manipulate material or utilize a process or group of processes to carry out his work. Colors in a painting result from the application of colored materials to a surface. The spectator may see a red area which is an integral part of an ordered esthetic relationship, but the artist had to manipulate paint to produce the area. The artist must control the physical properties of paint to achieve the esthetic results he has in mind.

Though a work of art may be discussed in the theoretical terms of its plastic elements, it must be recognized that these elements are products of, and therefore affected by, the physical media and processes used to create them.

Ideally, the manipulation of a medium should be inherent in the esthetic unit produced by the artist. In fact, however, many art objects demonstrate such an extraordinary technical virtuosity that exploitation of the medium overshadows the content of the work.

Thus, there is a great difference between the visual effect achieved by the artist and the means of attaining it. The shimmering brilliance of an area of color in a Monet painting (Pls. 11, 12, p. 65) derives from small touches of oil paint, mixed on a palette or taken directly from the tube and applied by a stiff brush to the surface of a canvas fabric stretched tightly over a wooden frame. The final effect depends upon Monet's choice of color and the size and disposition of the color areas, but it is also affected by the texture and viscosity of the paint, the flexibility of the brushes, and the surface of the canvas support. Similarly, the quality of the red area in John Marin's watercolor in Plate 26 (p. 109) is partially due to the physical properties of the medium employed.

Oil paint similar to that used by Monet can be employed to induce a great many different surface and color effects. For this reason, oil has been a popular medium since its introduction. It may be thinned into a transparent film and applied in successive layers, as in the work of El Greco. In *The Vision of St. John the Divine* (Pl. 27, p. 110) the artist began to work on a canvas tinted with a dark color. The light areas in the painting were created by laying films of white, transparent paint, one over the other, until the desired degree of lightness was reached. Finally, the local hues were introduced by the use of additional glazes of thinned paint.

Edouard Manet, in the nineteenth century, applied his oil paint directly on a white canvas in vigorous brush strokes that were meant to be seen. *Boating* (Pl. 28, p. 119), by this artist, is painted without the use of glazed overlays. Each color placed on the canvas was mixed in the hue and value the artist wished and then transferred directly from the palette to the surface of the painting. Another example of direct painting is Chaim Soutine's portrait of Moise Kisling (Pl. 29, p. 120), a work whose sense of immediacy and vitality derive in part from the thick paint surface the artist laid on in the impasto manner.

Each painting medium offers the artist a great number of possibilities for the production of color and surface effects. Decisions concerning the kind and number of technical variations to be used in a single work of art depend upon the artist's personal style and his esthetic and expressive intentions.

In the painting *Violin and Pipe with the Word "Polka"* (Pl. 30, p. 121), by Georges Braque, the artist applied oil paint to the canvas in relatively flat areas. The gray-green forms have been overlaid with a painted pattern: diamonds, circles, and broken lines in diagonal movements provide a contrast to the flat areas and, at the same time, repeat the diagonal and curved forms found throughout the composition. Additional variety is introduced by mixing sand with the paint, so that certain areas of the painting differ in surface texture. The rough texture tends to modulate the light that falls on the flatly painted surfaces, bringing forth a subtle variation in the color. The degree of roughness is controlled within specific areas, so that the smoother surfaces, like the white forms, contrast with the more obviously textured blacks in the center of the composition. Besides adding sand, Braque combed the thick film of brown paint covering those forms based on the table top and legs, so that the wavy lines were incised into the paint surface. Within this work the paint substance has been used in several ways, and yet the effect of the whole is one of an ordered composition, because the artist has used the technical variations as part of an overall compositional plan.

Acrylic resin plastic paints have become very popular in recent years. These synthetics produce intense, flat color areas and, when thinned with water, have much the same quality as transparent watercolor. Often, as in the Morris Louis painting in Plate 31 (p. 122), they are used on a giant scale with visual effects once restricted to the more modest sizes usually associated with the aqueous media.

Each artist uses those materials that suit his personal and esthetic needs. If the painter requires a medium that easily permits him to cover large areas of canvas quickly, acrylics offer an attractive possibility. If he is concerned with small detail and the subtle development of surfaces over a long period of time, oil paint may be the most practical medium for achieving the desired results. The artist knows, and the observer should realize, that each medium has its own advantages and its specific limitations. The painter learns to work within these limits, adjusting his concepts to the capacities of the medium, seeking another medium when the one he has been using lacks the qualities needed to fulfill his purposes.

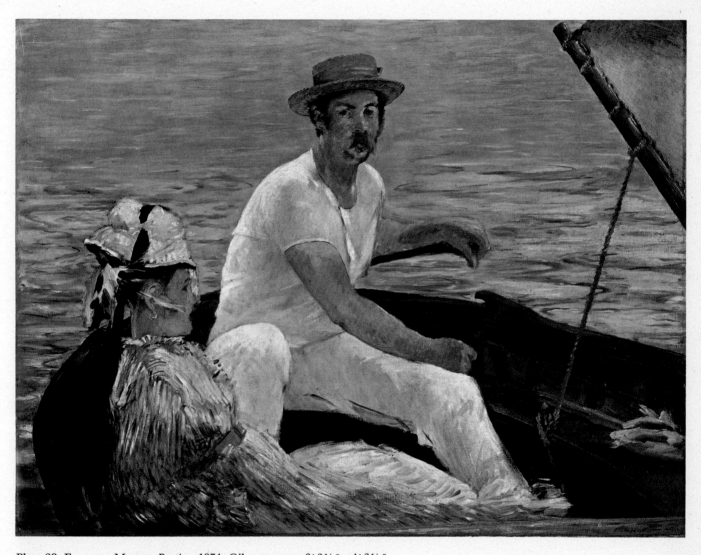

Plate 28. EDOUARD MANET. *Boating*. 1874. Oil on canvas, 3′ 2¹/₄″ × 4′ 3¹/₄″.
Metropolitan Museum of Art, New York
(bequest of Mrs. H. O. Havemeyer, 1929; the H. O. Havemeyer Collection).

Plate 29. CHAIM SOUTINE. *Portrait of Moise Kisling*. c.1930. Oil on canvas, 39 × 27¼".
Philadelphia Museum of Art (given by Arthur Wiessenberger).

Plate 30. GEORGES BRAQUE. *Violin and Pipe with the Word "Polka."* 1920–21.
Oil and sand on canvas, $17 \times 36^{1}/_{2}''$.
Philadelphia Museum of Art (Louise and Walter Arensberg Collection).

Plate 31. MORRIS LOUIS. *Untitled B*. 1954.
Acrylic on canvas, 8′ 7″ × 6′ 8″. Collection Carter Burden, New York.

chapter 5

PAINTING
Esthetic Organization

The plastic elements of the visual arts are the basic components used by an artist to construct each of his works, but the way in which he organizes these elements distinguishes one art object from another. A painter may, in one instance, combine color, form, texture, and line to produce a representational image; in another he may combine these same elements in an entirely different way to express his subjective response to a personal experience. Basic to every art object is a central intention, a focus, which requires the artist to make decisions about the number and the kind of elements he will use and the way they will be arranged.

Ideally, every element in a work of art should be an essential component of the artist's intended representational, functional, expressive, or esthetic meaning. It is this unified combination of selected elements which gives the work its meaning, and an observer who approaches a work of art must be able to recognize that the elements are unified before he can understand or appreciate their significance. In all art, unity and meaning are closely related. The appearance of a work of art rarely results from a purely expressionistic or representational intention on the part of the artist. Most often it is possible to recognize aspects of an art object which take their form from the artist's desire to give his work an esthetic order. Frequently it is difficult to separate this order from the total content of the work. The expressive meaning of a blue form in a painting is achieved by its position on the canvas, by the particular

color and shape of the form, and by the interaction between this part of the painting and the other parts that surround it. This meaning may also be determined by the identification that the viewer makes between the blue form and objects in nature. The blue form may be a part of a pattern of color or of forms, which can reveal itself to those who are aware that such a pattern may exist, and the content of the painting will be intensified or broadened when the viewer can recognize the multiple functions played by the elements in it.

In many art objects the expressive or descriptive aspects of the elements are restricted. In some, these elements are employed solely as parts of an esthetically satisfying unity. What can stimulate a viewer to respond to the appearance of a calligraphic line? The line is not a symbol. It does not describe or express an experience of anything seen in nature. The observer's response to the line must depend upon the direction, the rhythms, and the texture resulting from the drawing instrument, and then upon the position of the line on the sheet of paper. Imagine a calligrapher at work. He has before him an empty sheet. If he begins a stroke, his pen filled with ink, knowing that he wishes to make the stroke three times the length of the initial mark, how shall he complete it? Figures 116, 117, and 118 are possible solutions. It is not necessary here to agree on one of these solutions in preference to the others. It is important to realize that one of them, or rather one of many possible variations, will be chosen. After that choice has been made, others will be needed before the drawing is complete; more strokes may be added, or other instruments used.

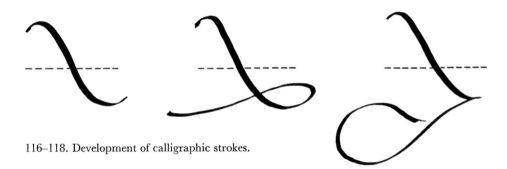

116–118. Development of calligraphic strokes.

In the process of working, the artist continually makes choices from the infinite range of possibilities available to him. Once the art object has been started, some of his choices follow as a result of his initial decisions. Forms and colors in the work suggest other forms, other colors, to a painter; the shapes and surfaces in a piece of sculpture suggest related treatments to the sculptor. The esthetic order sought by the ceramist, the sculptor, the painter, or the architect can be developed in many ways that are basic to all the visual arts. Young art students are introduced to these methods in the early phases of their training, and it will be useful for those who wish to understand the visual arts to acquaint themselves with a number of the ways employed to organize art objects. However, it should be understood that the skillful plastic organization of a

119. Repetition of forms in a rectangle.

work of art does not in itself ensure the production of a masterpiece, any more than the work of a skilled grammarian necessarily produces a great novel. Often, the person who defies the traditional esthetic form or who creates new forms of order is the one who produces the extraordinary work of art. A slavish adherence to established principles can result in a dull, academic exercise. Despite this possibility, it is still valuable to understand certain basic organizational principles, so that even those works of art which appear to be a reaction to precedent can be seen in contrast with it.

UNITY AND VARIETY

Esthetic unity is achieved when the parts of an art object fit together in some identifiable order. The order, or organization, of the elements may appear to be simple or it may be highly complex; it can be based upon one or several characteristic qualities in the elements.

Perhaps the simplest method for creating unity within a work of art is by repeated use of similar or identical elements.

In Figure 119 the large rectangle has been divided into four similar areas. This is a design in which there are many repeated elements. All the forms are rectangles, and all the rectangles are identical in size and shape. Their color is the same. They are placed so that their long and short axes are parallel. This extensive repetition produces a unified design, but though the similarity between the several elements is immediately recognizable, the design has little interest for most viewers. Yet the composition is undeniably unified. If the observer seeks meaning (and meaning in the visual arts derives from esthetic order), why does the diagram in Figure 119 seem so dull? Psychologists tell us that the need to understand, to find meaning in the world about us, is coupled with a need for stimulation and involvement. The individual needs to be challenged; he needs problems to solve, mountains to cross. He requires a sense of participation in his environment.

The "will to live," often said to be the great inclusive motive of all living creatures, is in human beings not simply the will to stay alive but rather the will to live in active relations with the environment. Being equipped with sense organs and motor organs and a well developed brain, the human individual

120–123. Variation in rectangular forms.

120.

121.

122.

123.

has a fundamental inclination to deal with environment. This motive is not primarily directed toward serving the organic needs and meeting the emergencies of life, but toward knowing objects and persons, doing things to them, and participating in what is going on in the environment. Just because this objective tendency is so all persuasive it is often overlooked and omitted from a list of fundamental motives, where it certainly belongs. It shows itself in the general tendencies to explore and manipulate the environment, and in a great variety of more specific interests.[1]

The artist recognizes the need to involve the observer by presenting him with a work that is ordered and seems comprehensible, but at the same time the artist understands that the observer cannot be bored. A work of art must provide enough of a challenge to maintain the interest of those who stop to view it. It must have unity, but it must also have within this unity a complexity, a challenging difficulty, to involve the viewer in a search for a meaning that he senses must be there in the work. Both of these attributes, unity and complexity, or, as it is often called, variety, are essential to any work of art, and the measure of an art object is often the result of the skill of an artist who combines the elements of his work into a unified whole with the imagination that adds variations to and within the basic unity.

In Figure 119 a more pleasing composition would result if some of the elements were unified and others were used to provide variety. The rectangle

in Figure 120 is the same as the rectangle in Figure 119. The four forms within the larger one are identical with those in the previous drawing, but the color of two of the areas has been changed. This design is not exceptionally exciting, but even a variation as simple as this adds interest to the original composition.

Figure 121 demonstrates another variation on the original design. Again four small rectangular forms are drawn. Unity is retained by repetition of rectangularity in the forms and by repetition of color, but the rectangles are no longer of identical proportions and size. Their major axis has been shifted, too, adding still another variation to the design. Figures 122 and 123 demonstrate two other ways of varying the basic scheme. In each one there remains enough similarity in the character of the four separate forms to give a sense of unity, but at the same time each drawing exhibits a variation or a number of variations which introduce a certain added degree of complexity.

Obviously, it is possible to combine a number of these variations in one design. The painting *Composition in White, Black, and Red* by Piet Mondrian (Pl. 32, p. 131) is an excellent example of just this kind of play with similar and dissimilar characteristics. Using a minimum of means, the artist has devised a composition in which the space of his canvas is divided into rectangular areas. Careful examination of the painting will show that areas which seem identical, including the width of the lines, have been subtly varied. The long red rectangle at the bottom of the canvas and the area of black at the top contrast with the other white rectangular forms separated by the black lines.

The apparent simplicity of this painting is misleading, for it is a carefully and painstakingly controlled composition. The precise size, shape, color, and position of the elements on the surface of the canvas are those which the artist felt were the optimum choices for the creation of the greatest esthetic effect. It is the precision of the decisions that makes this painting complex, so that a seemingly simple composition can, in fact, result from a complex series of interrelated and interdependent choices.

The paintings of Josef Albers are superficially even simpler than those by Mondrian. The example of Albers' work in Plate 75 (p. 460), *Study for an Early Diary*, is composed of three square forms aligned on a vertical axis. Each of the forms is painted in a single, relatively flat color. Actually, it is incorrect to describe this painting as having three squares, for only the center form is a square. The other two forms are more accurately characterized as square "doughnut" shapes. Such distinction is important, because the composition of this painting is based upon the effects produced by the interaction of color areas enclosed by other areas of color. By surrounding the blue center square with orange and the orange area with pink, Albers produced a brilliant, rather mysterious color experience. The painting seems to radiate light, and the flat forms appear to shift in space, moving toward the observer and then away.

The complexity in this painting depends upon the precise selection of the colors, the arrangement of those colors, and the size of the color areas. Albers has restricted the shape of the forms, severely limited the number of the forms, and applied the paint to the surface of the canvas in a simple and direct way.

above: 124. Peter Paul Rubens. *Tiger Hunt.* c. 1616. Oil on panel, 3′ 2″ × 4′ ³/₄″.
Wadsworth Atheneum, Hartford (Ella Gallup Sumner and Mary Catlin Sumner Collection).
(See also Pl. 33, p. 132.)

below: 125. Compositional analysis of Figure 124.

But even means as minimal as these provide the artist with combinations and variations of color and form that are overwhelming in number.

An adequate response to paintings of this type requires a highly discriminating sensitivity to the interaction of color. For those who can recognize the differences between very similar hues and values of color and the way color areas appear to change when related to other areas of color, this form of painting offers the basis for a satisfying esthetic experience.

Plate 33 (p. 132) is a painting by Peter Paul Rubens, dated in the seventeenth century. Though an initial glance at this painting may give the viewer the feeling that it is very much like a photograph, a more careful study will disclose important differences between the mechanical system of photographic representation and the work this artist has produced. Rubens was extremely careful about the organization of his work. Wherever possible, he has repeated curved lines and curved forms so that a basic unity is achieved. Note the repetition of the curve in the back of the tiger as it continues through the body of the attacked rider. This curve is echoed by the movement of the breastplate of the rider at the right. It is picked up and repeated innumerable times throughout the rest of the painting. Even the arms of the figure fighting with the lion have been stylized into curved muscular forms (Figs. 124, 125).

This composition is purposefully organized. In that respect it is similar to the Mondrian. It differs from the more contemporary painting in that here the basic design has been used as a skeleton for the arrangement of human and animal forms, whereas in the work by Mondrian the skeleton and the finished forms are one. In both cases, however, the repetition of qualities in the elements has been used as one of the basic means for the unification of the work.

Unity through Contrast

Unity may also be found where seemingly it should be absent—in contrast. If the repetition of similar qualities in the plastic elements produces unity, contrast might be thought to be an ideal way of creating chaos. Contrast may be defined as a relationship between extremes, an expression of differences. This definition in itself hints at the unity of contrast. In the statement that contrast is a *relationship* an assumption must be made that there is a connection between the contrasting parts; they are joined as extremes of the same or similar characteristic qualities. Black and white are bound together, as are green and red, empty and full, or up and down. In each instance the presentation of one-half of a polar couple calls forth its opposite number. Each part of the combination seems to need the other to reach completion, a state of equilibrium. The union which results from the combination of two opposite elements is a demonstration of a resolution of forces. It is a unity that most people can sense immediately. Often, it is referred to as a "sense of balance."

Many writers on art, including those who are trained as psychologists, consider balance a requisite for a satisfactory esthetic composition. No one is absolutely sure why balance should be an essential factor, but apparently it is.

above: 126. Formal balance.

left: 127. Informal balance.

The simplest form of balance is achieved by duplicating on one side the forces in operation on the other side of a fulcrum, as in placing two children of equal weight at equal distances from the center of a seesaw. This kind of balance, in which one side is identical to the other, is called "formal" (Fig. 126). It is an extremely limiting method of creating equilibrium. An artist v.ho uses it must be prepared to repeat all elements on each side of the center line. A state of equilibrium may be accomplished without this restrictive requirement. It is possible for two children of different weights to balance themselves on their seesaw by adjusting the distance between themselves and the center of the board, so that the heavier one is closer to the fulcrum. A similar adjustment can be made to achieve balance in other circumstances. This kind of balance, in which unequal elements are resolved, is called "informal" (Fig. 127). Dissimilar elements can be brought together to equal other combinations of dissimilar elements. In the case of the seesaw, weights and distances are combined so that their product is equal, even though the individual parts are different. However, the elements need not be restricted to two only. As our visual interpretation of balance changes from actual physical weight to other kinds of "weight," such as the "weight" of colors, the "weight" of textures, or even the "weight" of ideas, it is possible to perceive rather complex combinations of elements as equaling other combinations and therefore in balance with them (Figs. 128–131).

128. When forms are identical in shape and color, size affects visual weight.

129. When forms are identical in shape and size, color affects visual weight.

130. Shape can affect visual weight, though mass and color may be similar.

Plate 32. PIET MONDRIAN. *Composition in White, Black, and Red.* 1936. Oil on canvas, $40^1/_4 \times 41''$.
Museum of Modern Art, New York (gift of the Advisory Committee).

Plate 33. PETER PAUL RUBENS. *Tiger Hunt*. Oil on panel, 3′ 2″ × 4′³/₄″.
Wadsworth Atheneum, Hartford (Ella Gallup Sumner and Mary Catlin Sumner Collection).

131. The symbolic content of a form or group of forms can add visual weight to an area. Because the forms at the right are grouped to read as a word, their visual weight is affected.

POW!

As we have noted, there is little disagreement on the necessity for balance in art. However, once the composition of a work of art becomes complex and many different colors and irregular shapes are introduced, it is impossible to arrive at a balanced composition by a mechanical method. Balance in the visual arts is a function of *visual weights*. The apparent weight of an element in a composition may vary as its color is changed, its shape is altered, or its texture or size is varied. Its position on the sheet of paper or the canvas is a critical factor in this system. Elements may vary in weight as they are moved from the bottom to the top or from side to side in a composition (Fig. 132). Even the

132. Visual weight can be affected by the position of the form in relation to the edges of the space being composed.

symbolic significance of an element may influence its effect on the balance of a composition. For instance, a gray rectangular form will have a certain weight in a composition, depending on its size, shape, position, color, and surface variation. When a photograph of about the same tonality is substituted for the rectangle, the visual weight increases, because the image of the photograph gives an added level of meaning to the form it fills (Figs. 133, 134).

Obviously, the complexity of even the Mondrian painting (Pl. 32), composed with apparent simplicity, requires more than a mechanical placement of elements to arrive at a state of equilibrium. Thus, while all may agree about the necessity for a balanced composition, the most one can say regarding the

left and below: 133, 134. Visual weight can be increased by the use of an added level of meaning.

135. BRIDGET RILEY. *Current.*
1964. Synthetic polymer paint
on composition board,
4′ 10³/₈″ × 4′ 9⁷/₈″.
Museum of Modern Art, New York
(Philip C. Johnson Fund).

attainment of such an end is that the artist arrives at it intuitively and the
viewer must use his intuition in responding to the visual evidence. With so
many variables affecting the weight of his elements, no artist can consciously
control all the significant factors that must be resolved in the balance of a
work of art. Nevertheless, because he needs to achieve a feeling of equilibrium
when he studies his work, the artist organizes the elements in it to satisfy this
need.

Another use of contrast as the basis for the organization of painting is to
be found in the work of "optical" artists such as Richard Anuszkiewicz (Pl. 19,
p. 95) and Bridget Riley (Fig. 135). Anuszkiewicz was a student of Josef
Albers, and, like Albers, he concerns himself with problems of color interaction.
His paintings are composed of simple geometric forms, usually divided into
small areas. By restricting the light-and-dark (value) contrast of his colors and
exploiting the contrast between hues, through the use of such combinations as
red and green, orange and blue, or violet and yellow, Anuszkiewicz produces

paintings that shimmer and vibrate in a manner suggesting the brilliance of flickering neon light.

If the traditional concept of esthetic balance is applied to the Anuskiewicz canvas, the composition is seen to be symmetrically organized. In fact, the color spots and the forms in which they are arranged are formally balanced along both the vertical and horizontal axes. Given the degree of symmetry in this painting, an observer might expect to find a stable, somewhat restrained composition. Instead, the work is vibrant and exciting. Substituted for the contrast of forms that might have produced this excitement in an asymmetrical arrangement is a contrast of adjacent color areas.

Similarly, the English artist Bridget Riley presents us with a composition that employs symmetry along a horizontal axis in combination with a repeated linear form that alternates black and white (Fig. 135). Here, too, the dynamic visual impact results from the contrast of adjacent areas of color.

The seemingly shimmering surfaces in both these paintings are derived from the response of the human eye to the excitation aroused by the agitating patterns. It is correct to say that these two examples are balanced, but this description does not suggest the way in which opposing elements have been joined to bring about a dynamic composition. The unity in both paintings depends, in large part, on the fact that each color form is a part of an interacting matrix. Variety is not introduced by the usual methods but comes from *optical* shifts and movements that occur in the perception of the observer.

The use of color contrast to produce vibration is not, in itself, an innovation. The Impressionists adopted this device, but in Impressionist painting the vibration of areas was employed as a means for the representation of flickering light and shadow in nature. In these paintings it became a means for the production of an image to which the observer responds as the essential significance of the work. Paintings like those by Riley and Anuszkiewicz have been grouped into a category identified as "optical," or Op, art. Actually, all paintings are in a sense optical, for they all depend upon the function and the limitations of the eye for the perceptual response of an observer. However, Op painting does differ from earlier types in that the organization of the works is almost totally dependent upon the creation of a pattern of contrasting, interacting color forms.

The observer, like the artist, needs a world in balance, and he, too, is satisfied by a recognition of forces in equilibrium. But unless he realizes that balance can be effected by the operation of many plastic elements, he may respond only to those obvious visual weights that have become important to him. Given enough time, however, even an untrained observer can learn to recognize the significance of many of the plastic elements in a balanced composition.

Unity through Movement and Continuity

136. Movement and continuity.

In Figure 136 the reader is given a prescribed path to follow, which moves from separate element to separate element and ties them all together by virtue of a

continuous visual sign. The observer is offered a series of visual orders which moves him in a step-by-step awareness from part to part—now up, now to the right, then down, and back again. No matter how complex the path, no matter how devious the route, if he can follow it, the observer is able to sense a continuity between individual elements, because they are connected by a ribbon of linear movement.

In his desire to unify many different elements in a composition, the artist can make use of this sort of linear connection. He can establish a more or less continuous linear path which links all the separate elements into a large, understandable unit. This unit may be very simple—a geometric form such as a triangle or a circle—or it may be developed into a highly complex movement of mazelike appearance.

In the *Madonna del Gardellino* Raphael adopted such a device (Fig. 137). By it he was able to group the major elements of the painting into a triangular structure (Fig. 138). The three figures, the two infants and the female figure,

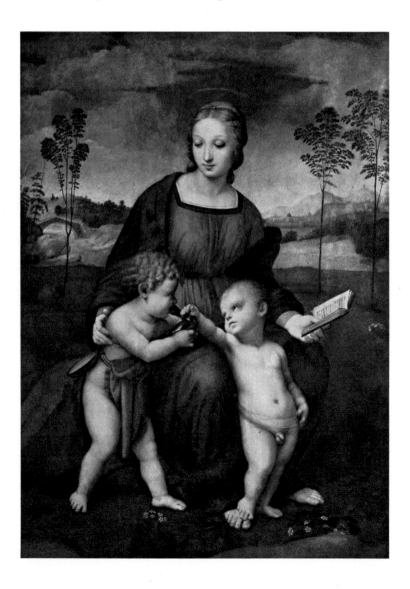

left: 137. RAPHAEL.
Madonna del Gardellino. 1505.
Oil on panel, $42 \times 29^{1}/_{2}''$.
Uffizi Gallery, Florence.

above: 138. Compositional analysis of Figure 137.

are placed so that they are contained within the space of the triangle. This simple geometric form is easily recognized and provides the unifying basis for the entire composition. Notice, too, that this large triangle sets the pattern for the introduction of many subsidiary triangular motifs, which the artist repeated in the position of the children's legs and in the movements in the drapery. Here is an instance of unity by repetition reinforcing unity by continuity.

Repetition, balance, and movement, or continuity, are often found in combination as unifying methods in a single work of art. It is rare that an artist depends on only one of them to establish the design of his work. In his desire to integrate his work the artist uses whatever seems to him effective for his purpose. He may make the individual choices consciously, but often he may make them as a part of a series of intuitive decisions as he works at his object, trying to complete it, changing element after element until each feels right and all go together.

PICTURE-PLANE ORGANIZATION

Painting can be understood as a flat, two-dimensional arrangement of colored forms, or it may be regarded as an instrument for presenting illusionistically an equivalent of three-dimensional form and space on a two-dimensional surface. In either case the methods of esthetic organization can be applied to arrive at a unified composition.

If the painting is considered in its actual two-dimensional context, the area to be organized is that bounded by the sides of the canvas. It is a flat, two-dimensional plane of measured length and width (Fig. 139).

139. The two dimensions of the picture plane.

This frontal plane is called the "picture plane." When the artist concerns himself with the organization of the picture plane, he thinks in terms of flat shapes, which may vary in size, shape, color, and pattern. These shapes can be arranged on the surface of the picture plane in an infinite variety of positions. No indication of depth in the painting is considered in picture-plane organization. It is as though the artist worked with a group of cut-paper forms which are never permitted to overlap.

Pablo Picasso's painting *Still Life with Fishes* (Pl. 22, p. 98) can be analyzed as a picture-plane composition which utilizes a number of the organizational methods described in this chapter. There is repetition of the shape of the forms. With few exceptions they are constructed out of triangular sections with straight edges. A number of curved forms are introduced, notably in the railing at the left. These curves are also repeated in the bottom of the drape at the right and in the tail of the lower fish. Triangular forms dominate the composition, but curves in a subordinate grouping help to unify the design. Color, too, is found in a repetitive distribution. Black forms and green, yellow, blue, and orange forms are placed in a complex interrelationship. Sizes of the areas vary greatly, as do the intervals between them, introducing a significant factor of variety within the basically unified composition. A number of edges are disposed so that there is a continuous movement along them. Sometimes this occurs without a break, as in the edge at the top left, which combines the black, green, and orange forms in a diagonal that echoes the major diagonal movement of the black form at the right edge of the table. Another movement continues the vertical edge of the right table leg into the form of the curtain. To the left there is still another vertical movement along the edge of the table; however, this time it is not continuous but, after a space, is picked up directly above to extend the vertical thrust.

A more extended structural analysis of this painting would show the same methods of organization applied to smaller details. However, it must be emphasized that an analysis such as the one above comes after the fact of the painting. It is doubtful that Picasso consciously planned all the relationships he organized in this painting; many must have been intuitively felt. Nevertheless, the finished work does take on much of its character from the interrelated plastic elements on the picture plane.

PICTORIAL SPATIAL ORGANIZATION

In contrast to the flattened picture-plane emphasis of the Picasso, Canaletto's painting *View of Venice, Piazza and Piazzetta San Marco* seems to deny the existence of a picture plane (Fig. 140). It is as though the artist wished to eliminate the front surface of the painting to make the viewer believe that an actual three-dimensional space existed behind the picture frame. Linear perspective (see pp. 172–176) is used here to represent the deep space, but at the same time the converging diagonal lines of the buildings produce a linear continuity which connects the many separate forms into a few basic movements on the picture plane

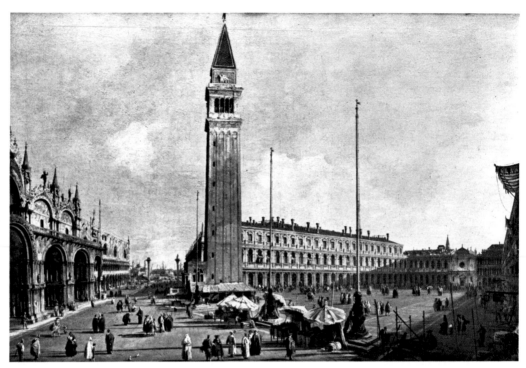

above: 140. CANALETTO. *View of Venice, Piazza and Piazzetta San Marco.* c. 1730. Oil on canvas, 26 × 40¹/₂″. Wadsworth Atheneum, Hartford (Ella Gallup Sumner and Mary Catlin Sumner Collection).

below: 141. Compositional analysis of Figure 140.

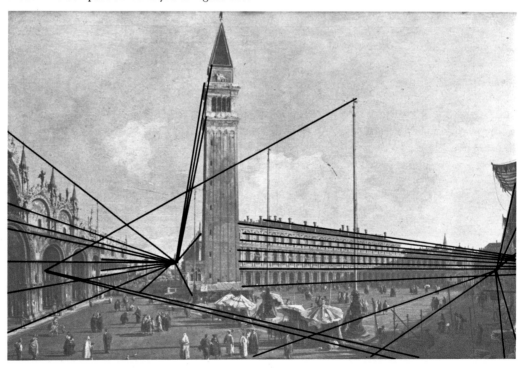

(Fig. 141). Vertical repetitions are also a unifying factor, as are the repeated curved forms in the arcades and umbrellas. Here, then, is a painting in which the organization of the picture plane seems to be disregarded, and yet that organization does exist, though it is not so complex as in the later painting by Picasso.

To assume that Canaletto was primarily concerned with the picture-plane composition would be to deny the obvious pictorial emphasis in this painting. The painter has produced an illusionary space representing two great squares in the city of Venice. However, the pictorial intention does not eliminate the need for esthetic organization in the painting. The illusionary space and the forms filling that space may be organized much as a choreographer or a director would organize the human and constructed forms which fill a stage. If the artist paints as though there were no picture plane, he may apply the methods of esthetic organization to the *pictorial* elements rather than to the *plastic* elements. He can arrange buildings, walks, trees, and people, rather than forms, lines, and colors.

Imagine the space in the Canaletto painting without the figures in it. If the artist had wished to, he might have painted figures so that they appeared to stand at any spot within the illusionary space of the two squares. All the figures could have been lined up, evenly spaced, along the front of the pictorial space, leaving the rest of the square empty. They could all have been grouped at the left or at the far right. Instead, the painter has arranged them in groups of various sizes and then arranged the groups in groups. Grouping is another form of linear continuity, and it is used rather frequently by painters in organizing a pictorial space.

Note, too, that the space created by the painter varies in depth, receding far back at the left-center but blocked by the mass of the building and the enclosed area of the Piazza at the right. The speed of the movement back seems to shift also, moving quickly at the left and more slowly at the right.

It might be argued that the composition of this painting was an *automatic* result of the arrangement of the buildings and spaces in the actual subject matter—that the artist did no more than record what he saw. Even if this were true, the artist could have placed himself anywhere in the Piazza to draw the forms and space there. His *choice* of observation point would be an important way in which he might arrange the elements of his composition. The fact is that this painting is not the simple result of the work of a painter who set up his easel in the Piazza San Marco and began to paint. It is, rather, the consequence of a careful construction of space based upon a perspective sytem of drawing, in which the receding, converging diagonals of the forms are organized as the artist wished them.

The detailed rendering of forms, textures, and light in this painting depends on the skill of the artist. No camera, unless fitted with a special lens, could have produced an image comparable to that created by Canaletto in this work. Had the camera or the eyes of a human observer been pointed down to the Piazzetta and the ships moored at the Grand Canal on the left, the deep space to the

right would not appear as it does. If the camera had been turned to the right, pointing into the Piazza, the space of the Piazzetta could not have been seen. The painting is actually composed of two separate views, though these views have been combined to conform to perspective rules. (It is known that Canaletto, during this period of his life, employed an instrument [*camera ottica*] to assist him in drawing perspective images. He could have made use of such an implement in the production of the painting in Figure 140. However, a combination of several views through the instrument would have been required to achieve the effect seen here.)

Divide the painting along the vertical axis of the bell tower, and two distinct scenes will appear, correctly organized according to linear perspective. That they have been united into one painting suggests that the composition is a deliberate organization based upon the artist's wish, rather than the result of an accurate transcription of a scene observed from a single viewpoint.

Esthetic organization in painting may take place either on the picture plane or in the illusionary space that an artist can suggest behind the flat surface of the painting. Whether the organization is two-dimensional or in the illusion of a third dimension, it unifies the elements employed by the painter into a coherent, interrelated structure. Repetition, continuity, and the balance of visual weights can be made to serve to the principle of unity just as they can serve to give variation or complexity.

chapter 6

THE VISUAL LANGUAGE
The Representation of the Third Dimension

Objects in the real world may be touched; they may be seen from front, side, or back; often it is possible to see them under different conditions of light. When these same objects and the space they occupy are to be represented on the flat plane of a painting or a drawing, the artist finds it impossible to include in the representation all he can perceive about them. Even the representation of the simplest solids gives rise to problems that suggest the restrictions placed upon the artist who works in the two-dimensional arts.

What is a cube as perceived by an observer? It is a solid that is square in cross section; it has six sides, each shaped as a square, each in a different plane. Each side is parallel to one other side and at right angles to the four remaining sides. All this information an observer can state about his perception of the cube. How is it possible for a painter to represent this information? If emphasis is placed on a form of representation that emphasizes the shape, it will be necessary to begin with a square.

Figure 142 represents the square form. The sides are equal and the angles are 90 degrees. But only one of the six sides is shown.

Figure 143 represents six sides, but the orientation of the sides does not correspond to the described perception of them.

Figure 144 does not seem to answer the requirements of the representation with any more satisfactory solution.

So long as the artist wishes to retain an accurate representation of shape relative to the perception of the cube, he is faced with the obvious limitations

142.

143.

144. 145.

142-147. Various approaches to the representation of a cube.

146.

147.

that exist in the previous three figures. What happens if a variation in the shape is permitted, granted that at certain times the square shape of the sides of the cube does not look square? At times the sides may look like single lines or edges (Fig. 145).

Even with this change it is still impossible to represent the sixth side. If the sides are represented as forms approximating rhomboids, what then? Figure 146 more closely fits the image most people would accept as a satisfactory representation of a cube, but only three sides are shown, and they present a considerable degree of variation from the perceived orientation of the sides in our initial description. Even the assumption that the cube is transparent, as in Figure 147 (surely a specialized case), does not give total satisfaction to our perceptions. (Notice that color and light conditions have not been introduced here, for these two factors cause even more complications.)

The difficulties in the representation of the simple three-dimensional cube on a two-dimensional surface indicate the problems that confront any artist in the depiction of the infinitely greater complexities of human form, landscape, and interiors. It cannot be stressed too often that it is impossible for an artist to represent on any one two-dimensional surface all he perceives of a single scene in the three-dimensional world.

The question might be asked: "Why does the diagram in Figure 146 seem so satisfying as a representation of a cube?" The answer is not known with certainty, but studies in human perception suggest that the limited amount of

left: 148. Photograph of a cube.

below : 149. Main street of Dodge City, set prepared in Hollywood for the television series *Gunsmoke.*

information conveyed by the diagram communicates to the observer that there is more to the figure than he can see. Though he can see only three sides, he deduces that there are three other sides which cannot be seen. A photograph of a cube (Fig. 148) gives information in a manner quite similar to that provided by the line drawing in Figure 146.

PHOTOGRAPHY

From a photograph showing only two sides of a building the assumption is made that the other two sides are there, too. Sometimes that assumption is proved wrong, and the observer discovers that he has been fooled, as he would be in the instance of a false-front movie set, which is revealed to be nothing more than a façade (Fig. 149).

left: 150. Photograph of a tree from about 100′ distance.

center: 151. Trunk area of same tree from about 2′.

right: 152. Leaf area of same tree.

Many people today believe that the photographic image is the "real," most truthful, and accurate way of picturing the three-dimensional world on a two-dimensional surface. This notion is not common to all times and all cultures. In fact, psychologists and anthropologists, including Carl Jung and Melville J. Herskovits, have reported that primitive men often cannot identify human images in photographs.

Each two-dimensional representational image is the result of a set of decisions. Even though some image makers are not aware of many of the factors that affect the appearance of the equivalents they produce, their images are shaped by the limitations and potentials of their media and, of course, by the attitudes and perceptions they bring to their efforts. In photography, which appears to many to be a relatively automatic method of recording accurately the real appearance of the world, many restrictions are placed upon the person who clicks the shutter. The most obvious are those that depend upon the relative positions of the photographer and his subject. The distance between them affects the amount of the subject included in the viewfinder. It also controls the scale of the image recorded on the film. A tree photographed from a distance of 100 feet will be represented in its totality as a large three-dimensional form, comprising trunk, branches, and leaves as parts of the primary image (Fig. 150). The same tree photographed from a distance of 2 feet will have its repre-

sentation in a detailed study of the texture of some small portion of the whole—the trunk or the leaves and branches (Figs. 151, 152). Because the photographer cannot in one shot photograph the tree as it appears from a 360-degree circumferential point of view, he must decide which side of the tree he will represent. Because photography is dependent upon light, the photographer is concerned about the intensity, direction, and perhaps the color of the light playing on the subject.

In addition, the camera itself imposes limitations. A great many different cameras are available, many with highly specialized uses, but all of them have the same basic components: a *lens*, or *lens system*, that focuses the light from the subject through a shutter, which controls the amount of light permitted to fall on sensitized *film*. The *lens*, the *shutter*, and the *film* can be altered to make significant changes in the image produced by any photographer. Even a cursory examination of possible variants will provide the reader with a sense of the changes these components can effect in the image-making process.

The seven photographs reproduced in Figures 153 through 159 were all taken with the same 35-millimeter camera from the same position. An 8-millimeter fish-eye lens was used in Figure 153. It has a 180 degree angle of view that permits the photographer to show the field, the surrounding trees, and the columns at the end of the sward. To achieve this extraordinary coverage the lens bends the light rays so that the focused image on the film alters the vertical axis of the trees to follow the curvature of the lens. Foreground and background seem to be stretched apart. A wide-angle lens was

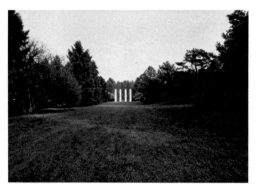

above: 153. Photograph through 8-mm. fish-eye lens.

above right: 154. Photograph through 24-mm. lens.

right: 155. Photograph through 50-mm. lens.

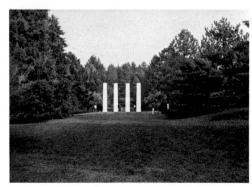

147

156. Photograph through 105-mm. lens.

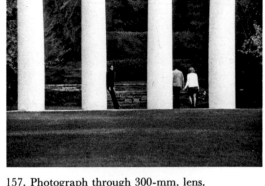

157. Photograph through 300-mm. lens.

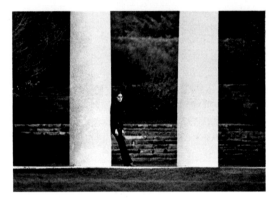

158. Photograph through 500-mm. lens.

159. Photograph through 1,000-mm. lens.

used to photograph Figure 154. It includes a field of view that is about twice the normal horizontal distance that the human eye can see sharply without moving from a fixed position. The image in Figure 155 was made with a 50-millimeter lens and closely approximates the field of view of the fixed observer. The remaining photographs were made with longer lenses that enlarge the image as they reduce the field.

The camera shutter controls the amount of light that enters the camera. It does this by changing the size of the hole, or *aperture*, that admits light through the lens and by changing the period of time the aperture is kept open. By altering the size of the aperture, the photographer can work under varying light conditions. He can enlarge the aperture when the light is decreased and reduce it when brilliant lighting conditions require limitation of the amount of light allowed to focus on the film.

The size of the aperture also affects the focus of the camera. As the aperture decreases in size, more of the background and foreground are sharply delineated. An aperture setting of f/2, which indicates that the opening is very wide, will produce a picture in which objects in only a very narrow band parallel to the camera will be reproduced in sharp focus. Objects in front of and

Plate 34. EDGAR DEGAS. *Woman at Her Toilette.* c.1903.
Pastel, 29^1/$_2$ × 28^1/$_2$″. Art Institute of Chicago (Mr. and Mrs. Martin A. Ryerson Collection).

Plate 35. IRENE RICE PEREIRA. *Oblique Progression*. 1948. Oil on canvas,
4′ 2″ × 3′ 4″. Whitney Museum of American Art, New York.

160. Photograph with aperture setting of f/2.

161. Photograph with aperture setting of f/16.

behind the band will be blurred (Fig. 160). A setting of f/16, which indicates a much smaller aperture, will produce an image with a much greater depth of field in focus (Fig. 161). Clearly, this control of the focus in a photograph offers the experienced photographer opportunities for emphasis and expression that can be a valuable communications asset.

The speed of the shutter can be used with the aperture adjustment to control the amount of light that reaches the film, but its most obvious application is in *freezing* motion. A moving object passing before a camera with a slow-moving shutter will register on the film as a blur. If the shutter speed is increased, the blur will be eliminated. Shutter speed can even be sufficient to stop the motion of objects that are blurred to the human eye (Fig. 162).

Camera film varies in its sensitivity to light. Fast film requires less light to initiate the chemical action that creates an image than does slow film. With fast film the photographer can use faster shutter speeds and smaller apertures,

162. Photograph taken with shutter speed of 500, stopping the action of the subject.

above: 163. HARRY CALLAHAN.
Chicago c. 1950. Photograph.

left: 164. GARRY WINOGRAND.
Metropolitan Opera Bar. 1954. Photograph.

152

165. Harold E. Edgerton.
Swirls and Eddies of a Tennis Stroke.
1939. Stroboscopic photograph.

or he can take photographs at limited light levels. Film varies, too, in its graininess, its ability to produce sharp images. Some films offer the option of hard-edged and clearly defined forms; others permit softened edges and lessened contrasts that approximate the character of a painting.

Harry Callahan's photograph *Chicago c. 1950* (Fig. 163) was taken on a dark winter day. The stark contrast of the black screen of branches against a featureless gray background creates an image that is both dramatic and poetic. The detail of the textural surface of the tree trunks has been eliminated so that the strong, simple blacks will make their effect. Callahan took this photograph with a very small shutter opening f/45 and exposed the film for 1/5 second, using a long 14-inch (355-millimeter) lens. The small aperture ensured sharply focused, clearly defined forms. The long lens tended to compress the apparent distance between the trees to emphasize the screenlike, flattened pattern of the branches.

Metropolitan Opera Bar (Fig. 164) was photographed by Garry Winogrand with the limited amount of light he found in this setting. Winogrand opened his shutter to a setting of f/1.5 and set the speed for 1/30 second. The lack of sharp focus combined with the graininess of the film gives a provocative, romantic quality to this photograph, in which the dramatic indication of depth combines with somewhat ambiguously defined details.

The limits of photographic representation are extended beyond the examples noted above when the photographer employs special lighting equipment. *Swirls and Eddies of a Tennis Stroke*, the photograph by Harold E. Edgerton shown in Figure 165, was made with the use of a stroboscopic light source. The image produced on the film is a record of movement. The form of the tennis

player is obscured, almost eliminated, and in its place the pattern of man and tennis racquet communicates information, but not the kind of data usually found in a snapshot.

Bill Brandt's photograph of a nude reclining on the pebbly surface of a beach (Fig. 166) was taken with an old wooden camera with a wide-angle lens. Using a very small aperture, so that the depth of field was at its maximum, and an ultrasensitive film to compensate for the limited amount of light that came through the aperture, Brandt transformed the nude into a strange sensual mass that is thrust into the space formed by the floor of pebbles and wall of rock. The camera lens has emphasized the inward direction of the pattern of pebbles, adding a kinetic quality that acts as a counterpoint to the simple, white form of the body.

The artist-photographer knows that there is a great difference between seeing a scene and producing a photographic equivalent for it. He uses the film, lens, and shutter adjustments that his experience suggests will realize the image he is seeking. Often he prepares the scene before the photograph is taken, so that the picture he wants will develop despite the limitations of his medium. Yale Joel had the assignment of photographing the ceremony that took place in St. Patrick's Cathedral in New York City during the visit of Pope Paul VI in 1965. The interior of the cathedral was dimly lighted, its high vaults,

left: 166. BILL BRANDT.
Nude on a Pebbled Beach.
1953. Photograph.

right: 167. YALE JOEL.
Pope Paul
Entering St. Patrick's Cathedral.
1965. Photograph.

nave, and aisles too dark to permit a shutter speed fast enough to stop the action of the participants in the services. Joel's seemingly simple and direct photograph of the event (Fig. 167) required the distribution in the upper section of the cathedral of fifty large electronic flash units wired to respond to the photographer's signal. Tripping the shutter of the camera released an artificial flood of light that made the picture possible.

Even after the image has been captured on film, the materials and processes of the darkroom can contribute to the fulfillment of the photographer's intention or misrepresent it. Many artist-photographers do their own developing, enlarging, and printing, for they know that such variables as the characteristics of the chemicals, the timing of print exposures, and the qualities of photographic printing papers offer further decisions that must be made in order to obtain the desired image. For a black-and-white print the selection of the paper alone presents many possibilities: in color, from blue-white to sepia tones; in texture, from hard-surfaced and glossy to soft and grainy; in contrast values, from low-keyed ranges of grays to sharp blacks and whites. Only the photographer himself really knows which choice will best carry out the effect he envisioned.

Clearly, then, the observer of two-dimensional representations of form and space cannot assume that pointing a camera at a scene and snapping the shutter will result in a picture that can be used to judge the accuracy of any other image of the same scene. The photograph is the most commonly seen representation of the three-dimensional world on a two-dimensional surface, but it, too, has limitations. The photographer, of necessity, must represent less than he can perceive, and it is misleading to assume that what is omitted by the photographer is insignificant. For another artist, using another medium, those aspects of reality that evade the photographer and his equipment may contain the essence of the subject. Freed of the restrictions of the camera image, the artist may find it possible to represent his perception of the real world through the use of visual forms that differ radically from those created with the techniques of photography. It is not only what the artist sees that shapes his images; it is also what he wishes others to see, and this intention is the motivating force behind the many representational systems that have been employed in the two-dimensional visual arts.

OTHER TYPES OF TWO-DIMENSIONAL REPRESENTATIONS

The history of art abounds in examples of two-dimensional representations of the three-dimensional world that bear no relation whatever to photographic representation. There is no evidence to suggest that these examples are solely the result of inadequacy on the part of the practitioners in this field at so-called "primitive" or "decadent" periods of time, for many of them are to be found in cultures that were vital and highly complex. It is probable that these other representational systems satisfied most of the artists who used them and that the images formed were acceptable to their patrons.

Had the Haida Indian artist used a photographic image of a bear instead of the drawing in Figure 168, he could not have communicated with the same degree of clarity the anatomical facts that are an essential part of the bear's appearance. The Haida motif tells the observer that the animal represented has two ears, two eyes, two nostrils in a single nose, one mouth, and four legs. These paired features are shown complete and in equal sizes, rather than partially and in different sizes, as they might be represented in a photograph.

Similar examples of two-dimensional images based upon clear, unambiguous information that cannot be represented photographically are to be found today in representational drawings such as maps and architectural plans. An aerial photograph of a section of Washington, D.C. (Fig. 169), establishes an image similar in many respects to that delineated in the map in Figure 170. Major traffic arteries are apparent, and certain of the capital's famed monuments can be discerned, as well as the Potomac River, Rock Creek Park, and a reservoir. Additional topographic details can be found in the photograph, but consider the information offered by the map that is not contained in the photograph: the names of districts, route numbers, mileages to other cities, the location of schools and military installations. To provide this information on the map, letters, numbers, and symbols are printed over its surface. Each of these printed black elements occupies a portion of the paper support that cannot be taken by another black element. Much that could be designated on the map has not been included. Such facts as geological, ethnographic, and agricultural data are omitted, as being outside the purpose of the map. Also, the pertinent information already included fills the usable space. The addition of more black marks would reduce legibility and obscure the labeling needed by the reader.

The section and plan of Westminster Abbey (Fig. 171) communicate intelligence regarding real form and space to the student of Gothic architecture. Construction details, measurable distances, and the relative position of the parts of the building are conveyed in a representational mode that has the completeness of the Haida drawing. Even significant historical data are included in the illustration, providing the viewer with material impossible to include in photographic representations.

168. Haida motif representing a bear. Franz Boas, *Primitive Art*, Instituttet for Sammenlignende Kulturforskning, series B, VIII, Oslo, Leipzig, London, and Cambridge, Mass., 1927, Fig. 222.

left: 169. Aerial photograph of a section of Washington, D.C.

below: 170. U.S. Department of the Interior map
of area shown in Figure 169.

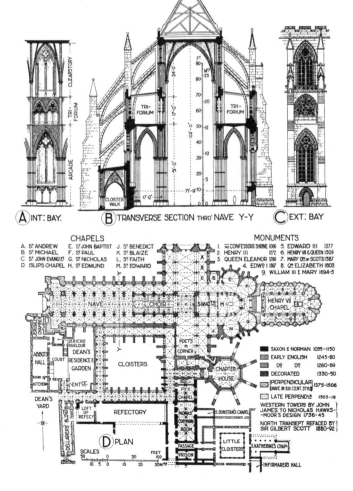

CHAPELS

A. St ANDREW E. St JOHN BAPTIST J. St BENEDICT
B. St MICHAEL F. St PAUL K. St BLAIZE
C. St JOHN EVANGST G. St NICHOLAS L. St FAITH
D. ISLIPS CHAPEL H. St EDMUND M. St EDWARD

MONUMENTS

1. THE CONFESSORS SHRINE 1066 5. EDWARD III 1377
2. HENRY III 1272 6. HENRY VII & QUEEN 1509
3. QUEEN ELEANOR 1290 7. MARY Q^{EN} of SCOTS 1587
4. EDW^D I 1307 8. Q^N ELIZABETH 1603
9. WILLIAM III & MARY 1694-5

171. Westminster Abbey, London, section and plan.
Banister Fletcher, *A History of Architecture...*,
Charles Scribner's Sons, New York, 1963, p. 424.

157

REPRESENTATION OF FORM AND SPACE
IN PAINTING AND DRAWING

Form

A form, as it is seen and known in nature, reflects light and stands out against a contrasting background. It can be touched; its shape, its texture, and its weight can be felt. We can walk about it. The exact process of knowing is a complicated and, as yet, incompletely explained part of perception, but it has been established that the response to the shapes of objects is in the first levels of perceptual development in human beings.

To represent a three-dimensional form on the flat plane of a drawing or painting, the artist must single out some fundamental visual aspect of the form selected and, by means of one or more of his plastic elements, reproduce that aspect on his working surface in such a way that the beholder can respond with a sense of recognition.

For this purpose the element of line can be used in several ways. Perhaps the most basic method is the drawn line made by moving a marking instrument on the picture surface so that the marks recording its path conform to the general outline or silhouette of the object to be represented. A silhouette can also be created by painting an area of color, the edges of which, in contrast to the background, are perceived as a linear boundary of the form. Both drawn line and linear color edges are utilized to define forms in the thirteenth-century Chinese ink drawing in Figure 172.

However, very few forms found in nature are as simple as those in the drawing by Mu-Ch'i. Natural forms are most often composed of a number of

172. MU-CH'I. *Six Persimmons.*
13th century. Ink on paper,
$14^{1}/_{2} \times 11^{1}/_{4}''$.
Daitoku-ji, Kyoto.

Plate 36. *Hunting Birds with a Throwing Stick*. Egyptian, 18th Dynasty, c.1400 B.C.
Wall painting, 32⅝ × 38″. British Museum, London.

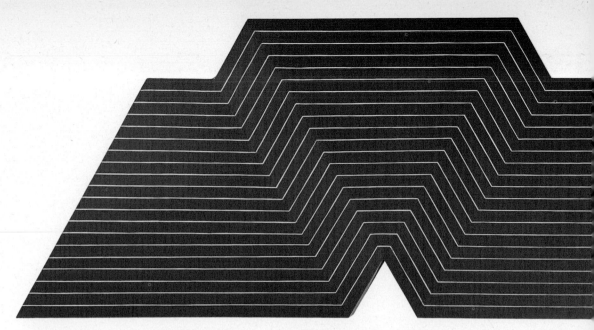

above: Plate 37. FRANK STELLA. *De la nada Vida a la nada Muerte.* 1965.
Metallic powder in polymer emulsion on canvas, 7′ × 23′ 5³/₄″.
Art Institute of Chicago (Ada S. Garret Prize Fund income).

below: Plate 38. DIEGO VELÁZQUEZ. *Surrender at Breda.* 1635.
Oil on canvas, c. 10 × 12′. Prado, Madrid.

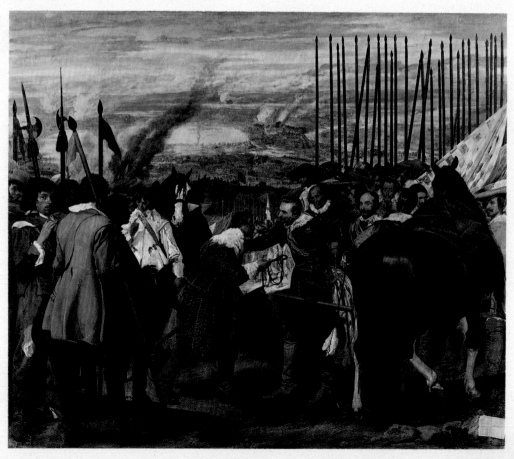

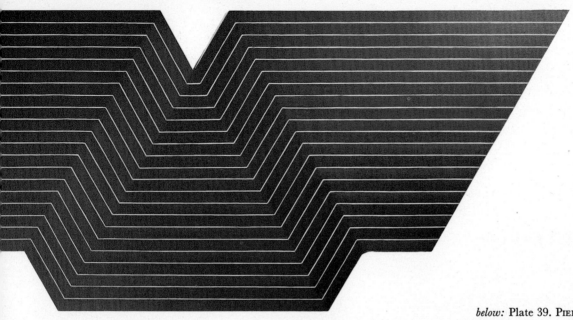

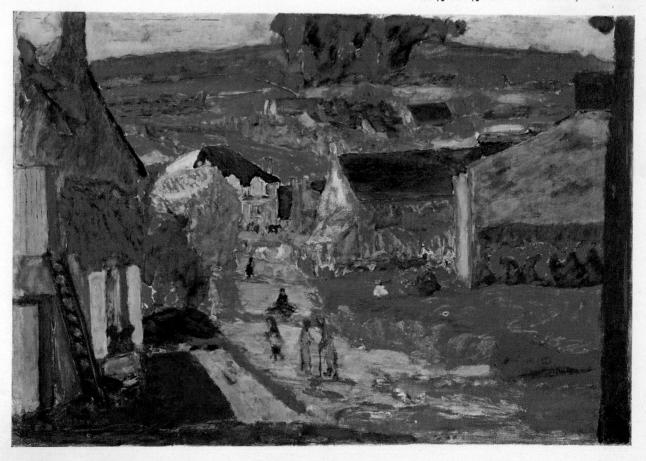

below: Plate 39. PIERRE BONNARD.
St.-Honoré-les-Bains. 1924. Oil on canvas,
$20^1/_2 \times 30^1/_2$". Private collection, New York.

Plate 40. HANS HOFMANN. *The Golden Wall*. 1961.
Oil on canvas, 5′ × 6′¹/₂″. Art Institute of Chicago.

162

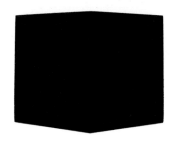

related masses or planes, each of which has a unique shape, joined to comprise a larger unit. A form as simple as the cube illustrated in Figure 148 is difficult to represent adequately in silhouette (Fig. 173), for the position and relationship between the six square planes is not clearly indicated by a simple outline. The human body is made up of six major form subsections—the torso, the head, and four limbs. Only when the body is represented standing in a frontal position, with the arms and legs somewhat separated from the torso (Fig. 174) does the silhouette give a viewer a significant amount of clear information. As soon as the figure is bent or turned away from the viewer, the separate forms of arms, legs, head, and torso can no longer be defined with certainty. Lost too is the more detailed information about the positions of the smaller forms—eyes, nose, ears, and mouth in the head; fingers and toes in the limbs; the planes and folds of skin in the torso (Fig. 175).

To define the components that physically exist within the confines of a silhouette, the artist can introduce lines or edges that divide the large external form. He can arrange these lines so that they suggest the relative positions and sizes of the parts. In Figure 176 the Greek vase painter Douris used internal lines

above: 175. A crouching figure photographed in silhouette.

right: 176. DOURIS. *Two Women Putting Away Clothes,* detail of red-figure kylix. c. 470 B.C. Painted earthenware. Metropolitan Museum of Art, New York (Rogers Fund, 1923).

The Visual Language: The Representation of the Third Dimension 163

to indicate the separation between legs, and by an apparent overlap one leg in each figure is shown in front of the other. In the figure on the left a sequence of overlaps clearly defines the relative positions of the left arm, the bundle of clothing, the two breasts, and finally the right arm, each in its turn partially obscured by the forms represented as closer to the observer. On a smaller scale the fingers and toes of the two figures form overlapping progressions. Both external and internal linear contours with overlaps are to be found in the eighteenth-century woodcut by the Japanese artist Katsukawa Shunshō (Fig. 177) and the head by Henri Matisse (Fig. 178).

Early in the history of art it was recognized that when rectangular solids are placed so that one vertical edge is measurably closer to the viewer than another, the horizontal edges appear to slant up or down as they recede. This illusion is the basis for the method of representation used by early Roman muralists in the architectural painting shown in Figure 179. Note that the angles used to suggest recession of the edges of the building are not equal, nor do they seem to conform to any consistent overall scheme. Later artists did utilize a system that determined the angles to be used in drawing the edges of receding forms, but it was not until the fifteenth century that the method, called *linear perspective*, was introduced.

left: 177. KATSUKAWA SHUNSHŌ. *Woman in Red.* Woodblock print, 27⁷/₈ × 6¹/₂″. Metropolitan Museum of Art, New York (bequest of Mrs. H. O. Havemeyer, 1929; H. O. Havemeyer Collection).

right: 178. HENRI MATISSE. *Upturned Head (Head of a Recumbant Figure).* c. 1906. Transfer lithograph, printed in black, 11¹/₈ × 10³/₄″. Museum of Modern Art, New York (gift of Abby Aldrich Rockefeller).

179. Architectural view
from the cubiculum of a villa
at Boscoreale, Italy.

1st century B.C. Wall painting.
Metropolitan Museum of Art, New York.

An examination of the pastel drawing by Edgar Degas in Plate 34 (p. 149) will reveal a number of methods adopted by the artist to represent the form of the figure. A strongly emphasized outer silhouette is interrupted by lines that break the edge to suggest overlapping forms. This is particularly evident at the lower edge of the front arm as it joins the body. In a progression that gives the sense of forms moving down and back, the arm overlaps the breast, which in turn overlaps the fold of skin above the abdomen. At the top edge of the arm another progression moves from shoulder to head, to cloth, to the bend of the arm, and finally to the elbow. The angular relationship of the edges representing the arms clearly places the left elbow closest to the observer, with the left hand and shoulder receding deeper into the composition. Degas used still another device. He drew the right arm at a smaller scale than the left arm. This difference between two forms that are normally identical in size is perceived as a difference in distance from the viewer.

In addition to line and edge for the representation of form, the artist may use graphic analogues for the play of light on the surfaces of three-dimensional

objects. Illumination from a single source of light will fall upon a three-dimensional object in a consistent pattern. Usually those surfaces nearest the light will receive the most illumination, and those surfaces which are turned from the light source will receive proportionately less illumination. The shape of the object has an effect on the pattern of light and dark areas produced in this way. Representing the light on the forms by graduated areas of dark and light colors on the two-dimensional surface of the painting or drawing, the artist can combine this device with that of contour edges and thus contribute further to the illusion of form (Fig. 180).

top: 180. Representation of form by dark and light areas illuminated from a single source.

below: 181. ALBRECHT DÜRER.
Two Heads Divided into Facets and St. Peter. 1519.
Drawing, $4^1/_2 \times 7^1/_2''$. Sächsische Landesbibliothek, Dresden.

right: 182. ALBRECHT DÜRER. *Portrait of a Young Woman.* 1506.
Oil on panel, $11^1/_4 \times 8^1/_2''$. Staatliche Museen, Berlin.

Albrecht Dürer's stylized diagrammatic study of the human head with the planes emphasized (Fig. 181) shows how dark and light tones in a drawing can be employed to augment line in the depiction of form. The portrait in Figure 182 by the same artist is an example of the play of light and dark subtly and sensitively used to amplify the representation of forms already delineated by their edges. However, the shading does not in itself accomplish the appearance of volume. If all the shading were eliminated, leaving only the outer and inner contours, the large-scale indication of form would remain clear.

In summary, it may be said that the illusion of three-dimensional forms can be created in the two-dimensional arts by a variety of methods, among which the following have been discussed and illustrated:

1. The drawn line or the edge contrast of a color area can serve as an equivalent for the silhouette of the subject.

2. Internal contours can offer information about the smaller subforms within the outline.

3. Both edges and lines can be overlapped to indicate nearer and farther features of the overall form.

4. Oblique lines have the capacity to suggest the recession into depth of planes with parallel edges.

5. It is possible for reduction in scale to represent increased distance of the form from the viewer.

6. And, finally, the shading of dark and light tones within drawn forms can represent the pattern created when light falls on the surfaces of a three-dimensional object and thus describes the configuration of its total shape.

All these methods, more or less freely conceived, have been adopted at various times throughout the history of art to communicate the artist's perception. Much more subject to rigid rules and controls for the artist is the linear-perspective system of representing three-dimensional form and space. This system, based upon mathematical and optical principles formulated for artists during the early Renaissance in Italy, remained virtually unchallenged in the art of Western civilizations for almost five centuries as the correct way to simulate the mass, depth, and expanse of the physical world within two-dimensional limits. It will be considered a little later in this chapter. First, however, it may be useful to examine some of the other means of conveying the sense of space in painting and drawing.

Space

Some of the devices for representing space on a two-dimensional surface are comparable to those used to produce equivalents of form. Actually, any three-dimensional form in nature occupies a space, and the distance between the front and back of a form is a measurable spatial dimension. One may consider the progression of forms by Degas in the painting seen in Plate 34 (p. 149), but it is also meaningful to take note of the space that is indicated between the left elbow and the bend of the right arm.

In nature, form remains constant, even though the space it occupies may change. That is, a sphere looks and feels the same whether it occupies one place on a table or another. However, space is not just that volume occupied by a form; it can also be the distance between forms. Certain forms can be perceived to be in front of others. They can be found close together or far apart. One form may be above another or below it.

Artists who have wished to represent on a flat surface the spatial relationships between forms in nature have traditionally used one or more of the following methods:

1. Overlapping planes
2. Variation in size
3. Position on the picture plane
4. Linear perspective
5. Aerial perspective
6. Color change

OVERLAPPING PLANES Figure 183 displays a typical example of the use of overlap to indicate the arrangement of forms in depth. In this thirteenth-century panel by a Tuscan painter the form of the Child overlaps a portion of the form of the Madonna. This simple device indicates to the viewer that the Child is placed in front of the mother. Similarly, the Madonna is positioned closer to the viewer than is the back of her throne, and her hand rests clearly in front of her body, all indicated by overlap.

Overlapping often becomes much more complicated than the illustrated example (Fig. 184). Several planes can overlap in sequence, or some planes may appear to be transparent, so that the illusion of looking through a forward plane to one behind enhances the viewer's feeling of three-dimensional space (Pl. 35, p. 150).

VARIATION IN SIZE Variation in the sizes of forms can be employed to indicate the relative importance of persons represented in a composition. This practice is typical of early Egyptian paintings and reliefs. The wall painting in Plate 36 (p. 159), from the tomb of Neb-amon at Thebes, reveals the lord of the burial chamber to be the center of his world, scaled a full 30 percent greater than his wife, whose own scale demonstrates the superior position she occupied in relation to her daughter within the hierarchy of Pharaonic life. The scalar significance is made emphatic not only by the pervasive flatness of the pictorial style, which denies the possibility of recession into deep space, but by the placement of the figures on the single ground line. They rest directly on it, a small boat, which makes them seem to share the frontal plane of the boat itself. Because the princess embraces her father's leg from behind, she could be seen as positioned farther back, but with her other hand she clasps a water blossom growing on the viewer's side of the boat, and this brings the daughter as distinctly forward as any form in the composition. Thus, it is not possible to see differences in the sizes of the figures as differences in their placement within cubic

above: 183. *Madonna and Child.* Tuscan, second half of 13th century.
Tempera on panel, 60¹/₂ × 36″. Metropolitan Museum of Art, New York
(gift of George Blumenthal, 1941).

right: 184. Overlapping planes to indicate depth.

below: 185. Variation in size to indicate position in depth.

right: 186. BEN SHAHN. *Miners' Wives.* 1948.
Tempera on board, 4×3′. Philadelphia Museum of Art
(given by Wright S. Ludington).

space. Given other applications of the plastic means, size change can, however, be made to suggest distance.

The observer who looks at a work containing objects of varying sizes may assume one of two alternatives: First he may say that the objects represented are, in fact, of different sizes in nature; or he may say that they are of the same size, but that the size differential in the representation corresponds to a difference in distance between the objects and the position of the observer (Fig. 185). This spatial interpretation of the size difference applies not only to objects assumed to be identical in size but also to objects having accepted proportional sizes; that is, a man is smaller than a house, and therefore the representation of a house drawn smaller than a man will suggest a much greater space differential than a similar comparison made between two houses (Fig. 186).

POSITION ON THE PICTURE PLANE In certain paintings the system of spatial representation is based upon the position of forms relative to the bottom margins of the picture plane. This method is frequently found in the work of medieval Western artists and the artists of China and Japan. Those objects which are near the bottom are closer to the observer, indicating that spatial distance changes with corresponding positions as measured from the bottom of the work

(Fig. 187). Sometimes this sytem is combined with changes in size, but it is not unusual to find works in which position and size are not correlated in spatial representation.

Duccio, an Italian fourteenth-century artist, painted a panel of the Transfiguration of Christ (Fig. 188) in which six figures are represented on a rocky mound. The figures are grouped in two rows of three. There can be no doubt

right: 187. Recession of forms indicated by their relation to the bottom margin.

below: 188. DUCCIO. *The Transfiguration of Christ,* from the back predella of the *Maestà Altar.* 1308–11. Tempera on panel, $18^1/_8 \times 17^3/_8''$. National Gallery, London.

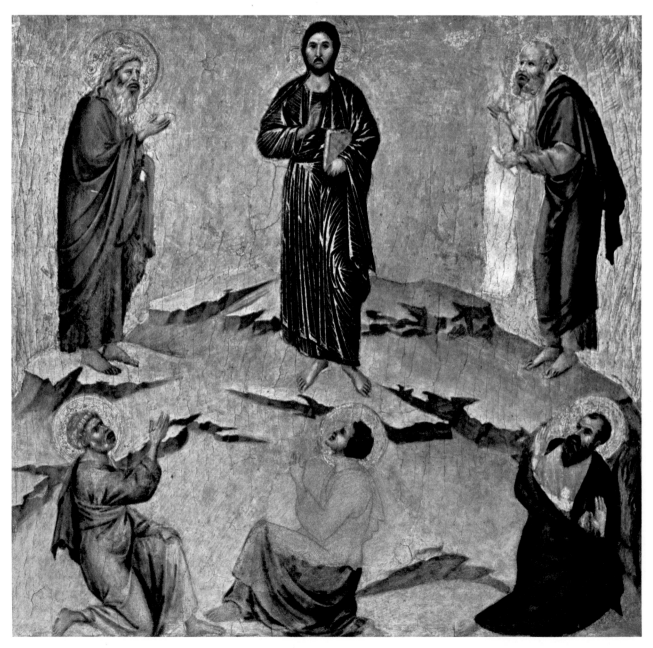

that the artist intended the upper row of figures to appear to be behind the forms in the lower group, and, in fact, they do seem thus placed. No overlapping is used here to achieve this effect, and the size of the figures does nothing to contribute to the representation of depth, for the lower group is somewhat smaller than the one above. It is the position of the forms relative to the lower edge of the painting which serves to suggest their respective distances from the observer.

LINEAR PERSPECTIVE

> Take a piece of glass the size of a half sheet of royal folio paper, and fix it well . . . between your eye and the object that you wish to portray. Then move away until your eye is two-thirds of a braccio [arm length] away from the piece of glass, and fasten your head . . . in such a way as to prevent any movement of it whatsoever. Then close or cover up one eye, and with a brush or a piece of red chalk finely ground mark out on the glass what is visible beyond it; afterwards copy it by tracing on paper from the glass. . . .[1]

This quotation from the notebooks of Leonardo da Vinci is the great fifteenth-century artist's description of "the way to represent a scene correctly." A painter following this procedure would produce a drawing con-

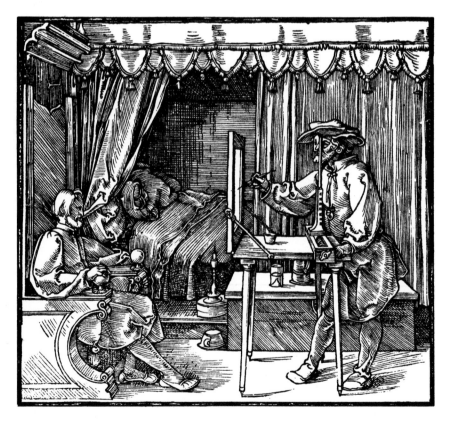

189. ALBRECHT DÜRER.
Artist Drawing a Portrait of a Man,
from the treatise
Underweysung der Messung... 1525.
Woodcut. Metropolitan
Museum of Art, New York
(gift of Henry Walters, 1917).

structed in *linear perspective*. A careful examination of Leonardo's instructions suggests some inconsistencies between the actual experience of looking at the world and the requirements placed upon an artist who is eager to obtain a perspective image. Most human beings do not go through life observing the world in the static manner described by Leonardo. They do not hold their heads immobile, nor do they keep one eye shut as they look about them. However, in fifteenth-century Europe linear perspective seemed to provide, as it still does for many people today, a means of drawing an image that the artist and the public alike could regard as an accurate representation of the real world on a flat surface. No existing drawing by Leonardo illustrates his method of accurate drawing through the use of an instrument, but the woodcut by Dürer in Figure 189 exhibits a device similar to that described by the Italian master.

An analysis of a picture drawn by the linear-perspective method would reveal certain basic characteristics of all linear-perspective constructions. They are:

1. All parallel lines that exist in nature appear to converge at a point in the drawing. This is called the "vanishing point" (Fig. 190).

2. A different vanishing point exists for each set of parallels, but all points used to construct objects parallel with the ground exist on the same horizontal line. This line is called the "horizon line" (Fig. 191).

above: 190. Convergence of parallel lines toward the vanishing point.

right: 191. Multiple vanishing points and the horizon line.

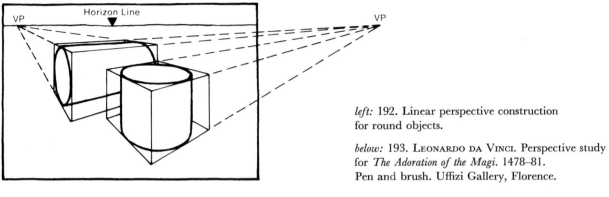

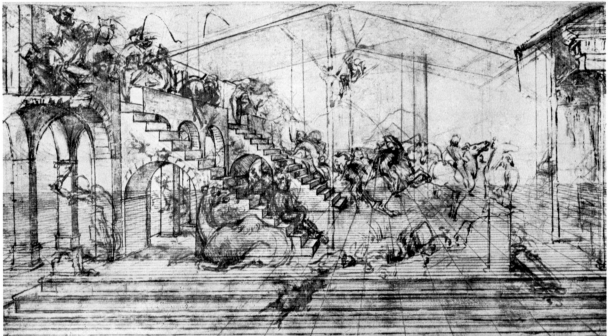

left: 192. Linear perspective construction for round objects.

below: 193. LEONARDO DA VINCI. Perspective study for *The Adoration of the Magi.* 1478–81. Pen and brush. Uffizi Gallery, Florence.

3. Round forms are drawn as though inscribed in the rectangles which have sides tangent to the curves (Figs. 192, 193).

There are certain exceptions to these rules, such as the use of supplemental vanishing points in drawing planes not parallel to the ground plane and the use of a vanishing point to converge the vertical parallels in objects seen from extreme up or down viewpoints; but they should not concern the reader, for they do not alter the basic concept of this description.

As noted in the section on the representation of form, oblique lines representing parallels moving away from the picture plane have sometimes been employed to suggest volume without the suggestion being made within a true linear-perspective system (Fig. 179). Similarly, the diagonal arrangement of

194. Jacquemart de Hesdin and others.
Christ Carrying the Cross,
from *Les Grandes Heures du Duc de Berry*.
1409. Illumination on vellum,
$14^7/_8 \times 11^1/_8''$.
Bibliothèque Nationale, Paris.

forms can be used to indicate spatial differences. To be effective these diagonals do not have to conform to a consistant linear-perspective system. In Figure 194 the receding forms of the crosses and the sides of the towers are drawn with parallel oblique lines. The spatial indications depend primarily upon overlapping forms, but in addition the artist has placed the figures, especially those behind Christ, in a diagonal progression toward the back of the main group.

Frank Stella, a contemporary American painter, has taken advantage of the same principle for the suggestion of space, but he has employed it in a new form (Pl. 37, pp. 160, 161). Stella stretched his canvas in an irregular shape to make it conform to the arrangement of the stripes in his painting. Flat color areas and the defined edges of the shaped canvas emphasize the two-dimen-

sionality of the painting, but the diagonal stripes, in conjunction with the diagonal portion of the shaped canvas, suggest a three-dimensional spatial relationship. The conflict between these two mutually inconsistent effects invests Stella's painting with a psychological tension surprising in a work so simple in concept and execution.

AERIAL PERSPECTIVE Another method of representing space, which often was combined with linear perspective after the sixteenth century, was *aerial perspective*. In this technique the artist approximates the observable atmospheric phenomenon by which distant forms lose the sharp definition of their edges and appear dimmer and less distinct than objects close to the observer. In aerial perspective the artist paints distant forms in lighter and less brilliant colors than those in the foreground. He also softens the contours of these forms so that they appear to blend into the areas adjacent to them. Note in Velázquez' *Surrender at Breda* (Pl. 38, p. 160) the strong contrast of the dark and light areas in the front plane and compare this portion of the painting with the background forms.

COLOR CHANGE The color of a form can differ from the color of another form in several ways. It may be lighter or darker. It may be more or less brilliant. And finally, but perhaps most obviously, one color can be distinct from another in its location on the spectrum. The identity of the colors located along the spectrum is designated by the common words associated with color—red, orange, yellow, green, blue, violet.

As noted above, aerial perspective uses changes in the dark and light quality and changes in the brilliance of color to indicate distance. Some painters have augmented the illusion of aerial perspective by giving distant forms in their paintings a bluish tint, but, in the main, aerial perspective does not derive from color change employed as a device for creating a simulacrum of spatial relationships.

The colors on the spectrum are often referred to as members of a "warm" or "cool" group. This division places those colors which are close to the red end of the spectrum in the warm family; those adjacent to the blue end are called cool. Under certain conditions warm colors give the illusion that they are closer to the viewer than are cool colors, and some artists have exploited this quality to enhance the distance of space in their paintings. By painting foreground forms in relatively warmer colors and background forms in relatively cooler colors, the artist can enhance the sense of space. The word "relatively" is important here, for it is possible to have one red that is cooler than another; that is, a red with a bit of blue in it will appear to be cooler than one without a blue cast. If spectrum color change is used consistently, the warmer red will appear to be in front of the cooler red.

Other spatial indications are made possible by *consistent* use of color variation within some characteristic quality of color—its value, its brilliance, or its spectrum difference. In each instance the artist makes change in color an equiv-

alent for change in spatial distance, and in each instance the success of the method he employs is directly related to the consistency with which he uses it. The types of color change capable of creating the illusion of space could include the following:

1. Variations in brilliance, the most brilliant colors in the foreground and progressively less brilliant colors receding to the back (Pl. 39, p. 161).

2. Variations on a single spectrum color against a background painted in a different single color. Colors which vary in contrast to the background would come forward in proportion to their contrast. If the background were painted red, forms painted in green, which is the color greatest in contrast to red, would separate from the red most obviously and therefore would appear to be farthest away from it. Red-violet forms in this system would be closer to the red and therefore not so close to the foreground (Pl. 40, p. 162).

REPRESENTATION OF TIME-SPACE PERCEPTIONS

The photographic image is remarkably similar to the linear-perspective image in its rendering of depth. Actually, the camera fulfills the demands made by Leonardo for the production of an accurate image. As a one-eyed instrument that does not move during the time it is "looking" at the scene before it, the still camera does not require the restrictive harness that a human being would need while producing the picture. The sheet of glass on which the scene is drawn is replaced by the flat surface of the photographic film behind the camera lens. The image produced by the camera would seem to be the ultimate form of three-dimensional representation, and yet in the nineteenth century a number of artists found a need to represent some aspects of "reality" which were not communicated by either the photograph or its hand-made equivalent system, linear perspective.

The camera is not moved when it is used to make a still photograph. The artist who produces the linear-perspective rendering draws as though his perception of the world were based upon a single, one-eyed view, in which neither the eye nor the head moves during the period of perception. He acts like a camera.

In the late nineteenth century, a period which burgeoned with new industry and technology, the idea of change and movement was in the air everywhere. Transportation was developing. Steam locomotion on land and on the sea added to the sense of dynamic change in the word. For scientists such as Darwin and Maxwell, the world and the people who inhabited it were parts of a changing condition. Some of the artists who lived in this period responded to the same forces that affected the scientists. They saw about them a world in flux, a world which could no longer be considered a static series of forms, spaces, and actions. Linear perspective was a product of a world which saw itself as a series of unchanging, separate views, a world which could accept as the most accurate representation of itself the one perceived from the immobile viewpoint of the bound observer described by Leonardo.

Let the reader lift his eyes from this page. As he looks about the room in which he finds himself, does he see that room from one unmoving position? The normal process of perception requires that an observer move his eyes, his head, and quite often his whole body as he perceives the space about him. That space and the forms within it are not seen all at one time, from a single viewpoint. They are discovered one part at a time, each movement of the observer, his eyes, or his body giving him a different view. And yet if a still photograph of that room were to be made, it could be shown only from the stationary position of the camera at the time the photograph was taken (Fig. 195). The picture taken by the camera and the perception of the mind-eye complex may be similar (though not identical) during each separate fixation of the eye as it looks at the room, but the perception of the room is based upon many fixes, and the perception of a broad landscape or of a narrow table is accomplished in the same way.

How, then, can an artist, working with a medium that requires him to represent his perceptions on a single flat surface, communicate the perception of the room as he has seen it? It can be done by separating the picture area into separate sections and placing a different picture, seen from a single vantage

195. Photograph of a hallway, with camera lens on an axis parallel with the floor.

Plate 41. PAUL CÉZANNE. *The Basket of Apples*. 1890–94. Oil on canvas, 25³/₄ × 32″.
Art Institute of Chicago (Helen Birch Bartlett Memorial Collection).

left: Plate 42. TOSHUSAI SHARAKU. *Iwai Hanshiro IV as Chihaya*. 1794–95. Wood-block print, $12^3/_4 \times 16''$. Museum of Fine Arts, Boston.

below: Plate 43. GIOVANNI BELLINI. *Madonna and Child*. 1509. Oil on panel, $41^3/_4 \times 33^3/_8''$. Detroit Institute of Arts (purchase, City Appropriation).

Plate 44. JEAN-ANTOINE WATTEAU. *The Embarkation from the Island of Cythera.* 1717.
Oil on canvas, 4′ 3″ × 6′ 4¹/₂″. Louvre, Paris.

above: Plate 45. ALFRED SISLEY.
Flood at Port-Marly. 1872–76.
Oil on canvas, $23^5/_8 \times 31^7/_8$″. Louvre, Paris.

left: Plate 46. Detail of Figure 205,
MONET's *Sunflowers.*

196. Photomontage of separate photographs of the same hallway (Fig. 195) taken with the camera lens directed at portions of the walls, floor, and ceiling.

point, in each section (Fig. 196). Or it can be accomplished by combining a number of separate views within the format of a single picture, representing each portion of the room as it was seen from the position required to view it most comfortably. This technique was the method devised by Paul Cézanne (Pl. 41, p. 179), a French painter of the nineteenth century, and then continued in the twentieth century by a group of artists who were identified as the Cubists.

Paul Cézanne was born in 1839 in the south of France. His development as a painter took place in an era of great and significant changes. The political, economic, and social life of Europe was in ferment. The political revolutions of the late eighteenth century, combined with the Industrial Revolution which began at about the same time, were matched by comparable developments in technology and science. Cézanne, retiring and diligent in personality, excited little interest through his personal appearance or his manner of living, but his painting was as revolutionary as the other forces that were stirring in Europe at the time (Pl. 41).

The traditional forms of painting and drawing which were the basis for the arts in the nineteenth century were extensions of the modes established during the Renaissance. Linear perspective was the unquestioned standard for the representation of form and space in the artist's vocabulary. Even the controversial painters who were contemporaries of Cézanne, Impressionists such as

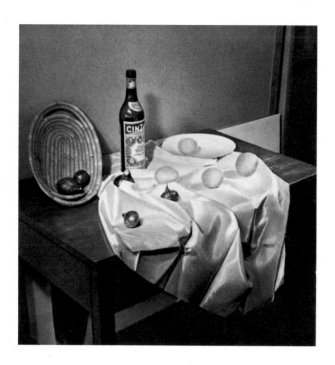

left: 197. Photograph of a still life,
with the camera lens directed
at the center of the table.

below: 198. Photographs of the same still life
(Fig. 197) with the camera lens directed
at different portions of the table.

199. Photomontage
of the same still life (Fig. 197),
made up of the separate
portions shown in Figure 198.

Claude Monet and Camille Pissarro, used a traditional linear-perspective construction in their representation of forms. The controversy aroused by their works concerned their use of color and the methods of paint application they employed, but basically they followed in the Renaissance tradition when they drew forms in space (Fig. 16; Pl. 6, p. 36; Pls. 11, 12, p. 65). The construction of the illusion of space was based upon the single horizon line and the fixed point of view.

The photograph of a table and the objects on it in Figure 197 is the equivalent, in its basic structural essentials, of a linear-perspective drawing. The single lens of the camera took in the entire scene without changing position, just as Leonardo suggested that the artist look at the scene before him. The four photographs in the following sequence (Fig. 198) were all taken from the same position, but the camera was directed to separate portions of the table, much as a viewer would direct his eyes when looking at portions of the table. By combining segments of the photographs (Fig. 199) and so constructing a composite montage, we can arrive at a representation of the table which differs considerably from a perspective representation.

Which picture gives a more accurate representation of the table? This question cannot be answered, for, as has been noted before, the difference in the pictures is not due to their accuracy but to the kind of information they present. The perspective representation seems to emphasize the forms of the objects, enabling the viewer to "read" the detail in a single, cohesive, isolated moment of time. The composite representation gives the viewer a sense of the

dynamics of the experience of vision. It was this kind of representation which became an important aspect of Cézanne's work. In his still-life painting (Pl. 41) note the similarities to the composite photograph. The back edge of the table breaks and rises, as does the front edge. The bottle is drawn with a number of shifts to the left as it rises from the table, giving it a tipped appearance. Similarly, the dish on which the rolls are placed is drawn from one viewpoint for the left contour and from another, higher point for the right. Cézanne's attempts to paint a new kind of formal and spatial representation were part of a searching study that he carried out during the course of his entire painting

left: 200. Georges Braque. *Violin and Pitcher*. 1910. Oil on canvas, $46^1/_8 \times 28^5/_8''$. Kunstmuseum, Basel (gift of Raoul La Roche).

right: 201. Juan Gris. *Guitar and Flowers*. 1912. Oil on canvas, $44^1/_8 \times 27^5/_8''$. Museum of Modern Art, New York (bequest of Anna Erickson Levene, in memory of her husband, Dr. Phoebus Aaron Theodor Levene).

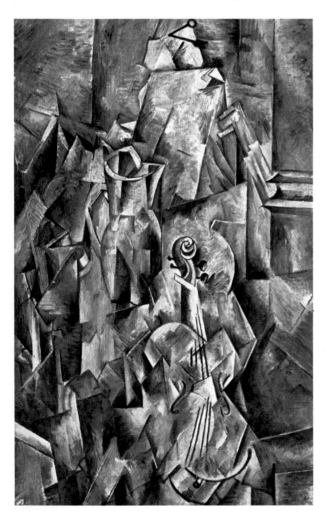

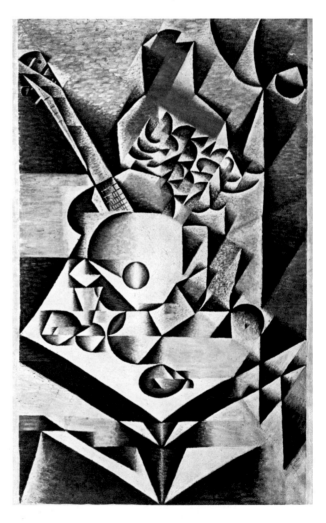

career. His initial inquiry into nonperspective spatial representation has had a major influence on the art of the twentieth century.

In Paris, during the first decade of this century, Georges Braque, Juan Gris, and Pablo Picasso cooperated to extend the concept of the representation of a nonstatic seeing experience. The style resulting from their studies is called Analytical Cubism (Figs. 200–202). In their painting of this period one can follow the development of a progressively greater complexity of construction, multiple viewpoint combined with multiple viewpoint until the overlapping edges of the separate views became so numerous that objects defy identification.

202. PABLO PICASSO. *"Ma Jolie."*
1911–12. Oil on canvas, $39^3/_8 \times 25^3/_4''$.
Museum of Modern Art, New York
(Lillie P. Bliss bequest).

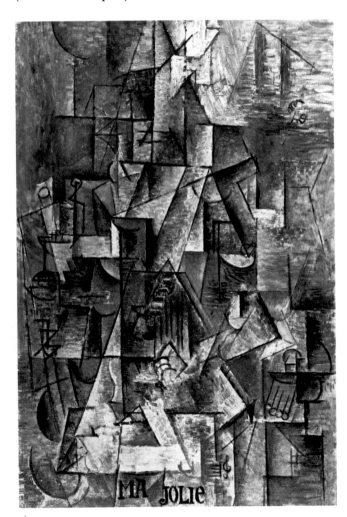

Movement and change fascinated many people about the turn of the century. In the United States, as early as the 1880s, Eadweard Muybridge experimented with stop-action photographs of human and animal subjects in motion (Fig. 203). A similar interest in the representation of movement gave rise to the system of Futurism, specifically proposed by a group of Italian artists in a "manifesto" published in 1909 and well exemplified by the work of Giacomo Balla (Fig. 63), one of the founding members of the group. These artists conveyed the sense of motion by depicting a sequence of poses caught in stopped action, one after the other, in the course of a movement, or by forms derived from the overlapping of such poses, as in the well-known *Nude Descending a Staircase*, by Marcel Duchamp (Fig. 204).

opposite: 203. EADWEARD MUYBRIDGE.
Walking, Hands Engaged in Knitting.
Photographed July 28, 1885; time interval
178 seconds. From *Animal Locomotion,*
Philadelphia, 1887, Pl. 39.
George Eastman House Collection,
Rochester, N.Y.

right: 204. MARCEL DUCHAMP.
Nude Descending a Staircase, No. 2.
1912. Oil on canvas, 58 × 35″.
Philadelphia Museum of Art
(Louise and Walter Arensberg Collection).

REPRESENTATION OF COLOR AND LIGHT

An awareness of the physical world is not limited to forms and spaces. Descriptions of objects can just as well refer to their color as to their shape or texture. "The coat is tan." One way of making a visual equivalent for that statement is to draw the form of a coat and paint the enclosed area within the form a single shade of the indicated ground color. This method of color representation is to be found in Plate 42 (p. 180), a Japanese print of the eighteenth century. But is the coat always seen as a single tan color? When shading is employed to represent form, the color of the coat is made lighter in the illuminated areas and darker in the shaded areas. The tan of the coat would be called its

"local color," but that specific color would be only one of many different tans the painter would have to use to create the illusion of a tan coat seen under natural conditions of light. This system of color representation, local color that is shaded, was used throughout the Renaissance (Pl. 43, p. 180) and remains current today.

The use of shaded local color for the representation of color in nature was not completely satisfying to some artists of the seventeenth and eighteenth centuries. The shaded areas they saw in nature did not always seem to be the color produced by adding black to a local color. Nor were the highlighted areas always the color produced by combining white with the local color. It is not unusual to find blue and green tones in the shadows of red clothing or on the heads of the subjects in paintings by Rubens (Pl. 33, p. 132) and Watteau. Watteau's painting *Embarkation from the Island of Cythera* (Pl. 44, p. 181) clearly shows the use of blue in the left and center distance and in the shadowed areas of foliage in the right half of the composition. The artist's utilization of warm colors in the foreground sunny areas and cool colors in the shadows is apparent throughout the painting.

In the nineteenth century, spurred on by the experiments in light and color by such scientists as Rood, Maxwell, and Chevreul, a number of painters began to experiment with new methods of color representation and paint application. These artists recognized that the apparent color of an object is affected to a considerable degree by the color of the light that shines upon it. The morning light is quite blue, as compared with the reddish light of the sunset. (Let doubters take photographs of the same scene, in color, before 8 A.M. and after the sun has begun to set in the evening and then compare them.) The color of the light not only affects the forms in the light but also alters the apparent colors in shadow, usually introducing hues that are the opposite of the color of the light source—for example, bluish shadows and yellowish sunlight. Some painters, including Renoir, Pissaro, Monet, and Sisley, realized that it was impossible to represent the brilliance of the colors of natural forms seen under sunlight by using the traditional methods of painting inherited from the Renaissance (Pl. 5, p. 35; Pl. 6, p. 36; Pls. 11, 12, p. 65; Pl. 45, p. 182). The paints available to these artists were just not bright enough to reproduce the color experience they had when they looked at a field at noon or the façade of a Gothic cathedral shimmering in the evening light.

Led by Monet, a group of artists, who were later given the name Impressionists, introduced a revolutionary method of paint application and color usage. They found that areas of the canvas painted in small strokes of color would appear, from a distance, to be more brilliant than similar areas painted in flat or in gradually modulated tones. They also found that an area of green appeared more intense and even greener when it had within it small numbers of red or orange spots. Blues could be made more brilliant by a similar introduction of orange. In effect, what they did was to create a form of optical vibration, which occurs when contrasting hues of similar value are juxtaposed. The vibrating small spots of color gave the surface of the canvas a shimmering

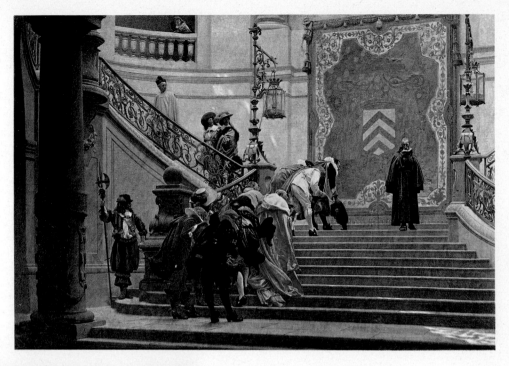

above: Plate 47. JEAN-LÉON GÉRÔME.
Gray Eminence (L'Eminence Grise). 1874.
Oil on canvas, 3′ 2¾″ × 2′ 1¾″.
Museum of Fine Arts, Boston
(bequest of Susan Cornelia Warren).

left: Plate 48. Detail of Plate 47.

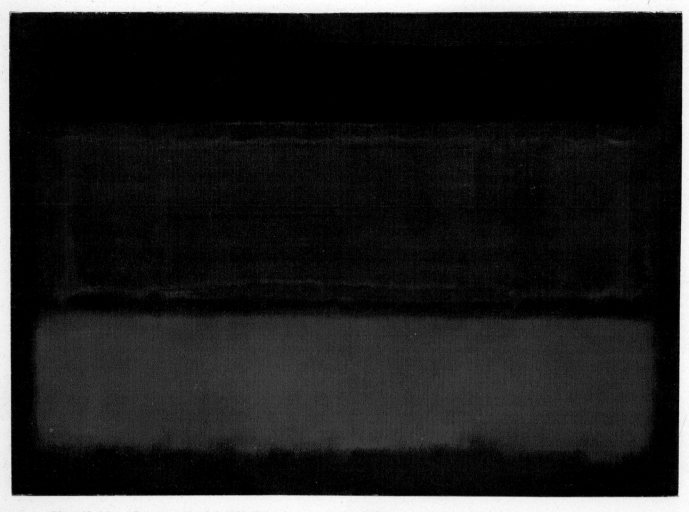

Plate 49. MARK ROTHKO. *Untitled*. 1962. Oil on canvas, 5′ 4″ × 7′ 8″.
Courtesy Marlborough Gallery, New York.

quality, which seemed to make the light and colors represented in the painting more like the original subject.

The Impressionist painter was excited and challenged by the light and color in nature. He saw form and space as secondary aspects of the light that delineated them. Objects, for the Impressionist, were not things to be touched but things to be seen. The method of representing this visual world made it almost impossible to represent forms with the detail and concern for texture that were traditional before the work of Monet and his colleagues. Application of paint in small broken strokes prevented the creation of sharp contours and surface variation, which are typical of the paintings of an artist who wishes to represent objects in a sculptural manner. Compare the detail from a painting by Monet with one by his contemporary Jean-Léon Gérôme. Monet's use of paint (Fig. 205; Pl. 46, p. 182) prevented his representing form with all the concern for detail we see in the work of Gérôme (Pls. 47, 48, p. 191), but Gérôme's method precluded the possibility of representing light and color with the brilliance of Monet's surfaces. Once again, we are faced with the conclusion that it is impossible to depict all aspects of real experience on the same canvas.

NONREPRESENTATIONAL PAINTING

A discussion of the representation of the "real" world on the flat surface of the artist's canvas would be incomplete without noting that many contemporary painters have turned from representational painting into other types of two-

205. CLAUDE MONET.
Sunflowers. 1881.
Oil on canvas, $39^3/_4 \times 32''$.
Metropolitan Museum of Art,
New York (bequest of
Mrs. H. O. Havemeyer, 1929;
H. O. Havemeyer Collection).

dimensional art. The creation of an illusionary world based upon the "real" world no longer interests them. There is no single reason for this change in attitude. In part, the movement away from representation must be related to the tremendous growth in the use of the camera. Certainly the change in painting coincides with the development of photography as a means of representing the real world on a two-dimensional surface. Since the beginning of the nineteenth century, the photograph has become the dominant form of pictorial representation. When it was combined with the printing technology which permitted photographic reproduction in magazines and newspapers, the product of the camera became the most influential image-maker of the twentieth century. Competition with a camera seems a fruitless activity for many present-day artists.

Another factor which appears to have influenced the movement away from representation is an increased concern with the personal, inner world of the individual. Many artists have turned their vision inward, exploring and expressing their subjective reactions to the world about them, and in some cases even creating a world of their own through the medium of paint and canvas. Chapter 14 examines the expressive content of the visual arts, and though the point is made that the expression of the artist's personal response to experience has

206. Cross Page,
from *The Lindisfarne Gospels.* c. 700.
Illumination. British Museum, London.

194

long been a part of the visual arts, the period since the beginning of the twentieth century has seen a growing concern with the subjective statement.

A third influence on the artist which has reduced the importance of representation in contemporary painting is an increasing interest in the work of art as an object, a beautiful or exciting combination of forms and colors that satisfies an esthetic need, without depending on the image-making or representation potential of the work. In the past, decorative painting has been used to enhance the surfaces of buildings, and it is to be found, too, in manuscript illuminations. Frequently decoration was combined with representation, as in Figure 206, which is a page from the *Lindisfarne Gospels*, painted about 700. The complex, meandering tracery is joined here with forms that suggest the heads of birds. The total effect is one of highly enriched surfaces at once mysterious and precious, for the arabesques seem to hide the images even as they lend a sense of importance and value to the page.

Even totally nonrepresentational painting can often have a spatial quality without recall to natural objects. Reference has already been made to the shaped canvases of Frank Stella (Pl. 37, pp. 160, 161), in which diagonals are used to suggest depth. Less obvious but equally pertinent is a detail (Fig. 207) of Jackson Pollock's *Mural on Indian Red Ground* (Pl. 78, p. 462), which shows much

207. JACKSON POLLOCK.
Mural on Indian Red Ground,
detail of Plate 78, p. 462.

208. AL HELD.
Phoenicia X. 1969.
Acrylic on canvas, 8 × 6′.
Courtesy André Emmerich
Gallery, New York.

of the same quality of tracery as the *Lindisfarne Gospels.* It is a much larger work than the book page, and obviously the arabesque is more freely drawn, but it, too, suggests a mysterious web, delicate and rich. The viewer is enmeshed in overlapping, intertwining skeins of color which produce a dense spatial field suggesting the enigma of a maze even as they form a rhythmically ornamented surface.

Al Held uses ambiguous linear constructions to divide the picture plane into angular areas which assume three-dimensional characteristics. Transparent cubes and other solid forms are produced in an irrational space. Forms bump against one other, seeming to fill spaces already occupied by other solids (Fig. 208).

The quiet intensity of Mark Rothko's painting (Pl. 49, p. 192) contrasts with Held's work. The large rectangular forms appear to float against and still be part of the subtly modulated, deep purplish brown of the back plane. The orange area at the bottom seems to force itself forward, held back slightly by the soft edges that are tenuously connected to the surfaces behind. The black form at the top has a spatial position somewhat behind the orange area but clearly in front of the transparent central element. The sense of space in Rothko's painting derives from a real, immediate experience that involves the viewer at the time of his contact with the work. The large scale of the canvas (approxi-

mately 5 by 8 feet) helps to produce the effect of a vista beyond the wall on which it hangs, opening into the void a warm, silent environment made for contemplation.

All artists working in two-dimensional media face the problem of the third dimension, for it is impossible to place a dot on a piece of paper without having it assume a spatial position in the mind of a perceptor. Does the dot sit on the white surface, and therefore in front of it? Does the dot indicate a hole in the plane of white paper, through which a dark depth is seen? Few observers will perceive the dot and the white area at the same spatial distance. Thus, few two-dimensional art forms throughout the history of art lack a hint of the third dimension. In many of them some accommodation has been made between the two-dimensionality of the medium and the illusion of depth. Some artists have emphasized the flat surface with but a limited concern for the effect of a space that moves in or out from the picture plane. Others have attempted to produce a three-dimensional illusion as though the flat surface of the picture did not exist, and the picture frame served as a window through which a viewer saw forms and spaces comparable to those in the real world. Each of these attitudes toward picture-making offers the trained observer a different form of visual communication. There is little profit in establishing one solution to the three-dimensional problem as the ideal standard for judging all others. A photographic approach to spatial representation cannot be fruitfully applied to Cubism or to the work of Mark Rothko. On the other hand, the methods of communicating three-dimensionality used by Cézanne, Picasso, Matisse, Pollock, Rothko, and others who have forgone the use of perspective systems offer no criteria for judging the work of painters who have substituted illusionistic equivalents for real space. Each approach must be seen as a part of a larger visual content, and the effectiveness of the spatial indication must be measured against the communicative intention of the individual artists concerned.

chapter 7

DRAWING

Henri Matisse's *Pink Nude*, a painting we saw in Plate 1 (p. 15), evolved over an extended period of time as the artist, proceeding by trial and error, gradually approached the final image. Beginning with a rather traditional attitude toward the representation of the female figure (Fig. 209), Matisse painted and repainted the forms of the model and the setting in which she was posed (Figs. 210–214). As the drawing changed under the impress of the artist's repeated revisions, the distribution of color changed. Progressively, the pink area contained within the drawn form of the figure was made to dominate the composition. The rectangular blue and white chaise—contrasting against the warm curved central form and the yellow area that once represented flowers—now sits strangely in the background, filled with an energy that threatens to push it forward. A spatial tension has been created between the yellow patch and the strongly stated frontal position of the left arm, drawn in an enlarged scale and tied to the lower (the most forward) edge of the canvas.

Matisse's realization of the composition was a form of purification. He purged redundant details, clarified and exploited essential contours and forms, using each stage in the sequence as preparation for the stages that followed. The *Pink Nude* now known to us exhibits such a comfortable disposition of linear edges and flat color areas the viewer may well take the painting to be the result of a rapid, spontaneous composition. This effect is a measure of the artist's skill, for only a master could have maintained the freshness of his original vision throughout the many weeks of active decision-making that Matisse committed to the *Pink Nude*.

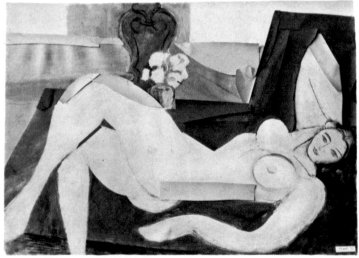

209–214. HENRI MATISSE.
Six states of *Pink Nude*
(Pl. 1, p. 15). 1935. Oil on canvas, $26 \times 36^{1}/_{2}''$.
Baltimore Museum of Art (Cone Collection).

above: 209. An early state of Plate 1,
Matisse's *Pink Nude.* May 3, 1935.

left: 210. A second state of Plate 1,
Matisse's *Pink Nude.* May 23, 1935.

below: 211. A third state of Plate 1,
Matisse's *Pink Nude.* May 29, 1935.

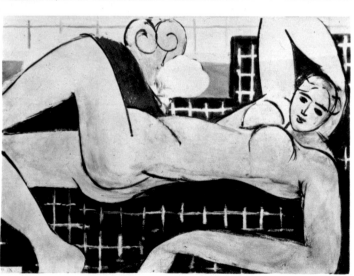

In painting and sculpture, even in architecture, the many acts required for the completion of a work are often so fused into the complex final form that the individual elements no longer are separately distinguishable. One decision is canceled or adjusted by still others. Even those works that offer the superficial appearance of simplicity have emerged from an extensive series of choices and procedures, often pursued over great lengths of time. Each stage of the *Pink Nude* reproduced in Figures 209 through 214 was a trial plan. Interactive, interdependent judgments were made on amounts and qualities of color and on the shapes of forms and lines. Drawing—the accretion of decisions that resulted in the edges, forms, and calligraphy in the painting—is an essential component of this composition, and it is rare to find a work of art that does not depend, to some degree, on the artist's ability as a draftsman.

Because it is so fundamental to, and pervasive in, all that an artist does, drawing evades every attempt to define it precisely. In the narrowest sense, drawings are essentially linear in character and modest in size, formed by a marking implement on a monochromatic support. An expanded definition would include the possible use of tonal areas that supplement or, on occasion, replace the linear elements, as well as a limited use of polychromed variations in both line and tone. But even this more liberal interpretation falls short of the reality of many works that, by general agreement among artists and art historians, should be regarded as drawings. Some pastel drawings (Pl. 34, p. 149) are intensely and variously colored, and the *sinopia* reproduced in Figure 251 was conceived and executed on an architectural scale.

Elusive as a definition of drawing may be, we can say with reasonable certainty that a body of two-dimensional art exists comprised of objects that are characterized by at least two of the following factors:

1. A mark-producing medium has been used in a relatively direct way.
2. Color is, frequently, limited to one or two hues.
3. Most often, though not always, paper has served as the support.

Yet to define drawing on the basis of physical properties alone would fail to grasp an essential truth about drawing. Of much greater significance to an understanding of drawing is a sense of its purpose—how it serves in the overall enterprise of the practicing visual artist. Painters, sculptors, and architects draw constantly. They draw to study, to record, to clarify their ideas. They draw for pleasure, moving an instrument and producing a line because it pleases the eye and uses the hand in a satisfying rhythmic activity. Many drawings are direct, single-purposed, and spontaneous. Often, they represent an intuitive reaction on the part of the draftsman to the stimulus of a provocative form, accidentally produced on the surface of a sheet of paper. And, finally, there are those drawings that take their place beside completely realized paintings and sculptures. Ambitious and demanding, they represent a major effort for the draftsman, and he considers them serious, fully developed works of art.

Drawings can be remarkably telling works of art, and the nonspecialist should feel free to enjoy them for the many delights they offer. Drawings are an opportunity to see the artist with his sleeves rolled up, his pretensions down, in

an immediate, often pleasurable confrontation with the drives generating him to be the image maker he is. Seen in this light, they can readily become the basis for an empathetic connection between the producer and the consumer of visual art—a relationship filled with promise for esthetic reward.

THE MATERIALS OF DRAWING

Drawn lines can result from two different processes. The first of these produces a mark by depositing minute particles of colored matter on a surface from a stick of material that is drawn against it. The second process leaves a mark as a fluid is allowed to flow from an instrument onto an absorbent surface. Both methods can be used to execute a solid line, without variation from dark to light, or gradually shaded areas of great delicacy.

Dry Media

The *dry* drawing media include silverpoint, pencil, pastel or chalk, charcoal, and wax crayon.

Silverpoint (Pl. 50, p. 209; Fig. 215), one of the oldest among the traditional drawing media, is rarely adopted today. In this medium a silver wire is drawn over a surface that has been specially prepared, usually with a chalk coating that is abrasive enough to cause small bits of the metal to adhere to it. Through oxidation, the metal tarnishes, altering the color of the line to a darker, delicately grayed hue. Silverpoint does not lend itself to a shaded line. Each line is as dark as every other line. If the artist wishes to develop gradations of tone, he must build them up slowly and carefully by making a series of lines so close together that from a short distance the linear notations fuse into a solid area. If a darker tone is desired, the lines are marked in a still tighter relationship or even made, by a technique called "cross-hatching," to intersect at various angles.

Silverpoint lines cannot be easily erased; therefore, the artist must work deliberately, with a firm idea of the image he expects to form. The technique encourages precision and clarity, and these qualities, combined with the reticent tonalities of the medium, can result in drawings of refinement and sensitivity. Because of the preparations he must make, the artist can add coloring pigment to the ground of his silverpoint drawings. In Plate 50 Leonardo has used red to introduce an intermediate tonality between the dark lines of aged silver and the highlights brushed in white. This is a particularly helpful device for modeling volumetric forms on a flat surface and for creating the effect of strong relief and plasticity.

In the upper section of this drawing Leonardo sensitively sketched a number of trial positions for the figure's head and shoulders. Here is the free, rhythmic grace so typical of this artist's mastery of calligraphic line. The lower half of the sheet demonstrates a more emphatic application of the medium. Carefully modulated tonalities define the folds of the cloth, the consequence of many individual parallel strokes.

left: 215. JAN VAN EYCK. *Cardinal Niccolò Albergati.* c. 1431.
Silverpoint on grayish-white paper, $8^3/_8 \times 7^1/_8''$.
Kupferstichkabinett, Staatliche Kunstsammlungen, Dresden.

below: 216. Detail of Figure 215.

Silverpoint drawings reward close scrutinty. In the fifteenth-century por-
trait study reproduced as Figure 215, the Flemish master Jan van Eyck has
left a record of his search for the precise contours he perceived in the subject.
Repeated attempts to record those contours have attained the appearance of
a composite line. It is only when the drawing is carefully scanned that the
separate contours become evident (Fig. 216). Tonal areas have been created
by drawing parallel lines unrelated to surface contours. These are deliberate
but substantially freer than the lines used to describe the edges of the forms.

The modern *pencil* dates from the end of the eighteenth century, when the
manufacturing process was invented in both France and Germany. Graphite
dust was mixed with clay, formed into thin rods, and baked to harden the clay,
fabricating a rigid drawing material that could be inserted into paper or wood-
en cases. Graphite, sometimes called "plumbago," had been mined in Europe
as early as the sixteenth century. Some drawings from the seventeenth century
include areas that are thought to have been produced by pieces of graphite.
Often such works are identified as pencil drawings, but accuracy requires that
they be called "graphite drawings," for the artists were limited to the natural
qualities of the mineral. One of the attractions of the new pencil medium was
based on the manufacturer's ability to issue the "leads" in several degrees of
hardness. By varying the proportion of clay to graphite it was possible to pro-
vide marking characteristics that approximated silverpoint at one end of the
scale and at the other extreme the dark, granular quality of black chalk. A

above: 217.
JEAN-AUGUSTE-DOMINIQUE INGRES.
The Forestier Family. 1806.
Pencil, $9^1/_4 \times 12^3/_4''$. Louvre, Paris.

right: 218. JOHN CONSTABLE.
Fir Trees at Hampstead. 1820.
Pencil, $9^1/_8 \times 6^1/_4''$.
Victoria & Albert Museum, London.

drawing by Ingres dated 1806, not too long after the introduction of the pencil, has the general character of a work executed with a metal point (Fig. 217). Another pencil drawing, by the English landscapist John Constable and inscribed with the date 1820, illustrates the softer, grainy texture so attractive to artists who prefer the dark tones and atmospheric diffusion that a thick, rich lead can offer (Fig. 218).

A study by Kimon Nicolaïdes, in Figure 219, suggests the tonal effects that can be achieved by rubbing or smudging the lines of a pencil drawing—effects that are not possible when a metallic substance is employed.

One of the most important advantages of the pencil medium is the ease with which the draftsman can correct or eliminate a line. The ability to erase marks reduces the need for restraint in the initial stages of drawing. Because a misplaced line can be changed at will, the artist is free to work spontaneously, making notes rapidly.

Figure 220 is a study for a portrait of the painter Edouard Manet made by Edgar Degas. Rapidly executed, the drawing reveals many ways in which pencil can be handled. There are fine, hard lines left by a sharp point, softer broad strokes made with the side of the pencil, and tones created by grouping parallel lines or by smudging. Light construction lines indicate trial positions for the arms and legs, and faint indications of a standing figure are to be seen, partially erased. A careful examination of the drawing can offer the

left: 219. KIMON NICOLAÏDES. Study for a painting in progress. c. 1930–37. Pencil on transparent paper, $10^3/_4 \times 8^1/_4''$. Collection Mamie Harmon, New York.

right: 220. EDGAR DEGAS. Study for a portrait of Edouard Manet. c. 1864. Pencil, $13 \times 9^1/_8''$. Metropolitan Museum of Art, New York (Rogers Fund, 1918).

221. KÄTHE KOLLWITZ.
Peasant Woman Sharpening a Scythe. 1905.
Black and white chalk, $17^1/_4 \times 14^3/_8''$.
California Palace of the Legion of Honor,
San Francisco.

viewer a sense of intimate connection with the artist's process as he reviewed the challenge presented by the figure.

Pastel, or *chalk,* is manufactured by combining pigment with a binder into an easily crumbled stick. *Charcoal* is formed by burning, or rather charring, selected sticks of wood or vine. These media produce lines in the same physical manner as silverpoint and pencil. The particles of chalk and charcoal are so easily dispersed over the surface of a sheet of paper that they have a tendency to smudge and must be fixed with a spray of thinned varnish before the media can be considered permanent.

Chalk drawings have been made for many hundreds of years. The medium is extraordinarily flexible, so that stylistic individuality can easily be accommodated within its potentials. The "organic" colors of chalk are as old as cave art, and they range from the talc white familiar in blackboard use through ochers and umbers to "sanguine," a red derived from iron oxide. Associated with drawings known as "pastels" are hues of the greatest purity, brilliance, and intensity. At widely separated times and places, such differing artistic personalities as Michelangelo, Käthe Kollwitz, and Jasper Johns have all found chalk a useful and attractive material.

The red-chalk studies by Michelangelo in Plate 51 (p. 210) include rapid calligraphic sketches as well as extended, careful linear and tonal drawings. The contours vary in width, and some are much darker than others. Each stroke retains its clarity, suggesting a measured involvement with the rhythms of the surface and edges of the model.

Käthe Kollwitz made her drawing (Fig. 221) four centuries after Michelangelo's Renaissance study, employing black and white chalk with a broad tonal emphasis. Edges are soft, contrasts are dramatic, and the drawn forms suggest more than they describe. Elegant contours are missing. Instead, areas of tone, textured by the surface of the paper as the chalk was drawn against it, give form to the powerful image reproduced here.

Several commercially produced forms of chalk are available to the draftsman. One of the most favored of these is *Conté crayon*, a highly compressed pigment and binder combination that originated in France in the nineteenth century. Conté drawings have characteristics generally quite similar to those of drawings made with chalk, but they appear a bit sharper and more precise because the crayons are somewhat harder than traditional pastels. In the drawing entitled *Café Concert* (Fig. 222) Georges Seurat worked black Conté over a textured paper to produce a vibrant modulation that is radiant with the light and life of the theater scene the composition depicts. Using almost no lines, the artist has invested both forms and atmosphere with a general suffusion of light and dark that is gradated from velvety black to a brilliant white reserved from the paper support.

Charcoal is combined with chalk in the drawing by the contemporary artist Jasper Johns (Fig. 223). This painter used the familiar forms of numerals,

left: 222. GEORGES SEURAT. *Café Concert.* c. 1887. Black Conté heightened with white, 12 × 9″. Museum of Art, Rhode Island School of Design, Providence.

right: 223. JASPER JOHNS. *0 Through 9.* 1961. Charcoal and pastel on paper, 4′ 6″ × 3′ 9″. Collection Mr. and Mrs. Robert C. Scull, Easthampton, N.Y.

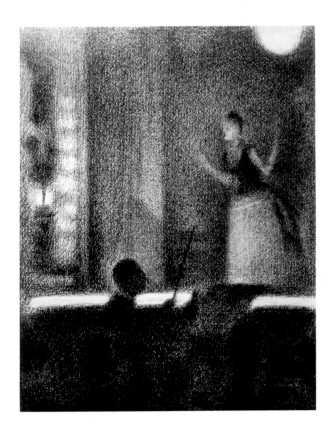

224. Jean-Baptiste-Camille Corot. *Landscape (The Large Tree)*. c. 1865–70.
Charcoal, $9^1/_2 \times 16^1/_4$". Collection Victor Carlson, Baltimore.

overlapping them to make a linear division of the picture plane. The areas
formed by the linear web are filled with tone and a texture that derives from
Johns' highly personal calligraphy. A complex two-dimensional organization
combines with a somewhat ambiguous spatial indication. The variety of sur-
faces that result from different ways of using the medium offer the viewer a rich,
sensual orchestration. This is an esthetic object that transforms its familiar
subject matter in an unexpected way.

A profitable comparison can be made of the Johns work with the charcoal
drawing by Corot reproduced in Figure 224. In contrast to the linear, sawtoothed
application of strokes clearly employed by the modern artist, the nineteenth-
century painter has applied soft, rubbed tones of gray to the paper, blurring the
edges to create a smoky ambience devoid of specifics. An overall granular tex-
ture gives the drawing the appearance of a mysterious illusion seen through the
screen of a gauze curtain, the elimination of detail suggesting as much as it
reveals.

The coloring materials consumed in the manufacture of pastels offer a
great range of pure hues and their tonal and chromatic derivatives for artists
who find too limiting the traditional blacks, browns, and reds so often used in
drawings. Some artists apply the full potential of pastels as another painting
medium, exploiting their intense color-blending capability and unique manipu-
lative characteristics (Pl. 34, p. 149).

Plate 50. LEONARDO DA VINCI. Study of drapery. c.1500. Silverpoint, brush in white on red tinted paper, $10^{1}/_{4} \times 7^{3}/_{4}''$. Gabinetto Nazionale delle Stampe, Rome.

Plate 51. MICHELANGELO. Studies for the *Libyan Sibyl* in the *Sistine Ceiling*. c.1508. Red chalk, 11³⁄₈ × 8¹⁄₄″.
Metropolitan Museum of Art, New York (purchase, 1924, Joseph Pulitzer Bequest).

above: 225. OSKAR KOKOSCHKA. *Portrait of Olda.* 1938.
Blue crayon, 17¹/₄ × 13³/₄″. Allen Memorial Art Museum,
Oberlin College, Ohio (R. T. Miller, Jr., Fund).

right: 226. LOVIS CORINTH. *Dr. Arthur Rosin.* 1923.
Lithographic crayon, 19³/₄ × 12¹/₂″.
Collection Maurice and Esther Leah Ritz,
Milwaukee, Wisc.

Wax *crayons,* like pastels, are a combination of pigment and binder formed
into colored sticks or pencils that can be shaped to produce a variety of marks.
The wax binder gives crayons a slippery quality as they are moved over the
surface of the paper support. Usually associated with children's activites, wax
crayons have been adopted by some artists who find such a basic, readily avail-
able medium inviting (Fig. 225).

Lithographic crayons, so-called because they are intended for use in the
water-and-grease technique of making prints by the process of lithography,
are favored by many draftsmen for the rich blacks and the shading, blending
possibilities they offer. Also, the smooth, oily substance lends itself to the deft,
gliding, exploratory gesture of an artist like Lovis Corinth (Fig. 226).

above: 227. PAUL KLEE. *Botanical Garden.* 1921.
Pen and ink, $9^7/_8 \times 15^3/_8''$.
Paul Klee-Stiftung, Berne.

left: 228. ERNST LUDWIG KIRCHNER.
Frau Erna Kirchner.
1921. Pen and ink, $12^1/_8 \times 9^3/_8''$.
Robert Lehman Collection, New York.

opposite: 229. JACKSON POLLOCK. *Drawing.* 1950.
Duco on paper, $1' 10^1/_4'' \times 4' 11^3/_4''$.
Staatsgalerie, Stuttgart.

212 *The Language and Vocabulary of the Visual Dialogue*

Fluid Media

Any colored liquid can be caused to leave marks on a surface, but certain qualities in a fluid marking medium are useful to the draftsman who prefers to draw with brush or pen. The artist normally looks for a material that is fairly permanent and will make opaque black lines and areas when he needs them. He wants a material that will flow from his instrument in a controlled manner, allowing the brush or pen to be manipulated with considerable freedom. Often he desires a medium that can be diluted to produce marks of different tonalities. Just as important as the fluid in drawing is the instrument itself. Fluid drawing techniques rely heavily on the characteristics of the brushes and pens used to carry the marking medium to the ground. The flexibility of the instrument, the width of strokes it will permit, and the amount of fluid it can hold all have their effect on the draftsman and the drawing.

The word *calligraphy* is frequently introduced in reference to drawings made with fluid media. Originally, the word meant beautiful writing, and it still retains that sense, but any clearly defined linear marks that have a distinctly kinetic character may be called "calligraphic." Calligraphy suggests the movement of the hand and of the instrument—the gestural experience. Paul Klee's *Botanical Garden* (Fig. 227) is a record of the short, staccato movements of the artist's pointed pen nervously creating arabesques that take the shape of recognizable but rather strange objects. A flexible quill pen was used by Ernst Ludwig Kirchner when he drew the portrait study in Figure 228. As the artist's hand changed pressure on the point of the instrument, it responded by modifying the line width. There is a sense of rapid, excited execution, the hand flickering over the paper in an impassioned calligraphic dance.

A drawing made with pen and brush often expresses the velocity of the artist's gestures. In his composition *Hagar and Ishmael in the Wilderness* (Pl. 52, p. 227) Giovanni Battista Tiepolo, one of the great draftsmen in the history of European art, has combined quickly brushed tonal areas of transparent ink, called *washes,* with rapidly drawn pen lines. The union of crisp lines, dark accents, and light, freely flowed washes gives this drawing a fresh vitality and an excitement as effective now as it was the day the artist completed the drawing.

Jackson Pollock's *Drawing* (Fig. 229) is a much more recent example of a calligraphic composition that expresses in the most dynamic way the motion of the artist's hand. Here is a work made by dripping and flicking Duco paint

against the surface of a sheet of paper. The viscosity of the medium and the controlled violence in the movement of the artist's arm together have produced calligraphic forms in unique and provocative shapes.

Calligraphy can be broad and dramatic, a few strokes of a brush. Compare Rembrandt's drawing of his sleeping wife (Fig. 230) with the nineteenth-century Japanese drawing of a teakettle hanging from a hook (Fig. 231). Different as they are in content and style, both works represent broad, calligraphic forms of drawing. A completely controlled brush has been used in each, with an economy and directness possible only from the hand of a master draftsman.

A contrasting scale of calligraphy is to be found in *Street Scene in a Village,* a drawing attributed to Pieter Bruegel the Elder (Fig. 232). The intimate scale of these pen strokes requires that they be studied carefully, perhaps under magnification, if they are to be appreciated as calligraphic elements.

A liquid drawing medium can be lightened by adding water or some other dilutant to the basic mixture. It is also possible to dilute the medium by applying it to a wet surface. Using either one of these techniques, or both, an artist can realize a wide range of tonalities in a drawing, exactly as he would in a watercolor painting. Figure 233, a drawing by Claude Lorrain, was painted in large part on paper that previously had been dampened. While the surface was still moist, a brush filled with color was touched to the paper. Where the

surface remained very wet, the areas softened along their perimeters, diffusing color into the surrounding field. Where the artist desired harder edges, as in the lower foreground, he waited until the surface dried before applying the ink. Interestingly, this drawing is almost completely devoid of calligraphic elements, but brushstrokes can be distinguished. They are broad and area-forming strokes, rather than linear marks. The full width of the brush has been utilized and not just the point. The effect is spatial, with the edges of forms overlapping

232. PIETER BRUEGEL THE ELDER.
Street Scene in a Village. c. 1560.
Pen and bister on buff paper,
$5^1/_8 \times 15^5/_8$".
Metropolitan Museum of Art,
New York (Rogers Fund, 1906).

233. CLAUDE LORRAIN.
The Tiber above Rome:
View from Monte Mario. c. 1640.
Brush and wash, $7^3/_8 \times 10^5/_8$".
British Museum, London.

above: 234. ANDREW WYETH. *Sleep.* 1961.
Dry brush, $20^3/_4 \times 28^3/_4''$.
Courtesy Mrs. Andrew Wyeth, Chadds Ford, Pa.

left: 235. Detail of Figure 234.

opposite left: 236. ERIC MENDELSOHN. Sheet of project drawings
for Temple Emanu-El and its Community Center,
Dallas, Tex. 1951.
Collection Mrs. Eric Mendelsohn, San Francisco.

opposite right: 237. ALBERTO GIACOMETTI. *Self-portrait.* 1962.
Ballpoint pen on a paper napkin, $7^1/_4 \times 5''$ (irregular).
Private collection, New York.

to indicate masses of trees that progress illusionistically from the immediate
foreground back to the distant base of the hills.

Dry brush studies like Andrew Wyeth's *Sleep* (Fig. 234) come from a unique
use of paint and instrument that yields tonal surfaces surprisingly similar to
those made by pencil or chalk. The liquid medium employed in this technique
has a "tacky," or viscous, consistancy. Having selected a stiff brush, the artist

touches the bristle tips to the paint and then, with minimum pressure, draws them across the surface of the paper support. Each bristle leaves its trace, and because they are closely spaced, the individual marks fuse visually to suggest tonal continuity. By varying the amount of medium borne on the bristles and by stroking the paint onto the ground in successive applications, the artist can control the values and textures of tonal areas (Fig. 235).

USES OF DRAWING

Both the drawing process and the resultant sketches or detailed drawings serve the artist's ultimate aim in various ways. The draftsman's relatively quick and flexible methods make it possible for the designer to project and visualize in a few deft strokes the appearance of a three-dimensional object as seen from a specific observation point (Fig. 236). Many drawings are direct, single-purpose, and spontaneous. They represent an intuitive reaction to an experience suddenly encountered or an idea that had to be caught as it flew by. In the excitement of the moment the artist's need to record a perception or an idea can find its immediate satisfaction in the act of drawing. A paper napkin and a ballpoint pen were available and suitable for the immediate needs of Alberto Giacometti when he felt urged to make the drawing reproduced in Figure 237.

238. Pierre-Paul Prud'hon.
La Source. c. 1801.
Black and white chalk, $21\,^1/_4 \times 15\,^3/_8''$.
Sterling and Francine Clark
Art Institute, Williamstown, Mass.

Another category of drawings, in direct contrast to the rapid sketch, emerges from a slow, deliberate manipulation of a drawing medium. Desiring to make a carefully wrought, fully realized visual statement, the artist may devote as much time to a formal, "master" drawing as he would to a major painting or sculptural composition (Figs. 234, 238; see also Figs. 257, 258).

Of all the drawings from the past the largest number probably are those made to record or study some aspect of nature. The range of subject matter is as varied as the interests of the draftsmen. Traditional subjects include the human figure, animals, landscapes, seascapes, individual flowers and plants, still life, drapery, and architectural details. The style of the drawings is directly related to the medium, but of equal importance is the artist's intention—what he sees or wishes to communicate about his subject.

Compare Claude Lorrain's landscape (Fig. 233) with one by Samuel Palmer (Fig. 239). Claude's drawing is a generalized study of the way in which foliage masses create a grand spatial pattern. Details are suppressed. Simplified forms are varied, giving a sense of the richness of the natural growth. Palmer's study also uses large areas of tone to denote foliage, but quite obviously his concern is for details within the landscape's larger elements. There are rapidly drawn indications of architectural details, leaf textures, and even references to the shape of individual leaves. Using the pencil line, the artist has, in addition,

succeeded in providing a great deal of information too small in scale to be easily represented by a freely handled brush.

Another sheet of drawings by Palmer (Fig. 240) is evidence of his interest in the study of natural forms on a number of different perceptual levels. The artist shifts easily from one form of drawing to another as he seeks to record the relevant characteristics of his subject. He looks at the forms of grain as they appear in isolation, as component parts of a single plant, and finally as part of a pattern of growing plants grouped together in the field.

The great master of the German Renaissance Albrecht Dürer had an insatiable curiosity about nature and an immense eagerness to enhance his art by understanding the forms and functions in nature. This led him to fill his sketchbooks with a wide variety of detailed studies recording both commonplace and unusual subjects. In 1521 a walrus was captured near the Flemish

right: 239. SAMUEL PALMER.
View of Tivoli. 1838–39.
Pencil, watercolor, and gouache,
$12^{7}/_{8} \times 16^{3}/_{8}''$.
Philadelphia Museum of Art.

below: 240. SAMUEL PALMER.
Study of Oats and Wheat.
c. 1846–47. Pencil, watercolor, and gouache,
$10^{7}/_{8} \times 15^{1}/_{8}''$. Art Museum,
Princeton University, N.J.

241. ALBRECHT DÜRER. *Head of a Walrus.* 1521.
Pen and ink with watercolor, $8\,^1/_4 \times 12\,^5/_8''$.
British Museum, London.

left: 242. ELLSWORTH KELLY. *Apples.* 1949.
Pencil, $17\,^1/_8 \times 22\,^1/_8''$.
Museum of Modern Art, New York
(gift of John S. Newberry, by exchange).

below: 243. MICHELANGELO.
Sketches for a *Deposition.*
c. 1540. Black chalk, $4\,^1/_8 \times 11''$.
Ashmolean Museum, Oxford, England.

coast; Figure 241 reproduces a pen and watercolor record of the artist's examination of the animal. This curious drawing combines carefully observed details with a decorative repetition of curved forms and pen strokes, a union that results in an intense, yet quite entertaining image.

With the spare and minimal means of the pure contour line the contemporary American artist Ellsworth Kelly has made a still life of apples (Fig. 242) that succeeds in suggesting not only the shape and volume of the fruit but also a spatial environment for the subject. Kelly's approach to nature is perhaps no less analytical or intense than Dürer's, but the device he employs—the unelaborated pencil line—is implacably selective, contrasting with the German master's extended development of form and surface details.

Figure studies that carefully trace the external forms of the body (Fig. 243) express the meticulously detailed perceptions of an artist when he treats the body as a static object. Another artist on a different occasion, concerned with the gesture of the figure as it assumes a position in a moment of time, may make another kind of drawing—loose, quickly executed, indicating the distribution of weights and the general axial directions of the torso and limbs (Fig. 244).

Architects have long employed drawing as a means of recording the structure, proportional relationships, and sculptural details of buildings they admire. Figure 245 is a pen drawing by the sixteenth-century architect Andrea Palladio, who here analyzed the contours and dimensions of portions of the fourth-century Arch of Constantine in Rome. His line is authoritative and precise but still spontaneous. It is combined with numbers and written notes in an arbitrary arrangement on the sheet, creating a dynamic arabesque. A contemporary student of this drawing benefits from the information established about the arch,

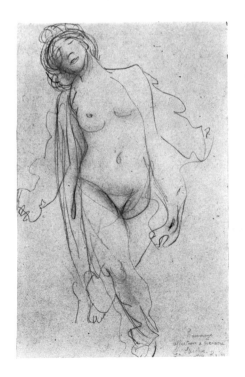

far left: 244. AUGUSTE RODIN. *Woman Dancing.* Pencil, $12^1/_8 \times 7^3/_4''$. Art Institute of Chicago (Alfred Stieglitz Collection).

left: 245. ANDREA PALLADIO. Sheet of details sketched from the Arch of Constantine. Pen on paper, $11^1/_2 \times 8''$. Royal Institute of British Architects, London.

Drawing 221

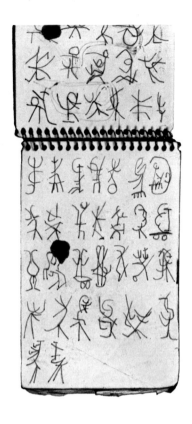

above left: 246. DAVID SMITH. *Imaginary Glyphs.*
1953–54. Pen and ink, 8 × 10″ notebook.
David Smith Papers,
Archives of American Art, Washington, D.C.

above right: 247. DAVID SMITH.
Study for *Personages* and *Tank Totems.* 1952–54.
Pencil, 8 × 10″ notebook. David Smith Papers,
Archives of American Art, Washington, D.C.

248. DAVID SMITH. *left: History of Le Roy Burton.*
1956. Steel, height 7′ 4¹/₄″.
Museum of Modern Art, New York
(Mrs. Simon Guggenheim Fund, 1957).
center: Portrait of a Painter. 1956. Bronze,
height 8′¹/₄″. Estate of David Smith,
courtesy Marlborough Gallery, New York.
right: Sitting Printer. 1955. Steel and bronze,
height 7′ 3³/₈″. Storm King Art Center,
Mountainville, N. Y.

222 *The Language and Vocabulary of the Visual Dialogue*

but he can also find satisfaction in the sheet as an esthetic object without reference to its technical function.

Drawings may also be used to study some aspect of a planned work of art that normally requires an extended period of time for its completion. Painters, sculptors, and architects all draw to try out ideas. The artist may be recording a sequence of thought; he may be trying to understand a process or procedure; he may be producing a list of visual alternatives from which he will make an appropriate choice; or he may be isolating a part of a larger composition so that it can be studied in detail.

A page from a notebook used by the sculptor David Smith (Fig. 246) contains a group of motifs that indicate the play of the artist's imagination as he conceived of variations on a linear theme suitable as the basis for sculpture. Two pages from another sketchbook by the same artist are filled with ideas in a more developed and detailed form (Fig. 247). Though the sculptures in Figure 248 are not directly based upon the drawings in the sketchbook, it is quite obvious that the works derive from the ideas recorded there.

Studies often are the means by which painters develop passages intended for incorporation into a detailed and complex composition. Figure 249 is a linear chalk drawing by the French eighteenth-century artist Jean-Antoine Watteau. The subject, a gentleman assisting a young woman as she attempts to rise from the ground, has been captured in what was evidently a very quick study. The artist made rapid notations of the position assumed by each figure

249. JEAN-ANTOINE WATTEAU.
Study for *The Embarkation
from the Island of Cythera* (Pl. 44, p. 181).
c. 1716. Red, black, and white chalk
on buff paper, $13^1/_4 \times 8^7/_8''$.
British Museum, London.

and then the relationship of the forms to one another. He indicated the pattern of folds in the clothing as well as the particulars of costume styling. This same couple appears in the most ambitious painting Watteau ever attempted, *The Embarkation from the Island of Cythera* (Pl. 44, p. 181). Found in the center-right of the painting, the pair of lovers first discovered in the drawing have been translated from chalk and line into oil and tone with considerable fidelity.

Architect and industrial designer Gio Ponti concerned himself with the organization of special-purpose rooms in the design of an apartment illustrated in Figure 250. He sought to find an efficient arrangement of spaces, traffic patterns, exposures, and window openings. The drawing is on tracing paper, a material frequently adopted by architects and planners. Instead of correcting or erasing parts of their work as they refine and alter the ideas, they place one transparent sheet over another, tracing the usable parts of the previous drawing on the new sheet, adding new details to those already fixed. Final drawings, with mechanically precise lines, are made after the loosely drawn sketches have resulted in a refined compositional scheme.

For most artists drawing is a natural extension of their perceptual and reasoning processes. Every accomplished draftsman uses his own form of notation. Like handwriting, drawing takes on visual characteristics that result from the flow of ideas, the unique rhythm of the motor functions of the body, and the personality traits of the draftsman. Often, these special qualities are combined, as they are in Gio Ponti's drawing, with a symbolic shorthand that represents objects, spaces, and textures in nature. The repeated exercise of a limited vocabulary of symbols, the unique applications of materials, the individualized movements of arm, hand, and fingers as the drawing instruments are made to mark the sheet, in combination, produce the artist's visual style. This style frequently is apparent in all the artist's graphic work, but it is most obvious in the rapid planning sketches, when the surge of ideas encourages spontaneity, unrestrained by the desire to execute a complete, finished work.

A particularly interesting type of drawing is the *sinopia* (Fig. 251), a preliminary study that until the 1430s mural painters made in preparation for the final work executed in fresco. Normally, fresco paintings were completed in two stages. An initial rough coat of plaster, called the *arriccio,* was applied to the wall. On this surface the artist drew freehand the basic outlines of his painting, sometimes in charcoal, but often with a brush in the thin, reddish, liquid medium called *sinopia.* Section by section, a second, smooth layer of plaster, the *intonaco,* was spread over the drawn composition, and in this material, still fresh and moist, the artist worked out, usually in full color, the final version of his painting.

Figure 251 reproduces the sinopia for the fresco in Figure 252. The drawing has a fluid, freely formed appearance that suggests quick, spontaneous inspiration. The broken calligraphy is so sure and authoritative the artist must have been drawing directly from the model. By comparison, the painted figures seem fixed and stereotyped, labored images posed in rigid, melodramatic gestures. Note especially the change in the body of Christ. The strict geometry

250. GIO PONTI. Sketch plan
of an apartment building
for the government of Italy.
Pencil on tracing paper, 20 × 33".
Collection the architect.

below: 251. Sinopia for Figure 252.
Palazzo Communale, Arezzo.

right: 252. PARRI SPINELLI. *Christ on the Cross
with the Virgin and St. John the Evangelist.*
c. 1448. Fresco, 4 × 3'. Palazzo Communale, Arezzo.

Drawing 225

253. WINSLOW HOMER. *Undertow.*
1886. Oil on canvas, 29³/₄ × 47⁵/₈″.
Sterling and Francine Clark
Art Institute, Williamstown, Mass.

of the axial S-curve and the hard edges of the contours introduce an arbitrary elegance into the finished work. The drawing is more relaxed, less self-conscious, and the softened linear definitions denote a greater understanding of human anatomy than is indicated by the formal precision of the fresco.

Clearly, the artist considered his initial drawing a tentative, loosely constructed plan. He was prepared to alter it as he went along, adapting the composition and formalizing the style. This sketch, like the several preliminary states of Matisse's *Pink Nude* (Figs. 209–214), offers a revealing insight into the pictorial processes of the painter. In the instance of the Renaissance artist, the drawing dramatizes the differences between the painter's immediate response to visual experience and the style he could adopt for the production of "major" work so as to make it consistent with the accepted conventions of the time.

Winslow Homer, the American illustrator and painter, witnessed the rescue of a woman from the sea in 1883 at Atlantic City, New Jersey. That year he began a painting of the subject, which was completed three years later (Fig. 253). The painting is a skillful, dramatic evocation of the original experience. It has been executed with studied care, even though sections of the areas representing water appear to be quickly and freely brushed. From our present point in time, with our visual experience of many photographs of dramatic action, the posture of the figures appears forced. The composition has a staged, melodramatic quality that contradicts the precise representational methods used in the individual figures.

When we compare the preparatory drawings for the painting with the completed canvas, the differences are telling. The drawings are fresh, filled with an energy that is absent from the painting. No accurate indication of

Plate 52. GIOVANNI BATTISTA TIEPOLO. *Hagar and Ishmael in the Wilderness.*
Brown ink and wash, with pen and brush, over black chalk; 16½ × 11⅛″.
Sterling and Francine Clark Art Institute, Williamstown, Mass.

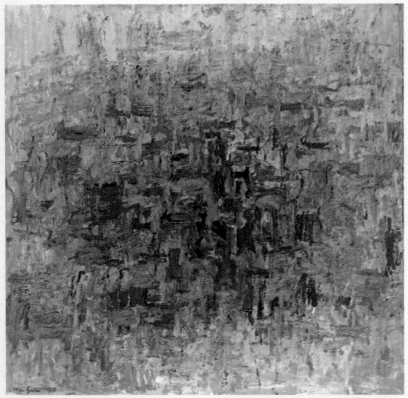

above: Plate 53. HENRI DE TOULOUSE-LAUTREC.
At the Moulin-Rouge. 1892.
Oil on canvas, 4′ 3/8″ × 4′ 7 1/4″.
Art Institute of Chicago
(Helen Birch Bartlett Memorial Collection).

left: Plate 54. PHILIP GUSTON. *To B.W.T.*
1952. Oil on canvas, 4′ × 4′ 3″.
Collection Mr. and Mrs. Leonard Brown,
Springfield, Mass.

the original sequence of the series exists, but Figure 254 appears to be an early attempt to decide on a composition. Two figures support the victim between them. The generally vertical postures of the group contrast with the horizontal and diagonal indications of the surf. At the right the artist has made three vertical lines successively testing the best position for the three figures as they relate to the right edge of the composition. The emphasis on the inner vertical indicates his choice, a choice that appears to have been followed in the final painting, even though the group went through many revisions.

Figure 255 continues the use of a three-figured composition, but here the forms are arranged in a basically diagonal grouping with a strong horizontal emphasis. The concept of a tightly intertwined group is introduced, and a striding figure is included at the left of the composition. The left figure appears to derive from that on the right in the previous study.

right: 254. WINSLOW HOMER.
First study for Figure 253. Pencil and black chalk on greenish-gray paper, 7 1/8 × 8 5/8″.
Sterling and Francine Clark Art Institute, Williamstown, Mass.

below: 255. WINSLOW HOMER.
Second study for Figure 253. Pencil, 5 × 7 7/8″.
Sterling and Francine Clark Art Institute, Williamstown, Mass.

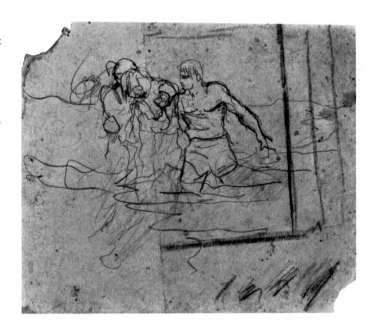

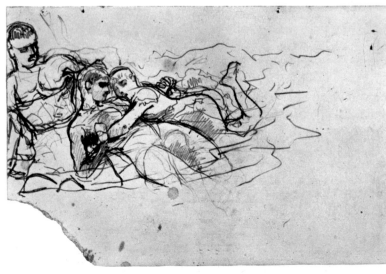

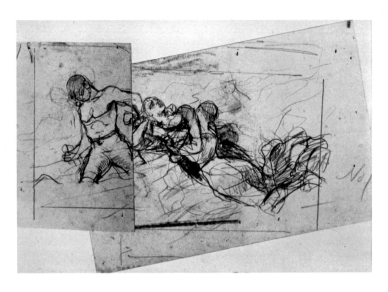

256. Winslow Homer.
Fifth study for Figure 253.
Pencil on greenish-gray paper, $5\,^1/_4 \times 3\,^1/_2''$.
Sterling and Francine Clark Art Institute,
Williamstown, Mass.

By the time Homer produced the drawing in Figure 256 he had established the final relationships among the figures. Much remained to be worked out. Other drawings exist for this project, and still others must have been made that are now lost. From those reproduced here the reader can see the image develop through a process of trial and error, gradually moving toward its final form.

Of particular interest are those characteristics common to this set of drawings. Entirely in line—with only minor indications of tone, registering the artist's concern for the contours and edges of the forms, for the tonal structure of the painting—the arrangement of dark and light forms differs considerably from the linear organization developed in the sketches. All the drawings share a rapidly drawn line, as well as a common set of shorthand notations for such details as the features of the head, the hands, and the movement of the water. These studies, with their sense of motion and vitality, may offer some observers satisfactions they cannot find in the artist's finished painting of the subject. In the arts there is no direct proportional relationship between size, seriousness, and esthetic response. Small-scale art objects and offhand sketches can offer certain qualities that may be buried in the pomposity of "important" works.

Most visual artists seem to enjoy the drawing process, and many drawings are really forms of skillful doodling, in which the artist passes time or plays with his drawing instruments. But there are drawings that unmistakably are the results of serious efforts by an artist who considers the medium equal to any available to him. In several instances throughout this chapter we have seen such work. Within this category are to be found productions as different as the brush drawing by the Japanese artist Tani Bunchō (Fig. 257) and the large charcoal composition by Hyman Bloom, an American painter (Fig. 258).

The Japanese honor calligraphy as a major art form. Japanese calligraphers learn to use brushes with subtlety and precision as they move their arms in seemingly effortless passes over absorbent rice paper. Each hair of the brush

leaves its record. The shape of the stroke, its position on the sheet, the textural quality of the marks, even the character of the edges of the fluent forms are controlled by the master draftsman. This is an art of compression, the drawing is completed in minutes. All the years of preparation are focused on the brief confrontation between the artist and the sheet placed there before him.

Hyman Bloom's *Landscape No. 20, Cloud,* 1967, is over 5 feet high (Fig. 258). It is a major effort by an artist who has used the rich tonal potential of charcoal to create a complex variety of forms and values. Unlike the Bunchō album leaf, this is a drawing of extension. Hours, days, perhaps weeks were required to complete it, and the length of the work period is clearly obvious to those who stand before the finished product. When seen across a room, the drawing takes on the appearance of a large, dark rectangle with a luminous field in the upper third. Light areas of varying tonalities and sizes are distributed over the entire surface, and linear elements make staccato paths and twisting rhythms in a pattern that is difficult to read. As the observer approaches the drawing, the

below: 257. TANI BUNCHŌ. *Banana Leaves.*
Late 18th–early 19th century. Ink on paper,
9³/₄ × 10⁷/₈″. British Museum, London.

right: 258. HYMAN BLOOM. *Landscape No. 20, Cloud.*
1967. Charcoal, 5′ 6¹/₄″ × 3′ 6¹/₂″. Museum of Art,
University of Connecticut, Storrs
(Louise Crombie Beach Collection).

ambiguous linear and value elements assume the characteristics of roots and branches, and the dark rectangle becomes a spatial volume seen through a tangle of interwoven limbs. Standing directly in front of the drawing, the observer finds textural variations in the application of the charcoal, with calligraphic elements alongside areas of intense, solid blacks. Rubbed sections and erasures add further complications. Economy, clarity, and elegance in the work of Bunchō are replaced here by baroque density and ambiguity. There are esthetic rewards to be had from both drawings, but only if one accepts the need to face them with different expectations and perceptions.

A discussion of drawing would be incomplete without a final elaboration of the role that drawing, inescapably, plays in other art forms. Frequently painters draw on their canvases, using calligraphy to define a contour, to emphasize an edge, at times to provide a detail in a larger form. In his painting *At the Moulin-Rouge* (Pl. 53, p. 228) Toulouse-Lautrec used calligraphic line freely in combination with flat areas of color. The gestural evidence introduces a quality of directness, a feeling that the work was quickly executed. Even the flat color areas reveal the action of the artist's hand as he applied the paint in vigorous strokes, bringing with them yet another and looser calligraphic element. Paint applied to the canvas as though drawn is also to be found in Plate 54 (p. 228), a composition by the contemporary American artist Philip Guston. Many drawn lines enliven the surface with an energy that depends largely upon the kinesthetic character of the calligraphic strokes.

Though many works of art contain drawn elements, there is another, larger sense in which drawing contributes to the formation of art objects. Every line, every edge produced or controlled by an artist is the consequence of a drawing process. Whether it is an ink mark on paper, the interface between two flat areas of color, or the outer limits of a sheet of metal cut with the flame of a torch, the artist must make decisions affecting the directions and the duration of linear movements during his forming procedures. There is a difference between the *process of drawing* and drawings. The drawing process— *the operation of making decisions that control lines, edges, and the proportional relationships between forms in works of art*—differs from the decision-making involved in the selection of colors and surface variables. In this sense the artist draws whenever he works, though he may be making other decisions at the same time.

Drawings are the clearest expression of the drawing process. As such, they provide an insight into the nature of the choices open to an artist as well as an indication of how those decisions are made. It is this openness and clarity that attracts admirers and collectors to drawing exhibitions. For many, the empathy stimulated by drawings cannot be matched by the effect of any other visual art. There is a great potential for esthetic response in a work that stirs a viewer to feel that he is sharing an intimate moment with the artist who produced it. And though many drawings contain characteristics that replicate the compositional and representational structures present in the more formal arts, more often than not it is the quality of intimacy and empathy that provides a unique satisfaction for those who study the drawn image.

chapter 8

PRINTS AND PRINTMAKING

The printed type and reproductions in this book are the contemporary forms of a technology for duplicating and multiplying images that had its European origins in the sixth century. Today, automatic presses turn out images at a breathtaking rate, but in artists' studios and in specialized shops throughout the world, multiple images are being made one at a time, in a manner essentially unchanged from that used since the very beginnings of the various printing processes. In our time, a careful distinction is drawn between the mass printing and reproduction methods and the hand processes of the artists and their technicians. The hand-made multiple impressions are called *prints*, and the word has been assigned a precise meaning by the printmakers and their galleries. The Print Council of America, in 1964, issued the following definition of an original print:

> The artist alone has created the master image in or upon the plate, stone, wood block, or other material for the purpose of creating the prints. The print is made from said material by the artist or pursuant to his directions; the finished print is approved by the artist.

The Council made it clear that this definition applied only to prints made after 1930, recognizing that many prints issued before that date, among them important examples of the art, were, in fact, the product of a commercial printing industry. Underdeveloped, in comparison with present capabilities, that industry in its own time represented the highest technological achievements.

Prints of an earlier period were frequently produced without the personal supervision of the originating artist. He acted as one member of a group of craftsmen, technicians, and laborers who issued printed images as a business enterprise. Current practice in printmaking is to consider each impression as a separate art object. The size of the edition is limited and each sheet numbered. Often, the artist uses a fraction as a numbering device. The denominator of the fraction records the total number of prints in the edition, the numerator is the number of the specific print in the sequence of printing. Signing the print is the artist's way of indicating that he has approved each impression.

Prints join with drawing, calligraphy, and the products of advertising and typographic designers and commercial printers to form a rather broad, loosely defined category called the *graphic arts*. Originally derived from the Greek *graphikos*, meaning to draw, write, or scratch, the word *graphics* continues this connotation but now also includes all forms of printed image making.

Most prints have qualities common to paintings and drawings. They may be read as representational equivalents for real objects or experiences. They may constitute the result of an esthetic organization and serve for the communication of personal and group responses. Most certainly a print is to be understood as a skilled use of a specialized process that produces an esthetically satisfying object. From the point of view of the observer, how, then, does a print differ from other two-dimensional art objects?

To begin with, a print is very often less expensive than a drawing or a painting. Rarity is an important factor in the price of a desirable object. Therefore, the cost of a single impression from an edition of prints is normally lower than the cost of a unique work by the same artist.

Multiple images were produced in the East as early as the third century. In the West, the Egyptians printed fabrics in the fifth century (Fig. 259), but printmaking, as we know it today, really started in Europe in the fifteenth cen-

259. *The Annunciation*,
fragment from burial grounds at Akhmin,
Upper Egypt. c. 5th century.
Printed linen.
Victoria & Albert Museum, London.

260. PAUL GAUGUIN. *Auti te Pape (Women at the River)*. 1891–93. Woodcut printed in color with the aid of stencils, $8^1/_8 \times 14''$. Metropolitan Museum of Art, New York (Rogers Fund, 1921).

tury. The technological and economic conditions of that period made it possible to produce and market inexpensive pictorial images. Improvements in the processes and the invention of new methods for producing multiple images came as a result of the artists' and printers' desire to extend and refine the qualities of the printed image so that it could compete with single-image methods as a representational and expressive medium. Early woodcuts, engravings, and etchings were used to produce images similar in style to those found in pen or brush and ink drawings. Print methods such as aquatint, mezzotint, lithography, and wood engraving, all later developments, extended the printer's ability to fix within the methodology of multiples tonal subtleties previously found only in expensive original works of art.

As artists became familiar with the new printmaking procedures, the best of them were stimulated to exploit the media, eventually issuing prints with special qualities impossible to achieve with other image-making methods. However, with the mechanization of the processes for the production of visual images in the nineteenth century, and the vastly increased numbers of duplicates made possible by machine printing, the economic relationship between the artist and printmaking changed. It was to change again sometime later, when a new specialist, the commercial artist or graphic designer, began to take advantage of developments in photomechanical and commercial printing technology. By the end of the nineteenth century the hand-produced master plates and blocks that had been the basis for prints during the previous five hundred years became technological anacronisms.

Having been replaced by machine-made reproductions and photography, the manually formed print took on a new function. One need only compare a woodcut by Paul Gauguin (Fig. 260), from the 1890s, with examples prepared

261. AUGUSTE LEPÈRE. Woodcut. c. 1890.
Bibliothèque Nationale, Paris.

by artists just a few years earlier to recognize that the medium meant one thing to Gauguin and another to his predecessors (Fig. 261). No longer useful for mass reproduction, the older printmaking methods were adopted by artists for the creation of satisfying images uniquely different in character from those in other two-dimensional media. This change sharpened the distinction between *fine art* and *commercial art*—a difference that was blurred when all printed images were the result of the manual efforts of an artist or an artist-craftsman.

As in the past, the printmaker today has the potential of multiple sales of a single edition of prints, but though a large market now exists for prints, the artist often disregards the economic factors implicit in the multiple impressions of printmaking and works with the processes simply because he likes them.

Some connoisseurs collect prints much as they might collect postage stamps. The market value of prints, and especially old prints, is based upon their esthetic quality, their rarity, and other rather specialized aspects, such as the size of margins and the condition of the plate at the time a particular impression was pulled. The price of a print, however, is not necessarily consistent with its esthetic value to the person who responds to it. Many prints of limited value in the marketplace can offer esthetic satisfactions to the collector who approaches them as he would a painting or drawing. From this point of view each impression is essentially a unique art object separate and distinct from all others. The print may be one of many that came from the same master plate, but this fact has meaning only when two or more impressions from the same edition are compared. Then, and only then, do the differences between impressions become apparent. There are esthetic rewards to be garnered from such

detailed comparison, but ordinarily they depend upon an extensive and specialized preparation in the history and technique of the medium. The nonspecialist need not assume that a satisfying response to prints presupposes highly informed perceptions. Much can be gained from prints by just looking at them, and even a limited understanding of the processes and the ways in which they have been used can increase the potential for a deeper and richer appreciation of the artist's achievement.

It is misleading to speak of prints and printmaking as though the medium consisted of a single process. Actually, there are many different ways to produce prints, each with different possibilities and limitations. In addition, each technique for the production of prints has gone through an evolutionary change from its invention to the present time, so that prints executed by the same basic processes, at different times in history, may not have much in common.

The survey of printmaking that follows takes a somewhat chronological form. It is not intended to be a history of printmaking but rather a discussion of the media, emphasizing the factors that shaped the processes. However, printmaking did develop gradually in response to cultural and economic forces, and it is useful to discuss the technological and stylistic changes in multiple image-making as a sequence of related and interdependent historical events.

The evolution of printmaking technology has a pattern that repeats itself with each of several media. Out of a need to produce pictorial or decorative objects more cheaply or faster there is developed a process intended to approximate the art forms previously executed by hand. Gradually, as the artists and craftsmen begin to experiment with the medium, they learn to control it and often obtain remarkable approximations of the processes they are emulating. Finally, as the printmakers acquire confidence in their medium, the images they make lose some of the imitative quality and take on an identity peculiar to the unique qualities of the printmaking process.

PRINTMAKING METHODS

There are four major methods of printmaking: *relief printing*, in which the image to be printed is raised from the surface of the master block or plate, and the areas intended to be blank are cut away, as in woodcut and wood engraving; *intaglio printing*, in which the image is incised or otherwise sunk into the surface of the master plate, as in engraving, etching, aquatint, and mezzotint; *planographic printing*, in which the printing surface of the master form is a level plane, as in lithography; and *stencil printing*, in which the artist's graphic elements are executed in cutouts, as in silk screen, or serigraphy. Each process, thus, is distinguished by the way in which an original image is formed on a master surface and by the way the image is transferred to paper.

Relief

The history of printmaking in Europe begins with the relief print. But even before the first prints appeared, economic and technological developments

above: 262. Drawing of wood block.

right: 263. Printed textile. German. 13th century.
Black pigment on linen. Cooper-Hewitt Museum
of Decorative Arts and Design,
Smithsonian Institution, New York.

paved the way for the introduction of multiple-image processes. For example, a demand for decorated fabrics less costly than tapestry, fine embroidery, and exotic fibers could be satisfied by the invention of a quicker process for duplicating designs on more readily available cloth.

Typical early block-printed fabrics were decorated with simple linear designs on a dark background. The lines had been cut into the flat surface of a wooden board. Those areas not intended to print were cut away from the block, leaving in relief, at the level of the board's original surface, the portions that were to appear dark in the printed decoration (Fig. 262). A pigmented viscous paste or liquid ink was applied to the flat areas in relief, and the block was pressed against the fabric to produce the design. The thirteenth-century German linen cloth in Figure 263 came from a block that was used several times, leaving a repeat pattern that resembles the designs found in more expensive and much-admired woven brocade, damask, and velvet fabrics.

Fabrics on which pictorial images were block-printed are to be found prior to the fifteenth century. An example is *The Marriage at Cana* in Figure 264, dated about 1400. The black outline was printed from a number of separate blocks. Areas within the linear boundaries were painted, by hand, in red and yellow. It is rewarding to compare the figures on this printed cloth with manuscript illuminations such as the illustration from an Austrian prayer book shown in Figure 265, which was painted in 1235. The linear character and the figurative style of the manuscript miniature suggest a precedent for the image on the printed fabrics, indicating that the printers were trying to reproduce the costlier effects of manual decoration.

By the end of the fourteenth century the *wood block* was an accepted device for the inexpensive production of decorative and pictorial image on fabric.

At about the same time the manufacture of paper on the European continent became an important commercial enterprise. Paper production is thought to have had its European introduction at Játiva, Spain, about A.D. 1150. There is evidence that papermaking was first developed in the East and carried west to Europe by the Moslems. Prior to the use of paper, manuscripts were drawn and painted on *vellum* (veal skin) or *parchment* (lamb skin). The importance of the invention of paper can be understood when one knows that 200 pages of parchment required the skins of 25 sheep.

It is not possible to imagine the development of printmaking or printing without an inexpensive, and adequate, source of material upon which the images of the blocks could be impressed. By the middle of the thirteenth century a paper mill was established in Fabriano, Italy, and later, in the last ten years of the fifteenth century, a mill was producing paper in Germany. With the knowledge of an image-making process that enabled the artist or craftsman to produce a large number of duplicates in a relatively short time, combined with the availability of paper as a suitable and inexpensive surface on which to imprint the images, printmaking required only an economic

264. *The Marriage at Cana.* Austrian. c. 1400.
Wood-block print on linen, partly hand-colored, 47 × 33″.
National Gallery of Art, Washington, D. C.
(Rosenwald Collection).

265. *The Dormition of the Virgin.* Austrian. 1235.
Illumination. Stiftsbibliothek, St. Gall, Switzerland.

stimulus to promote its growth and ensure its development. That stimulation existed in the fifteenth century in the demand for low-priced religious images by pilgrims visiting important shrines on the Continent (Fig. 266).

Another market was created by the growing interest in playing cards during this period (Fig. 267). From the early fifteenth century there are many records of the existence of card suppliers throughout Europe and indications that card games offered an extremely popular form of gambling. Cards were first painted individually, and, because of their high cost, the earliest cards were to be found only in the homes of the nobility. During the fifteenth century, however, they became so widely distributed that, in Bologna, St. Bernadino tried to persuade the gamblers of the city to burn their cards. In the guild books of the city of Ulm, in southern Germany, it was recorded that playing cards were exported by the hogshead.

The printmaker of this time needed the most advanced technology available to him to satisfy the demands of a new and growing social group who were affecting the market for portable visual images—a market that had, since the end of the Classical world, been reserved to the Church or to the nobility who could afford the original work of the scribe, the manuscript illuminator, and the painter. The *woodcut*, an illustration prepared in much the same way as the blocks for printing fabric designs, offered an inexpensive form of visual image. It provided pictures of religious subjects that the public had seen only in stained-glass windows or on the walls of churches and cathedrals.

right: 266. *Christ before Herod.* 15th century. Woodcut. British Museum, London.

below: 267. Playing cards, from Provence. c. 1480. Wood-block prints, hand colored. Cincinnati Art Museum (John Omwake Playing Card Collection on permanent loan from the United States Playing Card Company).

These images could be purchased, taken home, and placed on a wall or in a book as a souvenir of a pilgrimage or perhaps as an addition to the decor of the room.

The woodcut and movable type, which became practical in Europe after the fifteenth-century developments of Johann Gutenberg, were quickly combined as complementary methods of conveying information. Physically, the two were easily mated, for wood blocks could be planed to the same thickness as the blocks of type, locked into a single printing unit, or form, and printed with one impression of the press. Esthetically, the strong, linear character of the woodcut harmonized well with the hand-cut letters to make pleasing page designs, in which the pattern of type lines was contrasted against the freer but related quality of the linear elements in the illustrations. Much of the early history of the relief print is directly connected with the development of the printed book, and many of the prints now available were originally bound between boards with pages of type. In a page from a fifteenth-century book one can sense the close affinity between text and illustration (Fig. 268). The individual letter forms of the rather crudely produced type appear to have a *hand-made* quality that establishes a familial tie with the illustration. Though the whole page presents the viewer with a variety of textural-linear combinations, the controlled margins and stylistic simplicity of the pictorial and text components offered a strongly unified composition.

The production of a woodcut block was often the joint effort of a designer and a cutter. The designer drew the original image for transfer to the block or,

268. ULRICH ZAINER (printer).
Page from Boccaccio,
De claris mulieribus, Ulm. 1475.
Woodcut with movable type, $4^1/_2 \times 3''$.
Metropolitan Museum of Art,
New York (Rogers Fund, 1922).

left: 269. ALBRECHT DÜRER(?). *Portrait of Terence.* c. 1495.
Drawing on wood block, c. $3^1/_2 \times 5^1/_2''$. Kupferstichkabinett, Basel.

right: 270. ALBRECHT DÜRER and unknown woodcutter. Printed illustration
for Terence, *Eunuchus*, Ulm, 1486. Woodcut. Kupferstichkabinett, Basel.

in some instances, directly on the wooden surface. The cutter removed the
areas around the black lines to leave the raised, positive portions of the drawing
that were to receive the ink and transfer the image. This division of labor often
gave early wood blocks a somewhat anonymous character; eventually, it
fostered remarkable skills in the reproduction of complicated drawings.

By the end of the fifteenth century the woodcut had completed its first
hundred years as a graphic medium. During that period the commercial use
of block printing spread throughout Europe. The styles of figurative and
spatial representation changed somewhat, as changes took place in Renaissance
drawing. But, on the whole, the visual character of the prints remained closer
to earlier models than did the art of the painter and sculptor of this same period.

With rare exceptions major artists were not attracted to the design or cut-
ting of blocks. In Basel, Switzerland, a fifteenth-century printing center, there
exists a collection of wood blocks that give some insight into the reasons that
may have limited the esthetic growth of woodcut. About the year 1495 a set
of illustrations for an edition of the work of the Roman comic poet Terence was
begun in Basel. One hundred and thirty of these blocks have survived, of which
only a few were cut. The remainder were left in an unfinished state, the surface
of the blocks painted white with the original ink drawings of the designer
intact. Scholars ascribe a large number of these drawings to Albrecht Dürer.
A comparison between the drawings and the impressions from the cut blocks
(Figs. 269, 270) suggests why a major painter or draftsman might have felt
unhappy about woodcut as a satisfying graphic medium. The drawing is a free,
sensitive linear study. It has a spontaneous, direct air about it. The print, from
the partially cut block, is coarse and crude beside the drawing. The figures are
stiff and awkward, the details of the drawing are eliminated or reduced to

271. ALBRECHT DÜRER.
The Four Horsemen of the Apocalypse.
c. 1497–98. Woodcut, $15^1/_2 \times 11''$.
British Museum, London.

static conventions, and the areas of parallel lines, which in the drawing appear to have a logical relationship to shading in the figure and the landscape, are cut without an indication that the cutter understood their function in the image. That the designer was at the mercy of the cutter is clear, a situation which few important artists of that era could be expected to accept. Furthermore, another form of printmaking became available that reduced the artist's reliance on the talents of intermediary craftsmen. Prints from engraved metal plates appeared after 1450, and the engraving process offered painters a more expressive technique for printed images than they had found in woodcutting.

Albrecht Dürer remains the outstanding master of the woodcut in the fifteenth and early sixteenth centuries. With him the medium achieved an expressive and esthetic capability that was not approached again until the twentieth century. In 1498 Dürer published a book of woodcuts with accompanying text on the subject of the Apocalypse. Fifteen full-page cuts were issued, among them *The Four Horsemen of the Apocalypse* (Fig. 271). Some doubt

272. ALBRECHT DÜRER. *The Fall of Man.*
c. 1496–97. Drawing, 9¹/₈ × 5⁵/₈″.
Ecole des Beaux-Arts, Paris.

exists concerning the cutting of these blocks. Certain scholars believe they were
cut by the artist; others disagree but suggest that the woodcutter who worked
with Dürer must have been closely supervised by him. In any case, the prints
fulfill the expectations initiated by the artist's drawings of the period. The callig-
raphy of the pen line and the tonal variations in Dürer's drawings (Fig. 272)
have their counterparts in the print. The woodcut does not imitate the drawing;
instead, the knife of the cutter produces equivalents for the controlled, sensi-
tive marks of the pen without denying the materials or methods utilized in
manufacturing the block. Extraordinary skill is combined with a major expen-
diture of time-consuming effort to achieve the levels of subtlety and sophisti-
cation found in these printed images.

Woodcut continued well into the nineteenth century as an important
book-illustration process. However, since the middle of the sixteenth century its
application has generally been limited to the less-expensive editions prepared
by European publishers. Many artists of importance who were interested in
the production of multiple images turned to the intaglio process of engraving
and, later, etching. The major advantage of the relief wood block over other
methods of printing images resided in the fact that the block could be printed

Plate 55. CAROL SUMMERS. *Choeps*, from *Nine Prints*, a portfolio of mixed media. 1967.
Woodcut, 29¼×21″. Museum of Modern Art, New York (John B. Turner Fund).

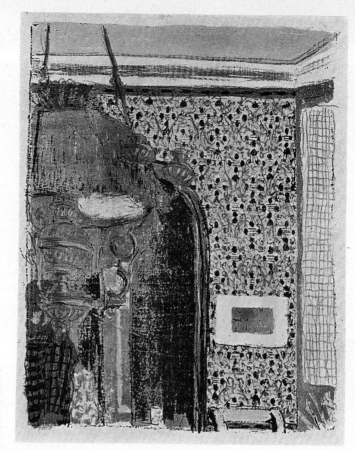

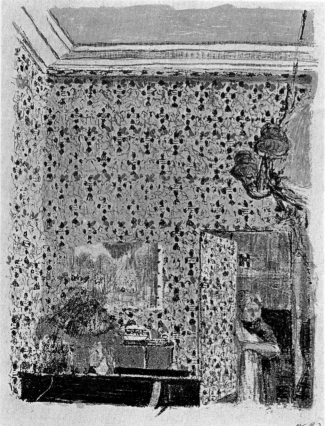

left: Plate 56. EDOUARD VUILLARD.
Interior with Pink Wallpaper I,
Plate 5 from *Landscapes and Interiors.* 1899.
Lithograph, printed in color from five stones; 14 × 11".
Museum of Modern Art, New York
(gift of Abby Aldrich Rockefeller).

above: Plate 57. EDOUARD VUILLARD.
Interior with Pink Wallpaper II,
Plate 6 from *Landscapes and Interiors.*

with the typographic elements in a book. Engravings and etchings required a separate process and a special press. Typical of the inexpensive editions employing woodcuts were the chapbooks sold by itinerant peddlers. The illustrations accompanying the verses, tales, and ballads were simple, even crude, by comparison with early fifteenth-century masterworks. Most historical surveys of woodcut tend to gloss over this period, but the chapbook illustrations are frequently direct and charming examples of printmaking (Figs. 273–275). They have the quality of folk art, naïve but clear and graphic, with uncomplicated, strong compositions.

In 1790 a book called *A General History of Quadrupeds* was published in England and illustrated with wooden relief prints by Thomas Bewick. For this work and a two-volume set called *Water Birds and British Birds*, published nine years later, Bewick produced a set of blocks that far surpassed the quality of illustrations commonly found in the chapbooks (Fig. 276). When designs are cut on the flat surface of boards parallel to the grain of the wood the direction

left: 273. Page from the chapbook *The Miracle of Miracles.*
18th century. Woodcut. British Museum, London.

center: 274. Page from the chapbook *The Wonder of Wonders.*
18th century. Woodcut. British Museum, London.

right: 275. Page from the chapbook *The History of the Two Children in the Wood.*
18th century. Woodcut. British Museum, London.

above: 276. THOMAS BEWICK. *Solitary Snipe,*
from *Water Birds and British Birds*, Newcastle, 1797–1804.
Wood engraving. Metropolitan Museum of Art, New York
(Harris Brisbane Dick Fund, 1931).

right: 277. Detail of Figure 276.

and changing density of the grain affect the cutting process. Bewick's blocks
were cut on the end-grain surface of boards. Sections of wood were laminated
so that the ends were aligned into a flat surface. The laminated end-grain block
was smoothed to provide a hard, nondirectional material that could be cut with
the graving tools used by metalworkers. Fine lines could be scribed on this
surface, and densely engraved blocks of extraordinary detail could be used to
print large editions without significant deterioration of the image. Though not
the originator of this technique, the quality of Bewick's work and the popular-
ity of his books encouraged the growth of the medium in the nineteenth century.

The end-grain relief print is called a *wood engraving*. Like woodcut, it is
the result of a process in which the cut-away areas do not print. Only those
areas remaining on the original, uncut surface of the block are inked and used
to transfer ink to paper.

Wood engraving was used extensively to reproduce drawings and paintings.
Because the prints made from engraved wood blocks were capable of represent-
ing variations in tone and texture, because they could be produced quickly and
inexpensively, and, finally, because the blocks did not wear under the repeated
impressions of commercial printings, wood engraving became the most popular
method of reproductive image-making in the nineteenth century. Methods
were developed to divide blocks with drawings on them into sections that were
distributed to teams of engravers. Each section was engraved separately and

above: 278. Illustration from *Harper's Magazine*. 1890. Wood engraving made from a painting.

left: 279. Enlarged detail of Figure 278.

then rejoined to the others to form the original large image. Blocks that might have required a week to engrave in the hands of one man were finished in a day or two. This rapid execution made the wood engraving useful for illustrating newspapers and periodicals, but the mechanical quality of the process changed the appearance of the blocks from demonstrations of creative engraving, in which each cut of the engraver's burin showed the integrity and care of an artist-calligrapher, to an anonymous, though skilled, production of tonal areas in which inventive cutting was forsaken.

Compare the print by Bewick and the enlargement of a section from it (Figs. 276, 277) with the print and enlargement from an edition of *Harper's Magazine* (Figs. 278, 279). The *Harper's* illustration has been cut into four sections, and the engraving is repetitive and uninspired. Even the direction of the

cutting is severely restricted. Bewick's print is composed of a complex combination of forms and engraved linear groups; black and white areas play against one another in a shifting arrangement of contrasting positive and negative elements.

In the last quarter of the nineteenth century the character of the wood engraving was made even more mechanical by a process that permitted transfer of photographic images to wood blocks. Photographic reproductions of paintings with a broad range of tonal variation were substituted for freely drawn sketches as the basis of the engraver's art. Figure 278 is an engraving that reproduces a painting, and it demonstrates the great difference between wood engraving as a responsive personal medium and wood engraving as a technological device for the production of images. One cannot say that the *Harper's* prints gave more information or were more detailed than the work that came from Bewick's hand. In fact, if a single impression by Bewick is compared with a single image produced by the combined photographic-hand-engraved process, the earlier print is clearly more detailed; it contains more information than the latter. On the other hand, considering the number of prints issued by Bewick and his associates in comparison with the much larger edition of images obtained from the mass-production techniques, we can argue that the total amount of information communicated by the mechanical methods is far greater. The demand for increased quality brought about a change from a craft that provided detailed information about one event to a technology that provided less detailed information about many, many more events. With the development of the photoengraving process by the end of the nineteenth century, the hand-cut

relief print lost its place as a method for producing commercially useful numbers of identical images and became purely an art medium.

The period of modern woodcuts begins with the work of Paul Gauguin. Working at the end of the nineteenth century, Gauguin was considered a revolutionary, avant-garde painter by his colleagues and the critics of the day. The artist spent the last years of his life in the South Seas, where his environment had a notable influence on his work. It is interesting to compare Gauguin's sculptured wood reliefs with the woodcuts he produced later. Though the sculpture in Figure 280 was carved prior to the artist's trip to Tahiti in 1891, it has many of the qualities that are to be found in his prints (Fig. 260). The composition is based on the use of large areas and calligraphic linear forms. The central figure is subtly modeled, in contrast to the flatter treatment of the two heads and the curved floral elements. The negative space around the major forms has been cut away in a manner very much like that employed by woodcut carvers. With careful application of ink one could print this relief as a woodcut block.

In 1893 Gauguin returned to France after his first visit to Oceania. He exhibited woodcuts in that year, including *Women at the River* (Fig. 260). Large simplified and flattened areas of black dominate the print. The freely gouged sections where the wood was removed below the surface of the block have been intentionally inked to produce a texture that contrasts with the undulating flat forms. Finely scribed lines within the black solids gently model the figure.

Gauguin's woodcuts and the influx of relief prints from Japan (Fig. 281) were important influences on the early twentieth-century graphic artists. The prints of the Norwegian Edvard Munch (Fig. 282) and the Expressionists,

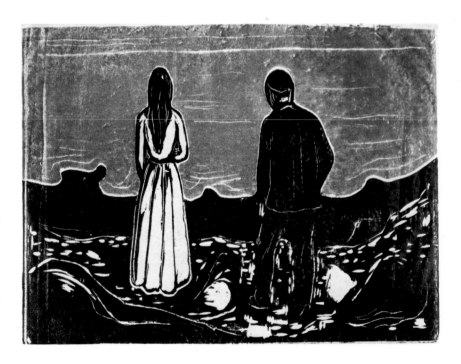

opposite left: 280. PAUL GAUGUIN.
Soyez Mystérieuses. 1890.
Painted wood relief. Collection
Mme Alban d'Andoque de Sériège,
Béziers, France.

opposite right: 281. UTAGAWA HIROSHIGE.
Storm on the Great Bridge. 1857.
Woodcut, $14^1/_2 \times 9^3/_8''$.
Philadelphia Museum of Art
(gift of Mrs. Anne Archbold).

right: 282. EDVARD MUNCH. *Two Beings.*
1899. Woodcut, $15 \times 21^3/_4''$.
Museum of Modern Art, New York
(Phylis B. Lambert Fund).

including Erich Heckel, Emil Nolde, and Wassily Kandinsky (Figs. 283–285) continued Gauguin's strongly organized, direct, and often spontaneous cutting of the wood block. The artists seemed to want the action of the knife and gouge to be recorded in the appearance of the finished impression. Instead of regarding the woodcut as a means for reproducing a previously conceived image, they used it as a primary expressive and esthetic medium.

above left: 283. ERICH HECKEL. *Man in Prayer.*
1919. Woodcut, 18⅝ × 13″.
National Gallery of Art, Washington, D.C.
(Rosenwald Collection).

above right: 284. EMIL NOLDE. *The Prophet.* 1912.
Woodcut, 12⅝ × 8⅞″. National Gallery of Art,
Washington, D.C. (Rosenwald Collection).

right: 285. WASSILY KANDINSKY.
Aus Klänge (From Sounds). 1913. Woodcut, 11 × 10¾″.
Museum of Modern Art, New York.

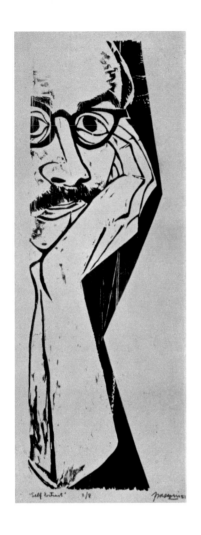

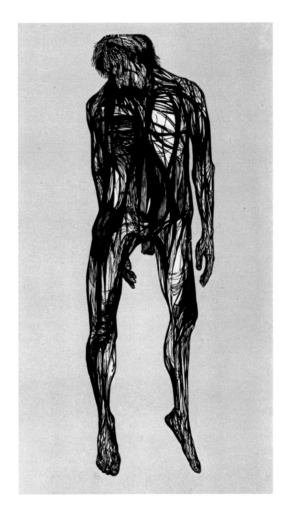

far left: 286. ANTONIO FRASCONI.
Self-portrait. 1951.
Woodcut, $21^7/_8 \times 6^5/_8''$.
Museum of Modern Art, New
York (Inter-American Fund).

left: 287. LEONARD BASKIN.
The Hanged Man. 1955.
Woodcut, $4'\ 7^1/_4'' \times 2'\ 6^1/_2''$.
Museum of Modern Art,
New York (gift of the artist).

Many contemporary woodcuts retain the technical and stylistic attitudes
of the early twentieth-century prints. Certainly Antonio Frasconi's *Self-portrait*
(Fig. 286) has the same feeling of direct and free use of the knife that is charac-
teristic of Expressionist prints. There is a similar contrast of strong, solid areas
against line. It is also possible to see a resemblance between Frasconi's print and
Japanese woodcuts (Pl. 42, p. 180; Fig. 281). The edges of forms have a precise
quality somewhat foreign to the Expressionists but quite consistent with the
way the forms were cut in Japan.

The sculptor and printmaker Leonard Baskin is another artist who follows
in the tradition of the German graphic artists. Baskin has published a great
many prints that combine an intricate linear complexity with dramatic areas
of solid black. His calligraphic rhythms have a stylistic quality that recalls the
Abstract Expressionist paintings of the recent past, and, like the paintings of this
period, the prints often are relatively large. *The Hanged Man* is nearly 5 feet high
(Fig. 287). Large prints have been made before; however, the scale of many

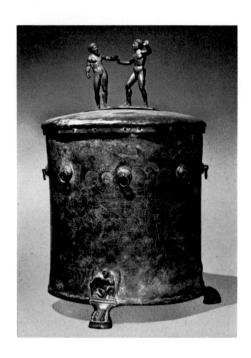

left: 288. Cista, from Palestrina, Italy, with figures of Trojan captives. c. 330 B.C. Engraved bronze, height 14¹/₂″. British Museum, London.

below: 289. Reliquary with scenes of the murder of St. Thomas à Becket. English. 1174–76. Silver, parcel-gilt, and niello, with ruby; 2¹/₄ × 2³/₄ × 1³/₄″. Metropolitan Museum of Art, New York (gift of J. Pierpont Morgan, 1917).

contemporary woodcuts indicates the current attitude of graphic artists to their medium. They seek to achieve art objects comparable to modern painting in both style and scale.

Today, there are multicolor woodcuts that match the intensity and subtlety of works of art produced by painters. Forms similar to those used in paintings are to be found in these prints. Large areas of color, some modulated, some flat, are juxtaposed. Instead of the complexity that derives from complicated cutting of the blocks, prints like those of Carol Summers have a sophistication and refinement based upon the number, the choice, and interaction of the color forms (Pl. 55, p. 245). Summers obtains additional variety by using a unique method of applying the ink to the paper, enabling him to vary the density of the ink film so that the color areas have changes in density. Hard and soft edges are given to the forms by careful use of the printing process.

Intaglio

Engraving, or cutting lines into soft metals with sharpened tools, was a frequent method of decorating bronze, silver, and gold. Skillfully engraved objects were made throughout the Mediterranean area thousands of years before the birth of Christ (Fig. 288).

By the fifteenth century the art of engraving was carried on expertly by many goldsmiths and silversmiths all over Europe. At this time, the atelier of a goldsmith was a center for the creation of a great many different art objects. Master craftsmen and their apprentices were prepared to manufacture, to order,

290. MASTER OF THE YEAR 1446.
Christ Crowned with Thorns. 1446.
Engraving. Kupferstichkabinett,
Staatliche Museen, Berlin.

gold and silver jewelry, goblets, plates, and other furnishings for the wealthy householder. They were also capable of producing paintings and sculpture, and, in fact, some of the most respected painters and sculptors of the early Renaissance, including Donatello (Figs. 317, 319–321), were first trained and later employed as goldsmiths.

The use of the engraving tool, the *burin,* was known to many excellent draftsmen. They were also familiar with a method of enhancing the engraved decoration of silver and gold with a material called "niello," a black paste filler that was forced into engraved lines to provide contrast against the uncut metal (Fig. 289). The effect was an attractive play of the reflective metal surface against the mat black line. Niello engravings were popular throughout Europe and could be found in many places before the twelfth century.

At times the artists who were cutting engraved images took impressions of their work in progress by filling the uncompleted graved lines with niello and then pressing the design on a sheet of paper. When the same economic and social conditions that encouraged the growth of the woodcut were felt by the goldsmiths, it was only a matter of time before they recognized that the metal engraving process used for decorating chalices and cups could be readily adapted to the production of multiple images with religious subject matter and the manufacture of playing cards. By the middle of the fifteenth century, engraving made its debut as a printmaking process.

The earliest date that can be assigned to an engraved print is the year 1446. Even at this early date the print had many of the qualities distinctive of all engravings (Fig. 290). It is essentially a fine-line image. Each line or dot

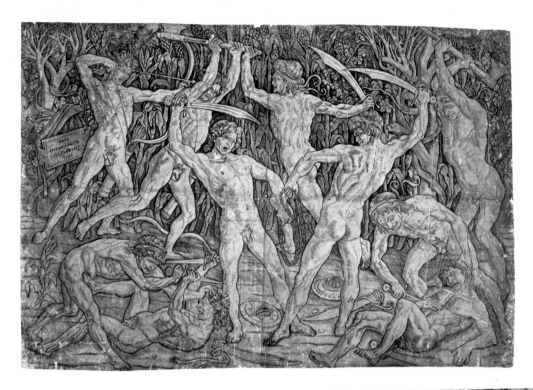

set down by the printmaker is the result of the cutting action of a sharp instrument that removes a thin portion of the surface of the plate.

In the woodcut, black lines are produced by cutting away the areas of wood around them, leaving a raised section to receive the ink. In the engraving, black lines are formed directly by cutting into the metal plate, much as a draftsman draws with a pen. After the lines are cut, the entire plate is covered with a viscous ink and then wiped clean with a nonabsorbent cloth. Excess ink is removed from the surface of the plate but allowed to remain in the cut lines, exactly as in niello decorations. When the plate is covered with paper and

subjected to pressure, the ink in the lines is transferred to the paper. This form of printmaking is called *intaglio,* from the Italian word that means "to engrave."

Because the painter and the goldsmith often had a common training and frequently were the same person, intaglio printmaking attracted some of the most skilled and talented artists in Europe. There was no need to depend upon the lesser abilities of woodcutters, who could spoil a fine drawing. Also, the relative ease with which an engraving could be made, as compared to the laborious cutting required for a woodcut intended to approximate a drawing, ensured the rapid acceptance of the engraving process for fine-line multiple images. Unlike woodcut, engraving was not so closely tied to the publication of books. Many fine books were produced with engraved illustrations, but the printing of type and blocks required one kind of press and engraving another, so the economics of publishing tended to favor woodcuts for inexpensive editions. Engraved pages were bound into books as separate frontispieces or single sheets when the detailed precision of engraving was needed to enhance an expensive volume. The modern industrial equivalent of intaglio is gravure printing, and it remains a special process, the one generally considered best suited to the reproduction of art works. The black-and-white illustrations in this book have been printed by gravure.

Single-sheet engravings were sold throughout Europe. One of the most celebrated of these is *The Battle of the Ten Nudes* by the Florentine artist Antonio Pollaiuolo (Fig. 291). Dated only two decades after the earliest known engraving, the print demonstrates the ease with which the medium was employed by Renaissance painters. The artist introduced modeling into the figures and shaded tonal areas into the background. Parallel lines, spaced closely together, create the tonal effects. They are lighter and thinner than the lines defining the contours of the figures. Deeper cutting on the contours ensured that those lines would hold more ink than the secondary parallels. When the ink was transferred to the paper during printing, there occurred a variation in the color of the line consistent with the differences in ink levels.

The Pollaiuolo print can demonstrate one of the technical problems of printmaking. The original drawing on the block or plate is a mirror image of the printed impression. For it to be legible once printed, lettering must be drawn backwards. To represent his men doing battle with their right hands (Fig. 291), Pollaiuolo had to draw left-handed swordsmen, as in the photographically reversed version of *The Battle of the Ten Nudes* in Figure 292. Many printmakers can work within the reverse-image process and conceptualize the final form of the print directly onto the master surface. Others prefer to check the progress of their drawing in a mirror as they proceed with it.

A variant of engraving is *drypoint.* Instead of removing the metal that is lifted from the grooves cut by the burin, the engraver uses a cutting action that forms a burr on one edge of the cut. This burr remains in place during the inking and printing process. As the ink is wiped from the plate, the burr catches some of it; and when the plate is impressed on paper, the trapped ink gives a soft, somewhat blurred appearance to the engraved lines (Fig. 293).

top: 293. REMBRANDT. *Goldweighers' Field.* 1651. Etching and drypoint, early impression; $4^3/_4 \times 12^7/_8''$. Pierpont Morgan Library, New York.

above: 294. Later impression from the plate reproduced in Figure 293. Metropolitan Museum of Art, New York (purchased 1945, Jacob H. Schiff Fund).

Eventually, if many impressions are made, the burr breaks off and the drypoint line comes to resemble that of an engraving. Comparison of early impressions of a drypoint and later ones reveals the change from a soft-edged image to one that is hard and precise (Fig. 294).

Iron armor and weapons were decorated in much the same way as workers in precious metals decorated their products, but the problem of cutting lines into iron was more difficult than that of engraving the softer silver and gold. Perhaps for this reason, toward the end of the fifteenth century, a method was devised for eating thin lines into iron by the application of acid. By the year 1515 Dürer had been able to etch iron printing plates. What is thought to be his first etching is reproduced in Figure 295. It is a curious and interesting print, composed of figural and landscape fragments that are confused in scale and spatial relationships. Each part appears to have been drawn with little

concern for consistency with the other components. This is just the kind of drawing that an artist might make while experimenting with a new medium.

Etching, like engraving, is an intaglio process. The major difference between them is the way in which the lines are sunk into the plate. In an etching the polished surface of a metal plate is covered with an acid-resistant coating (the "resist"), often consisting mainly of wax. When the coating is dry, a needle is used to draw upon it. Little pressure is required, for the etcher wants only to remove lines of resist, not to cut into the metal. Drawing upon the resist is easy, as compared to the pressure and control required to engrave metal. The artist is free to use his needle as he would a pen. Upon completion of the drawing, the plate is immersed in a "mordant," an acid that eats through the open lines in the resist to bite depressions in the plate. When the plate is taken from the acid and the resist removed, the plate is covered with ink-retaining grooves much like those in an engraving. Typically, an engraved line has an elastic form (Fig. 296); that is, the beginning of the stroke is thin, or tapered, and the line gradually thickens as the engraver increases the pressure on the burin; it tapers down to a thin line as the pressure is reduced before the burin is lifted from the plate. An etched line has blunt ends and a consistent width, for the needle does not vary the width of the strokes made in the resist (Fig. 296).

left: 295. ALBRECHT DÜRER. *The Desperate Man.* 1514–16. Etching. Albertina, Vienna.

296. *below:* Enlarged engraving line.
bottom: Enlarged etching line.

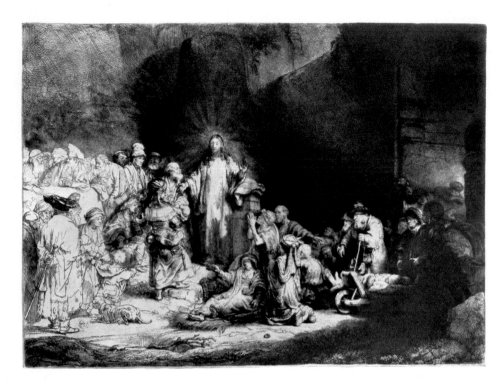

297. Rembrandt.
Christ Healing the Sick. c. 1649.
Etching, $10^7/_8 \times 15^1/_2''$.
Metropolitan Museum of Art,
New York
(H. O. Havemeyer Collection, 1929).

As in the case of engraving, darker lines are created by making deeper grooves that hold more ink, but in the etching this change in depth is controlled not by the pressure of the stroke on the plate but by the length of time the metal surface is subjected to the chemical bite of the acid bath. When the etcher wishes to keep some of his lines light, he can pull the plate out of the mordant, cover those lines with acid resist, and then return the plate to the bath so that the remaining lines may be etched more deeply to print darker.

The etching is printed by exactly the same procedure developed for engravings. Though iron plates were used for early etchings in some parts of Europe, they were quickly superseded by copper, which became the preferred metal for this medium. Current etching practice continues the use of copper, but aluminum and zinc are also frequently employed.

In the prints of Rembrandt van Rijn etching reached extraordinary levels of expressive and esthetic achievement. A great draftsman, Rembrandt was capable of drawing freely on the plate without sacrificing the control required for the creation of a convincing image. In addition, the concern for light that dominated his paintings was transferred to his prints. The dramatic use of dark, transparent areas in his etchings gave them a rich tonality and offered compositional devices not previously exploited in prints. In the etching *Christ Healing the Sick* (Fig. 297) the artist used an impressive variety of linear drawing techniques to convey a sense of light, form, and space. He also inked the plate in an unorthodox manner to enhance the spatial atmospheric effects. By wiping

the plate carefully, he was able to leave a thin coat of ink on some portions of the surface, while cleaning other areas to a high polish. When the plate was printed, the varying tonalities of wiped ink reinforced the etched tones, producing a range of values that could not be obtained with the etched line alone.

However, as a process for duplicating images, Rembrandt's method of inking was inefficient and inconsistent. To achieve a greater tonal range he had to sacrifice the capacity of the printing process for producing identical images, for every imprint of the plate required his unique form of inking and wiping; and it was impossible to standardize the tonal effects. Each print differed somewhat from every other proof in the series. Though he used a mechanical process, Rembrandt extended its potential to satisfy his own esthetic requirements, ignoring the economic advantages of large numbers of prints identically reproduced without further intervention of the artist in the duplication procedure.

At the same time that Rembrandt was using etching as a highly personal form of communication, others were employing it in a more orthodox, mechanical way. Jean Morin, working in France during approximately the same period, was one of many etchers who could make skilled reproductions of paintings on the plate. His portrait of Anne of Austria, after a painting by Philippe de Champaigne, is meticulously drawn (Fig. 298). A careful study of an enlarged detail of the print (Fig. 299) shows how the etcher used a combination of lines and dots to reproduce the tonalities of the painting. The cool,

controlled precision of the portrait is a remarkable demonstration of craftsmanship, but all evidence of the etcher as an individual is gone. Only the expert connoisseur of printmaking, studying the magnified marks of the etching needle, could assign the plate to a specific artist. In contrast, every mark on the plate made by Rembrandt is as personal as his signature. Morin's print is an example of a technical process in the service of an exceptional craftsman. In the Rembrandt etching there is evidence of the skill of the craftsman joined to the original invention and expressive needs of the artist.

Efforts to extend the capacity of intaglio plates to realize tonal variations without the use of linear cross-hatching were rewarded with two technical innovations. The first of these is *mezzotint*. In this process the printmaker first covers his plate with a texture created by rocking a multitoothed instrument, called a "hatcher," back and forth on the polished surface. From this comes a granular texture composed of thousands of small depressions. If this surface were inked, and printed, it would produce a deep, uniform blank, but the printmaker carefully scrapes and burnishes areas of the plate he wishes to lighten. The scraping operation reduces the depth of the depressions so that they will hold less ink and therefore print lighter. Gradually, the artist produces shallower ink-holding areas for lighter and lighter tones, until finally he polishes the portions that are to print white back to the original untouched state of the plate. When the process is completed, the plate is covered with a manually produced surface of minute depressions that vary in depth according to the tonality desired. The mezzotint plate can yield a velvety black that is unattainable through any other printmaking process, but the method is so laborious very few artists use it. Mezzotints were long employed almost exclusively to reproduce paintings (Fig. 300), but the rich and subtle tonal range of the

300. WILLIAM WARD.
The Daughters of Sir Thomas Frankland.
c. 1795. Mezzotint after a painting
by JOHN HOPPNER, $23^1/_4 \times 18^1/_4''$.
National Gallery of Art, Washington, D.C.
(Rosenwald Collection).

Plate 58. NICHOLAS KRUSHENICK. *Untitled.* 1965. Lithograph, 28³/₄ × 20⁵/₈″.
Pace Editions, Inc., New York.

Plate 59. JACK YOUNGERMAN. Composition from the suite *Changes*. 1970.
Serigraph, 43 × 33″. Pace Editions, Inc., New York.

above: 301. MARIO AVATI. *Nature Morte à la Danseuse.* 1962. Mezzotint, 11¹/₂″ square. Associated American Artists, Inc.

right: 302. BORTOLOMEU DOS SANTOS. *Figure in Space.* 1970. Aquatint. Courtesy Curwen Press, London.

medium has attracted a few artists who are prepared to expend the time and labor demanded to prepare the plates (Fig. 301).

A second method of producing intaglio tonal areas was developed in the last half of the eighteenth century, and it has remained as one of the basic techniques of the contemporary printmaker. Called *aquatint,* possibly because of its early use in imitating wash drawings, the process is relatively simple and quick (Fig. 302). The plate, often with an etched drawing already in place, is covered with an even dusting of powdered rosin. Heat is applied, and the rosin dust melts slightly, causing it to adhere to the metal. The plate is then immersed in acid. Those areas covered by the rosin are protected from the biting action of the mordant, but the spaces between the dust particles admit the acid and the plate is eaten. The length of time the acid works on the plate determines the depth of the bitten texture produced, and this in turn affects the value of the tones printed. To control the bite on areas intended to print as light tones, the plate is removed from the acid bath so that those areas can be covered with an acid-resistant coating. When the plate is returned to the acid, the biting continues except on the protected areas. Successive repetitions of the application of protective resist and re-etching finally result in a plate that can be printed with a variety of flat tonal masses incorporated into the composition.

Prior to the twentieth century the most successful use of aquatint is to be found in the prints of the Spanish painter and printmaker Francisco Goya (Fig. 303). His work is even more remarkable when one realizes that he adopted aquatint only a few years after it was first introduced. Often combining etched lines with the flat, granular areas of aquatint, Goya's prints remain the models for many contemporary graphic artists who employ the intaglio medium.

left: 303. FRANCISCO GOYA. *No Hay Quien Nos Desate?*, from *Los Caprichos.* 1796–99. Etching and aquatint, $7^5/_8 \times 5^1/_2$". Brooklyn Museum.

below: 304. ALEXANDER COZENS. Blot from *A New Method of Assisting the Invention in Drawing Original Compositions of Landscape,* 1785. Aquatint.
Beinecke Rare Book and Manuscript Library, Yale University, New Haven, Conn.

266

305. GABOR PETERDI. *Cathedral*. 1958.
Etching and engraving, $31\,^3/_4 \times 22\,^3/_8''$.
Courtesy Print Council of America,
New York.

One final variation on the aquatint is worth mentioning, for it is frequently used in contemporary prints. Called *lift-ground* aquatint or etching, it enables the artist to realize images that have the quality of freely brushed calligraphic drawings (Fig. 304). A rosin coating is applied to a polished plate, just as it is for the standard aquatint. After the plate has been heated, the printmaker paints his image on the rosin surface with a syrup of sugar and water. The dried painting is then covered with the usual acid-resistant coating. When this stage is complete, the dry plate is immersed in water. The portions of the resist that covered the syrup brush strokes are lifted from the plate as the water dissolves the sugar mixture underneath. As a result of this procedure, when the plate is put into the acid bath, those portions once covered with the syrup are exposed to the mordant, and those originally untouched by the artist's brush strokes are protected. When the plate is removed from the acid, inked, and printed, the image of the brushed composition on the paper has the quality of the broad calligraphy characteristic of brush and ink drawings.

As in the case of relief printing, the late nineteenth- and early twentieth-century advances in the technology of reproduction and printing left the intaglio methods for the production of multiple images to the artists, who found the processes attractive and compatible with their personal esthetic motivations. Today, some artists continue the traditional techniques in a relatively pure form (Fig. 305). Others have found that the engraving and etching methods

of the past can serve for the production of prints that satisfy contemporary compositional and expressive demands (Fig. 306). Still others have extended the limits of intaglio printmaking, combining processes and developing new image-forming techniques. *Yonkers II* (Fig. 307), by Romas Viesulas, works with the mixed media of deep etching and lithography. In addition, cut-out pieces of metal have been added to the plate to form embossed areas, and sections have been removed from the plate with power tools.

Lithography

About 1800, Alois Senefelder, searching for an economical way to print music and books, invented a process that quickly became the most popular method of reproducing pictorial images for newspapers and periodicals. The invention, called *lithography*, is still used today in a somewhat altered form. As *offset lithography*, or more properly *photo-offset lithography*, the process has widespread acceptance as a high-speed, high-quality form of industrial printing—the process employed for reproducing the color plates in this book. The original Senefelder technique, relatively unchanged, has continued to serve the needs

306. MAURICIO LASANSKY.
The Cardinal. 1964. Intaglio, $23^3/_8 \times 18''$.
Whitney Museum
of American Art, New York
(gift of Mrs. Derald H. Ruttenberg).

307. ROMAS VIESULAS.
Yonkers II. 1967.
Lithograph and intaglio,
$26 \times 39^{1}/_{4}''$. Brooklyn Museum.

of artists as it did throughout the nineteenth century. The attraction of lithography for the artist derives from its extraordinary flexibility. The medium can provide prints with the quality of spontaneous pencil or pen and ink drawings, but it is just as suitable for the production of large color prints comparable in size and esthetic subtlety to contemporary paintings.

Lithography is a planographic process; that is, unlike relief and intaglio prints, which depend on difference in the height of the inked and noninked surfaces of the master matrix, a lithograph printing surface is essentially flat. Senefelder took as his "plates" slabs of Bavarian limestone that were ground level on one side. The flat surface was grained so that it had a smooth, granular finish. Using wax crayons and special inks with a high fat content, he drew on the stone. As the crayons were pulled across the stone, they left microscopic pieces of wax on the separate grains of the surface. A thin, light line would touch only a few grains and deposit only small amounts of wax. A heavy line would leave a wider trail of grains that had been in contact with the drawing medium. In the application of large areas of tone, thousands of separate grains were touched by the crayon. Once he had completed the drawing, the artist then dampened the stone with water, and, by reason of the incompatibility of oil and water, those grains holding the wax would repel water and accept an oil-based ink, while those grains free of the crayon drawing would accept water and repel ink. In this way the drawing image, itself an original work from the artist's own hand, became the basis for printing an inked duplicate.

In both its commercial applications and its studio capability lithography satisfied the stylistic requirements of many artists. Toulouse-Lautrec designed large colored posters to advertise the night life of Paris, using lithography to

produce flat, simple areas and a quickly drawn, free line (Pl. 14, p. 83; Fig. 308). In the United States the firm of Currier & Ives printed lithographic posters for "six cents apiece wholesale." For them, carefully shaded drawings were made by anonymous draftsmen, and after the posters were printed in black and white, teams of young women tinted them with paint in assembly-line order (Fig. 309).

Edouard Manet was able to capture the fresh immediacy of a rapidly drawn sketch on stone (Fig. 310), and Edouard Vuillard used color, carefully arranged areas of drawn pattern and crayon texture, combined with calligraphy, to create lithographs (Pls. 56, 57, p. 246) with the pictorial and compositional character of his paintings.

Like all the printmaking media, contemporary lithography has taken its place as an important alternative to the other two-dimensional arts. Metal plates, as well as stone, are now used to print editions of lithographs that rival painting in their visual effects. Especially suitable to the printing of flat color fields, lithography offers the painter who uses color-form organizations a method for obtaining multiple images of the color effects he develops in his paintings (Pl. 58, p. 263). There are printmakers who take pleasure in creating textural and tonal qualities that can be achieved only with this medium. They tease and coax the stone to perform, allowing the image to form out of the process itself.

This attitude is not limited to artists working in lithography; it is to be found among those who work with intaglio prints too. For these artists the medium has become the subject, and printmaking a kind of search-research activity in which controlled experiment is joined with unexpected discovery (Fig. 311).

308. HENRI DE TOULOUSE-LAUTREC. *Jane Avril*. 1893. Color lithographic poster, 4' 1⁵/₈" × 3'¹/₈". Museum of Modern Art, New York (gift of A. Conger Goodyear).

above: 309. CURRIER & IVES.
Midnight Race on the Mississippi.
1860. Lithograph, $18^1/_8 \times 27^1/_8''$.
Museum of the City of New York
(Harry T. Peters Collection).

left: 310. EDOUARD MANET. *Les Courses.*
1864. Lithograph, $14^5/_8 \times 20^1/_2''$.
National Gallery of Art, Washington, D.C.
(Rosenwald Collection).

below: 311. DICK WRAY. *Untitled.* 1964.
Lithograph, $28^1/_4 \times 38^1/_8''$.
Museum of Modern Art, New York
(gift of Kliner Bell & Co.).

Silk Screen

The simplest, most recent, and popular printmaking process is *silk screen,* also called *screen printing* or *serigraphy.* This medium is an extension of the process of stenciling which has been used since the time of the cave men as a method for producing multiple images. Hands stenciled on the walls of caves in Spain are among the earliest images created by man (Fig. 312). In Japan, during the seventeenth and eighteenth centuries, intricate stencils, made of layers of laminated paper, were prepared for the printing of fabrics (Fig. 313). Strands of hair held the delicately cut interior designs securely in position and tied the center sections to the outer edges. Stencils were used by the Chinese as early as fifteen hundred years ago, and in Europe, from medieval times, they have had currency as a means of decorating walls and fabrics (Fig. 314).

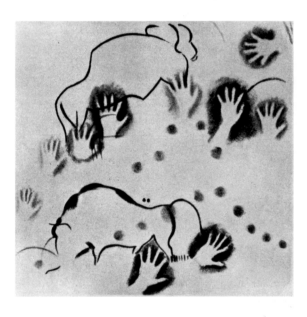

above left: 312. Hands stenciled in red (superimposed bison in yellow), from caves at Castillo, Spain. Prehistoric. Rendering by Fernand Windels, Montignac, Dordogne, France, 1952.

above right: 313. Japanese stencil used to decorate silk. Tokugawa Period, c. 1680–1750. Slater Memorial Museum, Norwich, Conn. (Vanderbilt Collection).

right: 314. "Domino" wallpaper. French, c. 1720. Printed from stencils and wood blocks. Cooper-Hewitt Museum of Decorative Arts and Design, Smithsonian Institution, New York.

Even the most complicated stencils are essentially the same as those made by primitive peoples. Openings are cut in a durable material, which is placed over the area meant to be printed. Paint, usually in a viscous form, is applied to the stencil with a stiff brush or cloth. Wherever the stencil has an opening the paint passes through. Areas that are covered by the stencil remain blank. By using several stencils in succession, registered so that their openings have a planned relationship to one another, and by forcing different colors through each stencil, the printmaker can fashion fairly complicated designs.

In silk-screen printing a gauzelike mesh of silk, nylon, or metal is stretched over an open frame. A stencil is adhered to the mesh. The printmaker uses a rubber-bladed tool called a "squeegee" to force thick, creamy ink or paint through the silk. When he lifts the screen, the image remaining on the ground appears in the form created by the open portion of the stencil. As in the case of other stencil prints, a number of screens can be employed to add colors to the print.

This process has been used commercially for years to produce signs, labels, and printed fabrics. In the 1930s printmakers began to work with silk screen in their studios. Their prints were called "serigraphs" to distinguish them from the products of the commercial silk-screen plants. The medium has many attractions for the printmaker. Perhaps the most important of these is the limited expenditure of funds needed to set up a print shop. No press is required; almost any flat table can serve as a suitable printing surface. Screens are easily made, and almost any kind of paint can be used for printing. In addition, it is possible to print a screened image on almost any material, and some contemporary painters have used screens for applying paint to portions or all of their paintings on canvas (Fig. 315).

315. ANDY WARHOL. *Marilyn Monroe Diptych.* 1962. Oil on canvas, 6'10" × 9'6". Collection Mr. and Mrs. Burton Tremaine, Meriden, Conn.

273

Serigraphs are most suitable for the production of large areas of flat color, and this explains further their adoption by many printmakers. Lithography can also be used to print oversize, solid color-forms, but it requires a skillful printer, large heavy stones or awkward plates, and a press capable of applying an enormous amount of pressure to a large surface. By comparison, a screen necessary to print an area 24 by 36 inches can be made for about ten dollars and operated by one man without too much difficulty (Pl. 59, p. 264).

The market for prints has expanded enormously in recent years, particularly for large contemporary prints. Prints are priced at many levels, and huge editions of screened prints, in the form of posters, are available in shops throughout the country (Fig. 316). In many instances it is difficult to distinguish between a mass-produced silk-screen poster and a small-edition serigraph by the same artist. The artist's signature on the "original" print ensures that the proof has been released by the printmaker himself, and for those who seek that cachet, the cost of the signed print is justified. But for the purchaser seeking an attractive addition to his wall, the inexpensive reproduction offers complete satisfaction.

We return again to the basic reason for printmaking, the production of multiple images. At the time Rembrandt published the print reproduced in Figure 297 he sold it for less than one guilder, the equivalent of four or five dollars today. Present prices for Rembrandt's prints reflect the law of scarcity in a market that includes individuals capable of spending large sums of money for things they wish to own. Given the multiple image-making capability that now exists, there is no technical, esthetic, or ethical reason that prints could not or should not be issued in huge editions available at moderate cost to all who want them. This is especially true of prints executed in large, simple forms and bright, clear colors. For the collector who finds his pleasure in prints that defy adequate reproduction in the high-speed commercial processes or for those who have a need to own a unique print that would probably not appeal to a mass market, there is no alternative but the signed impression that comes from a limited edition of hand-printed sheets.

316. ROBERT INDIANA. *Love.* 1966.
Silk-screen poster, 32 × 24″.
Poster Originals, Ltd., New York.

274

part **III**

THE LANGUAGE
AND VOCABULARY OF
THE VISUAL DIALOGUE
Three-dimensional Forms

chapter 9

SCULPTURE
The Plastic Elements

When a sculptor begins to work with a mass of clay in his studio, he initiates a process which may eventually result in the production of a work of art. The inert material is pulled and pushed into shape; pieces are added and removed; sculpture tools, hands, and fingers are used; and gradually the work approaches its final form. The forms are fixed; concavities, convexities, and open spaces all assume positions. Out of the soft, yielding, inanimate portion of earth a sculpture emerges. Shapelessness turns into ordered forms and spaces, chaos into meaning.

Rarely does the sculptor, painter, or writer build a work of art as a child would build a tower of blocks, by placing one block upon the other so that each section sits firmly on the section under it and supports the section above. Instead, motivated by an experience or by the desire to fashion an image or an object of unique character, the artist commences with a limited number of forms arranged in a configuration that approximates his conception. Then begins a period of trial-and-error during which the ultimate design and organization of the piece gradually grows. Subtleties and complexities of formal and spatial relationships, not previously planned, develop as the sculptor reacts to the process of parturition. Sometimes the original motive is considerably altered or even transformed in the shaping process. Finally, the work is complete; nothing more can be added or taken away that will increase the artist's satisfaction with the web of interrelated elements he has constructed.

For some image makers the developmental process takes place in a brief, intense period of time; for others the work is extended, requiring preparatory

studies and models; for still others, a very limited group, the process advances without deviation along a predetermined path from a minutely conceptualized idea to total realization. But no matter what differences exist in the procedure of individual artists, the result of their efforts depends upon the utilization of their chosen medium and the basic elements they can manipulate in that medium. Each art form has its own primary compositional units, or plastic elements, and these serve the painter, sculptor, and architect much as the syllable, word, sentence, and paragraph serve the writer.

Sculpture is a three-dimensional art form. It is possible for a sculptor to imitate quite precisely the forms of things he finds in nature. The sculptor Donatello,

left: 317. DONATELLO. *St. George.* c. 1417.
Marble, height 6′ 10¼″. Museo Nazionale, Florence.

below: 318. JOHN ROGERS. "*Wounded to the Rear,*"
One More Shot. American Civil War period.
Bronze, height 23½″. Metropolitan Museum of Art,
New York (Rogers Fund, 1917).

above left: 319.
Rear view of Figure 317.

above center: 320.
Right side of Figure 317.

above right: 321.
Left side of Figure 317.

who worked in Italy in the fifteenth century, appears to have approached sculpture in just this representational way. So does John Rogers, a nineteenth-century American. However, if we compare Donatello's *St. George* (Fig. 317) with Rogers' statuette entitled "*Wounded to the Rear*," *One More Shot* (Fig. 318), there are differences which obviously set them apart. Both statues represent human forms clothed in fabric; but if we study the *St. George*, there appears to be a concern for the disposition of the folds of cloth on the figure, which suggests that the sculptor wished to do more than imitate the appearance of a casual arrangement of the cloak. When seen from the back, the forms of the cloak in the *St. George* are simplified into a strong diagonal plane (Fig. 319); the folds are indicated with an emphasis that repeats the diagonal. Seen from the front or the side, this statue seems contained in a relatively simple contour edge. Notice the sweeping curve which begins at the statue's left shoulder, continues down the arm to the elbow and through the drape of the cloak, and is then picked up by the diagonal line formed by the edge of the shield and carried down to the base. The figure's right side has a similar contour, which moves in a quieter arc from shoulder to arm to shield (Fig. 320). A study of the statue from its left side (Fig. 321) reveals the form of the cloak used once again to provide

a simple, direct contour at the back, contrasting with a more active contour at the front edge, but even this complex movement seems to be unified into a strong diagonal.

Clearly, the arrangement of the forms in the *St. George* is based on a deliberate, conscious design. Donatello's main concern was the creation of a religious image, but he also wished to create an esthetic object.

The statuette by Rogers is also concerned with representation. It is fair to say that representation is the sole intention of the sculptor who produced this piece. The forms of the clothing appear to be determined by the artist's desire to imitate cloth arranged and folded in response to the posture of the bodies within the uniforms. One feels that the sculptor wished to isolate a moment in time. The naturalistic detail in figures and drapery serves to involve a viewer with the activity and condition of the subjects. It is possible to admire the careful observation of the artist and his skill at producing an accurate equivalent for a real-life scene, but the intent of the piece is limited by the medium the artist has used. A 23-inch bronze statue does not convey the scale and physical quality of the original subject. No degree of skill will convince even the most naïve that bronze has been transformed into flesh, hair, and cloth, and no effort on the part of the sculptor can ever really make us forget that the object produced by him is, in fact, a statuette. Rogers appears to have ignored this fact; Donatello did not.

Both Donatello and Rogers were limited in the way they could arrange the material which formed their sculptures. They may not have been fully cognizant of the limitations upon them, but the need for a relatively naturalistic form of representation restricted the disposition of the shapes, contours, and masses which, in total, comprise both pieces of sculpture. The human body has certain general characteristics of form which cannot be changed without suggesting grotesque distortion. There are proportions of head to body, of eye to head; there are positions natural to the torso, to the arms and legs; there are forms which are naturally concave, others which are convex. No sculptor may depart from these relationships and characteristic shapes, to any appreciable degree, and still maintain the integrity of a representational statue.

Within these limitations, however, there is a possibility for a great many arrangements that the artist may choose to exploit. Like the choreographer who directs his dancers to take certain poses, the sculptor may arrange the position of torso, head, limbs, and drapery in a great variety of ways. He may simplify or selectively emphasize certain forms. The surface of the sculpture may be treated to enrich the appearance of the material, even though this limits its imitative function. Bronze can be colored or polished; marble can be made satin smooth so that its hard, cold character is emphasized.

The *St. George* communicates to a viewer in several ways. It represents the figure of a young man in the costume of a warrior; it represents a religious symbol; and an observer may respond to the work on the basis of one or both of these equivalencies. But, in addition, the statue exists as a testament to itself. Donatello's sculpture, unlike that of Rogers, has been conceived as an ordered

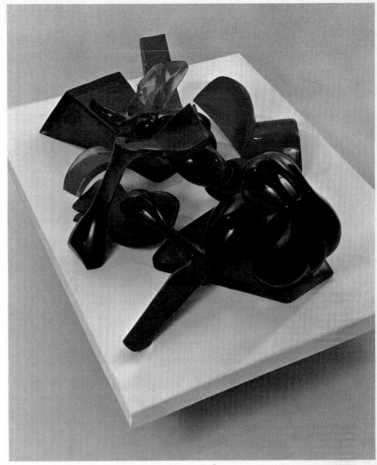

left: Plate 60. ALBERTO GIACOMETTI. *Man Pointing* (detail).
1947. Bronze, height 5′ 10¹/₂″.
Museum of Modern Art, New York
(gift of Mrs. John D. Rockefeller, III).

above: Plate 61. DAVID WEINRIB. *Polychrome No. I.* 1966.
Plastic, 18 × 36 × 36″.
Courtesy Royal Marks Gallery, New York.

281

above: Plate 62. *Virgin and Child.* c.1500. Polychromed wood,
height 10$^{1}/_{4}$″. Metropolitan Museum of Art, New York
(bequest of George Blumenthal, 1941).

right: Plate 63. GEORGE SUGARMAN. *C Change.* 1965.
Laminated wood, height 9′ 2″.
Collection Albert A. List, New York.

282

322. ELIE NADELMAN.
Standing Female Nude. c. 1909.
Bronze, height 21³/₄″.
Museum of Modern Art, New York
(Aristide Maillol Fund).

arrangement of planes and surfaces cut into stone, as well as a symbolic repre-
sentation. The differences between this sculpture and the original model who
posed for it are not deficiencies; they are positive factors contributing to the
impressive dignity the statue possesses, an affirmation of its presence as the
product of the mind and physical effort of its creator.

Should a sculptor decide that the esthetic relationships in his work will
be his primary concern, he is released from the necessity for arranging the
forms and spaces of his sculpture in a manner that approximates the forms and
spaces found in natural objects. He may place concave and convex contours
where he feels they will yield the most satisfying esthetic result. He may make
his forms angular or rounded; he may finish them to a smooth, light-reflecting
surface or leave rough surfaces still showing the marks of the tools used to
fashion them. If the sculptor feels that two forms should be separated by a
space, or that one should be placed above and to the right of another, he can
arrange them in that position. Often, a sculptor will base his work on natural
objects, using his subject as a point of departure for the statue but altering the
natural arrangement of forms and spaces so that they satisfy his esthetic sensi-
bilities. The nude by the American sculptor Elie Nadelman (Fig. 322) is an

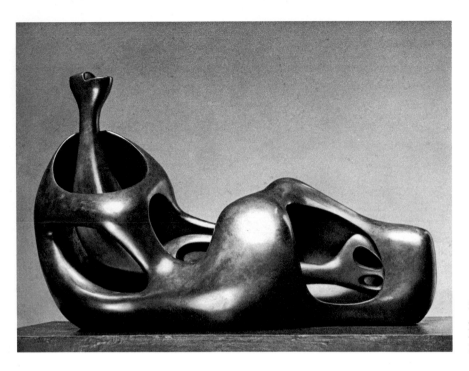

323. HENRY MOORE. *Reclining Figure, Internal-External Forms*. 1951. Bronze, length 21".
Museum of Fine Arts, Montreal.

example of just this kind of sculpture. If Nadelman's figure is compared with Donatello's *St. George,* Nadelman's greater concern for the esthetic relationships is obvious. Nadelman consciously treats the female figure as a group of simplified spherical forms. Each portion of the statue becomes a part of a flowing sequence of curvilinear masses and silhouetted edges. As a result of the emphasized rhythmic flow of edges and surfaces, the image of the nude figure is given an enhanced quality of grace and motion. In addition, the surface of the bronze has been burnished, creating a sensuous object that can offer tactile and visual pleasure to those who come in contact with it.

Henry Moore also took the female figure as the subject matter for his statue *Reclining Figure, Internal-External Forms* (Fig. 323). Concern for sheer esthetic relationships is even more obvious here than in the work by Nadelman, and, as a result, the naturalistic representational aspect of the statue is reduced. Moore shaped an enveloping hollow shell reminiscent of some of the forms to be found in the female figure. Within the space of the shell he placed another, more linear mass, which also derives from human forms. The outer shell is pierced by openings permitting the viewer to look into the somewhat mysterious inner recesses which contain the enfolded figure. The openings in the exterior affect the shape and the disposition of the solid parts of this envelope. Open spaces and solid forms are interrelated, each affecting the shape and placement of the other, and it is obvious that it is this organization of open and closed form, inner and outer space, which dominates the conception of this work, and not the demands of representation.

Form

The sculptor's intention, his original motivating conception, automatically limits the forms he will use. He may also be limited by a personal esthetic attraction to some forms rather than others. Whatever his basis for choice, he begins with masses shaped in some way. He may use or produce solid forms of varied sizes and configurations; they may be many or few; they may be clustered into dense, compact groups or separated from one another by open space. The decisions which affect the quality, the number, and the disposition of the forms are basic to the final appearance of the sculpture.

Though it is possible to discuss the forms in a single sculptural piece as separate and distinct entities, the isolation of the element of form is but a convenient device. Actually, the characteristics of forms used by an artist are also dependent upon the spaces left between them and the material used to produce them. Forms made of clay, which is opaque (Fig. 324), are very different from transparent forms produced in plastics or glass (Fig. 325); the form of a doughnut is affected by the shape and size of the space, the hole, in the center; and the reflection of light by the surface of certain forms can introduce visual effects that may appear to strengthen or diminish the scale and importance of the actual masses that would be perceived by touching the sculpture

below: 324. REUBEN NAKIAN. *Voyage to Crete.*
1949. Terra cotta, length 26″.
Collection Mr. and Mrs. Thomas B. Hess, New York.

right: 325. HARVEY LITTLETON. *Cut Blue.* 1969.
Copper-blue blown glass, 6 × 7 × 10″.
Courtesy Lee Nordness Galleries, New York.

326. MEDARDO ROSSO. *The Bookmaker.* 1894.
Wax over plaster, height 17¹/₂″.
Museum of Modern Art, New York.

with the eyes closed. Yet, with care and an awareness of the simplification involved, it is possible to focus attention on the rounded knoblike forms in Henry Moore's *Reclining Figure* (Fig. 323) and see them as significantly different from the rounded forms in the Nadelman nude (Fig. 322) and even more different from the forms to be found in *The Bookmaker* by Medardo Rosso (Fig. 326).

SCULPTURE AND SPACE

Space is an element that is difficult to illustrate unless an actual three-dimensional object is present. The following diagrams may be of some help. Figure 327 represents four thin cylinders standing upright upon a flat, square field. The cylinders vary in height, and the distances between them are irregular. The cylinders are the vertical forms in this three-dimensional arrangement.

Figure 328 represents an overhead view of the arrangement in Figure 327. The cylinder forms are seen as circles. Each one of these circles is at a measurable distance from every other circle and from the edges of the square on which they are placed, and each one forms an angle with any other two (see solid lines). These distances and angles describe the space between the forms. When this group of three-dimensional forms is seen from the side, as in Figure 327, it is possible to sense a spatial relationship between them which results from their

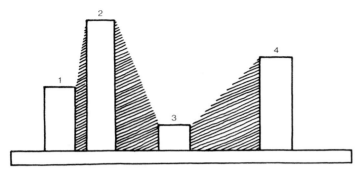

above: 327. Cylinders viewed from the south.

below: 328. Forms in Figure 327 viewed from above.

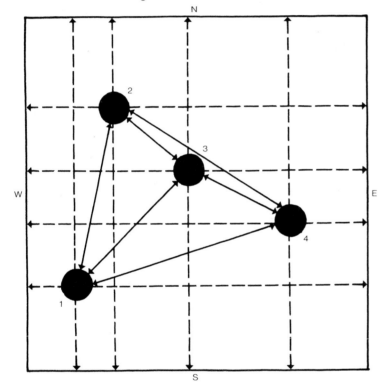

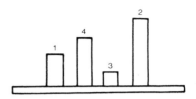

329. Forms in Figure 327 viewed from the east.

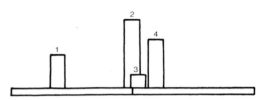

330. Forms in Figure 327
viewed from the southeast.

331. Forms in Figure 327
viewed from the east-northeast.

332. Forms in Figure 327
viewed from the southwest.

varying heights (see shaded area). The arrangement indicated in Figures 329–332 will give the observer a variety of *apparent* form-space relationships when he views them from different vantage points. Shifting the position of the forms can result in an infinite range of different spatial relationships.

When the forms used in a three-dimensional composition are more complex than simple cylinders, the variation in shape has a stronger effect on the shape of the space between them. This interaction of form and space can become very complex and highly interrelated. Imagine Emile-Antoine Bourdelle as he was working on the clay model for his bronze sculpture *Hercules*

(Figs. 333–334). The forms of the work are directly controlled by the forms and proportions of the human body, but had he raised the left arm a bit, the size and shape of the space between the body, the left leg, the arm, and the bow would have changed. Similarly, changes in the forms and the positions of the legs and in the forms of the rock would have altered the shape and size of the space bounded by these elements. The decisions Bourdelle made that resulted in this statue had to include those which affected the open spaces between the forms. In Henry Moore's composition (Fig. 323) the artist has integrated forms and spaces without the restrictions inherent in a representational work. As in the diagrams, the spatial organizations of the Bourdelle and the Moore pieces create different space shapes as a viewer changes the distance or the relative positions between himself and the sculpture.

When discussing sculpture we can consider space in still other ways. If Moore's bronze were covered with a plastic bubble conforming to the external shapes of the piece and then removed from the formed shell, the empty volumes within the plastic case would express the space actually filled by the physical structure that comprises the sculpture. But there is also a *presence*, a form of psychological energy, created by the art object that extends beyond its actual physical dimensions. This vitality can seem to appropriate some limited volume of space about the object, like a light that illuminates a dark void, most intense at the source of energy and gradually losing its effect as the radiation diminishes at the outer perimeter. The amount of space psychologically filled by a work of art differs with the size of the work, with its composition, and, of course, with its

impact on a viewer. Quite probably, the space energized by a particular art object will differ for individual viewers, but the effect does exist, and this does become a part of the plastic organization shaped by the sculptor.

TEXTURE, OR SURFACE

The *texture* or *surface* of the material used by the sculptor can be controlled and made to function as a significant element of his composition. The sculptor can create texture in his medium by working the material with tools, or by smoothing and polishing it. If the basic substance is soft, the act of pushing and pulling it into a final shape, the caress of the artist's hands, or the slash of his knife will produce tactile surfaces which must be subjected to a considered judgment before they are allowed to remain as part of the completed work.

The small figure by Medardo Rosso (Fig. 326) is made of wax. Rosso was interested in the play of light over his work. The artist found the soft, reflective surfaces of wax an ideal material for the luminous effects he wished to achieve, and he therefore developed a method of working wax around a plaster core. The surface of the wax figure retains the evidence of the way the material was manipulated with fingers and warm instruments. Hollows and built-up forms suggest surfaces collected from dripping candles as much as they do the image of a figure.

The Japanese-American sculptor Isamu Noguchi carved *Black Sun* from a block of granite (Fig. 335). Great physical effort was required to shape

opposite left: 333.
EMILE-ANTOINE BOURDELLE.
Hercules (The Archer). 1908–09.
Bronze; height 25″, length 17″.
Wadsworth Atheneum,
Hartford (Keney Fund).

opposite right: 334.
Rear view of Figure 333.

right: 335. ISAMU NOGUCHI.
Black Sun. 1960–63.
Black Tamba granite, diameter 30″.
Private collection, New York.

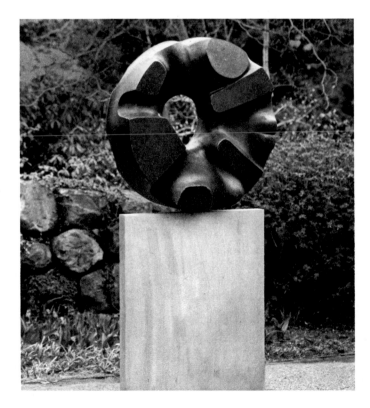

the hard stone from its rough state to the highly resolved forms and surfaces of the completed piece. The rich undulating skin of the granite was ground and polished after the sculptor had used cutting tools to arrive at the essential forms. This final surface treatment deepened the color of the granite, perfected the contours of the forms and gave them the appearance and feel of a firm, cool, sensuous material. The marks of the chisels were eliminated, and the reflections of light replaced them to become an important part of the image.

The dramatic juxtaposition of light and dark patterns on the ribbon of metal shaped by the Swiss sculptor Max Bill (Fig. 336) requires a careful polishing and buffing process that results in the elimination of surface irregularities common to most metals that have been worked into sculptural forms. The machinelike perfection of this surface enhances the curvature of the forms and, at the same time, creates the appearance of an object produced effortlessly by an extraordinary technological process.

Cubi XXIV (Fig. 337), by David Smith, is constructed of welded stainless steel. Had the steel been polished to a mirror finish, like Bill's warped surfaces, the light reflected from the surfaces would have emphasized the stark geometry of the construction. Instead, Smith ground the surfaces with an abrasive wheel to obtain a calligraphic light pattern that becomes a counterpoint to the severity of the geometric solids.

Every material employed by a sculptor has the potential for many surface treatments. Each method of shaping and finishing stone, wood, and metal leaves traces on the material, and the artist may decide to complete his work with the evidence of the shaping process clearly demonstrated in the marks made by tools and hand. He may prefer to alter the surface by procedures that file, grind, polish, or color the basic element. It is even possible that the artist may cover the sculpture with a surface that hides the quality of the primary material. In every instance the tactile and visual surface characteristics of a sculptural object will affect the response to it, and the artist must consider them a variable factor in the image he wishes to produce.

LINEAR ELEMENTS IN SCULPTURE

Another basic constituent of sculpture is *line*. When applied to the work of the sculptor, "line" can have a number of meanings. It can mean an incised line, a mark scribed into the surface of a form, much as a line is drawn by a pencil on a sheet of paper (Fig. 338), but it is also possible to consider line as part of the element of form. When the edge of a form is seen in silhouette, its shape may function as a linear element, so that one might speak of the curved line produced by the form of the thigh in the figure by Elie Nadelman (Fig. 322). Then, too, when a form has a sharp edge, that edge may be regarded as a linear element. The head by Brancusi has a curved form derived from the eyelashes of the subject (Fig. 95). This form comes to a hard, sharp, curved edge. Its lower surface is in shadow, while the upper plane reflects the light. The edge produced by the change in plane is linear, and it repeats similar linear elements in the

left: 336. MAX BILL.
Monoangulated Surface in Space.
1959. Gilded brass, $15 \times 18 \times 26''$.
Detroit Institute of Arts
(gift of W. Hawkins Terry).

left: 337. DAVID SMITH. *Cubi XXIV*. 1964.
Stainless steel, height 10′.
Museum of Art, Carnegie Institute, Pittsburgh
(Howard Heinz Endowment Purchase Fund).

above: 338. GIACOMO MANZÙ.
Death on the Earth, study for *Doors of Death,*
Basilica of St. Peter's, Rome.
1963. Bronze, $37 \times 23^{1}/_{2}''$.
Courtesy Paul Rosenberg & Co., New York.

above: 339. Naum Gabo. *Linear Construction.* 1942–43.
Plastic with nylon string, height 24¹/₄″.
Phillips Collection, Washington, D.C.

right: 340. Richard Lippold. *Variation Number 7:*
Full Moon. 1940–50. Brass rods, nickel chromium,
and stainless-steel wire; height 10′.
Museum of Modern Art, New York.

work resulting from other modulations in planes, as well as the obvious curved silhouette of the entire piece.

The sculptor can also treat thin strands of wire or string as line in space, reflecting light, connecting forms to suggest tensions between them (Fig. 339), or seeming to float as if light were suspended in an extraordinarily controlled pattern (Fig. 340).

COLOR IN SCULPTURE

In three-dimensional art, form and space are closely related; a change in one will produce a change in the other. To a somewhat lesser degree there is an interdependence between surface and *color* in sculpture. As noted in the comments on the granite carving by Isamu Noguchi (Fig. 335), the polished surface of a material such as stone has a marked difference in color from a rougher surface of the same material. If a sculptor is working in black granite, he

341. FRANK GALLO. *Bikini Girl.*
1964. Polyester resin, height 36″.
Courtesy Graham Gallery, New York.

cannot produce a deep, dark color in his work unless he polishes the surface to a high finish. Similarly, the surface reflections on Max Bill's sculpture (Fig. 336), which become a part of the color of his work, are directly dependent upon polishing.

Many sculptural materials have natural colors that become an integral part of a piece produced in that material. A sculptor may choose a certain material primarily because of the forms he wishes to realize from it and thus be required to accept the color natural to the substance. If the artist acknowledges this limitation, he may find it necessary to accommodate his design to the color available to him. However, many materials can be made, through appropriate treatment, to yield or vary color effects. The surface of the bronze by Alberto Giacometti (Pl. 60, p. 281) has been given a dark *patina;* that is, it has been heated and treated with chemicals to darken it permanently. Similarly, stains and waxes can be applied to wood to deepen or alter the natural coloration.

The recent use of acrylic resins as a material for fabricating and casting sculpture has enlarged the possibilities for polychromed work in which the color is an integral part of the material. Resins can be mixed with dyes to create transparent, highly colored forms like those in David Weinrib's *Polychrome No. 1* (Pl. 61, p. 281). Other methods of treating these plastics produce opaque and dense surfaces like those in Frank Gallo's *Bikini Girl* (Fig. 341).

Painted sculpture has well-established historical precedents. The late-Gothic *Virgin and Child* (Pl. 62, p. 282) is a wood carving whose forms have been

left: 342. JOHN CLAGUE.
Overture in Black and White. c. 1964.
Fiber glass and steel, 4′ 8″ × 5′ 8″ × 3′ 6″.
Courtesy Grippi and Waddell Gallery,
New York.

below left and right: 343.
HOWARD JONES. *Skylight Two*
(two stages). 1966. Aluminum
with programmed lights, 4′ square.
Minneapolis Institute of Art
(gift of Mr. and Mrs. Bruce B. Dayton).

colored to approximate the appearance of flesh and cloth. Paint can also be
used to isolate areas on a three-dimensional object for increased decorative
effects. George Sugarman employs bright color to paint the sections of his lami-
nated wood constructions. The color is the means of isolating each part of the
work, with the result that in shape and color the individual segments are joined
in a progression of contrasts (Pl. 63, p. 282). John Clague painted his *Overture*

in Black and White (Fig. 342) so that the pigmented areas actually appear to contradict the three-dimensional forms on which they were applied.

As noted above, some coloristic effects result from light reflecting on the surface of sculpture; still others are created by the use of transparent materials that tint the light that passes through the forms of the piece (Pl. 64, p. 315). Several contemporary sculptors are constructing works that include artificial light. Howard Jones, who was trained as a painter, has for a number of years been working with electric light as a form and color medium. The individual sources of illumination in his constructions can be varied in color and in the forms they produce. Their design permits them to glow or remain dark in a predetermined or random sequence. His *Skylight Two* (Fig. 343) has concentric rings of small bulbs wired into six circuits that are timed to flash on and off. The effect is one of a random distribution of forms and colors constantly changing in what appears to be an unlimited set of variations.

Glass tubes filled with gases that emit colored light when energized with electric current have been used for years by manufacturers of signs. These tubes can be placed in front of or within constructed forms to introduce light and kinetic effects that offer an additional visual vocabulary to the more traditional form-space-color elements employed by artists who are working in three dimensions.

Stephen Antonakos' construction of neon tubes (Pl. 65, p. 315) uses the thin, linear forms of the glass to compose an airy, disarmingly simple work in architectural scale. The energy concentrated in the tubes of brilliant blue and orange light causes the adjacent planes of the wall and floor to glow, simultaneously providing the illusion that the force of gravity has been temporarily suspended.

The use of electric light and the kinetic possibilities that exist in circuits permitting sequential illumination of light sources have been seen in eye-catching signs and theater marquees for many years. Sculptors have just begun to investigate this technology for purely esthetic purposes, and the present use of these visual elements has much in common with the earlier applications in advertising design. Even though the economics of light constructions tends to limit experimentation in the field, it is probable that the use of artificial light in sculpture will increase and become more complex and subtle as artists learn to manipulate it.

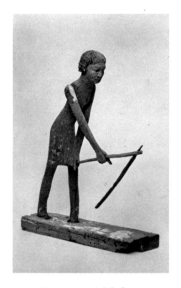

344. *Ploughman at Work.*
Egyptian, 6th Dynasty,
2100 B.C. Wood, height 9³/₄″.
Metropolitan Museum of Art,
New York (Rogers Fund, 1926).

MOVEMENT: FORM, SPACE, AND TIME

Walking around a piece of sculpture, the observer sees the work's forms and spaces in changing relationships. The movement of the viewer introduces a kinetic variation into his experience of the object. The idea of producing actual movement in three-dimensional objects has intrigued artists for centuries. Some ancient Egyptian statuettes have articulated elements (Fig. 344). Arms, eyes, mouth, and head were made to move in three-dimensional representations, probably as a way of increasing the lifelike character of the subjects.

Other examples are to be found in the art of the Greeks and Romans. Moving elements are also present in the ritual masks of indigenous native cultures throughout the world.

The development of clockwork mechanisms that activated portions of sculpture invested toys and objects of art, in both the East and the West, with entertaining and sometimes magical qualities. Often, these moving statues were highly sophisticated in form and movement. New York's Metropolitan Museum has in its collection a statuette of Diana mounted on a stag that is automated to rear on its hind legs (Fig. 345). Several animals are placed beneath the leaping stag, including two dogs with heads that move when activated by the same small mechanisms that power the figures above them.

More recent examples of movement in sculpture are works by Alexander Calder, an artist who pioneered the development of *mobile sculpture* (Fig. 346). A mobile is a construction in which portions of the piece are connected by articulated joints. This structural device enables the parts to move, changing their positions relative to the other parts in the composition. Through the use of motors or the action of the wind, mobile elements can be made to flutter, wave, undulate, or spin in small and great arcs. Calder remains one of the foremost exponents of sculptural constructions that are designed to move. For him the joints of his constructions are as important as the forms, for the joints control the kind of movement that will occur when the connected elements are activated. As can be seen from the stroboscopic photograph of a Calder mobile (Fig. 347), the movement produces a pattern in space, and this pattern is directly related to the way in which the parts are connected.

Early in his experiments with an art of movement Calder used electric motors to provide the motion in his sculpture. He abandoned them because he felt that the movements generated by motors were too predictable and preferred the unexpected and random motion provided by air currents. In the late 1950s and the 1960s a number of sculptors became interested in the possibilities of

345. JOACHIM FRIESS.
Diana the Huntress. Augsburg,
early 17th century.
Silver, silver-gilt, and jewels; height 14³/₄″.
Metropolitan Museum of Art, New York
(gift of J. Pierpont Morgan, 1917).

motorized constructions. Their work, along with mobiles like those of Calder, have been brought together under the general category of *kinetic art*.

The esthetic and expressive potential in kinetic art ranges from the assemblages of Jean Tinguely, rather crudely joined machines made from the material available in junk yards, to the exquisitely crafted constructions of Pol Bury. Tinguely's machines move like insane or drunken robots, shaking, creaking, sometimes singing with the voice of a pretuned radio, sometimes erupting in a frenetic dance of self-destruction (Fig. 348). To a casual observer

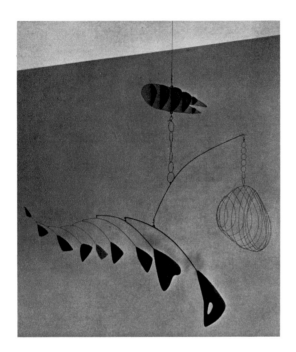

left: 346. ALEXANDER CALDER. *Lobster Trap and Fish Tail.* 1939. Steel wire and sheet aluminum, c. $8^1/_2 \times 9^1/_2''$. Museum of Modern Art, New York (gift of the Advisory Committee).

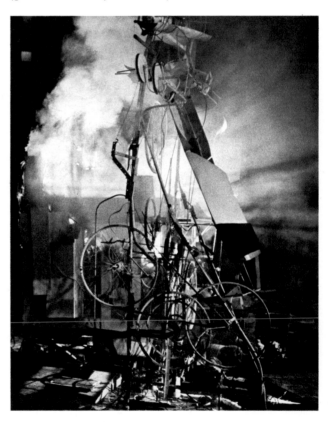

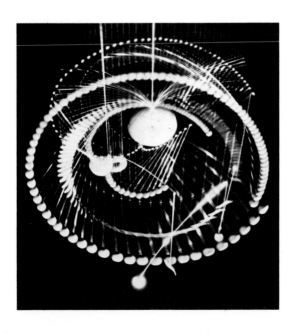

left: 347. Stroboscopic photograph. ALEXANDER CALDER. *Hanging Mobile* (in motion). Aluminum and steel wire, width c. 28″. Collection Mrs. Meric Callery, New York.

above: 348. JEAN TINGUELY. *Homage to New York: A Self-constructing and Self-destroying Work of Art.* 1960. Assemblage of piano, machine parts, bicycle parts, weather balloon, fireworks, etc.

Sculpture : The Plastic Elements 297

349. POL BURY. *Thirty-one Rods
Each with a Ball.* 1964.
Motorized construction of wood, cork,
and nylon wire; height c. 40″.
Museum of Modern Art, New York.
(Elizabeth Bliss Parkinson Fund).

Bury's geometric compositions appear interesting but static. Unexpectedly, parts begin to quiver, vibrate, or slowly shift position in a manner which causes the viewer to doubt that he did, in fact, see movement (Fig. 349).

Time is a major factor in the organization of art objects that incorporate moving elements or systems of changing light patterns. Like a composer of music, the visual artist who conceives of his work as a series of shifting compositions thinks in terms of the relationships that can exist between an arrangement of form and color elements at one moment in time and other arrangements that occur before or after it. The esthetic content of a temporal composition depends upon the sequential system in which events occur. For some artists this sequence is carefully planned. Mechanical or electronic devices are designed or programmed according to a specific scheme. Stages in the series may be arranged to reinforce one another, maintaining a harmonious continuity, or used as contrasting variations; fast movements may be succeeded by slow and deliberate ones, large areas of color will perhaps anticipate or follow fragmented, short-duration explosions of smaller, intense patterns of color spots.

A growing number of artists who work with time as a prime element in the structure of their compositions have deliberately replaced the conscious selection of variations in a fixed order with mechanisms that allow some degree of randomness to enter the organization of events. They do not control the sequence of changes. Instead, they assemble the components capable of producing visual or kinesthetic effects, start the process, then step back to observe the interaction of accidental, unprogrammed phenomena. Because he has

determined the initial decisions on the nature and number of the components combined in the system, the artist has some measure of control and responsibility. He may bring a considerable degree of knowledge and past experience to this decision-making process. He may anticipate many of the relationships that potentially exist in the system, but he cannot conceive of them all. He assumes that the system will bring forth unexpected effects, initiating unpredictable responses in himself and others who witness them.

If the number of events occurring simultaneously is large, many of them may not be perceived by the observers. Each viewer will apprehend only a few of the relationships created by the moving elements in the composition, and, most probably, the perceptions of one observer will not be identical with those of any other. However, even though the series of form and color changes is relatively unplanned, many viewers will find an order in the experience. They will tend to make perceptual, esthetic, intellectual, and emotional connections among the events they perceive, introducing their own personal characteristics into the totality of the experience. Each individual, including the artist who initiated the program, will impose his own order on the experience he is having and on his recollection of it when the activity has stopped.

In many ways, art forms that depend upon a time sequence of random events reflect the human experience of quotidian living. Each person exists within a more or less structured, ordered time system. For some individuals almost every activity in each day is predetermined. Waking, dressing, eating, going to work, the routine of the job, the return home, and the habitual close of the day are all laid out. Yet, in a highly routinized life, unexpected and unpredictable events occur, frequently causing individuals to seek logical associations between the lives they lead and the unanticipated experience. Even those whose lives seem free and in a continual state of flux find in the chance encounter a certain meaning as it relates to the events that preceded it.

Some artists with an interest in sequential systems of sense-stimulating events have expanded their original concern with visually perceived phenomena to include tactile and aural experience. They have created physical environments that stimulate those who enter them in surprising and often disquieting ways. Projected images, changing colors and textures, variations in spatial effects are exploited to create an ambience that requires a visitor to respond to events for which he has not been previously prepared. He is not looking at an organization of changing plastic elements; he is within it, a participant, rather than an observer.

Many of these environmental constructions are carefully designed and programmed; others combine planned events with random effects, chance combinations of moving forms, colors, representational images, and sounds. Human participants may be added to the optical and mechanical inputs; dancers, actors, even unprepared members of the audience can become part of the totality of the involvement.

These *happenings* are difficult to place in a clearly definable category of art, for they are, in fact, a hybrid, crossing over and joining the visual arts of

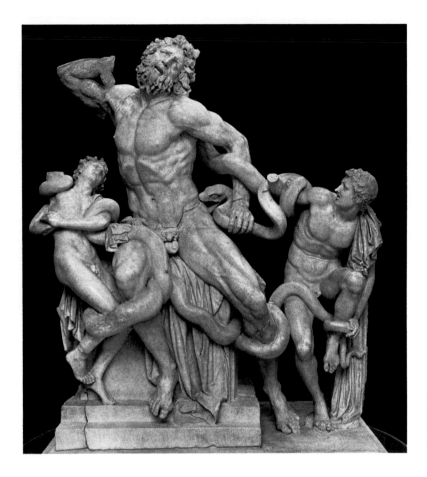

350. AGESANDER, ATHENODORUS, and POLYDORUS. *The Laocoön Group.* Roman copy of a Greek original of c. 50 B.C. Marble, height 7′ 11¹/₄″. Vatican Museums, Rome.

painting, sculpture, and architecture to the arts of dance and theater. It is even more difficult to illustrate them with still photographs or drawings and diagrams, because their esthetic effect is dependent upon the interrelationships that are perceived between sequential or simultaneous events. Each participant responds in his own way to the sensory stimulation that he isolates from the matrix of the total experience.

Interest in this participatory art form has grown in the past few years, and it is possible that many artists will find the problems and potentials in these complex esthetic undertakings sufficiently inviting and rewarding to strengthen the sometimes tenuous relationship between theater and the visual arts and develop a new medium that will offer to those with a sense of involvement new opportunities for an intensified and broadened esthetic dialogue.

THE SCULPTOR AND HIS MATERIALS

The plastic elements in all the visual arts, but particularly in sculpture, are intimately tied to the material employed in the construction of the work. When

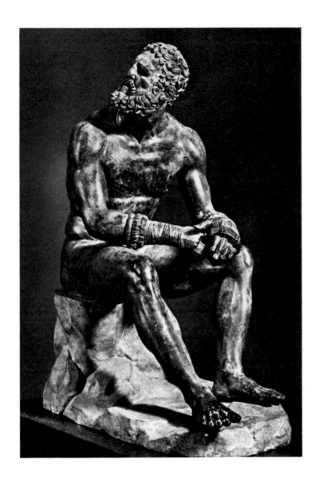

351. *Boxer*. c. 50 B.C.
Bronze, height 4′ 2″.
Museo Nazionale
delle Terme, Rome.

the artist takes clay, plaster, or wax as his working material, he often intends the final stage to be completed by casting the original model in some more permanent substance. He designs the forms, spatial organization, and surfaces with the anticipation that the ultimate realization will take form in bronze, brass, perhaps concrete, or yet some other material. When he uses stone, wood, or welded metals, he can work directly to the completed piece, without a preliminary step. In this case, the strength of the material, its ductility, hardness, grain, and the surface qualities that can be given it are necessary considerations in choosing the medium.

Some examples of sculpture seem to be unrelated to the substance they are fashioned from as a basic compositional element in their organization. Greek sculpture of the first century B.C. differs little, whether it was carved in marble or cast in bronze. Compare *The Laocoön Group* (Fig. 350) with the *Boxer* (Fig. 351). There is no major stylistic difference between these two statues, though the former is a marble piece and the latter bronze. A similar lack of concern for the qualities of material, as an influence on composition, is to be found in the Renaissance. A comparison of three statues by Donatello—the

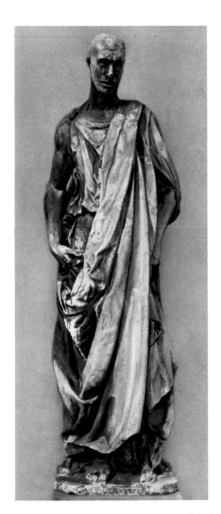
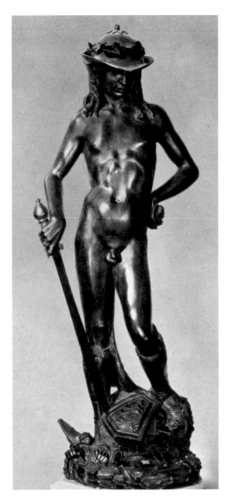
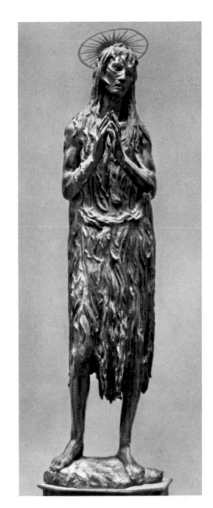

left: 352. DONATELLO. *Habakkuk* (called "*Zuccone*"). 1423–25.
Marble, height 6′ 5″. Museo dell'Opera del Duomo, Florence.

center: 353. DONATELLO. *David.* c. 1430–32.
Bronze, height 5′ 2¹⁄₄″. Museo Nazionale, Florence.

right: 354. DONATELLO. *St. Mary Magdalene.* 1454–55.
Wood, height 6′. Baptistery, Florence.

so-called *Zuccone*, the *David*, and the *St. Mary Magdalene*—suggests the similarity in this artist's approach to sculpture in marble, bronze, and wood (Figs. 352–354).

About the beginning of the twentieth century sculptors trained in the traditions that stemmed from the Renaissance became aware of the existence of a body of sculpture that did not conform to the esthetic canons of European art. Wooden and bronze pieces from Africa (Fig. 355), stone carvings of the pre-Columbian cultures of South and Central America (Fig. 356), the sculpture of

the Far East and India (Fig. 369) gave the twentieth-century artist an expanded vision of the nature of sculpture. The simple and direct way in which many materials were developed in these non-European arts suggested that there was a vitality and expressive quality to be found in each medium available to the sculptor. The wooden masks of the Bamenda of the British Cameroons derived their forms in large part from woodworking methods (Fig. 357). The hardness

below: 355. Bakota funerary figure, from Gabon.
19th century(?). Wood, copper, and brass; height 21¹/₂″.
Museum of Primitive Art, New York.

right: 356. Maya-Toltec head of the god Tlaloc,
from Yucatán. Pre-Columbian, 10th–11th century.
Stone, height 13³/₄″. Museum of Primitive Art, New York.

below right: 357. Bamenda mask, from British Cameroons.
Late 19th–early 20th century. Wood, height 26¹/₂″.
Rietberg Museum, Zurich (Von der Heydt Collection).

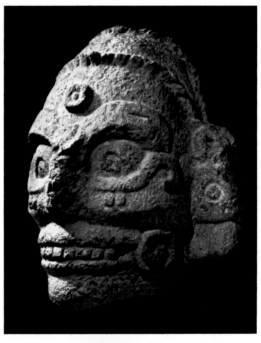

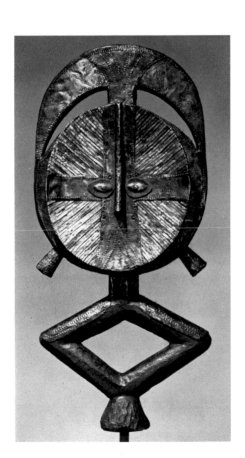

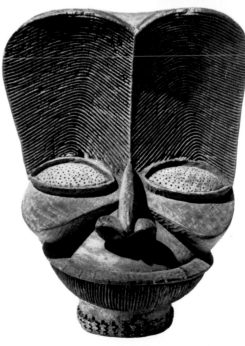

of stone and a limited ability to cut it gave the figures of the Mayans from Chichén-Itzá a monumental simplicity (Fig. 358). The inscribed designs on the bronzes of the Chou period in China provided new insights into the possibilities of this long-used material (Fig. 359).

Artists and critics were stimulated by this tradition-shattering art to see positive values also in periods of Western sculpture which had long been neglected because the work of these eras did not fit the criteria inherited from the Renaissance. Egyptian sculpture (Fig. 360), Cycladic statuettes (Fig. 366), the sculpture produced by the Greeks prior to the fifth century B.C. (Fig. 361),

below: 358. Toltec rain god Chac-mool, from Chichén-Itzá, Mexico. Pre-Columbian, 10th–11th century. Stone, 3′ 5¹/₂″ × 4′ 10¹/₄″. National Museum, Mexico City.

right: 359. Chinese covered food vessel. Chou Dynasty, 1115–1077 B.C. Bronze, height 21¹/₄″. Metropolitan Museum of Art, New York (gift of J. Pierpont Morgan, 1917).

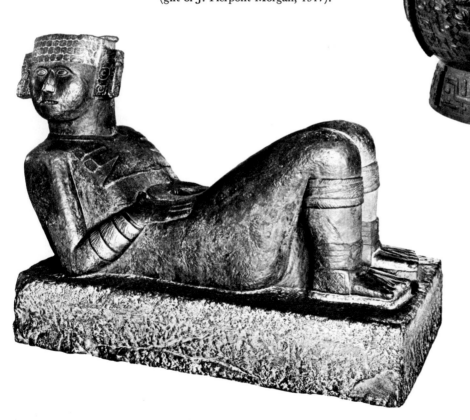

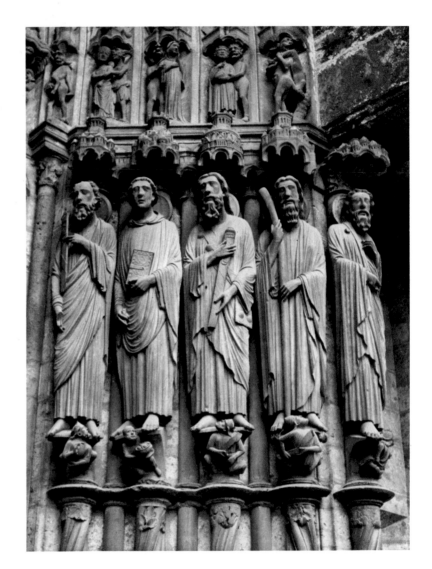

above: 362. Etruscan fighting warrior.
7th–6th century B.C. Bronze, height 6′⅝″.
Metropolitan Museum of Art, New York
(purchased by subscription, 1896).

right: 363. *St. James the Greater,*
St. James the Lesser, St. Bartholomew,
St. Paul, and *St. John,* on the south portal
of Chartres Cathedral. Stone, height 7′ 10″.

as well as the work of the Etruscans (Fig. 362) and of Romanesque and early
Gothic sculptors (Fig. 363) took on a new importance in the twentieth century.

Today, much of the esthetic concern in sculpture is directly related to the
materials employed by the artist and the way in which he works them; but the
sculptor may react to a material even before he begins to use it, intrigued by its
inherent formal and expressive potential.

It is possible to discuss Hans Haake's *Condensation Box* (Fig. 364), which is
closely involved with the materials adopted, in terms of the plastic elements.

364. HANS HAAKE.
Condensation Box. 1965–67.
Plexiglas and water,
30″ cube. Courtesy
Howard Wise Gallery, New York

The clear cube that is basic to Haake's construction has measurable dimensions and a surface which can be described by its tactile and visual qualities, but the work's essential character does not emerge from these static features. Sealed within the cube, water is acted upon by the natural forces of vaporization and condensation as the exterior temperature rises or falls. A continuous process takes place, causing beads of moisture to form on the interior surfaces of the planes. As Haake conceived of this piece, he could limit the size of the interior space enclosed by the six sides, he could regulate the water content sealed inside the controlled environment, and he could predict that the water would successively vaporize and condense within that environment; but he could not control the appearance of the globules or runs of water that would form on the surfaces. His knowledge of the material he chose to use and the process he initiated was basic to his conception, as basic as the organization of plastic elements to another sculptor. The material and the process were the elements he organized; and though many writers on the visual arts do not consider Haake's materials as plastic elements, such recent activities as the happenings have dramatized the importance of such unfamiliar media.

An artist like Haake may conceptualize to some extent the way in which a material or process will act under certain conditions, knowing that he cannot have it totally under his control. Some element of chance will operate as the material acts in accordance with the physical characteristics natural to it. When Robert Morris cut the limp felt fabric comprising the composition in

365. ROBERT MORRIS. *Untitled.* 1968.
Wool felt, 9' 6" × 12'.
Walker Art Center, Minneapolis.

Figure 365 he could assume that, hanging from a wall, it would form a group of reverse arches with certain twisted configurations, but he could not know exactly what those open and closed areas would finally look like.

The work of Haake and Morris is clearly dependent upon the conceived potential in the material they selected. This involvement with the anticipated behavior of the substance is similar to the attitude of the sculptor who carves wood and stone. The experienced carver knows that oak is hard, that elm twists, that alabaster is transparent. He understands these physical characteristics when he begins to cut into the raw block or log.

To the degree that it forces the composition into certain forms and surfaces, to the extent that certain spatial organizations are limited or facilitated by its very substance, the material must be regarded as a basic element that concerns the artist prior to and during the creation of his work.

These elements—form, space, texture, line, color, movement, and material—are the principal preoccupation of the sculptor as he works. He thinks in terms of these components. If he is working on a portrait bust which is to approximate the physical forms of his model, he must think, "How shall I form the clay to construct an equivalent for the physical shape and the nonphysical personality of my sitter?" Or, carving a large piece of wood, he may ask, "What forms, what spaces will best utilize the living pattern of grain? Shall I leave the marks of the chisel, or will polishing the wood to a rich luster enhance its appearance?" Decisions such as these are part of the creative process. They are made continually during the progress of the work, and in total they are the work.

chapter 10

SCULPTURE
Representation
and Esthetic Organization

Because he works in three dimensions, the sculptor can, if he wishes, produce an exact replica of the forms and spaces in natural objects. Yet this imitative potential rarely satisfies him, for though natural forms share their three-dimensionality with sculpture, the differences between a statue and its subject require a sculptor to develop representational equivalents that often seem far removed from the physical appearance of animals and human beings.

What differences do exist between a human being and a careful duplication of the forms of that human being in a sculptural form? The most obvious difference would be found in the potential of the human body for movement and the static nature of the sculpture. Even at rest a living form moves. Each breath animates the forms of the body; eyelids flicker, nerves pulsate. And, of course, larger movements are normal—changes in the position of legs, arms, torso, and head. The human form devoid of movement seems to lose some of its essential character.

A second difference between sculpture and living forms, the difference in material, is almost equally obvious. Sculpture can be formed of a great variety of metals, woods, stones, plastics, and other materials, but there are sharp differences in color and surface texture between these materials and skin, hair, teeth, nails, and clothing.

Finally, living forms do not exist in isolation. The sense of reality conveyed by the appearance of the human body depends in part upon the fact that the body is seen in the context of some surrounding environment. Life seems to flow

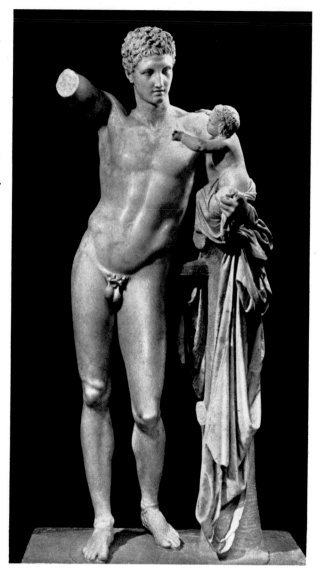

below: 366. Statuette of a woman, from the Cyclades Islands.
c. 2500 B.C. Marble, height 14¹/₄″.
Metropolitan Museum of Art,
New York
(Fletcher Fund, 1934).

right: 367. PRAXITELES.
Hermes and the Infant Dionysus.
c. 340 B.C.
Marble, height c. 7′.
Museum, Olympia.

around the living. Light changes; the air moves and brings with it the sounds and wafted motions associated with human experience. The figure exists in a landscape or within the interior space of a room filled with the evidence of the human presence. The sculptor usually produces a figure that is isolated from an environment. With the exception of certain forms of bas-relief, which have characteristics similar to painting, sculpture tends to isolate representational images from the environment that would normally surround the figure.

Though the sculptor can copy the *forms* of a human being exactly, the other distinctions between the statue and its subject remain significantly manifest. The sculptor, like the painter, can create only an equivalent for his subject. When he

seeks to represent a subject in the world about him, he must devise a combination of forms and surfaces in space which will suggest, symbolize, or become a surrogate for that subject.

Many three-dimensional images, in great variety, have been used throughout the history of sculpture as equivalents for human and animal figures. Even if the study of sculpture is restricted to the human figure, the range of representational images is remarkable. Compare a Cycladic statuette carved on an Aegean island about 4,500 years ago (Fig. 366); a figure of Hermes by the Greek sculptor Praxiteles, made about 340 B.C. (Fig. 367); a thirteenth-century *Virgin and Child* from France (Fig. 368); a twelfth-century figure from India (Fig. 369); a Maori figure from New Zealand (Fig. 370); one from the North-

left: 368. *Virgin and Child* from France. 13th century. Oak, height 31 1/2″.
Wadsworth Atheneum, Hartford.

center: 369. Figure from India. 12th century. Stone, 22 × 13 3/4″.
Metropolitan Museum of Art, New York (gift of Robert Lehman, 1947).

right: 370. Maori figure from New Zealand. 19th century(?).
Wood, height 43 1/8″. Museum of Primitive Art, New York.

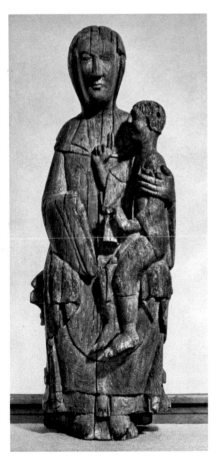
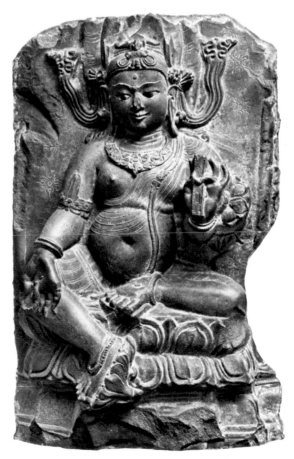
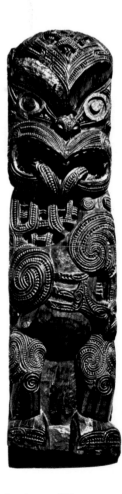

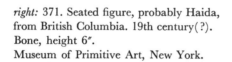

right: 371. Seated figure, probably Haida,
from British Columbia. 19th century(?).
Bone, height 6″.
Museum of Primitive Art, New York.

left: 372. ALBERTO GIACOMETTI. *Walking Man.*
c. 1947–49. Bronze, height 27″.
Joseph H. Hirshhorn Collection, New York.

west Coast Indians of British Columbia (Fig. 371); and, finally, two more recent
examples by Alberto Giacometti and Henry Moore (Figs. 372, 323). All these
examples represent the human figure for some society or individual. The figure
by Praxiteles seems to correspond most closely to the forms of the human figure
as it appears in nature, and yet, as suggested above, it, too, must be considered
an abstraction from real life.

Actually, a child's doll, made of a single piece of wood representing a
torso, to which has been added a crosspiece suggesting arms, a knob for a head,
and two additional lengths of wood for legs, is easily recognized as a symbol for
the human body. The body is so much a part of each person's experience that
even the crudest simulation of parts combined into a figurelike group will be
recognized as a figural image.

The particular combination of forms that satisfies a sculptor in his desire
to represent a real subject may be strongly influenced by the traditions of his
culture. This is demonstrated by the examples above from Greece, India, France,
New Zealand, and British Columbia. Working within these stylistic canons, an
artist may be able to indicate differences of sex, movement, and expression.
These potentials are certainly utilized in the sculpture of the Greeks. Often,
however, the style is more restrictive, and in the figures typical of a cultural

group the artist seems to have disregarded some or all of the individual differences that exist between human beings.

In the work of Giacometti and Moore we have two contemporary artists who do not conform to any single stylistic pattern imposed upon them by an external group or culture. Each artist has developed a symbolic image of the human form that satisfies his own expressive and esthetic needs.

Because the image of the figure is so readily grasped, even when a figural piece is markedly different from the forms of the real subject, the contemporary sculptor is free to depart from imitative surfaces and forms in his work. He may combine representation with a subjective comment about individuals or societies, or he may emphasize the purely organizational aspect of his composition and seek to produce an esthetic object that satisfies or delights its beholders.

MATERIALS AND METHODS

Sculpture is an ordered arrangement of actual masses that have their existence in a real space.

The plastic elements of sculpture, as has been said earlier, are form, space, line, material, color, movement, and texture, and the sculptor, like the painter, seeks to organize these elements into a unified composition.

The organization of sculpture begins with the material. Stone, wood, metal, clay, and other substances are transformed through a number of processes into the final forms and spaces, which are, in total, the finished work.

The sculptor can shape his material in two separate and distinct ways. He can join small parts into larger components by pressing bits of wax or clay together, or by fastening metal segments with mechanical or welding techniques; or he can cut away or carve into a block of stone or wood larger than the finished work, eliminating the extraneous parts of the block and leaving the statue as the residue of this process of reduction. The first method is called *additive sculpture* and the second *subtractive sculpture*.

373. AUGUSTE RODIN. *The Little Man with a Broken Nose*. 1882. Bronze with some gilt, height 5″. California Palace of the Legion of Honor, San Francisco (Spreckels Collection).

Additive Sculpture

The term *additive sculpture* is almost synonymous with the word *modeling*. Both terms refer to the use of a pliable material, such as wax or clay, which can be formed into three-dimensional masses. This procedure permits the artist to make quick, spontaneous sketches, as well as prolonged studies. Because the material is soft and easy to manipulate, the artist can use a great variety of tools, as well as his fingers, to shape it. Contemporary additive sculpture also includes pieces composed of small elements of wood or metal joined by various methods to form the complete work.

Auguste Rodin's *Little Man with a Broken Nose* is an example of modeling (Fig. 373). The completed form of the work was cast in bronze, but the original was clay. Clay models are fragile and perishable, so that it is usual for works constructed in this medium to be cast in another, more durable material. Some-

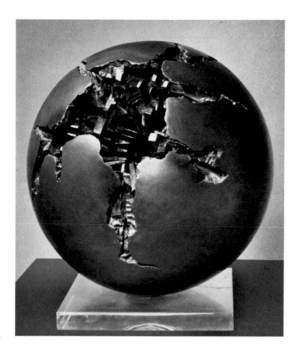

374. Arnoldo Pomodoro.
Sphere with Perforations.
1966. Bronze, diameter 23¹/₂″.
Courtesy Marlborough Gallery,
New York.

times the clay is baked at high temperature in a kiln, like pottery. The resultant product is called *terra-cotta*, and it is considered a satisfactory finished material for certain limited uses.

The person interested in the appreciation of sculpture need not get involved with the intricacies of the complex technology required to transform an original clay model into a finished metal statue. However, he should realize that the sculptor who works in this method, in order to integrate his idea with the material he has used, must think as he works in terms of the final casting and not of the clay. He must look at the gray earthen forms and see bronze. He must consider the bronze surfaces, the patina they will take, the manner in which the light will be absorbed or reflected from the metal. He may ask himself, "Will the forms I have used look suitable in metal? Will they suggest the ductility, the strength of the material?" These questions are typical of those which would influence the appearance of the finished work. The answers given by contemporary artists have produced a great variety of sculptural forms and surfaces. Some works have been polished until their surfaces took on the quality of a mirrorlike skin, reflecting the light in flashes or star-bright brilliance (Fig. 336). Other surfaces have been made to suggest the fluid quality of metal hardened into rough, lavalike incrustations (Pl. 60, p. 281). Still others are engraved and worked after the casting process to contrast the inner color of the metal with the color of the outer surfaces (Fig. 374).

Sculpture cast in metal has all these possibilities, but for the contemporary sculptor it poses important disadvantages. Metal casting is relatively expensive. In the past, when patrons commissioned works, it was not too difficult for the

above left: Plate 64. Larry Bell. *Untitled.* 1966.
Glass with deposits of metallic film, 18″ cube.
Courtesy Pace Gallery, New York.

above: Plate 65. Stephen Antonakos. *Green Neon from Wall to Floor.*
1969–70. Neon tubing, $8 \times 24 \times 5'$.
Courtesy Fischbach Gallery, New York.

left: Plate 66. Jean Dupuy (artist);
Ralph Martel and Harris Hymans (engineers).
Heart Beats Dust. 1968. Wood, glass, rubber, lithol rubine,
tape recorder, coaxial speaker, tungsten-halogen lamp; 22″ cube.
Courtesy Howard Wise Gallery, New York.

315

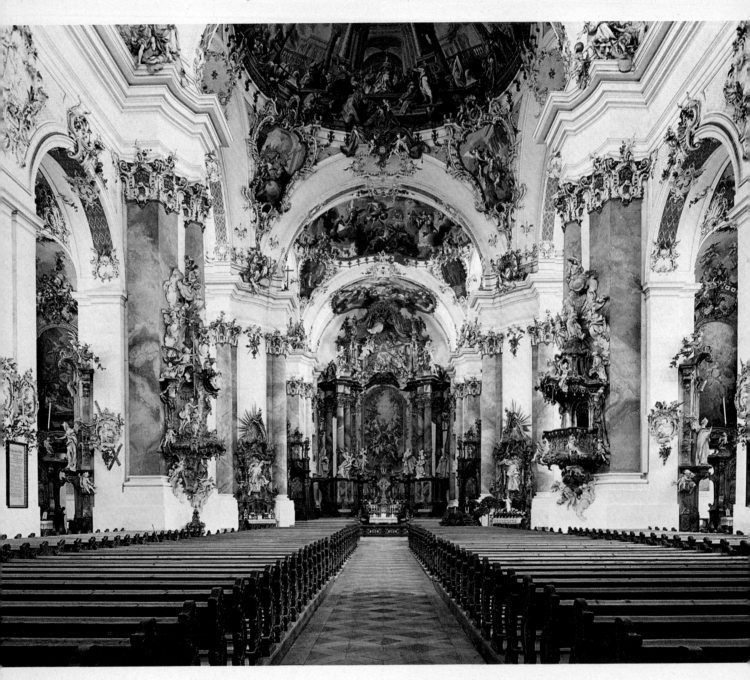

Plate 67. JOHANN MICHAEL FISCHER. Interior, abbey church, Ottobeuren, Germany. 1736–66.

artist to find the financial support to have his pieces cast or to cast them himself. Much of the work of the contemporary sculptor, however, is done before a buyer is found. He frequently must take on the burden of the casting procedure. As a result of this economic hardship, many modern sculptors have been frustrated in their desire to create permanent metal sculpture. One solution to the problem was the introduction into the studio of the techniques and procedures of the industrial metalworker. By forming his sculpture of small pieces of metal and welding them into larger, more complex structures, the artist attained the means of working directly in steel, brass, or even precious metals and of producing a work with all the permanence of a cast piece.

The problem of costs was not the only reason for the introduction of *direct-metal sculpture*. Many artists were drawn to this process because it had esthetic and expressive values which they found appealing. One of the first men to work in this medium was Julio González, who came from a family of ironworkers in Barcelona, Spain. Trained as a painter, González turned to wrought-iron sculpture only in his maturity, in the late 1920s and the 1930s. *Torso* is an example of the use of flat sheets of iron hammered into curved forms (Fig. 375). These sections were then welded together. The completed construction combines the image of a female torso with the surface, edges, and beaten forms of the ironworker's craft.

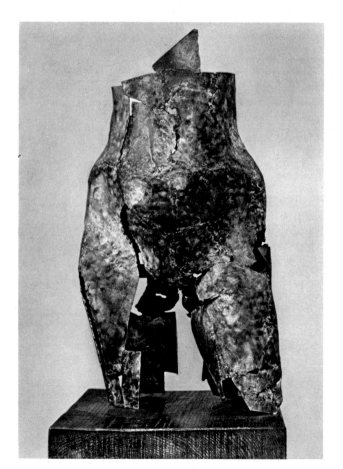

375. Julio González. *Torso*. c. 1936.
Hammered and welded iron, height 24³/₈″.
Museum of Modern Art, New York
(gift of Mr. and Mrs. Samuel A. Marx).

317

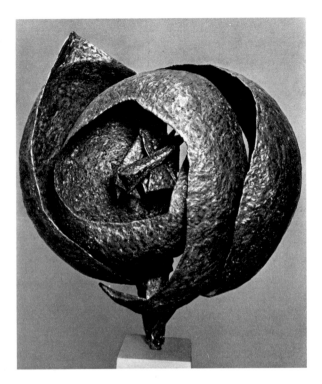

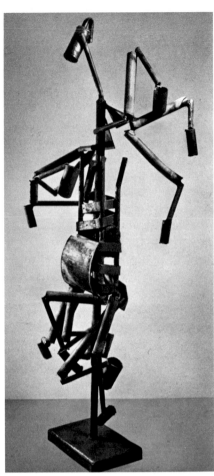

above: 376. SEYMOUR LIPTON. *Sanctuary.* 1953.
Nickel silver over steel, height 29¹/₄″. Museum of Modern Art,
New York (Blanchette Rockefeller Fund).

below: 377. IBRAM LASSAW. *Procession.* 1955–56.
Wire, copper, various bronzes, and silver; length 40″.
Whitney Museum of American Art, New York.

above: 378. RICHARD STANKIEWICZ.
Marionette. 1960.
Steel, height 4′ 7″.
Courtesy Stable Gallery, New York.

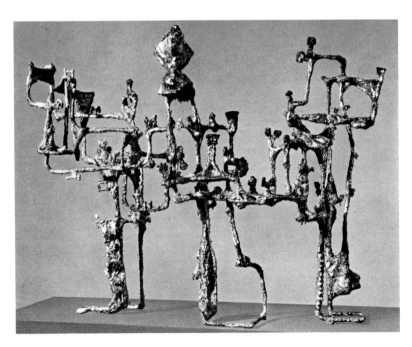

González was followed by others, and today one can name artists such as Seymour Lipton, Ibram Lassaw, Richard Lippold, and Richard Stankiewicz, among many who work directly in metal.

Lipton beats metal sheets in the manner of the González *Torso*. His construction *Sanctuary* (Fig. 376) is made of welded steel coated with a layer of nickel silver. Ibram Lassaw covers a wire skeleton with layers of bronze, copper, and silver to produce a linear composition in which melted metal seems to have solidified into a weblike complex (Fig. 377). A similarly open construction, in which the forms are reduced to thin lines of light, is the work of Richard Lippold, who welds wire and rods into complex geometric structures (Fig. 340). Some sculptors, including Richard Stankiewicz, employ the metal refuse found in junk yards as the components of their work. Sections of pipe and cast-off gears and wheels are welded together. *Marionette* (Fig. 378) becomes a grotesque doll while still retaining the identity of the pipes and assorted hardware that were combined to form it.

The word *assemblage* has been used to describe the category of art works, including such constructions as that of Stankiewicz, created by combining separate and distinct ready-made parts found and manipulated by the artist. These parts may be used as they are discovered or altered slightly by shaping, cutting, or changing their color. The work of John Anderson called *Big Sam's Bodyguard* (Fig. 379) is constructed of sections of wood, still retaining much of

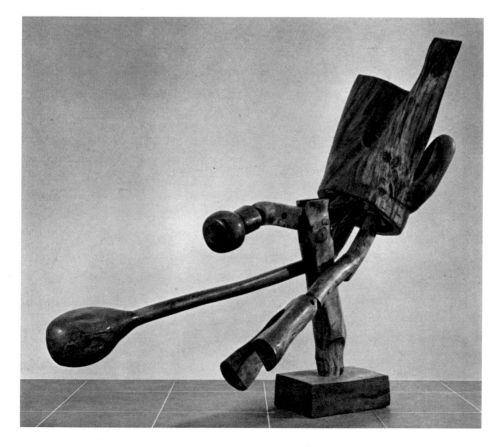

379. JOHN ANDERSON.
Big Sam's Bodyguard. 1962.
Ash wood, 6′ 10¹/₂″ × 6′ 9¹/₂″.
Whitney Museum of American Art, New York.

above: 380. GABRIEL KOHN. *Bird Keys.* 1962. Wood, 39 × 40″.
Courtesy Marlborough Gallery, New York.

right: 381. SOL LEWITT. *Untitled.* 1966.
Aluminum and flat enamel, 5′ cube.
Courtesy Dwan Gallery, New York.

their treelike appearance, which are combined with other sections carved into related forms by the sculptor. Gabriel Kohn, who also produces works that might loosely be described as assemblages, laminates flat sections of machine-cut lumber into carefully crafted forms and joins them into spatial constructions (Fig. 380).

The severe geometric construction of Sol LeWitt (Fig. 381) is another instance of an art object that has been formed by joining a large number of components into a coherent unit. LeWitt creates a visually complex three-dimensional grid out of an extremely simple modular repeat, building his structures with basic carpentry and sheet metal methods and materials.

Many sculptors working in large-scale metal constructions have turned to industrial fabricators to produce their work (Fig. 382). Metal-forming techniques, welding processes, and commercial methods of surfacing materials have been added to the artist's means. Simple planes bent and cut by large presses are joined to form three-dimensional solids or open spatial organizations. The artist may provide the fabricators with a small-scale model of his proposed design, or he may join the workmen in the actual construction process, altering the design as the work progresses.

382. Sculpture under construction. Lippincott, Inc., near New Haven, Conn.

right: 383. Armature for supporting sculpture.

When he works by joining pieces of material together, the sculptor can change his composition by both addition and subtraction. He may continue to add material, rearrange material already in place, or remove sections completely. This highly flexible method of working applies to modeling and to direct-metal sculpture.

Also possible in additive sculpture are advantages of cost and effort that make this procedure attractive to practicing artists. The traditional modeling materials—clay, plaster, and wax—and the tools required to manipulate them are relatively inexpensive. A sculptor can cast clay models in plaster, giving them a limited degree of permanence, and he can then keep the casts indefinitely, waiting for the time when they can be reproduced in a final metal form.

Even for those sculptors working directly in metal the expense of making large pieces is considerably less than the costs that would be incurred were the pieces cast at a foundry. In addition, sheet steel, the raw material of most direct-metal pieces, is easily transported and manipulated in the studio.

Though the additive method permits an unlimited number of changes as the artist proceeds with his work, it would be misleading to assume that he begins to model or weld pieces of metal without some preconceived idea of the final form his sculpture will have. Clay models, because of the softness of the material, must have a metal or wooden *armature* (Fig. 383) inside them to provide a more rigid skeletal support to bear the weight and pressure of the mass

that is shaped into the external forms of the piece (Figs. 384, 385). Metal must be cut and sometimes forged or beaten into shape before it is joined to other pieces of metal. Drawings or small sketches often precede the execution of full-size pieces. Still, as he works toward his preconceived image, the artist can, and often does, refine his concept, reacting to the material and to the forms and spaces being created, reevaluating the original idea in an open-ended process that offers an extraordinary degree of flexibility.

Subtractive Sculpture

As the word "modeling" is synonymous with additive sculpture, *carving* is often the term substituted for subtractive sculpture. The process of reducing a block of wood or stone to the forms he wishes to retain requires no small physical effort on the part of the carver. Cutting into wood, or into the even harder stone, is laborious and time-consuming, and for this reason carved pieces often lack the quality of spontaneity to be found in many examples of modeled or direct-metal sculpture. An artist who must devote extended periods of time to the completion of a work does not begin to carve on a whim or a capricious fancy. Modeling is an ideal method for the production of the quick sketch, and many sculptors precede their work in stone or wood with studies in clay. Carving, however, tends to be a serious business, and the attitude of the carver usually finds its way into his finished work.

Materials suitable for carving can differ in many ways. Their hardness varies as well as their initial size. They may have a neutral physical structure that does not affect the cutting action of the sculptor's tools, or they may have a structure, such as the pronounced grain of certain woods, that draws the chisel along definite paths.

A sculptor may produce his original model in a flexible material like clay or wax, or perhaps in plaster. It is then possible to transfer this original, through a complex measuring process called "pointing," to the block from which it is to be carved. The final process of removing the excess stone can be carried out by craftsmen employed by the sculptor, or he may do it himself. This rather mechanical approach to carving is not so popular today as it once was, for many contemporary sculptors feel, like Michelangelo, that each new block has within it a hidden form, and that the sculptor's function is to reveal and release this form by removing those portions of the block which seem to obscure the essential image. As he works, there is a continuous interaction between the original concept of the carver and the material. Each cut may reveal a new clue to the structure and the formal characteristics of the stone or wood. Though the sculptor initially chooses his raw block because he feels that it has a potential which corresponds to his original conception, he can adjust his composition to the structure discovered in the material as the work proceeds.

Raoul Hague is an American sculptor who is known for his massive wood carvings. *Sawkill Walnut* (Fig. 386) is a typical piece by this sculptor, and it exemplifies his involvement with the material he uses. Many of Hague's carvings

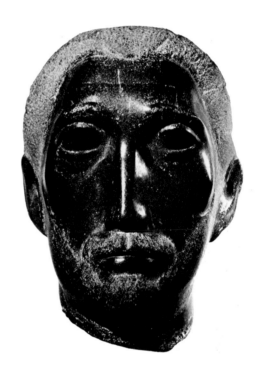

left: 386. RAOUL HAGUE. *Sawkill Walnut.*
1955. Walnut, height 42″.
Whitney Museum of American Art, New York
(gift of the Friends of the Whitney Museum).

below: 387. WILLIAM ZORACH. *Head of Christ.*
1940. Stone peridotite, height 14³/₄″.
Museum of Modern Art, New York
(Abby Aldrich Rockefeller Fund).

are named after the wood he shaped to form them, indicating the importance
he gives to the material. In *Sawkill Walnut* the forms seem to be a result of the
growth process itself. Note how the grain becomes an integral part of the com-
position, flowing with the forms, reinforcing their directional movement, and at
the same time enriching the surface. Even the wedged cracks in the wood seem
to become essential to the composition, adding a textural variation to a
flattened plane.

The hardness of stone and the textural possibilities inherent in the carving
process are suggested by the *Head of Christ* in Figure 387, the work of another
American sculptor, William Zorach. The material here is peridotite, a very
hard rock. It has been polished to a smooth, satiny finish on the surfaces that
represent skin, but the marks of the sculptor's tools are retained on the forms of
the hair and beard. Over all there is a sense of the obdurate stone, which gave
way reluctantly to the hammer and the steel edge of the chisel.

ORGANIZATION

The sculptor faces the same problems as the painter when he wishes to organize his work. He must create an esthetic unity which includes enough variation to offer contrasts and complexities that will challenge and surprise the viewer. Here again, it is necessary to note that the esthetic organization of the work cannot truly be isolated from its expressive or representational aspects. Ideally, esthetic organization, expression, and representation are all interrelated, but,

left: 388. Jacques Lipchitz. *Man with Mandolin.* 1917. Stone, height 29³/₄″. Yale University Art Gallery, New Haven, Conn. (Collection Société Anonyme).

right: 389. Side view of Figure 388.

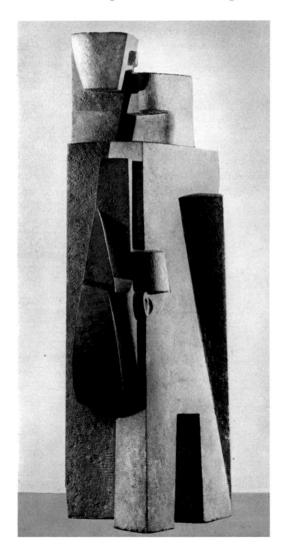 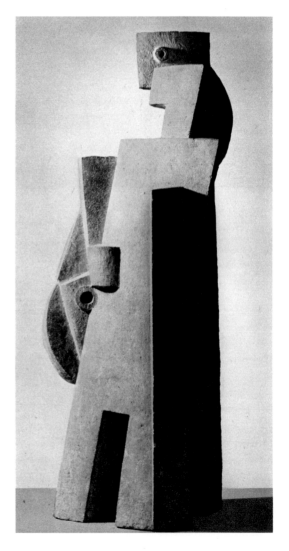

like the painter, the sculptor can use *repetition, continuity,* and *contrast* as esthetic choices in the creative process. Important in sculpture, however, is the fact that a statue is a three-dimensional object. Except in the case of relief sculpture, the organization is not restricted to one surface or face. The sculptor must relate the back to the front, and both front and back must be related to the sides. Indeed, it becomes difficult to describe many pieces as though they had four distinct surfaces, for the artist has formed them into groups of elements which appear to have a continuing relationship through a 360-degree circle. A form or plane or linear movement may begin at one point, and a viewer might need to move all the way around the piece of sculpture before he can trace the entire shape or path of that element.

The sculptor's material can have a strong unifying effect on a composition. The material can provide a unity of color and surface texture. However, once the sculptor begins to shape that material, he must organize his forms, carved or modeled surfaces, and linear movements so that they are integrated. Repetition of shape and surface and continuity of edges and planes are frequently used to this end. The sculptor may repeat the size or shape of forms and spaces. He may repeat surface treatment, that is, rough or smooth textures. Without duplicating shape or forms exactly, he will perhaps give them a similar character. They could be angular and cubelike or softly rounded and sensuous.

By use of the inscribed line, the hard linear edge of forms, the linear edge of the silhouette of his work, and slender linear elements, the sculptor can produce a unity based on a continuous movement.

In *Man with Mandolin* (Figs. 388, 389) Jacques Lipchitz employed repeated rectangular and triangular forms to unify the work. When seen from the front, the repeated vertical edges of some of the forms establish the primary emphasis in the composition. This vertical movement is contrasted against a number of diagonals created by form edges. Note how the diagonal on the left ties together a series of small elements as it moves along on the left side of the lower central group and then continues upward along the right side of the upper forms of the head. Cylindrical forms also are used on this face of the sculpture, as a subordinate and contrasting part of the composition, but the curves move away from the viewer, so that their characteristic arcs do not interrupt the vertical and diagonal emphasis. The face of the large plane on the right is placed at an angle so that it directs the viewer around toward the right side, where the sculptor has carved forms which echo those on the front face of the piece. Diagonals and verticals dominate the composition again, but the curved forms are somewhat more insistent. A study of the rear view and the left side of this carving would reward the spectator with the discovery of further unifying relationships similar to those noted here. The problem for Lipchitz was to tie each view of his composition to the view that was exposed before. The composition of the side had to appear inevitable, once the front of the piece had been seen. Yet the skillful sculptor arranges his forms so that, while they may seem to be an inevitable extension of the views already seen, they are, at the same time, unexpected, surprising variations of the other faces of the structure.

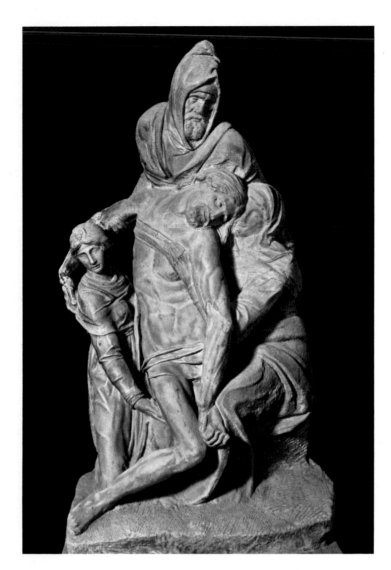

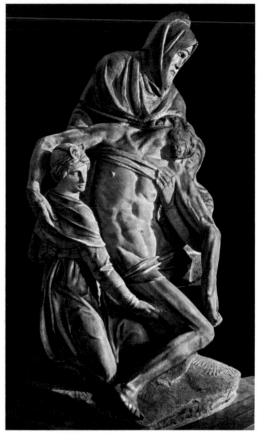

left: 390. MICHELANGELO.
Deposition from the Cross.
Left unfinished, 1555. Marble, height 7′ 5″.
Cathedral, Florence.

above: 391. Side view of Figure 390.

A composition based upon strong planar movements is to be found in the *Deposition*, or Florence *Pietà*, by Michelangelo (Figs. 390, 391). Here the figure of Christ twists so that the left arm, the head, and the knee form the forward edge of a plane that moves back from this line and around toward the left. It is intersected by another plane created by the female figure at the left, which continues this movement back behind the central axis of the group. To the right the forms of the other female figure interlock with those in the foreground and move back, this time in a secondary direction toward the right. Another planar movement runs upward from the juncture of the knee and the hand in a slow curve to form an arc with the hooded head of the figure behind Christ, which leans forward over the dead body.

Linear movements are carried along the edges of the forms and through the axis of the fallen figure and those which support it. A slow arc is repeated over and over again: in the body of Christ, in the position of his left arm, in the right arm of the female figure to the left, in the hood of the rear figure, and in the arch of the body of the female figure at the right. The whole group could easily be enclosed by a form shaped like a tall cone with slightly curving sides.

In some contemporary examples of sculpture, particularly those made in welded metal, the organization of space is emphasized over the organization of forms. Ibram Lassaw's *Procession* (Fig. 377) is a composition based on the repetition of roughly vertical and horizontal movements. The irregular, elongated forms of the sculpture bulge out into lumpy masses and surfaces, but they retain their essential linear character. Rectangular spaces of many sizes and shapes are trapped between the thin solid elements. These spaces are arranged so that they look like a flat screen, but they also move back away from the observer to form a three-dimensional maze, which appears to change when seen from different viewpoints. Because they are so thin, the forms become movements in space, which connect the three major clusters of the construction and provide for secondary movements within the large groupings.

As noted earlier, most sculpture can be fully understood only when the observer moves around the entire piece and views the relationships and movements uniting all the parts. There are exceptions to this rule. Some compositions in three dimensions are based upon a series of contrasting forms arranged vertically one above the other. *Torso of a Young Man* (Fig. 392), by Constantin Brancusi, is a brass figure set on a base of wood and marble designed by the artist to create a symmetrical organization of the whole along a major vertical axis. The forms of the figure and the base contrast against one another, as do the textures of the materials used in the individual sections. It is the juxtaposition of one form, one texture, against another that produces the full esthetic effect of this piece. Extremely important in its organization are the surfaces worked on the sculpture's forms. They offer to the viewer the sensuous pleasure of touching the warm, living firmness of wood; the granular, yet smooth surface of marble; and the cold perfection of polished metal. It is an esthetic satisfaction which can be sensed even though the piece is seen and not touched.

George Sugarman's work (Pl. 63, p. 282) is also an exercise in sculptural organization based upon contrasts. Sugarman constructs a sequential group of forms into a composition which seems literally to be teetering in a precarious, unbalanced state. Each form is shaped to play against the forms above and below it, and the color accentuates the contrasts tying the work together in a series of related tensions.

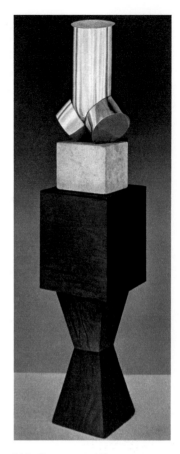

392. CONSTANTIN BRANCUSI. *Torso of a Young Man.* 1924. Brass; height 18″, on original base of marble and wood. Joseph H. Hirshhorn Collection, New York.

Relief Sculpture

Relief sculpture is produced by creating three-dimensional forms which rise from, or are cut into, a flat, two-dimensional surface. Relief combines many of the characteristics of painting and sculpture and, in general, seems to parallel

painting in methods of representation and organization. A comparison between a miniature painting of *The Transfiguration of Christ* from *The Gospel Book of Otto III* (Fig. 393) and a relief version of the same subject on a column (Fig. 394) in the Church of St. Michael, Hildesheim, both dating from about the year 1000, reveals the similarities that exist between these two art forms. In both examples the figures are placed against a neutral background. Both have a strongly linear quality, with a flattened, stylized representation of the figure. The primary difference is the method used to create the linear forms. In the painting these forms are drawn on the flat surface of the manuscript page. Areas are separated from the background by outlines and color changes. In the relief the linear elements are the result of shadows cast by the slightly raised portions of the bronze surface. Instead of using a drawn line, the sculptor has "drawn" with shadows and highlights. The entire figure is separated from the background on the column, because it projects from it, and again it is the variation of light and shadow produced by this change in thickness that substitutes for the painted separation in the manuscript.

left: 393. *The Transfiguration of Christ*, from *The Gospel Book of Otto III*. c. 1000. Illumination. Bayerische Staatsbibliothek, Munich.

right: 394. *The Transfiguration of Christ*, detail of reliefs on the Easter Column, Church of St. Michael, Hildesheim, Germany. Early 11th century. Cast bronze.

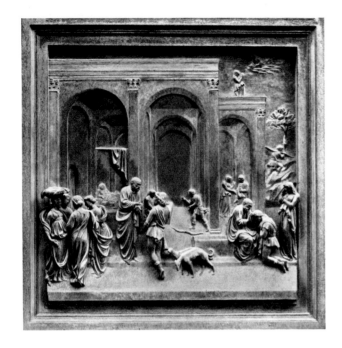

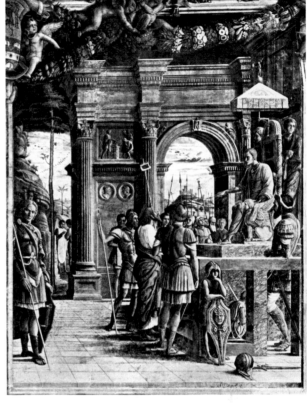

above: 395. LORENZO GHIBERTI. *The Story of Jacob and Esau.*
c. 1435. Gilt bronze, 31″ square.
East doors, Baptistery, Florence.

right: 396. ANDREA MANTEGNA. *The Judgment of St. James.*
c. 1495. Fresco. Ovetari Chapel, Church of the Eremitani,
Padua (destroyed).

A similar comparison can be drawn between Lorenzo Ghiberti's relief
composition of *The Story of Jacob and Esau* (Fig. 395), made about 1435 for the
Baptistery of Florence, and a painting of *The Judgment of St. James* (Fig. 396),
executed some twenty years later by Andrea Mantegna in the Eremitani
Church at Padua. This relief and the painting show more concern with the
illusion of depth and three-dimensional form than the two earlier examples.
Both demonstrate the use of linear perspective as a means of representing deep
space. The three-dimensionality of architecture and figures is simulated by
Mantegna in painted, shaded forms. This shading suggests a single light source,
which models the solids in the picture to make a strong definition of edges and
masses. Ghiberti's relief is constructed so that some portions of the composition
project from the background farther than others, creating stronger light-
and-shadow effects on the masses in the foreground. In fact, some of the fore-
ground figures are almost formed in the round. However, the representation

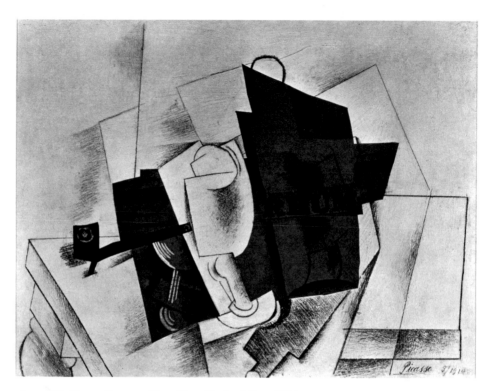

above: 397. PABLO PICASSO. *Pipe, Glass, Bottle of Rum.* 1914.
Pencil, gouache, and pasted paper on cardboard; 15³/₄ × 20³/₄″.
Museum of Modern Art, New York (gift of Mr. and Mrs. Daniel Saidenberg).

below: 398. JACQUES LIPCHITZ. *Still Life with Musical Instruments.* 1918.
Stone relief, 23⁵/₈ × 29¹/₂″. Collection Mr. and Mrs. Joseph Pulitzer, Jr., St. Louis.

of the space behind the figures owes far more to the perspective illusion than to the actual difference between planes.

A more recent use of relief is to be found in examples of Cubist art from the early years of the twentieth century. Again, the similarity between painting and relief is obvious. Picasso's 1914 collage drawing *Pipe, Glass, Bottle of Rum* (Fig. 397) makes use of the Cubist devices of overlapping planes, simplified forms derived from objects seen from several points of view, and an emphasis on the division of the flat picture plane rather than on an illusion of deep space. A stone relief by Jacques Lipchitz, *Still Life with Musical Instruments*, dated 1918, exhibits similar qualities (Fig. 398). Hard edges and changing planes provide the linear and tonal elements in the relief, as they did in the earlier examples of this art form. The same emphasis on the picture plane is seen here, as are the compositional use of repeated shape and the continuity of edges.

The separation between relief sculpture and painting has become increasingly vague since the beginning of the 1950s. Painters such as Roberto Crippa are constructing collages with thick pieces of three-dimensional material glued to board. Crippa's *Composition* (Fig. 399) is made from sections of bark mounted

399. ROBERTO CRIPPA. *Composition.* 1959. Bark mounted on plywood coated with paint, sawdust, and plastic glue; 6′ 6 ⅞″ square. Museum of Modern Art, New York (gift of Alexandre Iolas).

400. Lee Bontecou. *Relief.* 1959. Welded steel, cloth, and wire; 4′ 10¹/₈″ × 4′ 10¹/₈″ × 1′ 5³/₈″. Museum of Modern Art, New York (gift of Mr. and Mrs. Arnold H. Maremont).

on plywood coated with paint, sawdust, and plastic glue. Lee Bontecou, a sculptor, works with welded wire and painted canvas. *Relief* in Figure 400 is a typical example of her constructions, a bulging hollow form that rises like a tent from the vertical surface of the wall on which it is hung.

It could be properly said that many contemporary artists seem to work in a combination of painting and sculpture, bringing the potentials of both arts into their work. Bontecou is working as a painter when she organizes the linear elements of her constructions and tints the raw forms that are attached to the wires. Crippa concerns himself with three-dimensional masses and surfaces, and, in so doing, thinks in terms common to sculptors. Both these artists, and others who are creating in a style that unites painting and sculpture, share with the artists utilizing more traditional modes the problems of esthetic organization and the expression of their responses to the world about them. For each,

the form and substance of his art derives from the necessity that motivates the artist to work. Differences in style, method, and materials result from differences of intention, personality, and sensibility.

Kinetic Sculpture

The artist who concerns himself with movement in sculpture is always working with separate elements joined so that some form of articulation is possible. In a real sense this is additive sculpture.

Sculptural compositions with moving parts offer the artist two organizational possibilities as a basis for the conception and construction of their work. One approach is to consider motion a way of creating changes in the spatial relationships between the forms in the sculpture. Articulated parts will move toward or away from one another. Distances and angles of separation will vary. At any moment in time the parts will have a definite ordered relationship, but this may change so that another moment in time will find the parts distributed in a different composition. Because the artist has determined the shape of the forms in the sculpture, because he has designed the joints to permit movement, he can predict the general character of the form-space relationships possible in his piece; but he cannot accurately predict the composition at every single moment in time.

Another approach to kinetics in sculpture is based on the quality of the movement rather than on the arrangement of the parts. These two approaches are not mutually exclusive; they tend to overlap and affect each other. Any artist who chooses motion as a major characteristic of his sculpture uses articulated forms in a spatial interrelationship, but he may emphasize the character of the movement rather than the position of the parts. He designs the joints and moving elements to jiggle, to wave, to bounce, or to soar. He is less concerned with where the parts of his construction are placed and more concerned with the dancelike way in which they move within their prescribed orbits. To quote George Rickey, the creator of the work reproduced in Figures 401 through 405 and one of the leading artists in this field:

> The artist finds waiting for him, as subject, not the trees, not the flowers, not the landscape, but the *waving* of the branches and the *trembling* of stems, the piling up or scudding of clouds, the rising and setting and waxing and waning of heavenly bodies, the creeping of spilled water on the floor, the repertory of the sea—from ripple and wavelet to tide and torrent. . . .[1]

The examples and illustrations of kinetic sculpture represented in the preceding chapter (Figs. 346–349) are works whose articulated elements receive power and move when driven by motors or by the action of gravity or wind. Rickey has suggested a number of other possibilities. They include the attraction of magnetic fields on metal elements; jets of water to suspend forms or perhaps to turn paddles; plastic, cloth, or rubber membranes susceptible to shaping or distortion by changing stresses; color and motion variations

right: 401. GEORGE RICKEY.
Six Lines in a T. 1965–66.
Stainless steel; height 6′ 8″, length 11′.
Storm King Art Center,
Mountainville, N.Y.

below: 402–405. Four different views
of Figure 401.

406. John Goodyear. *Hot and Cold Bars.* 1968.
Aluminum, plastic, and electric circuitry; $5^3/_4'' \times 5^3/_4'' \times 6'$.
Collection J. Kelly Kaufman family, Muskegon, Mich.

produced by polarized light; differences in tactile stimuli that are felt by the observer; and even the participation of people as an integral moving element in large architectural environments. Such inventions occupied a number of artists in the early 1960s and have since found rather frequent application in the design of sculptural objects.

As one such innovation, Jean Dupuy, Ralph Martel, and Harris Hymans have built a freestanding box with a glass panel in one side (Pl. 66, p. 315), The observer, looking through the panel, sees a cloud of red dust moving in time to the rhythms of an enclosed tape recorder that plays an amplified recording of heartbeats. The dust is lithol rubine, a brilliant red pigment of low specific gravity, which is activated by a tightly stretched rubber membrane in the bottom of the open space. At the top of the opening an intense light is focused through a lens to illuminate the moving pigment. The effect is one of a mysterious, almost animated, cloud that pulses like a living thing, a presence of amorphous form.

In contrast to the movement in the Dupuy-Martel-Hymans construction, the *Hot and Cold Bars* of John Goodyear has no visual moving elements (Fig. 406).

Instead, the "viewer" is invited to touch the two bars attached to a wall. The bars appear the same, but one has been heated and the other chilled electronically. The response to this tactile surprise is the basis for the esthetic response.

Clearly, one cannot approach John Goodyear's construction expecting to react as one does to the sculpture of Henry Moore or George Rickey. Art objects so different in conception may be arbitrarily placed in a category of things called "sculpture," but they are, in fact, as different from one another as a book of poetry from a textbook on atomic physics. An observer must confront these objects, and others equally different, on their own terms, responding to the stimuli presented by the artists, and seek what each offers without demanding that it conform to a preconceived set of limitations defining the nature of sculpture.

chapter 11

ARCHITECTURE
The Plastic Elements

Much of what has been said about the nature of sculpture could be applied to architecture, and both share the plastic elements of form, space, texture, material, line, and color. Both are three-dimensional art forms; both are concerned with the organization of forms in space. There are, in fact, many examples of architecture which can be regarded as monumental pieces of sculpture. If a division is to be made between these two art forms, we may best define it by recognizing two aspects of architecture which do not find a parallel in sculpture.

First, architecture is a *functional art*. A building is erected to fulfill some practical purpose. It may be argued that sculpture also functions for a purpose, but the purpose of the sculptor's art is restricted to symbolic communication and the evocation of an esthetic response. The architect may wish to include these two principles in his work, but he must also be concerned with the problems of providing a sheltered space for some specific human function.

Second, architecture is a *structural art*. The art object designed by the architect is always large enough to require a structural system to keep it erect. There are sculptors who make the structural systems of their pieces basic to the image produced. Kenneth Snelson, for example, uses rigid short lengths of metal as compression units seemingly suspended in air but actually supported by fine wires in a network of tensile complexity (Fig. 407). But it is possible to think of most sculpture without concern for the way in which the forms are

407. KENNETH SNELSON.
Landing. 1970. Stainless steel;
length 32′, height 9′.
Courtesy Dwan Gallery,
New York.

held together. In architecture the method used to make the seperate elements adhere is an integral part of the design. For this reason the materials selected by the architect, the strength of these materials, and the way they are joined to keep the building erect become a primary concern in the conception of an architectural design.

Ideally, function, structure, and materials in architecture should be so interrelated that they become a tightly woven fabric which gives the building its form, space, and textural variation. This ideal condition rarely obtains. There are often social and economic factors which have an effect on architectural design, requiring the architect to compromise ideal solutions for practical ones. The painter and the sculptor are, for the most part, removed from the pressures of cost in the completion of their work, but the architect seldom is. Some person or group must pay for the erection of the architect's work of art, and it is an exceptional client who will permit the artist to do as he wishes without regard for cost or the client's own taste. A critical assessment of a building would be unrealistic if the architect-client relationship were disregarded.

ARCHITECTURAL SPACE

A building may be perceived from either the outside or the inside. When seen from without, a simple colonial house has the form of a modified cube (Fig. 408). An observer who looks at this building from the street has no accurate idea of

the layout of the interior rooms. For him the building exists as a solid form pierced by window and door openings. Once inside, he is no longer able to react to the exterior, sculptural appearance of the building; the house becomes a volume of space created by the placement of walls, floors, and ceiling (Fig. 409). The visitor, glancing around the entrance hall, can sense the size and proportions of this space. Doors on either side of the hallway allow him to enter other spaces, each one somewhat different from the others in size and proportion. Windows permit him to look out into the surrounding environment. These connected spaces exist between the limits of the exterior and interior walls that surround them, and though they fill the house, cutting it into many different volumes, each one can be seen and understood only when the viewer stands within it, or studies a plan that graphically represents the spatial organization of the building (Fig. 410).

right: 408. The Towne House, relocated from Charlton, Mass., to Old Sturbridge Village, Mass. 1787.

below: 409. Dining room, the Towne House (Fig. 408).

below right: 410. Plan, the Towne House (Fig. 408).

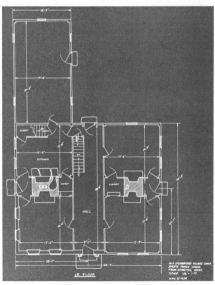

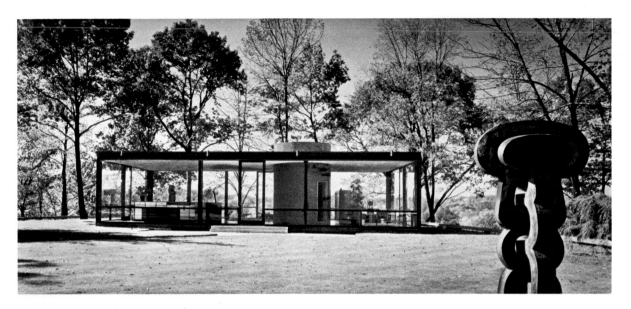

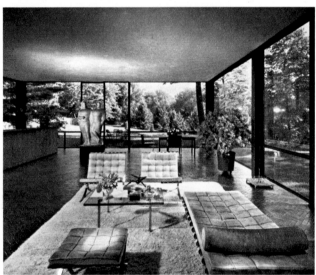

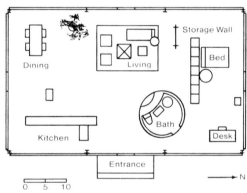

top: 411. PHILIP JOHNSON. Glass House,
New Canaan, Conn. 1949.

left: 412. Interior, Glass House (Fig. 411).

above: 413. Plan, Glass House (Fig. 411).

In the colonial house there is a certain similarity between the forms of the exterior of a building and the spaces of the interior. For the most part, both aspects of the building are rectangular, and the size of the exterior gives some suggestion of the interior dimensions. An example of a building that seems to integrate form and space to the point at which they become almost indistinguishable is the Glass House, designed by Philip Johnson as his residence (Figs. 411–413). The walls of glass do not act to isolate its exterior from its interior space. The transparent walls give the viewer a hint of the rectangular form of the building as the reflections in the glass delay his perception of the interior.

The flat plane of the roof and the supporting columns also work to define the form, but it is the interior volume which dominates the conception of this structure. Though it too is the work of Johnson, the adjacent guest house (Figs. 414, 415) offers a marked contrast to the transparent cubic form of the main building. It is opaque. The relatively small openings which pierce its sides only heighten the sense of the opacity of its exterior mass. The interior of the guest house gives further evidence of the desire of the architect to isolate form and space in this design. Within the blocklike exterior shape Johnson has constructed a series of canopied vaults, creating a rounded space within the cube, a surprise to the visitor who anticipates an interior which reflects the exterior forms.

above: 414. PHILIP JOHNSON. Guest House, New Canaan, Conn. 1953.

left: 415. Interior, Guest House (Fig. 414).

Space in architecture is created and defined by the shape, the position, and the materials of the forms employed by the architect. Opaque planes set at right angles to one another to form a box will produce an interior space that is cubelike. The effect of this space will be directly related to the volume enclosed by the opaque planes. A small spatial volume with low ceilings will affect the person within it in a manner entirely different from a space of similar proportions but enlarged dimensions. If the planes used by the architect are of glass, the enclosed space will differ from the apparent space felt by an observer, and both of these spatial volumes may be controlled by the architect's design.

Quite obviously, the shape of the forms used by the architect will shape the space. Even the flat, two-dimensional photograph of the interior of Eero Saarinen's Trans World Flight Center at Kennedy International Airport in New York (Fig. 416) conveys the sense of an enclosed space which flows through the building, shaped by the fluid forms of concrete into a dynamic series of connected curved volumes.

ARCHITECTURAL MASS

Many of the forms developed by architects derive from the materials employed and the structural system selected. The simple conical form of the tents of the American Plains Indian is created by stacked poles covered by skins or fabric (Fig. 417). Buildings constructed from stone or brick depend upon the methods of stacking and bridging used to raise the walls and support the floors and roof. The forms that emerge from these construction systems tend to emphasize the vertical and horizontal planes and right angles. When arches, vaults, and domes are used, they add curves and spheres to the architect's vocabulary of form (Fig. 418).

416. Eero Saarinen. Interior, Trans World Flight Center, Kennedy International Airport, New York. Opened May 28, 1962.

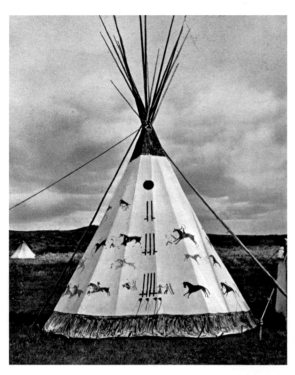

417. Painted tepee. Plains Indian (probably Cheyenne).

below: 418. Louis I. Kahn. Interior, "Presidential Square,"
Second Capital of Pakistan, Dacca, East Pakistan.
Under construction.

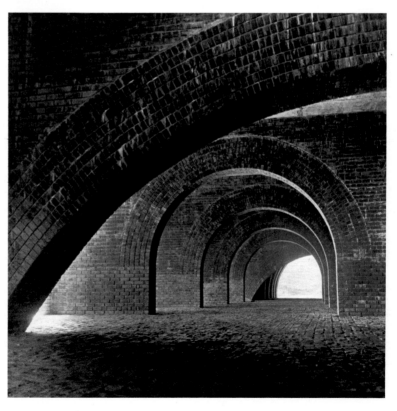

Architecture: The Plastic Elements 343

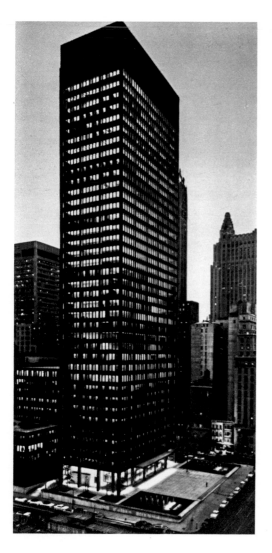

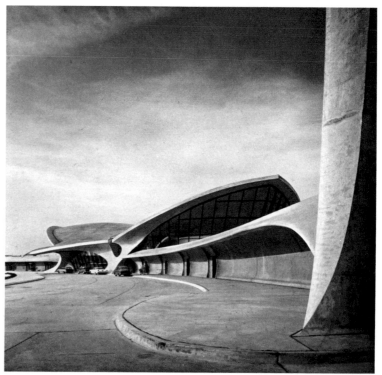

In a similar way the tall steel-and-glass office buildings of the contemporary city owe much of their appearance to the nature of their construction. The severe rectangularity of Miës van der Rohe's Seagram Building (Fig. 419), in New York City, results from the fact that the architect used relatively short steel beams connected into a vertical and horizontal web or cage. The buildings seen behind and beside the Seagram Building are constructed in a similar manner, and though they are sheathed in stone, brick, or concrete, they display the same boxlike forms.

Contrast these buildings with the TWA terminal (Fig. 420). The exterior forms of this building repeat the flowing movement of those within it. They result from the use of reinforced concrete, which was poured into wooden forms much as batter is poured into a muffin tin. The fluid concrete filled the

above: 421. McDonald System hamburger stand, with identifying arches.

right: 422. JAMES RENWICK. St. Patrick's Cathedral, New York. 1850–79.

forms and, when rigid, produced a group of soaring shells which remained when the supporting forms were removed.

These examples all demonstrate the prime influence of material and structure on form in architecture.

It is possible to shape the materials of the builder into forms which deny their inherent characteristics or the structural system of the building. An obvious example is to be found in the roadside restaurant with two nonstructural but very prominent arches as a part of its design (Fig. 421). Esthetically pleasing examples can be found, including many of the eclectic buildings in imitation of early historical styles of architecture. St. Patrick's Cathedral in New York City (Fig. 422) is a relatively modern building constructed from 1850 to 1879 on a metal frame. The architect wished to create the impression that the

423. Church of St.-Ouen, Rouen. Begun 1318.

building was constructed entirely of stone, like the Gothic church of St.-Ouen in Rouen (Fig. 423). The forms of St. Patrick's Cathedral were designed with little or no concern for their structural function, and even though stone was employed on the exterior surfaces, some of the interior vaults have plaster surfaces in imitation of stone. In this instance, both form and space, as conceived by the architects, were unrelated to material and structure. Instead, they were the consequence of a desire to create an architectural illusion to satisfy the esthetic taste of those who saw and used this building.

SURFACE AND PATTERN IN ARCHITECTURE

Texture is no less significant in architecture than it is in sculpture. Stone, brick, and wood—the age-old primary materials of architecture—can be made to form patterns by the way walls and partitions are erected; or, by their very nature, the materials architects build with can provide opportunities for textural design. In the Crane Memorial Library (Fig. 424) at Quincy, Massachusetts, Henry Hobson Richardson specified rusticated, cut stone for the major wall surfaces and had the rectangular blocks arranged in parallel courses at the base of the building. Above the base, blocks of varying sizes have been organized with an apparent spontaneity that is in contrast to the regularity of the lower section. The rough, chipped surfaces of the stones provide a textural unity over the entire façade, which invests the building with a fortress-like strength and monumentality. Carved stone moldings accentuate the door and window openings and help to refine the essentially powerful conception. The wooden shingle roof, a large area of finer surface variations, creates a textural counterpoint to the stonework, echoing but subordinate to it. The line of tiles at the peak of the roof makes a strong horizontal termination to the façade and helps to pull the asymmetrical elements into a cohesive, but dyna-

mic, whole. Even here, however, the vertical pattern fixed by the tiles agitates the basic horizontality, to offer a crisp, final recapitulation of the tactile theme fundamental to the building.

A more recent example of the studied exploitation of texture as a major architectural element appears in the city hall and auditorium at Kure, Japan (Fig. 425). This complex of buildings was completed in 1962, the work of

above: 424. HENRY HOBSON RICHARDSON. Crane Memorial Library, Quincy, Mass. 1883.

left: 425. JUNZO SAKAKURA. Municipal Office and Civic Auditorium, Kure, Japan. 1962.

347

Junzo Sakakura. The architect took poured concrete as his main building material. He retained on many of the exposed interior and exterior surfaces the textures created by the wooden forms that supported and shaped the liquid, homogeneous material. The unfinished concrete, with its combination of surface irregularity and repetitive pattern, is set off against the gleaming skin of blue tile that covers the drum of the auditorium. The glazed, highly reflective, and brilliant tile has a fluency that enhances the curves of the forms it sheaths. Surface, color, and form of the auditorium oppose and dramatize the massive, coarse-grained city hall, linking the two structures in a contrasting, interdependent visual statement.

Certain materials may be preferred by an architect who wishes to integrate the design of his building with the site on which it is constructed. An extraordinary example of this approach to the esthetics of architecture is the impressive complex of buildings designed by Frank Lloyd Wright at Taliesin West, near Phoenix, Arizona (Figs. 426, 427). Constructed of local stone and

above: 426. FRANK LLOYD WRIGHT. Taliesin West, Phoenix, Ariz. Begun 1938.

left: 427. A second view of Taliesin West (Fig. 426).

opposite: Plate 68. MINORU TAKEYAMA. 2-ban-kahn, Tokyo. 1970.

Plate 69. *Notre Dame de la Belle Verrière*, Chartres Cathedral. 12th century. Stained glass window.

428. LE CORBUSIER. Savoye House, Poissy-sur-Seine. 1929–30.

wood, the forms of these buildings seem almost to grow out of the desert which surrounds them. Forms and textures of building and site share a common quality in the sun and heat of the desert.

Contrast this intimacy of texture and form with the severe separation of building and land to be found in the Savoye House (Fig. 428), whose architect, Le Corbusier, used flat concrete, glass, and steel to isolate his work from its natural surroundings. The Savoye House could be placed in many different sites without its losing essential character, for it seems to be designed as a separate and distinct unit, indifferent to the appearance of the surrounding landscape. The architectural approaches of Frank Lloyd Wright and Le Corbusier reflect two major esthetic attitudes in contemporary building, and in each instance the textures of the materials used in construction are important to the total effect of the finished architecture.

LINE IN ARCHITECTURE

Line is a secondary element in architecture, as it is in sculpture. Line exists for the architect in the silhouette of forms (Fig. 429)—in the edge created by a

above: 429. FRANK LLOYD WRIGHT. Kaufmann House ("Falling Water"), Bear Run, Pa. 1936–39.

left: 430. LEON BATTISTA ALBERTI. Palazzo Rucellai, Florence. 1446–51.

change of plane or at the juncture of two or more planes. It is also possible to consider the axis of a form or a spatial volume as having a linear quality, so that the Seagram Building (Fig. 419) can be described as having a strong vertical line, meaning a vertical axis that is emphasized. One might also refer to the vertical lines created by the forms of the metal elements, which produce the regular patterns on the surface of the same building.

In addition, many architectural features, both external and internal, provide linear effects. Among these are the horizontal bands known as "string courses," the exposed planks of half-timbered construction, the vertical emphasis of columns and pilasters, the linear directions of railings and banisters, exposed ceiling beams, cornices, and dados. Any long thin form in a building can be read as a linear element. As light-reflecting and shadow-casting features, such details offer a changing pattern of lines and edges and divide interior walls or external façades into geometric segments, the ultimate effect dependent upon the time of day, the season, or the quality of artificial illumination.

In his design for the Palazzo Rucellai (Fig. 430) in Florence, Italy, the Renaissance architect Leon Battista Alberti kept the walls flat and articulated them with a minimum of sculptural detail below the cornice at the roof line. Separations between the individual stone blocks and pilaster strips are precise, regular, and relatively shallow. They cast shadows that rule the façade like the carefully placed lines with which a draftsman divides a drawing.

Edward Durell Stone has achieved a very different linear result in his design for the United States Embassy in New Delhi, India (Fig. 431). There, the open lattice of the screen covering the atriumlike garden modifies the intense light of the Indian day and throws a dappled, striated, and shifting pattern of shadows onto the walks and reflective surfaces of the pool. Both the light and the heat are controlled by this organic, decorative feature.

431. EDWARD DURELL STONE.
Interior Court, United States Embassy,
New Delhi, India. 1954.

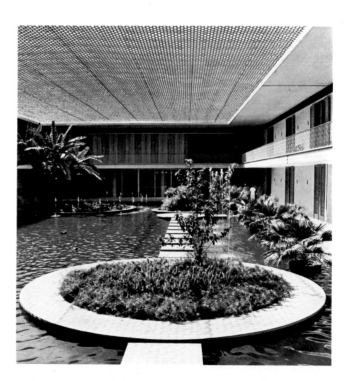

COLOR IN ARCHITECTURE

Throughout history, interior and exterior surfaces of buildings have received polychrome decoration. The three-dimensional parts of a façade like that at San Miniato al Monte in Florence (Fig. 432) can be delineated and enriched by a combination of materials in different colors. At times, colors seem to have been chosen in an effort to contradict the structural integrity of the building they decorate, to dematerialize the masonry with an aggressively active pattern. Also, the decorative effect of mosaic and painted design has often been com-

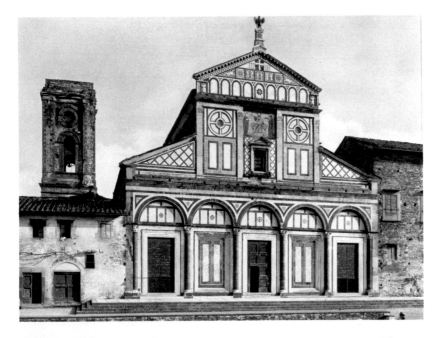

left: 432. San Miniato al Monte, Florence. Completed c. 1062.

below: 433. Antonio da Sangallo and Michelangelo. Courtyard, Palazzo Farnese, Rome. 1530–89.

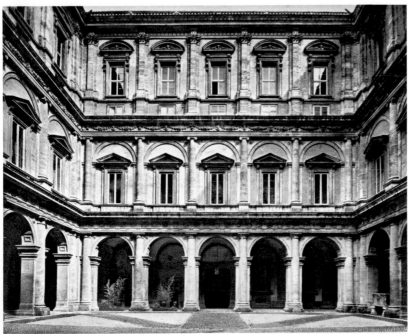

bined with symbolic content to make enthralling architectural environments. The interior of the Benedictine abbey church at Ottobeuren (Pl. 67, p. 316), in Germany, is an ambience of spatial fluidity and fantasy of form in which structural, sculptural, and painted components fuse in a pulsating relationship, whose impact is theatrical and of overwhelming proportions.

The Japanese architect Minoru Takeyama has used color in an aggressive and light-hearted manner on the exterior of 2-ban-kahn, a commercial building located in the heart of Tokyo (Pl. 68, p. 349). This unique shell houses fourteen bars, several restaurants, and a games room. Treated like a giant three-dimensional poster, the design includes mirrored glass panels that reflect the city movement and the changing light of both street and sky, making a kaleidoscopic counterpoint to the brilliantly painted walls. Festive as a fair building, 2-ban-kahn candidly proclaims its recreational purpose.

With new developments in the treatment of metals to give them permanent, integral color, with the advances made in plastics and their increased use in construction, and with the deeper understanding of the psychological function of color, it is certain that this factor will have still greater importance in the architecture of the future.

LIGHT

Even more than in sculpture, light has joined color as a functional and expressive principle in architecture. With the invention and utilization of electricity for illumination, the architect had an opportunity to reconsider many of the limitations on the design of public and private buildings.

Dependence upon natural light to make interior spaces usable required designs that employed the window as a wall-piercing device. This necessity had its positive values, for the window could be treated in many esthetically satisfying ways. It could be shaped into openings that left rhythmic accents on the surface of the wall (Fig. 430) and decorated with moldings that added detailed sculptural variations or color notations to interior and exterior areas (Fig. 433). And, of course, as in the Gothic cathedrals, window areas could be glazed with colored glass to enrich the light within the great inner spaces of the buildings, simultaneously introducing pictorial and decorative images that added expressive meaning to the function of the church (Pl. 69, p. 350).

The limited artificial light that was available tended to restrict the size of interiors for all but the wealthiest, free-spending clients who could afford the substantial cost of copious illumination.

Oil and, later, gas lighting fixtures began to affect the design of domestic and public buildings, but the availability of inexpensive electric light made possible a new era in design. When looking at the window-walled office buildings and apartment houses now common to all urban centers, one can regard the use of the window in these contemporary structures as identical in function and necessity to the use of the window in buildings a century older. It is true that the window allows light to pass through the wall, but it is equally true that interior

434. WILLI WALTER.
Swiss Pavilion, Expo 70,
Osaka, Japan.

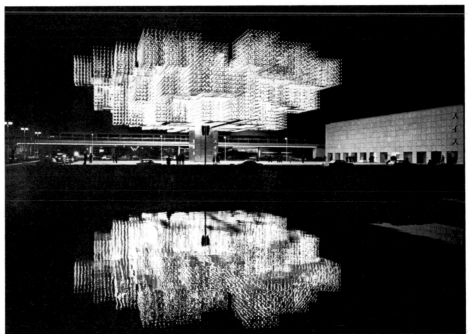

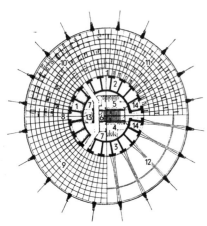

435. HARRY SEIDLER
& ASSOCIATES,
architects; PIER LUIGI NERVI,
structural consultant.
Australia Square Office
Centre, Sydney. Plan of
typical floor:
(1) low-rise lifts;
(2) medium-rise lifts;
(3) high-rise lifts;
(4) gentlemen's toilets;
(5) ladies' toilets;
(6) fire stairs; (7) ducts;
(8) lift lobby; (9) office space
showing radial and
concentric partition grid lines;
(10) typical partition layout;
(11) ceiling plan showing
lighting and sprinkler
positions;
(12) floor structure with
reinforced concrete floor
beams;
(13) goods lift; (14) express lift
to revolving restaurant
and observation floor.

walls and partitions in these same modern buildings restrict the daylight from illuminating all but the perimeter space. Light cannot enter from above, as in older, single-storied structures, and the length and width of the typical office building necessitates interior central areas on each floor that throughout the day must be lighted with artificial illumination. We have become so accustomed to the electric light that, even when after sunset we see from the exterior the lighted windows of our buildings, we rarely think of the way in which they have permitted the architect to plan his interior spaces (Fig. 419). Not until a failure of our electrical system occurs are we dramatically made aware of the interdependence of modern architectural design and lighting systems.

The pleasurable experience felt by many during the Christmas season, when colored lights brighten the night, is a simple demonstration of the esthetic potential of light. A more dramatic use of light for decorative effect is to be found in the Swiss Pavilion at Expo 70 in Osaka, Japan (Fig. 434). An aluminum "tree" of 35,000 lights has been constructed with the points of light energy massed to give the appearance of an architectural form. Though this "tree" is in fact more sculpture than architecture, it suggests the possibilities of utilizing light to define form and space in architecture without the traditional materials of enclosure. The transparent cubes that appear to exist in space in this construction take their shape from the position of the lights in clusters. Whereas the light in the late-afternoon photograph of the Seagram Building (Fig. 419) is contained by the fabric of the walls, the very walls of the Pavilion are created by the light, the dark areas in the construction performing as "windows."

SERVICE SYSTEMS

Contemporary architecture cannot be designed or understood without some consideration of several other systems that, like lighting, have become basic to the early planning stages in the preparation of complex buildings. Heating and air-conditioning systems require space for the installation of large pieces of equipment. The duct work necessary to carry the cooled air, the vents to provide and exhaust heat at critical locations, are all a part of the total design. Water and waste plumbing must be placed to coincide with the organization of walls and partitions. Elevators and escalators consume large amounts of space, and they, too, must be located in conformance with the traffic patterns that are assumed for a specific building (Fig. 435).

Some highly specialized buildings may require the installation of facilities for many services related to their function, and the cost of preparing for these services may exceed all the other costs of erecting the structure.

Buildings designed by Louis Kahn for the Salk Institute of Biological Studies (Figs. 436, 437) are composed of a stack of three laboratory floors separated by two service floors. The service floors are placed to permit easy access to the electrical, plumbing, and air-moving systems that can be directed to the laboratories above or below the service levels. The planners for the Salk Institute

left: 436. LOUIS I. KAHN. Salk Institute of Biological Studies, La Jolla, Calif. 1968.

below: 437. Section of the south building and plan, Salk Institute (Fig. 436).

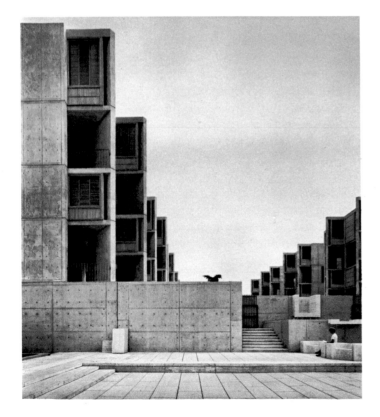

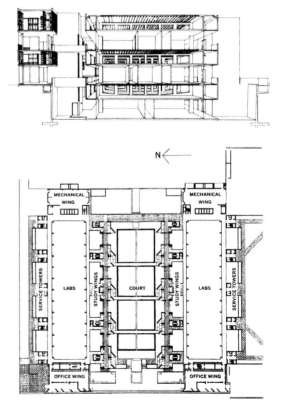

wished to provide an extraordinary degree of flexibility to suit the requirements of the scientists and technicians who might need to change the arrangement of their experimental equipment as their research progresses.

URBAN PLANNING

We have seen how individual buildings, in their conception, design, and construction, can be the result of the architect's efforts to organize the significant elements that define the purpose and appearance of his commission. It is important, however, to remember that buildings do not exist in isolation. Always, they are part of a larger system, joined to the natural environmental elements of the site. The slope of the land, the condition of the soil and ledge formations, the proximity and amount of available water, the prevailing weather—inevitably all such factors must have their effect on the design. In many instances, particularly on urban sites, a building has functioned within a man-made system of pedestrian and vehicular traffic patterns, water and waste disposal networks, and, finally, the social, economic, and political conditions found in each community.

As the world has become urbanized, a growing proportion of the population has made its way to the densely settled urban centers. Motivated by their awareness of the influence relationships among buildings have on the form and content of human life, architects and planners have devoted an increasing amount of attention to the problems of city planning.

What should a city be? How must it be organized? What goals and priorities are appropriate for the city planner? These questions confront present-day planners of such new urban centers as Chandigarh (Fig. 456), the capital of the Punjab in India, just as they face those concerned with the problems of renewal and reconstruction in cities already established. To approach an understanding of certain basic problems in modern urban design, we can examine some of the cities of the past and consider the factors that were influential in their development.

Man's desire for protection, his need to sustain himself, and the human tendency to seek the companionship of others have motivated the cooperative acts that unite men into social groups. These basic human concerns have been the root causes for siting communities in locations offering natural advantages for defense and for the production of or ready access to food supplies. In some instances, a site with the qualities of a natural fortress or strong point was desirable even though it offered difficulties for those who sought to supply the position with food and the other materials essential to the maintenance of life. By contrast, other sites more vulnerable to the ravages of nature or to the attack of alien groups were chosen because they held such appeal as sources of food and water the inhabitants were prepared to hazard the dangers in exchange for the plentiful bounty.

Fifty miles northwest of the Peruvian city of Cuzco are the ruins of the Inca citadel of Machu Picchu (Fig. 438). Discovered in 1911, this decayed

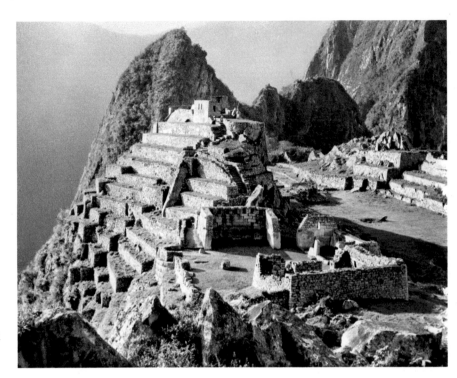

438. Aerial view of the Inca citadel
Machu Picchu, in modern Peru.
15th century.

mountain city lies astride a ridge between two peaks about 10,000 feet above
sea level. The site is extremely difficult to reach, resting as it does some 2,000
feet above the Urubamba River, which is unnavigable at this point. Sheer
walls rise above the river and make movement along the shoreline all but
impossible. Archaeological evidence indicates that some farming took place in
artificially terraced areas, but it could not have provided an easy life for the
original inhabitants. Even today, the shipment of produce over the snow-filled
passes is a chancy and tortuous business. Clearly, the extraordinary effort to
construct this complex of buildings derived from a desire to exploit the advan-
tages of the high ground as a defensive position. The Inca builders constructed
ramps and stairways. They placed narrow streets between large rock outcrop-
pings. With ingenious and remarkable feats of engineering, they wedged build-
ings under overhanging ledges. Here is a striking example of the effects of
the site on the town plan, and evidence of the willingness of the builders to
adjust their physical needs to the more important advantages that an inhospi-
table location offered to a people anxious about invaders and marauders.

The Tuscan city of Siena is a fascinating community with a long history
that begins after the tenth century B.C. during the period of Etruscan settle-
ments. In succession, the Romans, the Goths, the Lombards, and the Franks
held the town until the twelfth century, when it became a free commune. Siena
is typical of many of the hill-top Italian towns that probably share a common
basis for their foundation—the desire of a group to use the natural advantages

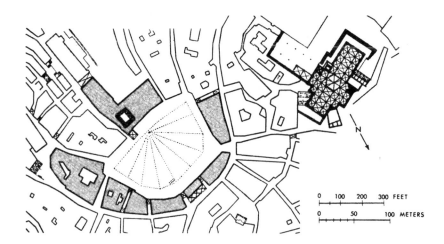

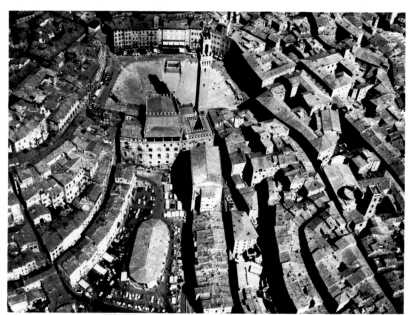

above: 439. Plan of the central area
of 14th-century Siena, Italy.

right: 440. Aerial view of Siena.

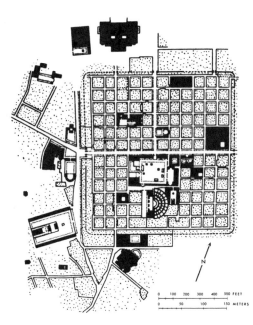

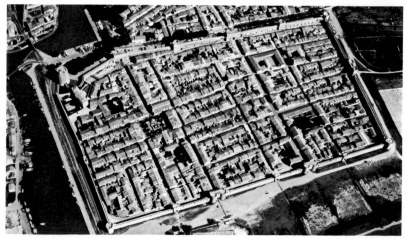

above: 441. Plan of the Roman provincial
city of Timgad, in modern Algeria.
A.D. 111–117.

right: 442. Aerial view of Aigues-Mortes,
France. Founded c. 1240.

of high ground for protection. Plotted on a flat, two-dimensional map, the streets of Siena wind in a seemingly haphazard manner, but the arrangement assumes logic when understood in relation to the topography of the land (Fig. 439). The streets fit the profiles of the hills in an organic pattern that adjusts to changing elevations, converging finally on the central square, the Piazza del Campo (Fig. 440). Here are found the main municipal buildings and the broad open space that for centuries has been the meeting place of the entire population, as well as the locus of the *Palio*, the world-famous horse race between the major sections of the city. Siena remains today relatively unchanged from the medieval form given it in the twelfth century, when the craftsmen, merchants, clergy, and noblemen established subordinate centers within the town. These smaller focuses usually surrounded a small square that fronted the local church. Each of the local piazzas provided a community center, an open space in the dense system of winding streets that surrounded it.

Circumscribing the entire city was a wall that gave the Sienese additional protection from their aggressive neighbors. Such fortifications were constructed around many early settlements, and their remains survive in cities and towns throughout the world.

Comparing Siena with a map of the ancient Roman city of Timgad (Fig. 441), a prototype for the rectangular grid pattern common to many Western urban communities, we can contrast a plan that is related to topography and internal forces organic to the population with one organized along rigid geometric lines. The arrangement at Timgad has been *imposed* on the landscape. The site is relatively flat, but even this factor would fail to account for the relentless regularity of the divisions in the plan, had not the planners begun with a preconceived idea. The basis of this conception was the typical plan of a Roman military encampment. As the conquest and settlement of the surrounding territory advanced, this scheme was carried over into the city that arose on the camp ground. The arrangement is almost identical in principle to that of the numerous cities located in the former holdings of the Roman Empire and founded by the Roman legions. Main avenues begin at the gates that protected the entrances. At the crossing of the primary thoroughfares was placed the civic center, actually the symbolic heart of the community. Secondary centers were distributed throughout the city, their size and positions made to conform to the fundamental rectangular module.

A later form of the rectangular-plan fortress city is that underlying Aigues-Mortes in southeastern France (Fig. 442). Founded about 1240 as a staging point for the Crusades of St. Louis, king of France, this so-called *bastide* town is another demonstration of a scheme that provides an easily organized system of streets and lots within an enclosed, protected perimeter.

Both Timgad and Aigues-Mortes are cities imposed on the land. They were created at the will of a powerful central political agency to fortify and hold a section of the countryside that belonged to the ruling power. Like Siena, they were intended to provide protection for the inhabitants, but in a way uncharacteristic of the Italian city this was their primary function. Thus, when political

conditions changed these cities died or languished, for though a community may be raised to satisfy the need for protection, its continued existence is dependent upon the vitality of the activity within it. To remain vigorous, cities must be susceptible to the changing needs of the economic and political units they serve. Siena has always been an important commercial center. Situated between Rome and Florence, the city continues its role as a transfer point. It serves the merchants and craftsmen of the region.

Commerce in its various guises is another basic force that has stimulated the establishment and growth of urban environments. Many communities have risen at important crossroads, and natural harbors and inland waterways have attracted settlers who used them for the transportation of goods as well as for ready sources of food.

For the first colonists, the great bay at the terminus of the Hudson River was an obvious site for a settlement. Situated at the edge of the sea, it offered a harbor that could serve the vessels transporting goods to and from the European continent. The river provided a waterway to the interior of the land, permitting settlers to move north and the produce of their farming and trapping enterprises to come down river to the ships waiting to convey the produce abroad. As the settlement grew, modifications were worked upon its plan, and these offer a revealing insight into the dynamics of urban change.

The southern tip of New York City, as shown in a seventeenth-century map (Fig. 443), is composed of a system of streets in part established by the first plans that were drawn in 1660 by Jacques Cortel, at the request of town officials of the community then known as New Amsterdam. The fortified northern boundary is identified on the map of 1797 (Fig. 444) as Wall Street. The adaptation of the plan to the topography is obvious in these early maps. The site is an island, and the focus on the shipping, wharfage, and commerce activities of its periphery is visible. As the city grew northward, the early north-south avenues were extended within the central portion of the community. Shoreline streets still served the sea-going and related commercial interests of this growing port. Narrower connecting streets tied the business and residential areas together in a flexible but functional pattern.

The 1828 lithograph reproduced in Figure 445 suggests the appearance and activity of the port city at a time when a major segment of the community's life was centered upon shipping.

A map published by the City of New York in 1811 (Fig. 446), based upon a survey of 1807, shows plans for the division of the island for future development. The original map of the new plan was almost 8 feet long, but even in the small reproduction used here the contrast is evident between the grid plan imposed upon the northern reaches of the city and the organic planning of the seventeenth century.

The "Commissioners' Plan" in Figure 446 was the result of a legislative act that sought to divide lands that had been expropriated from fleeing British Loyalists after the American Revolution. The rectangular division of lots was a device for the creation of blocks of land that could be sold efficiently. As at

left: 443. Map of New Amsterdam, made in 1670 from a 1660 map by JACQUES CORTEL. Museum of the City of New York.

below left: 444. Map of New York City. Published 1797. New York Public Library (I. N. Phelps Stokes Collection of American Historical Prints).

below right: 445. WILLIAM I. BENNETT. *South Street, New York City.* 1828. Lithograph. New York Public Library.

446. "Commissioners' Plan" for New York City, the first representation of the "gridiron" street pattern. 1811. Map adapted by William Bridges from the 1807 survey of John Randel, Jr., and engraved by P. MAVERICK.

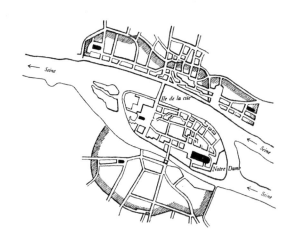

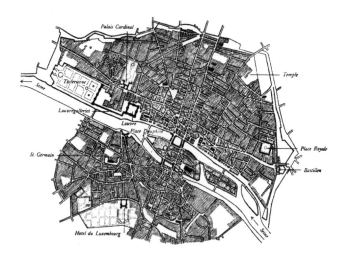

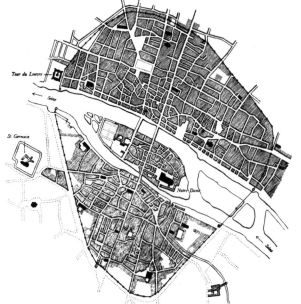

447. Maps of historic Paris. *above left:* Paris in the Early Middle Ages. *below left:* 13th-century Paris. *above right:* 17th-century Paris.

below: 448. Aerial view of the Louvre and the Tuileries Gardens, Paris.

Timgad, there was no meaningful relationship among the people, their activity, and the land. We have here an instance in which the land of the city has become an important economic force. Just as the plan of lower Manhattan expresses the way in which patterns of urbanization are shaped by the productive work of the community, the plan of the northern section demonstrates the economics of the ownership and sale of real estate as an important design consideration in densely populated areas. The appearance of New York City today is a direct result of the economics of industry and commerce interacting with the economics of real estate.

As land becomes more desirable its economic value is enhanced. Economic pressures encourage utilization of valuable land, which in turn produces an

increase in the density of population. In New York City these forces were among those that caused the construction of high-rise buildings situated on relatively small street level acreage. High land values have their effect also on one of the most troublesome factors in the design of modern cities—circulation, the patterns of vehicular and pedestrian traffic. In the small community, movement is a secondary consideration. People and vehicles move between buildings for short distances only. Towns surviving from the Middle Ages and the small New England villages established in the eighteenth and nineteenth centuries are filled with narrow streets and paths providing delightfully picturesque walkways but uncomfortable, inefficient, and dangerous passage for modern vehicular traffic. As the life of the city becomes more complex and related groups and activities are separated by greater distances, the problems of traffic multiply enormously. An unhappy conflict has now developed between the need for space adequate to the requirements of streets, avenues, and mass transportation networks and the rising value of the land that lies beneath the circulation system.

One of the classic solutions to this problem was demonstrated in the nineteenth-century redevelopment of Paris by Baron Georges-Eugène Haussmann. Medieval Paris was an important center of commercial, political, religious, and educational life. The original site of Paris (in antiquity called Lutetia) was settled before Julius Caesar's conquest of Gaul. The small island now known as the Ile de la Cité in the middle of the Seine River provided both protection and opportunities for easy access to food and water. When the Romans subdued the Gaulish lands they rebuilt the island town and surrounded it with a wall. They also improved the bridges that joined Lutetia to the mainland. Under Roman rule the city grew in importance as the capital of northern Gaul (Fig. 447, above left). By the twelfth century, after five hundred years of Frankish rule, Paris was one of the great European cities. The left and right banks of the Seine were developed, and some of the streets still serving modern Paris were laid down (Fig. 447, below left). As the city grew along the banks of the river and out away from them the protective walls were rebuilt to enclose the new areas. A circular development emerged from the tendency of the builders to keep to the flat land that was enclosed by a rim of surrounding hills (Fig. 447, above right). The exception to this rule was the system of streets that wound around the high crest of Montmartre, now capped with the Church of the Sacré Cœur.

As the royal city of the French kings, Paris in the sixteenth and seventeenth centuries was treated in a manner consistent with the symbolic function of the seat of monarchical power. The great form and space arrangement of the Tuileries-Louvre palaces and grounds was undertaken at the end of the sixteenth century and completed in the nineteenth century (Fig. 448). With Renaissance admiration for symmetry and geometric order, a succession of French rulers continued to add to this complex until it became the eastern end of an important axis that eventually was carried to the Arc de Triomphe and then beyond to the suburb of Neuilly. This grand projection along the Champs-Elysées gratified the taste of seventeenth-century planners for the creation of deep spatial compositions and dramatic vistas. Such love of receding spaces is thought

by some historians to be related to the earlier development of linear perspective and its use in the illusionistic painting of the Renaissance and Baroque periods.

A source for the concepts informing the French Baroque town plans can be found in the work of Andrea Palladio, one of the most important and influential architects of the sixteenth century. Palladio conceived of the street as an esthetic space, and in his designs for the permanent stage set of the Teatro Olympico, in Vicenza, the Italian architect constructed an image of the ideal city, a place of ordered perspective vistas created by carefully related façades whose alignment in parallel positions defines a dramatic corridor leading to an important far-off focus (Fig. 449). Combined with intellectually determined and designed spaces, plazas, or squares, this esthetic model was the basis for much of the formal

left: 449. ANDREA PALLADIO. Interior, Teatro Olympico, Vicenza, Italy. 1580–84.

below left: 450. Aerial view of the Place de la Concorde, Paris. Designed and built in 1753–70 as the Place Louis XV.

below: 451. Haussmann plan of Paris. 1853–69.

organization of city plans prior to the nineteenth century, and it prevails today in many cities throughout the world. Once made to serve the absolutism of the Bourbon monarchy, the plaza—used at Siena to set off a building or by the populace as a meeting place—became a monumental space, as in the Place Louis XV, now the Place de la Concorde (Fig. 450). Protected from the citizenry and open at the corners, as well as at three central points, such a space has the character and form of an outdoor stage, a focus for all the grand avenues converging upon it and the scene of the pompous pageant of royal dramas, as well as the public execution of Louis XVI during the French Revolution.

At the beginning of the nineteenth century, Paris was a grand symbol not only of opulence but of regal indifference toward the problems of its inhabitants and toward the physical conditions of those quarters lying beyond the grand boulevards. In 1825 the English essayist William Hazlitt could write that "Paris is a vast pile of tall and dirty alleys, of slaughterhouses and barber shops, an immense suburb huddled together within walls so close that you cannot see the loftiness of the buildings for the narrowness of the streets."

When Baron Haussmann was given the commission to renovate Paris in 1853 he received a city that was in actuality a conglomerate of many separate districts. Water and sewage systems were primitive or nonexistent for most of the community. Transportation was difficult, for though grand avenues flanked the length of the Seine, much of the street system covering the rest of Paris was a legacy from the Middle Ages, a mazelike warren of discontinuous passages that no longer served the capital's complex needs. After a prolonged survey study of the metropolis, Haussmann proposed a plan that would integrate Paris into an operative unit. He based his scheme on the creation of a system of circulation that would release the city from internal strangulation and permit it to function. Traffic flow was the key to the entire plan. He pulled districts together by connecting them with broad avenues which he caused to be cut through the impacted chaos of medieval accumulation. Plazas were introduced, not for their ceremonial value but as interchanges for intersecting boulevards and avenues (Fig. 451).

Haussmann had another basic concept in his plan. He sought to open the city, to allow light and air to fill the atmosphere all the way to the level of the street. To this end he introduced open spaces into the street pattern, places left free of buildings and roads. Like skylights in a building, these openings would provide relief from the vertical walls lining the city's streets.

The autocratic power of Napoleon III supported the Haussmann program. To attain his goals, the planner ruthlessly had to hew giant swaths through the fabric of the old city. An inconceivable procedure for a contemporary democratic urban center, Baron Haussmann's renewal effort required, before it was completed, that three-sevenths of all the houses in Paris be destroyed, among them many important architectural monuments of the past. Critics differ in their estimate of the Haussmann achievement. They point out that despite the planning and the construction of roads, Paris still retained many of its traffic problems in the areas between the avenues. They condemn the wholesale

below: 452. Plan of Bournville, England. 1879.

right: 453. Aerial view of Harlow, England. Planned 1947.

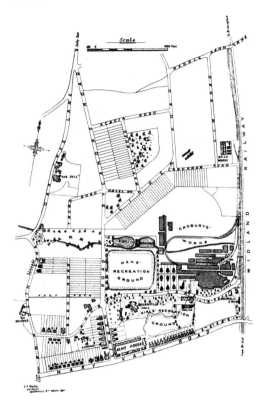

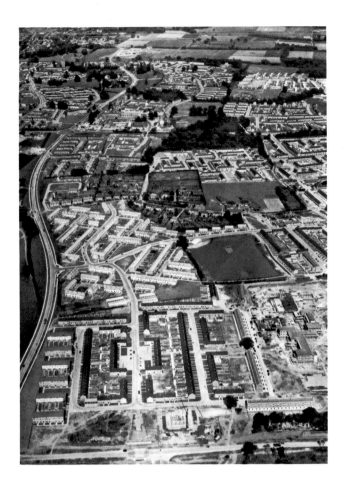

destruction of major sections of the city. What remains, however, many years after the plan was executed, is a civilized environment of extraordinary charm and quality. The narrow sections of the city continue to provide spaces whose human scale contrasts with the theatricality of the boulevards. Paris still has its neighborhoods, each with its own character and its small park or open space. Not a few of the problems now troubling New York City also beset Paris, but they seem a bit less oppressive when removed from the dispiriting monotony of the rectangular grid that subdivides the American city into anonymous and repetitive spaces.

The industrialization of the city in the nineteenth century brought with it a chaotic expansion that quickly spread from the industrial towns to the major capitals of Europe and the United States. Human values eroded as the factory buildings, transportation means, and residential areas of the working classes were intermixed into a confused, compressed density of men and machines. Attempts were made to combat the dehumanization of the industrial laborer and the degeneration of city life. In England, as early as 1879, the Cadbury family purchased land to build a community for the workers in their chocolate

factories. The town of Bournville (Fig. 452) was designed to give to the factory hand the advantages of English village life. This self-contained community has many of the characteristics of the *zoned garden city*, which has been the basis for much of the decentralized planning done by twentieth-century environmental designers. The community's internal road system is independent of a perimeter loop. As planned, the town combines housing with related green space. The recreation needs of the population have been accounted for, and, finally, the industrial area is located at one end of the community, somewhat apart from, but convenient to, the residential area.

Similar communities were established by other proprietary industrial families with a paternalistic concern for their workers, but not until 1898, with the publication of the theoretical writings of the English socialist Ebenezer Howard, did the idea of an autonomous garden city develop in detail. Howard described an ideal city of no more than 32,000 persons. His plan called for a series of concentric circular zones with a park at the center, surrounded by public buildings that in turn would be ringed by houses and gardens. Beyond this zone, at the perimeter of the settlement, were the factories. The whole plan was assumed to occupy the space that could be enclosed within a circle 1 mile in radius. Howard's plan was in reality an attempt to destroy the centralized city and the evils it appeared to generate. By decentralizing the population and the industrial machine, Howard hoped the individual human being might enjoy the fruits of his labor in an environment that encouraged the growth of his human potential.

The concept of the garden city has been one of the most influential forces in town planning in the last fifty years. Harlow, England, one of the "new towns" started after World War II, is a typical example of the modern garden city (Fig. 453). The town is highly decentralized. Rows of attached homes are surrounded by large areas of green space. Complete with its own shopping center and zoned industrial district, this community has much in common with many similar projects developed in the United States during the same period. It also has a remarkable similarity in concept and form to Bournville, the Cadbury workers village, designed seventy years earlier (Fig. 452).

Recent critics of the garden city solution to urban problems insist that it is not possible to decentralize the city and yet conserve the environment. They assert that the density of a central urban complex is necessary to maintain a viable economic structure. Decentralization places heavy burdens on transportation and communication systems. In addition, the pro-city advocates find themselves attracted to the metropolitan center, even with its present problems. For them the city, because of its size and complexity, is a vigorous, exciting place. It provides the opportunity for interaction with other people, representing a wide range of life styles, in an association stimulating to thought and creativity. In their view, modern civilization would be unthinkable without the city. These observers insist that the solution to human ills lies not in the destruction of the urban environment but in its improvement so that the deleterious forces may be reduced and the civilizing potential enhanced.

Architects Moshe Safdie and Paolo Soleri have sought to redesign the city by moving the circulation systems above the ground level, their purpose being to conserve space, just as the tall building did in elevating the residential unit. Safdie, an Israeli, seems to find his inspiration in the clusters of houses that rise steeply from the edge of the Mediterranean in so many seaside sites, climbing the hills in a geometric pattern resembling an arrangement of children's blocks. Figure 454 is a model of Safdie's proposal for a community of 1,500 units to be constructed in Jerusalem. The complex includes covered parking areas, pedestrian streets, and private terraces—all part of an interlocking design that provides a densely populated area with many of the amenities found in unattached housing.

Paolo Soleri dreams of even greater achievements. He conceives of great self-contained urban environments that rise from the level of the ground to stand free in the landscape. Soleri considers these complexes ecology-conscious architecture, and he has coined the world "arcologies" to identify them (Fig. 455). The scale of Soleri's proposals is enormous, for they are intended to serve the needs of metropolitan-size communities. They compose the residential, commercial, and cultural components of our horizontal cities into vertical configurations, the whole of it joined to a matrix of automated transport.

A somewhat more conservative solution to urban planning has been developed at Chandigarh, one of a number of new cities conceived and constructed for Eastern and African countries. The Swiss architect and planner Le Corbusier became a member of a team commissioned in 1950 to design the new capital

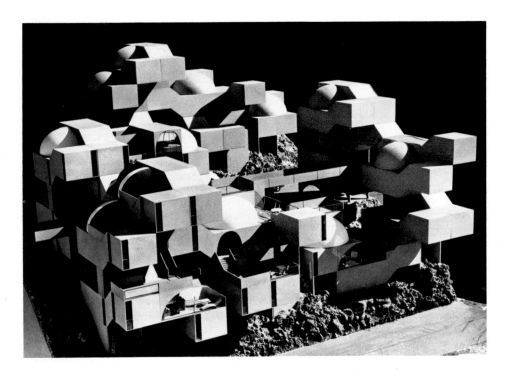

454. MOSHE SAFDIE.
Model, "Habitat Israel."
Commissioned 1969.

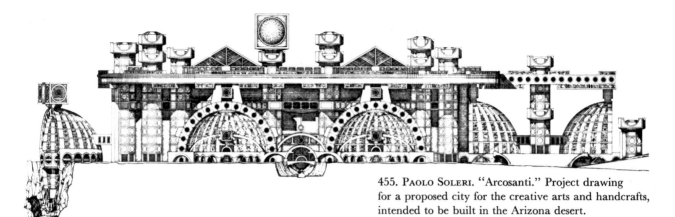

455. PAOLO SOLERI. "Arcosanti." Project drawing for a proposed city for the creative arts and handcrafts, intended to be built in the Arizona desert.

of the Punjab. This project was to include residential areas, a commercial center, a government compound, an industrial area, religious buildings, schools, and a university. Included, too, were the means of transportation, sanitation, power, and service necessary to the operation of a modern city with a population of 23,000 (Fig. 456). Le Corbusier's master plan for Chandigarh was based on the following principles:

1. A city center free of congestion.

2. High density concentration of the population.

3. Pedestrian and vehicular traffic accommodated at flows consistent with the needs of the city.

4. Large park and recreational areas integrated into the total scheme.

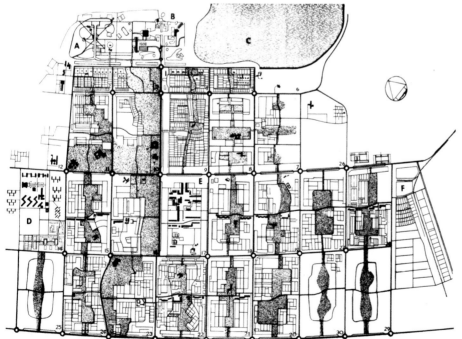

456. LE CORBUSIER. Master plan of Chandigarh, India. Begun 1953.
A. Rajendra Park.
B. Capitol complex.
C. Lake.
D. University (Sector 14).
E. Central business district and civic center (Sector 17).
F. Industrial area.

To realize these goals Le Corbusier began by devising a seven-level traffic system to permit different patterns of movement through and around the city. Beginning with the major highways that link Chandigarh to other cities, the network provides specialized roadways for fast-moving vehicles, shopping streets, loop roads that distribute slow-moving traffic, paths that lead to the doors of houses, and tracks designed to carry pedestrians and cyclists through the community's park belts. The high-speed routes divide the city into thirty sectors, each approximately the size of a typical Punjab village. Though no two sectors are identical, all follow the same basic plan. Each contains a park, a bazaar strip intersecting the park, a loop roadway meant to distribute traffic within the sector, and blocks of housing that fill the irregular areas between the park and the perimeter roads. The government district is at the north of the city, situated before a range of low mountains. At the western end of the development is the university sector. The main business district and civic center have been located at the core of the arrangement of sectors and the industrial area at the eastern boundary of the city.

Complete as the plan for Chandigarh was, its fulfillment has left some critics unhappy with the environment the scheme produced. Norma Evenson, who has written a definitive study of Chandigarh, admires much of the work that went into the plan and its implementation, but she also provides some cause for reflection: "Chandigarh is a reminder that cities, like human beings, are not easily reduced to formula, and the good city may be as much of a bore as many good people." [1]

Basic to urban planning is an awareness of the cultural, economic, educational, and physical requirements of the affected population. These factors influence major design considerations, such as traffic and transportation systems; the location of educational, health, and governmental centers; the density of housing; the need for and location of commercial and industrial centers and of public spaces for group interaction. The history of the city, including recent designs, emerges from some combination of these design variables.

At one time social and economic concerns would have had little influence on urban planners. Emphasis in design would have been placed on those elements that controlled the esthetic organization. The forms of buildings, the spaces about them and the spaces their occupants could see, the textures of the city, plantings, building surfaces, and the light that filled the streets would all have played important roles in the artist's conception. These factors would have been applied to the practical problems of civil defense, the disposition of vehicular and pedestrian traffic, and an accommodation and exploitation of the physical features of the landscape. Other basic planning elements included the economic demands of the city, a concern for raising sufficient monies to construct, maintain, and expand the design. Systems for the supply of power and water, for waste disposal, and for transportation were required as the complexity of the city increased and concern for human needs intensified.

Now, however, many planners and critics of environmental design point out that the functional, social, and esthetic elements of planning cannot be

considered separately; they interact to create an extraordinarily complex system, with more variables than can be controlled by the methods now employed in an attempt to solve urban problems. Such critics state that the design of cities and the application of design elements take on meaning only as they affect the people inhabiting these cities.

New urban designs and plans for redevelopment of existing urban concentrations require an understanding of how city populations live and interact, and very little is known about these processes. One of the foremost contemporary critics of city planning, Jane Jacobs, has made the following statements in her book *The Death and Life of Great American Cities:*

> One principle emerges so ubiquitously, and in so many and such complex forms. . . . This ubiquitous principle is the need of cities for a most intricate and close-grained diversity of uses that give each other constant mutual support, both economically and socially. The components of this diversity can differ enormously, but they must supplement each other in certain concrete ways.
>
> I think that unsuccessful city areas . . . lack this kind of intricate mutual support, and that the science of city planning and the art of city design, in real life for real cities, must become the science and art of catalyzing and nourishing these close-grained working relationships.[2]

Miss Jacobs would add to those elements that are basic to the organization of city plans two primary human requirements: a sense of personal security and a provision for public contact and personal privacy. She sees the design of cities

457. Street in Vicenza, Italy.

as the creation or encouragement of a number of essential processes necessary for the healthy urban organism. Design elements are valuable, she argues, only as they become part of a viable organic system that permits the human being to have a sense of participation in a living, interdependent social group (Fig. 457).

Albert Chandler's discussion of the satisfaction required for the esthetic experience (see p. 6) includes this definition: "The word *satisfaction* may be defined indirectly as the state of mind which is indicated by the willingness to prolong or repeat the experience in question." If we apply this criterion to the experience of the urban environment, we can agree that the esthetic response to a city is directly related to the feeling of comfort and ease that one has in it. The sense of pleasure evoked by parks, individual buildings, and certain streets may be considerable, but an esthetic response to a city as a whole can be measured by the desire one has to return to it.

The plastic elements of architectural design and urban planning have traditionally been thought of as physical entities capable of being organized into a rational and esthetic order or system. Current theories of planning have introduced sociological, economic, and psychological factors into the design process, relating esthetic considerations directly to the sense of well-being that is generated by the environment.

chapter 12

ARCHITECTURE
*Esthetic and
Expressive Organization*

Architecture throughout history has never eliminated the concern for the interior volumes contained by the exterior shell. In certain periods this concern has taken precedence over the esthetic relationships of the external elements in the design of a building, and the appreciation of architecture must include an awareness and concern for the nature and quality of interior space. This does not mean that it is impossible to be impressed by the exterior of a building. The size, the shape, the materials, and the overall design of the outside of a building are often esthetically satisfying, even thrilling, but this is only a part of a building. As it is possible to respond to one small part of a painting, so, too, it is possible to respond to a portion of an architectural work. More complete understanding can come only with an interaction between the viewer and the entire building, inside and outside.

This kind of total appreciation presents problems more difficult in architecture than in any other form of the visual arts. As in the case of seeing sculpture, there is the problem of the partial view, the necessity of seeing only a portion of the work at any one time. In architecture the problem is amplified. A piece of sculpture may be seen completely from the outside, whereas a full knowledge of a building requires the experience one has within the enclosed space as well as outside it. The size of the architectural design is often a complicating factor in the process that leads to its appreciation. To understand a building that covers hundreds of square feet and is constructed on more than

one level means that the observer must relate spaces and forms isolated by the barriers of walls and stairways. It requires the ability to see esthetic relationships between visual experiences separated by minutes and possibly by hours.

The esthetic organization of architecture is often based upon the principles of unity and variety common to both painting and sculpture. The Pazzi Chapel in Florence, by the Italian architect Brunelleschi, lends itself to this kind of examination (Fig. 458). The dominant element on the front of the chapel is a screenlike façade, which introduces the characteristic design elements used repeatedly throughout the building. Six columns with Corinthian capitals are set in two groups of three. The same rhythm is repeated on the flat upper portions of the façade, but here the columns are replaced by twin pilasters of smaller scale. Areas between the pilasters are filled with rectangular panels. An arch connects the two sections of the screen, which flank the entrance, focusing attention on the front doors just beyond the porch. A combination of horizontal and vertical elements, curved arch forms, and Corinthian details are stylistic devices unifying the building both within and without.

Repeated pilasters adorn the outer walls of the chapel, echoing the division of space established on the front screen. This same rhythmic scheme is found

inside the building on both the long walls (Fig. 459). Tall, narrow windows topped with arches are placed between the pilasters, and they, too, are found repeated as decorative moldings within.

The interior space is covered by a large ribbed dome, which rises from supporting arched elements, echoing the curves in the porch. Each flat wall surface is tied to the general decorative scheme in a consistent repetitive use of vertical, horizontal, and curved motifs. Even the domed space of the main body of the chapel finds its introduction in a smaller dome over the entrance of the porch and its echo over the alcove that houses the altar.

The plan of this building shows an essentially symmetrical composition, but it does not suggest the variety of spaces created within the basically simple scheme (Fig. 460). The sheltered, shadowy space of the porch leads the viewer into an inner volume that rises upward into the interior dome, which is illuminated by a group of circular windows between the ribs.

A more detailed analysis would find additional repetitive elements that tie the parts of this structure into a single unified composition. Here, then, is an example of a classic method of esthetic organization, repetition, used in architecture as a means of producing an elegant series of planes and spaces.

opposite: 458. FILIPPO BRUNELLESCHI. Pazzi Chapel, Florence. 1429–43.

right: 459. Interior, Pazzi Chapel (Fig. 458).

below: 460. Plan, Pazzi Chapel (Figs. 458, 459).

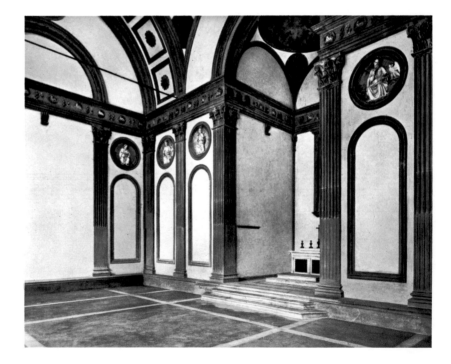

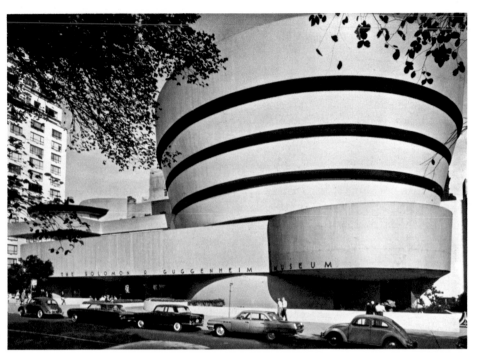

461. FRANK LLOYD WRIGHT.
Solomon R. Guggenheim Museum,
New York. 1959.

Repetition has also served as the primary compositional device in the Solomon R. Guggenheim Museum (Fig. 461). Here, the architect, Frank Lloyd Wright, took the curve as the basic design motif.

The museum exhibition area is a great open, spiral ramp, which descends six stories from a ribbed, translucent dome to the ground level. This spiral is housed in the southern portion of the museum. From the outside, the inner structure is mirrored in the inverted truncated-cone form of this main section of the building. To the north a smaller cylindrical mass houses the administra-

462. FRANK LLOYD WRIGHT.
Auditorium, Solomon R.
Guggenheim Museum (Fig. 461).

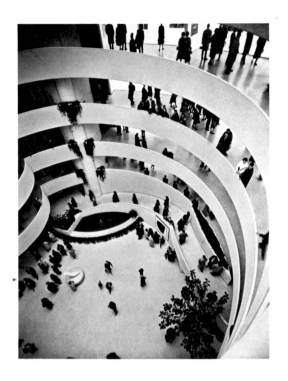

tive offices and library. The two curved sections are tied together with a massive horizontal band, which contrasts against the curves while also functioning to relate the building to the ground plane and to provide the dramatic emphasis for the entrance. A secondary repeat of the horizontal occurs above the lower band, in a form of cornice, which creates a sharp angular contrast above the rounded corner of the building at the northwest.

A visitor enters the museum under the horizontal mass. The low ceiling height of the shadowed entrance dramatizes the great volume of space and light that expands out and up from the entry. Nowhere is one permitted to forget the unity of this extraordinary composition. Throughout the building, curved forms are repeated: on the exterior, in the design of windows, screens, walls, and planting areas, and, of course, in the two masses comprising the main features of the façade; in the interior, in the shape of the lavatories, the elevators, and even the pattern of the terrazzo flooring, which echoes the motif. An intimate auditorium in the basement has a stage, seating area, and ceiling which continue the circular repeats (Fig. 462).

Contrasts to the dominant shape are to be found in the spiral itself. Instead of permitting the rising curve to continue unbroken from floor to dome, Wright interrupted the corkscrewlike movement with a section on each story that bulges out in a reversal of the main arc (Fig. 463). Another important contrast begins with the design of the main stairwell, which abuts the ramp. In this area it is the triangle that unites all elements of the design (Fig. 464). Like the repeated curves in the gallery, the triangular repeats are everywhere, even in

left: 463. FRANK LLOYD WRIGHT. Ramp and reflecting pool, Solomon R. Guggenheim Museum (Fig. 461).

right: 464. Stairwell, Solomon R. Guggenheim Museum (Fig. 461).

Architecture: Esthetic and Expressive Organization 379

465. FRANK LLOYD WRIGHT.
Interior dome,
Solomon R. Guggenheim Museum
(Fig. 461), New York. 1959.

the exterior shape of the stairwell pylon, which intersects the coil of the spiral on the east side of the building. Stairwell and main gallery are joined compositionally by the introduction of the triangular shape in recessed lighting fixtures, which dot the ceiling of the ramp, and finally in the ribs of the dome which crowns the building (Fig. 465).

Like the painter or sculptor, both Brunelleschi and Wright sought to order their compositions by using repetition, continuity, and contrast; but, unlike their counterparts in the other two visual arts, the architects had to consider more than the esthetic organization of their designs when faced with the problem of creating these two structures. Before Brunelleschi's building was a complex composition of curves and horizontal and vertical elements, it had to be considered a *chapel*—a structure that would stand erect, a shelter in which a group of people expected to worship their God. Before Wright's design could exist in space, it had to be constructed with sufficient strength to function as a ramp that would carry the weight of hundreds of people and to support the dome over it. It also had to resolve the problems of lighting and displaying a collection of paintings and sculpture.

An architect applies the principles of composition employed by other artists, but he must conceive of these principles within an esthetic scheme which includes practical limitations that do not apply to the other two visual arts.

Vitruvius, who wrote his *Ten Books on Architecture* in the first century B.C., stated that the fundamental principles of architectural design were convenience, beauty, and strength. In our own time, the word "function" has often been

substituted for "convenience," and to this requirement has been added the idea that beauty and strength (that is, esthetic order and the structural use of materials) are inseparably united. In some instances, architects and critics of their art have insisted that all three are part of one unity. "Form follows function" is a phrase often used in architectural criticism, and it is interesting to note that the belief in an interdependent relationship between esthetic value and usefulness had its champions in the United States as early as the middle of the nineteenth century. The American naval architect John Griffiths, in 1849, published a book on the theory and practice of ship building, in which he said: "With regard to beauty in ships, we have said that it consisted in fitness for the purpose and proportion to effect the object designed."[1]

Louis Sullivan, an American architect who worked at the end of the nineteenth century, was one of the leaders in the development of this idea in the design of buildings. In an essay discussing the problems inherent in the design of tall office buildings, Sullivan stated his beliefs as follows:

It is my belief that it is of the very essence of every problem that it contains and suggests its own solution. This I believe to be natural law. Let us examine, then, carefully the elements, let us search out this contained suggestion, this essence of the problem.

The practical conditions are, broadly speaking, these:

Wanted—1st, a story below-ground, containing boilers, engines of various sorts, etc.—in short, the plant for power, heating, lighting, etc. 2nd, a ground floor, so called, devoted to stores, banks, or other establishments requiring large area, ample spacing, ample light, and great freedom of access. 3rd, a second story readily accessible by stairways—this space usually in large subdivisions, with corresponding liberality in structural spacing and expanse of glass and breadth of external openings. 4th, above this an indefinite number of offices piled tier upon tier, one tier just like another tier, one office just like all other offices—an office being similar to a cell in a honey-comb, merely a compartment, nothing more. 5th, and last, at the top of this pile is placed a space or story that, as related to the life and usefulness of the structure, is purely physiological in its nature—namely the attic. In this the circulatory system completes itself and makes its grand turn, ascending and descending. The space is filled with tanks, pipes, valves, sheaves, and mechanical etcetera that supplement and complement the force-originating plant hidden below-ground in the cellar. Finally, or at the beginning rather, there must be on the ground floor a main aperture or entrance common to all the occupants or patrons of the building.[2]

How different are the functions of a building of commerce rising out of the streets of Chicago or New York in the twentieth century from the functions of a building dedicated to an ancient god, sited on a plateau overlooking the Mediterranean over two thousand years ago! Geography, history, economics, politics, religion—all these can have their effect on the function of any single building in the architectural continuum. But essentially there are three major functions that must concern the architect: the *operational* function, the *environmental*

function, and the *expressive,* or *symbolic,* function. Often, one of these areas dominates the other two in the development of a particular stylistic period. Ideally, they would all make important contributions to the resolution of any one architectural design.

THE OPERATIONAL FUNCTION

Who is to use the building? How many people will occupy it? What will they be doing when they are within it? These are questions which would apply to the operational function of a building. In the extensive study of architecture entitled *Forms and Functions of Twentieth Century Architecture,* edited by T. F. Hamlin, the table of contents lists forty-two building types. Under the headings "Buildings for Residence," "Buildings for Popular Gatherings," "Buildings for Education," "Government Buildings," "Commerce and Industry," "Buildings for Transportation," and "Buildings for Social Welfare and Recreation" the contributors discuss the problems relating to the design of each of these categories. Our society has grown so complex, its needs served by so many specialized groups and highly sophisticated organizations, that it is no longer possible to restrict the forms of architecture to a few limited types.

A partial list of the limitations facing an architect who must design a space suitable for the operational requirements of the occupants includes traffic patterns; room sizes and shapes; location of various areas of activity; wall, floor, and ceiling finishes; acoustics; plumbing; lighting; and ventilation. The simple problem of how the occupants are to reach the upper levels of the building may take on a major significance in the development of a design. Finally, it must be noted that one of the most pressing practical concerns of the architect is cost. With rare exceptions, the architectural designer is always faced with the problems of budgets and the concern of his client to control the construction and operating costs of the building. One must always remember that the architect's designs are never complete on the drawing board. They reach completion only after the drawings are transformed by the efforts of masons, carpenters, plumbers, and electricians, each of whom requires instruction and supervision, and, of course, recompense for his labor.

THE ENVIRONMENTAL FUNCTION

Given the forty-two building types mentioned above, the architect must think of his building not just as an efficient machine designed to facilitate the activity of its tenants but also as an environment in which human beings will spend a portion of their day. This obvious statement is not so self-evident as it may seem. The human being has often been considered a cog in some huge mechanism. Often, his physical needs have been satisfied, but little concern has been given to his emotional or esthetic needs. Today, however, there is a growing awareness of the connection between environment and human efficiency in the production of goods by the efforts of men and women. Office buildings

466. RICHARD NEUTRA.
Room in the Von Sternberg House,
Santa Monica, Calif. 1935.

and huge assembly plants, as well as other structures designed for commercial, industrial, and public purposes, house great populations for a substantial portion of their lives. The atmosphere in which these people work cannot fail to affect them, and, of course, whatever may be said for the buildings that shelter our public and economic complex is equally, or even more significantly, pertinent to the design of our residential architecture.

Light, color, the size of rooms, the kinds of materials used—all can have a pronounced effect on the physical and psychological response to the architectural environment. The architect begins with the individual human being—his size, his need for identity as an individual, his response to sound and movement in his restricted sphere of activity. Within the restrictions imposed upon him by the operational functions of the building, the architect can try to create the environment that best suits the needs of his building. Are the occupants required to be alert? Are they required to be impressed by the social, or perhaps the political, significance of the structure?

Richard Neutra, architect and theoretician, concerned himself with the problems of architectural design as the creation of environment (Fig. 466). He noted that we are most conscious of possible effects of an architectural environment upon us when they are presented in the extreme. As an example he cited the design of certain "fun houses" in amusement parks, in which the rooms are built askew and the angles and planes of the walls are constructed in bizarre relationships. The occupant of such a room is placed in a different environment from that which he has normally experienced, and often he becomes puzzled or even frustrated by it. His sense of the pull of gravity no longer relates to the visual experience he is having. Size and space relationships are confused.

The whole is a striking example of how deep down the disturbance will reach if we break the co-ordination of visual experience and gravity sense in the inner ear and the many muscle-senses, which help our usual balancing act. This stereognostic co-ordination is slowly acquired from infancy and, through a network of nerve connections, governs glandular secretion, blood circulation, the rhythmic intestinal movements. Reassured feelings are related to this established harmonization of sensory clues, termed stereognosis, and other emotions arise promptly from a disharmony among them.[3]

Neutra saw this extreme example as part of the whole complex interaction between the individual and his environment. In Neutra's concept the architect can produce an environment designed for the ideal physiological and psychological requirements of the inhabitants of the buildings. He explained his point of view in his book *Survival Through Design*.

In human dwelling places, complex *inner* stimuli derive from the design of the rooms and the articles in them with which we surround ourselves. The chair, together with the desk, determines our posture; so does the couch on which we read with a light source, either well or inconveniently placed. Or, for example, that same couch may be planned and placed in poor relationship to a magnificent window and make us crane our neck in vain to enjoy the view. The problems of posture relate a vast number of other sensory experiences to vision, which concerns and directs not only our eyes but our whole body.

It is clearly the design of a room and its furniture which call for certain habitual movements and placements of our body. The taking and holding of a posture, the going into any muscular action, in turn establish what is called a kinesthetic pattern, a pattern of successive and simultaneous inner stimuli. Important responses are then elicited by such stimuli, reflexes are touched off, conditioned by a routine usage of furniture, lighting fixtures, and a thousand little items which, in their placement and function, may be variously right or wrong. The responses mentioned are frequently not conscious ones, and in many cases not motor responses directed toward a remedial action. Often these responses are emotional but cumulative, so that lasting depressions or exhilarations may be their effect, and thus the effect of the room in which we spend our time.[4]

The creation of an architectural environment is directly dependent upon the esthetic aspect of the interior spatial design of a building. As in other art forms, the architect is concerned with the creation of an esthetic organization. He attempts to use form, texture, and color in a spatial order, but these plastic elements are related to and are, in part, created by the structure of the building, which is, of course, related to the operational function.

As noted earlier in this chapter, it is possible to examine an architectural design in a manner similar to that of studying the esthetic organization of painting or sculpture. However, it should be obvious from the discussion of the functional areas of operation and environment that an observer often cannot respond immediately to the characteristics of an architectural composition directly related to these factors.

To appreciate the operational function of a building it is necessary to know what operations take place in it and how the requirements have been satisfied. This information is frequently not available to the lay observer, and judgments on the efficiency of many buildings must inevitably be left to those who use them. However, many types of buildings are used by the public at large (stores, offices, apartment houses, schools, and residences), and it is possible for many within the nonspecialist public to draw pertinent conclusions about the ingenuity employed to accommodate the needs of the occupants.

The environmental function of an architectural design is, once again, that aspect of a building which most affects the people it serves. An occupant would find it difficult to isolate those elements in an environment which generated a state of pleasure or well-being, but he would know when that state existed. The appreciation of environmental design must inevitably come from an intuitive response to the combination of architectural elements acting upon the observer. Differences of personality and physiology among occupants of a building will color the reactions to a planned environment so that no single consistent response is possible. Each person who seeks to understand a building will have an individual subjective response to it, as a place to live and work, that will affect his appreciation. The subjective response operates also when one responds to the third function of architectural design, the expressive or symbolic function.

THE EXPRESSIVE, OR SYMBOLIC, FUNCTION

Architecture has limits.

When we touch the invisible walls of its limits then we know more about what is contained in them. A painter can paint square wheels on a cannon to express the futility of war. A sculptor can carve the same square wheels. But an architect must use round wheels. Though painting and sculpture play a beautiful role in the realm of architecture as architecture plays a beautiful role in the realms of painting and sculpture, one does not have the same discipline as the other.

One may say that architecture is the thoughtful making of spaces. It is, note, the filling of areas prescribed by the client. It is the creating of spaces that evoke a feeling of appropriate use.[5]

These are the words of Louis Kahn, designer of the research facility for the Salk Institute of Biological Studies (Figs. 436, 437). Like many other architects, Kahn recognizes the need to consider a building as a symbol for the activity housed within it. By its appearance, a school, a church, an office building, and a seat of government must be distinguishable to those who use as well as pass by and through it.

The symbolic function of architecture depends in part upon the response of the public to the forms erected by the builder, as the agent of the architect, who satisfies the need of his client. A portion of this response will most certainly be conditioned by buildings of the past, which have had historical significance

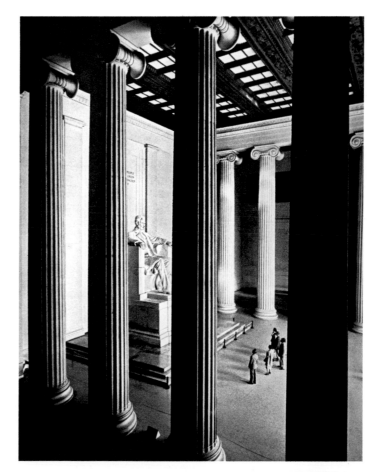

above: 467. HENRY BACON. Lincoln Memorial,
Washington, D.C. 1914–22.

right: 468. Interior, Lincoln Memorial
(Fig. 467).

in some aspect of the culture of the contemporary society. One need only look at the hundreds of government buildings in the United States and abroad which have been influenced by the forms of Greek and Roman architecture to realize that the columned temple has been identified with public buildings. The Lincoln Memorial in Washington, D.C., is one of many examples of an architectural design modeled on Greek antecedents (Fig. 467). The monument was completed in 1922 and is in the form of an unpedimented Doric temple. Certainly one of the buildings of great significance to many Americans, this monument derives much of its expressive content from the Classical style chosen by the designers. The colonnade surrounding the great statue of Lincoln in the interior announces to the visitor that he is about to enter a space of importance (Fig. 468). The scale of the building and the white marble surfaces of its walls and columns add to the grandeur and the emotional impact that most visitors feel before and within the Lincoln monument. It does not debase this response to suggest that some significant portion of it is owing to the stylistic connection between the building and other, more ancient examples of monumental architecture.

If the Lincoln Memorial is compared with the Jefferson Westward Expansion Memorial (Fig. 469), in St. Louis, Missouri, which was designed by

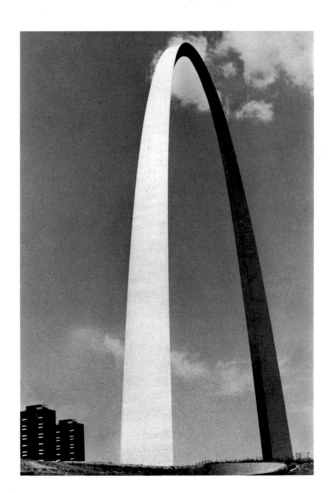

469. EERO SAARINEN.
Jefferson Westward Expansion Memorial,
St. Louis. 1966.

Eero Saarinen, the difference in conception is startingly evident. The Lincoln monument is tied to the past, with all its associated meaning and content; the great catenary arch of the Jefferson Memorial has no stylistic precedent. Age-old, the idea of an arch as the entrance or a gateway to an important space is indeed present, but the stark simplicity of the form devised by Saarinen could have been conceived only in the twentieth century. The grand scale, the gleaming surface of stainless steel, and the soaring form of the structure create an expression of the vision of Thomas Jefferson, the opening of the West, and the achievements of the early pioneers who traveled through St. Louis to reach the new frontiers beyond the Mississippi.

Expression in architecture is not confined to monuments. Each human activity can suggest the environment, the forms, and the spaces appropriate to the quality or character of the function performed within a building. The architect, if he is able, may select and combine those materials and structural systems which serve as both the container and the symbol of the activity for which the building is intended. A building may indicate wealth, power, modernity, tradition, ambition, or repose. It may suggest withdrawal from society or stand as an invitation to visit and share the hospitality of the owners. It can stand apart from the land, a man-made object suggesting the scientific technology that has resulted from the application of the human mind and the industry of the contemporary society (Fig. 411), or it can remain close to the earth, rising from the soil and rocks, a part of nature, associating man with all other forms of life, like the great rambling Arizona home and studio of Frank Lloyd Wright (Fig. 426).

Expression in contemporary architecture cannot evade the traditions, the common cultural heritage, of the society that sponsors it and whose needs it must satisfy. Architectural critics often condemn eclectic or imitative architecture because it does not find its expressive forms in the present-day world; when a building is given a superficial, imitative skin that camouflages an internal design with an anachronistic shell, the inconsistency between the nature of the building and its appearance can be bizarre and even ridiculous. To clothe a municipal office building, a residence, a library, and a church (Figs. 470–473) in the same architectural forms sacrifices expressive design to stylistic consistency. However, many of the personal and social activities common to men of the past still exist in a somewhat similar form today, and in these areas of our culture eclectic designs may serve in much the same way as their antecedents. The typical eighteenth- or early nineteenth-century house is still able to meet the needs of many twentieth-century families with but few alterations in design. For many people, particularly those who live in the northeastern part of this country, the so-called "colonial" house expresses security, the warmth of family life, and a continuity of earlier cultural values which, in total, provide a satisfying esthetic environment (Fig. 474). A man from New England may leave his home, a contemporary version of a 200-year-old design, and travel to his office in a steel-and-glass tower without feeling that there is an inconsistency between these totally different environments. This dichotomy

470. Municipal offices.

471. Residence.

472. Library.

473. Church.

above: 470–473. Eclectic buildings of "colonial" type.

below: 474. "Colonial" ranches. WILLIAM A. CLARK. Wilmont Homes, Pa. 1953.

above: 475. Kallman, McKinnell & Knowles. West façade and south side, Boston City Hall. 1968.

below: 476. East façade and south side, Boston City Hall (Fig. 475).

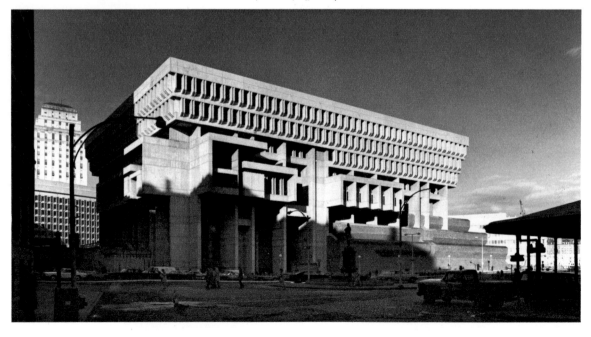

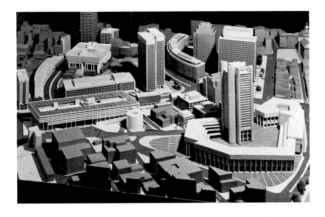

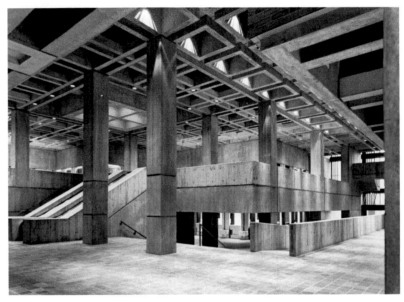

above: 477. Architect's model,
Boston City Hall (Fig. 475).

right: 478. North Lobby,
Boston City Hall (Fig. 475).

may suggest a lack of cohesion in our culture. However, the fact remains that many people can accept eclectic architecture as a part of contemporary life. In general, however, each cultural period has seen expression in architecture result from the forms and the materials common to the time. Each building speaks best when it speaks of its own time in its own idiom. Most attempts to look back to forms that were expressive in the past have produced a dilution of expression, a kind of sentimental nostalgia.

The new City Hall for Boston is the work of a team of three architects, Gerhard Kallman, Noel Michael McKinnell, and Edward Knowles (Figs. 475–479). It represents the efforts of the designers to resolve the difficult problems of housing the several varied departments and functions of a major metropolitan government in a single building that must also symbolize the political center of the community. The design (Figs. 480–482) is the winning entry in an archi-

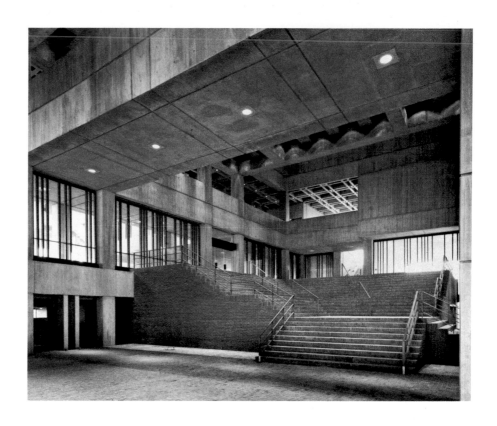

above: 479. KALLMAN,
MCKINNELL & KNOWLES.
South lobby, Boston City Hall
(Fig. 475). 1968.

left: 480. Plan of third floor,
Boston City Hall (Fig. 475):
(1) south lobby; (2) open courtyard;
(3) mayor's stair; (4) offices.

tectural competition that presented the participants with a predetermined site and plan for traffic circulation. The City Hall was to be one of a number of buildings in a large administrative center in a redeveloped portion of central, downtown Boston. The building would measure 100 to 130 feet high and approximately 275 feet square. To be included in the plan was a substantial amount of office space, provided for the mayor, his staff, and other city officials, large ceremonial meeting halls, a municipal library, and public office space accessible to transient visitors. Each of the space allocations identified as a part of the requirements for the design had different functional, environmental, and expressive characteristics.

Many architects have solved problems of this kind by designing a large envelope that encloses several varied functions of a public building, giving an external appearance of unity to an internal complexity. Such a solution is the

481. Plan of fifth floor,
Boston City Hall (Fig. 475):
(1) open court;
(2) south lobby;
(3) mayor's stair;
(4) reception of mayor's department;
(5) reception of mayor's office;
(6) mayor's conference room;
(7) mayor's private office;
(8) mayor's dressing room and bath;
(9) offices of mayor's staff;
(10) council chamber;
(11) council chamber galleries and access;
(12) councilors' offices and conference rooms;
(13) exhibition hall;
(14) reference library.

482. Plan of eighth floor,
Boston City Hall (Fig. 475):
(1) open court and terrace;
(2) public corridors, empty space;
(3) service;
(4) offices and conference rooms;
(5) Building Department;
(6) Cashier;
(7) public service counters;
(8) Building Department Administration.

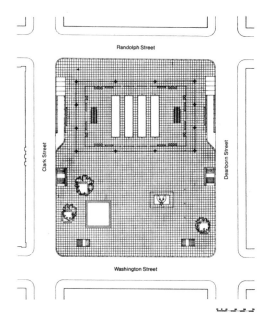

left: 483. C. F. Murphy Associates;
Skidmore, Owings & Merrill;
and Loebl, Schlossman & Bennett.
Chicago Civic Center. 1964.

above: 484. Site plan,
Chicago Civic Center (Fig. 483).

basis for the design of the Chicago Civic Center (Figs. 483–485). The 31 floors of this building are designed so that each one is anonymous and flexible, suitable for a number of possible functions. The Civic Center houses 140 courtrooms and their associated offices. Included also are hearing rooms and the public spaces necessary to accommodate the inquiries and activities of approximately 12,000 people who use the building each day.

The approach of Kallman, McKinnell, and Knowles to the design of the Boston City Hall was in direct contrast to that taken in Chicago. The Boston plan has an external face indicative of the internal complexity. Beginning with a sloping site, the architects specified a brick platform to connect the lower portion of the building with the great plaza that surrounds it.

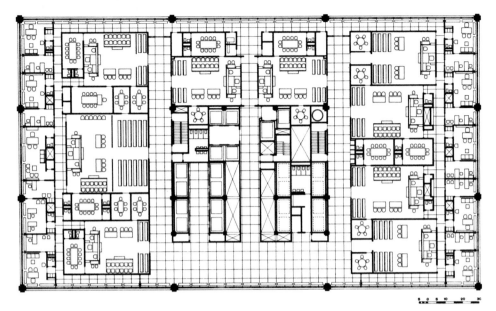

485. Plan of twenty-fourth floor,
Chicago Civic Center (Fig. 483).

The first two floors contain offices and counters, located for the convenience of the citizen who needs to obtain licenses or registrations and permits. On the first floor a concourse is open to those who wish to walk through on their way to one of the other buildings in the complex. There is an appearance of openness and accessibility. Large public inner courts and stairways announce the public and symbolic character of these impressive spaces. The citizen knows he is in an important building, but a building that is a part of the city, not isolated from it. On the fifth floor (Fig. 481) the mayor's offices and chambers, the council chamber and associated offices, and the reference library are placed in close proximity, emphasizing their functional and symbolic relationships. These three areas are expressed externally by massive geometric elements that punctuate the façades on the east, south, and west, supported by gigantic concrete pillars that raise the building over the plaza. The third floor (Fig. 480) provides offices for services related to the fiscal operation of the city, which are easily reached by the public from below and by the mayor and members of the council from above. Finally, the top four stories are designed as utility office space, a form of beehive that serves the entire complex and, from the exterior, presents a powerful horizontal band, like a classical frieze, that binds the vigorous energies of the voids and solids into a coherent visual statement. This building expresses the intricacy and scale of the modern city government, but its oblique similarity to the multicolumned classical buildings of the past (Figs. 467, 468) ties it to history and tradition.

The architect Ludwig Miës van der Rohe saw the design of buildings as the organization of sensitively related structural elements to create flexible anonymous spaces suitable for many different purposes. He was one of the most influential architects of the twentieth century. His dictum "less is more" is a

way of saying that a designer must attempt to eliminate the inconsequential and specialized elements in a building, to distill, isolate, and refine the essential character of a design problem, and then attempt to express it in a carefully controlled integration of form, space, structure, and material. The Seagram Building (Fig. 419) represents this point of view when applied to a multi-storied office building.

Crown Hall (Fig. 486), on the campus of the Illinois Institute of Technology, is one of the clearest statements of Miës' philosophy. It is a building intended to serve the needs of architectural education. By employing giant steel beams that support the roof from above, the architect was able to provide an unobstructed interior space measuring 220 by 120 feet (Fig. 487). The steel frame-

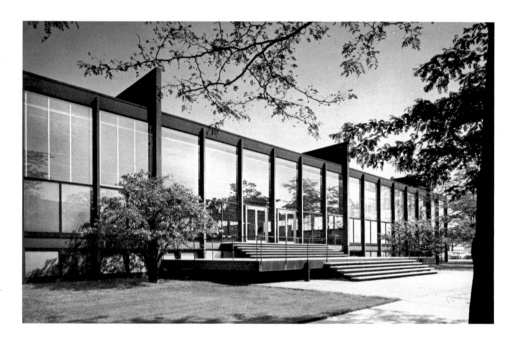

above: 486. LUDWIG MIËS VAN DER ROHE. Crown Hall, Illinois Institute of Technology, Chicago. 1955.

right: 487. Plan, Crown Hall (Fig. 486).

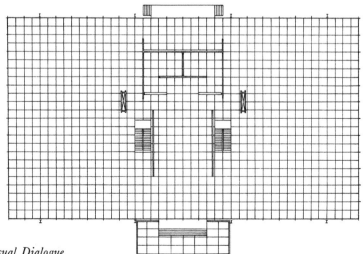

The Language and Vocabulary of the Visual Dialogue

work filled with glass panels is arranged in a subtle, refined rectangular system, as simple and classic as the materialization of an elegant mathematical formula. This building is one part of a master plan for the campus commissioned from the architect. Of his plan he said:

> It is radical and conservative at once. It is radical in accepting the scientific and technological driving and sustaining forces of our time. It uses technological means but it is not technology. It is conservative as it is based upon the eternal laws of architecture: Order, Space, Proportion.

In his book *Complexity and Contradiction in Architecture,* Robert Venturi champions a concept of architectural design that argues against the esthetic position of Miës van der Rohe:

> I like complexity and contradiction in architecture. I do not like the coherence or arbitrariness of incompetent architecture nor the precious intricacies of picturesqueness and expressionism. Instead, I speak of a complex and contradictory architecture based upon the richness and ambiguity of modern experience, including that experience which is inherent in art. Everywhere, except in architecture complexity and contradiction have been acknowledged. . . .
>
> But architecture is necessarily complex and contradictory in its very inclusion of the Vitruvian elements of commodity, firmness, and delight. And today the wants of program, structure, mechanical equipment and expression, even in simple buildings in simple contexts, are diverse and conflicting in ways previously unimaginable. . . .
>
> Architects can no longer afford to be intimidated by the puritanical moral language of orthodox Modern architecture. I like elements which are hybrid rather than "pure," compromising rather than "clean," distorted rather than "straightforward," ambiguous rather than "articulated," perverse as well as impersonal, boring as well as "interesting," conventional rather than "designed," accommodating rather than excluding, redundant rather than simple, vestigial as well as innovating, inconsistant and equivocal rather than direct and clear. I am for messy vitality over obvious unity. . . .[6]

Venturi has made it quite clear in his short, intense book that he does not recommend an anarchic architecture but, rather, architecture organized on many different levels at once. He wants architecture to look to the past for solutions to problems that have been solved before, without slavishly imitating past styles. He wants it to reflect the complexity of the activities and services of which it is a part. He wants the design of architectural units to recognize that a building can play many visual roles rather than one. It may be seen as a wall when the viewer is standing beside it, a gateway when he moves through it. It can serve a sculptural function when viewed as a part of an urban skyline, and certainly it will provide the spaces needed to fulfill the requirements of those within it. A building is an economic unit, a space, a series of forms, a home, or a place of business, a part of a community. All these things are part of the

nature of a building, and each one may demand a different design solution. Venturi asks that the designer recognize and deal with these often contradictory requirements in each building, accepting the complexity instead of attempting a simpler, more easily understood solution that seems esthetic but meets only one aspect of the overall need.

The Boston City Hall seems to satisfy many of Venturi's esthetic conditions, and for most observers it is a building of powerful visual impact that stirs an initial response of pleasure. As the building slowly reveals itself, the logic and order of the many parts, the variation of spatial and formal design, offer to the attentive observer a dense, many-leveled series of esthetic experiences.

Crown Hall and the Seagram Building also have much to offer those who seek satisfaction in their reaction to architecture. They reveal a different kind of solution to another sort of problem. Externally, the buildings are ideal, rational constructions exhibiting a visual perfection rarely experienced in nature. This is an expression of the *ideal,* the abstract reality that can be conceived by man, a reality that encompasses both the recognition of specific problems and a timeless quality, adaptable to many human requirements.

In architecture we are once more confronted by the obvious fact that individuals are capable of esthetic responses to different stimuli. In architecture no less than in painting and sculpture an abstract relationship of visual elements can give pleasure, which may be prolonged or intensified by an awareness of the rationale that shaped the elements we experience in individual buildings. It is also possible to find satisfaction in architecture that becomes a part of a larger environmental complex. Such architecture can be satisfying because it serves its purpose within the context of human need without asserting itself as a unique and isolated *art* object. Similarly, we may take pleasure in the perception of a city, aware of the vistas down avenues, stimulated by the varieties of spatial order that are shaped by sensitive design of streets, parks, and the ordered relationships of buildings. In addition, satisfaction can result from the sense of productive human activity, neighborliness, security, the pleasure of the unexpected discovery that is to be found in a shop window or around the corner of a street.

To review, then, the expressive and esthetic organization of architecture shares with the other visual arts, and particularly with sculpture, the need for a unified focus. An architect may achieve some portion of this unity through the use of the organizational devices employed by the painter and the sculptor— repetition, continuity, and contrast, or opposition; but, unlike the other two visual arts, architecture most often has a functional basis for its unifying composition. It is the operational nature of a building, which controls the selection of materials, the methods of construction, and, finally, the forms, spaces, and surfaces that are, in total, the building itself. In the ideal architectural design, esthetic organization, expression, function, structure, and materials are all interrelated and interdependent. It is possible for an observer to respond to any one aspect of a building, but the full appreciation of architecture is dependent upon an awareness of the full range of factors that can influence design.

STRUCTURAL SYSTEMS
OF ARCHITECTURE

Intimately connected with the form, function, and expression of any structure are the methods of construction and the materials used to build it. In creating the space needed by his clients, the architect can never ignore the basic problems of how walls should be raised and what will support a roof. Practical, structural considerations are part of the total complex to be resolved in the architect's design. There are instances in which the structural problems of the builder do not seem to concern the designer or the person who looks at the completed work. A viewer who delights in the appearance of a large equestrian statue need not know that there is within the statue a complex skeletal structure. Just so, the person enclosed by the geometry of a classic Renaissance church (Fig. 488), the bombastic drama of a Baroque building (Fig. 489), or the soaring arches of a contemporary ferroconcrete reception hall (Fig. 490) may have a rich and satisfying esthetic response without knowing how the building has risen. Nevertheless, there can be a connection between the knowledge of the way a structure has been erected and the satisfaction a viewer can feel when confronted by the building. Understanding the manner in which the architect fights the forces of gravity that tend to keep the walls of his building from rising and the roof from remaining suspended above the earth can excite the mind and alert the senses. No one who has crossed one of the great suspension bridges can think of neglecting the part played by each thin strand of wire in the overall form, function, and esthetic impact of these structures (Fig. 491). The following

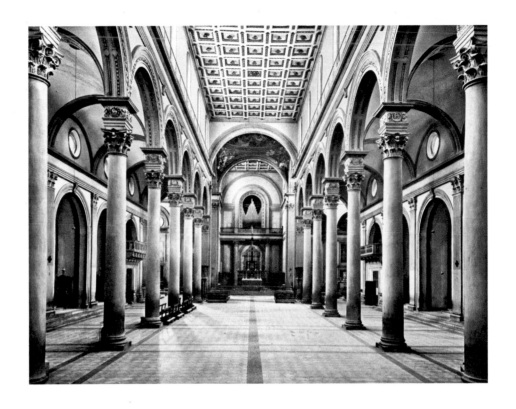

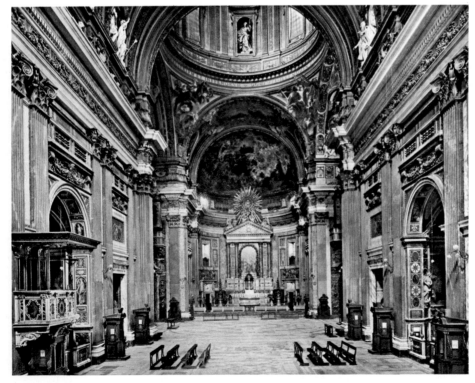

above: 488.
FILIPPO BRUNELLESCHI.
San Lorenzo, Florence. 1423.

left: 489. GIACOMO VIGNOLA.
Interior, Il Gesù, Rome.
Begun 1568.

section provides a short description of the major structural systems and a discussion of their significance in the design of architecture.

A material that is to be used structurally must resist certain forces which test its strength. It may be required to support weights that operate to crush it, exerting what is known as "the force of compression" (Fig. 492). Or perhaps it will be pulled and stretched like a rubber band, by the "strain of tension

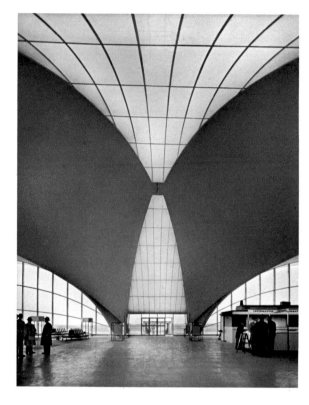

left: 490. GEORGE FRANCIS HELLMUTH, JOSEPH WILLIAM LEINWEBER, and MINORU YAMASAKI. Airport Reception Building, St. Louis. 1953–55.

bottom: 491. O. H. AMMANN and CASS GILBERT. George Washington Bridge, New York. 1927–31.

right: 492. Forces of compression.

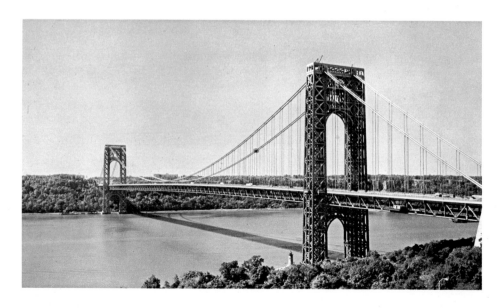

493. Forces of tension.

forces" (Fig. 493). Both these forces, compression and tension, may be applied to a single element in a structural system, or, possibly, they may operate separately. In building it has always been man's problem to find materials that can resist these forces and to develop structural systems in which his materials can serve to their best advantage.

In his need to protect himself from the elements man has used his ingenuity to take materials from nature and form them to suit his social and physical needs. The range of materials includes the snow blocks of the northern Eskimo, the great stone blocks of the Egyptians, the animal skins and thin wooden frames of the American Plains Indian, and the living rock of India, from which monolithic temples were carved like sculpture. For the most part the early history of building is tied to the materials that were readily available to the peoples of a particular area, and characteristic architectural styles resulted from demands imposed by these materials. Only in the most primitive societies do we find people living within the hollow of a single tree or within an open cave or beneath a rock shelf. As soon as man has more sophisticated living quarters, he must cope with the problem of combining a number of separate pieces of a material into a larger unit. If he uses wood, each piece must be attached to another piece. The pieces must be woven, tied, joined, nailed—somehow they must be united to form upright walls and, perhaps, a roof to protect the inhabitants from the weather.

Building in stone or brick requires the solution of similar problems. The examples in India of temples carved completely out of stone cliffs (Fig. 494), which become forms of giant hollow sculpture, constitute an incredible monument to man's perseverance and ingenuity. They are, however, rare exceptions, for stone construction, perhaps to an even greater degree than construction in wood, requires the union of relatively small elements into much larger structural complexes.

THE POST AND LINTEL

One of the simplest and most universally used systems of construction is the *post and lintel* or wall and lintel. Examples of this method of construction are to be found in Egyptian temples dating back to 2700 B.C., in Greek temples of the sixth and fifth centuries B.C., and in buildings of the Roman Empire and the European Renaissance. The half-timbered medieval houses and the one-room cabins of the early Colonial settlers are found in this group, too. The

494. Kailasanatha Temple, Ellora, India. c. 750.

Japanese, the Chinese, and the peoples of India and of the Yucatán peninsula learned to raise their buildings by this structural method. The system is nothing more complicated than the erection of two vertical elements, posts or walls, which are bridged by a horizontal element, the lintel. The repetition of these structural units in different ways has permitted the development of many architectural styles (Figs. 495–499).

left: 495. Hall of Amenhotep III,
Temple of Karnak, Luxor, Egypt.
c. 1400 B.C.

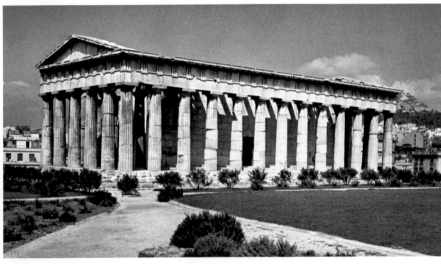

left: 496. Theseum (Hephaesteum),
Athens. Begun 449 B.C.

below left: 497. Peristyle House
of the Vetti, Pompeii. c. A.D. 50.

below right: 498. Great Chamber,
Eleazer Arnold House,
Lincoln, R. I. 1687.

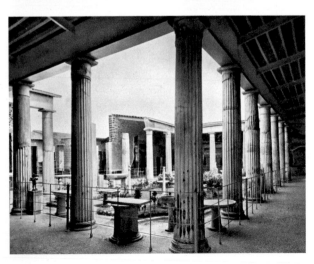

A glance at the façade of a Greek temple will show the characteristic form of the post and lintel (Fig. 500). In the Parthenon, built during the fifth century B.C., a row of columns is placed at the perimeter of the building. Stone lintels span the spaces between the columns to create a horizontal band called the *entablature,* a major design element in the typical Greek temple. A second row of columns on the east and west ends of this building also supports lintels. Stone walls within the line of columns act with smaller interior columns to support additional bridging elements to complete the structural system.

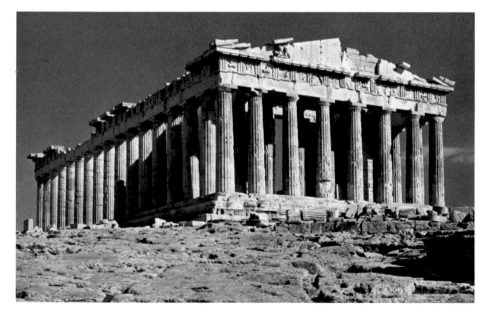

above: 499. Narrative scroll *Matsuzaki-tenjin engi* (detail). 1311. Ink and color on paper. National Museum, Tokyo.

left: 500. ICTINUS and CALLICRATES. The Parthenon, Athens. 447–438 B.C.

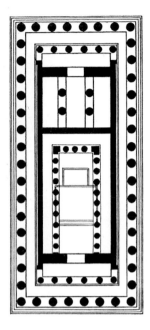

Though simple, post-and-lintel and wall-and-lintel construction can be employed to create highly refined architectural designs, but the need for vertical supports to carry overhead loads limits the usable space in this sytem of building.

Reference to a floor plan of the Parthenon (Fig. 501) will show that much of the interior space is occupied by the columns or walls which support the roof. This abundance of supports is required because the stone lintels could not be very long in relation to their width and thickness. Stone, which is very strong in compression, is inefficient as a material for lintels, because it is not elastic and tends to give way under tension.

Figure 502 indicates the way in which posts and a lintel work. Note that the weight (*W*) carried by the lintel is countered by an equal and opposite force exerted by the posts. This action of forces tends to bend the lintel in a bowlike manner (represented by the dotted lines). The upper portion of the lintel is forced into compression as the material yields to assume the bowed shape; the lower portion is placed under tensile stress as the material tends to assume the bowed shape.

Wood is a more satisfactory material than stone in this method of construction, but it remained for the development of a material that was strong in

above: 501. Plan, the Parthenon (Fig. 500).

right: 502. Compression and tension in post-and-lintel construction.

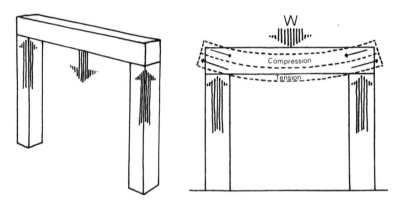

both compression and tension before wide spaces could be bridged without the use of large numbers of vertical supports. This development occurred with the introduction of steel into construction, but it had to wait for the end of the nineteenth century before its use had a marked influence on architectural style.

THE ARCH AND VAULT

Because stone is permanent and fireproof, as well as impressive, builders adopted the material wherever it was available. The earliest attempts at building with stone were probably no more than rows of rocks heaped one upon the other, with a small space left open within the pile. A covering for the open space was created by laying flat stones about it so that the upper stones projected slightly beyond the lower ones, gradually converging from all sides until they joined at the top of the structure. This is *corbeled* construction (Fig.

503). Examples of this method of construction go back to the early history of architecture, but it was not until the development of the principle of the arch that stone construction reached its zenith. There are essential differences in the systems. Corbeled stone elements are laid parallel to the ground, layer on layer. Each course of stone projects out into the opening between the walls a bit farther than the course beneath. The weight of the upper courses pressing down on the stones beneath them permits a builder gradually to close the gap over an opening. The projections produce a characteristic saw-tooth form in the closure. In the arch the stone parts, called *voussoirs,* are placed radially, with their axes directed toward a central focus. The wedge-shaped voussoirs direct the weight of the arch and the stone above it out at an angle, rather than down, so that the resulting force tends to spread the sides of the arch and flatten the form (Fig. 504).

The arch is a more sophisticated form of stone construction than corbeling, for it requires that the faces of the stone be dressed accurately, so that each voussoir is at the proper angle to its neighbor to form the semicircular structure. Incorrect cutting of these sides would cause the separate components of the arch to slip, making a structural weakness that would result in its collapse. In

below: 503. Interior, "Treasury of Atreus," Mycenae, Greece. c. 15th century B.C. Stone, height 44¹/₂′.

right: 504. The function of the voussoirs in arched construction.

Voussoir

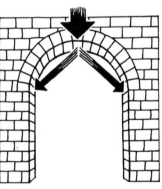

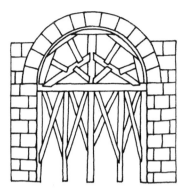

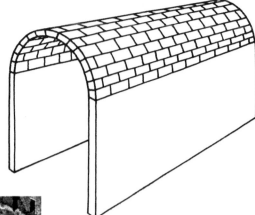

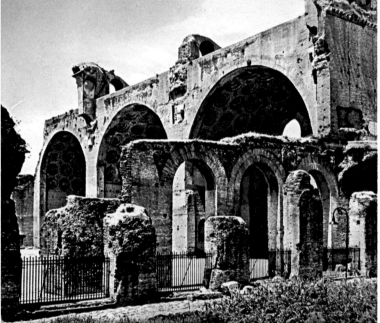

above left: 505. Centering
in arch construction.

above right: 506. Barrel vault.

507. Basilica of Constantine, Rome.
Begun under Maxentius c. A. D. 306–12,
completed by Constantine.

addition to the requirement of skilled stonecutting, there is the necessity of build-
ing a temporary support for the single voussoirs until all of them are in place.
An arch will not stand until each of its parts is in place, for it is dependent upon
their interaction for its strength. To hold them in position during the process
of construction, it is usual to build a semicircular wooden form called "center-
ing." When the voussoirs have been fitted, the centering is removed and the arch
stands unaided (Fig. 505).

The basic concept of the arch was used to provide buildings with continu-
ous stone roofs. Setting one arch behind another produced a structure which
resembled a tunnel (Fig. 506). This was the *barrel vault*. It provided early
builders with stone roofs which could span impressively wide spaces and could,
of course, be continued in length for extended distances (Fig. 507).

The forces working on the barrel vault act just as those on the arch do, but they exist over its entire length and require similar counterforces to resist the tendency to collapse. As in the case of the arch, centering is required to support all parts of the vault until they are in position. This is a limiting factor in the construction of vaulted roofs, for centering is expensive and time-consuming. Another restriction imposed by the barrel vault is the limited amount of light admitted to a building covered in this manner. Builders were hesitant to pierce the sides of vaulted buildings for fear that the opening would endanger the strength of the vault. Any openings introduced were, of necessity, small. Only the arched ends of the structure were free for the entry of light. These problems of illumination and centering were partially resolved in the development of the groin vault.

As early as the third century, builders in Rome experimented with variations on vault construction. They arrived at a vaulting system which eliminated many of the drawbacks inherent in the barrel vault. It was found that if two barrels vaults were built at right angles to one another over a square area, all the thrust of the two intersecting vaults would be concentrated at the corners, permitting openings at each side of the square. Even though it was essential to provide an enormous amount of buttressing at these points, this new system freed the architects from the necessity for continuous, heavy walls. They could divide any building into squares, or *bays*, and cover each square with its own vault (Figs. 508, 509). These *groin vaults* were relatively free of the stresses from the other similar vaults in the building, so that upon the completion of each vault, the wooden framework employed in its construction could be removed and used elsewhere.

below: 508. Intersecting barrel vaults.

right: 509. Interior reconstruction,
Baths of Caracalla, Rome. A.D. 211–17.

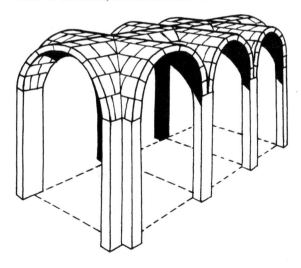

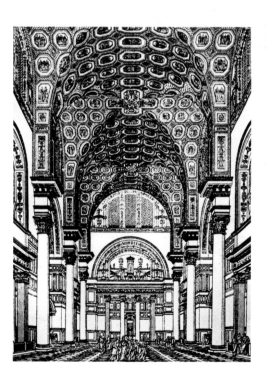

The design of Roman vaulting was highly refined. The early builders recognized that not all parts of the groin vault required the same strength. Most of the vault's work was carried by the arches at the outside faces and at the crossing. If these portions were built of heavy stone, the areas between them could be filled in with relatively light material. An additional advantage was that the major supports could be removed, once the heavy ribs, or arches, were in place. Since these elements remained freestanding, only the space between them, the web, required additional centering, and this could be supplied by material of much lighter weight (Figs. 510–512).

Stone vaulting remained at this stage of development until the end of the eleventh century. Previously, the design of a groin vault had been based upon

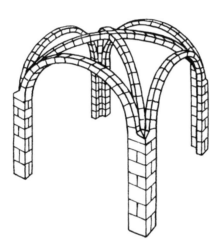

left: 510. Open cross vaulting.

left: 511. Arch of Janus, Rome. Early 4th century.

below: 512. Structural principles of the Arch of Janus (Fig. 511).

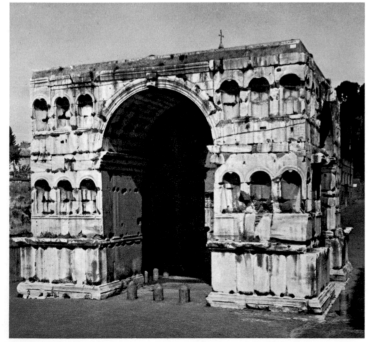

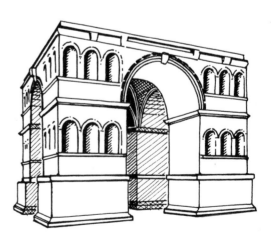

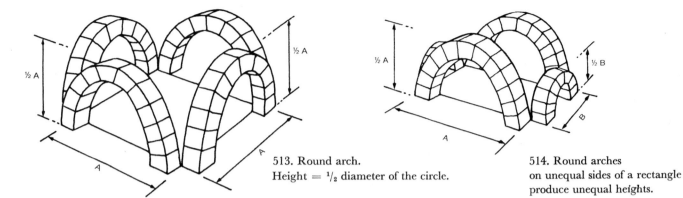

513. Round arch.
Height = 1/2 diameter of the circle.

514. Round arches
on unequal sides of a rectangle
produce unequal heights.

the geometry of the circle. A round arch is a segment or arc of a circle, and the height of the arch cannot be more than half its width (Fig. 513).

If a builder wished to construct a groin vault in which all the arches rose to the same height, he had to use arches of identical width and so produce square bays. On the other hand, if he wished to use a bay of rectangular plan, having unequal sides, he could not readily use round arches, for the vault would rise to different heights on the long and short sides of the bay (Fig. 514). Several methods of covering a rectangular bay with round arches were developed by Romanesque builders, but none of these was completely successful. During the Renaissance groin vaults were constructed with a combination of round and elliptical arches, employing a more sophisticated geometry than was used by the earlier builders.

An imaginative, efficient solution to this problem was achieved by constructing arches in the form of two arcs rising upward to a pointed joint at their intersection. By changing the radius of the arc segments and the angle of their intersection, it was possible to vary the width of the arc while maintaining a single height (Fig. 515). Not only did the pointed arch permit the use of rectangular and irregularly shaped bays, but it also directed the thrust of the arch in a more nearly vertical direction, requiring less buttressing to counter the outward thrust of the normal arch forces (Fig. 516).

516. Pointed arches direct
the thrust downward.

515. Pointed arches
permit uniform height,
although sides are unequal.

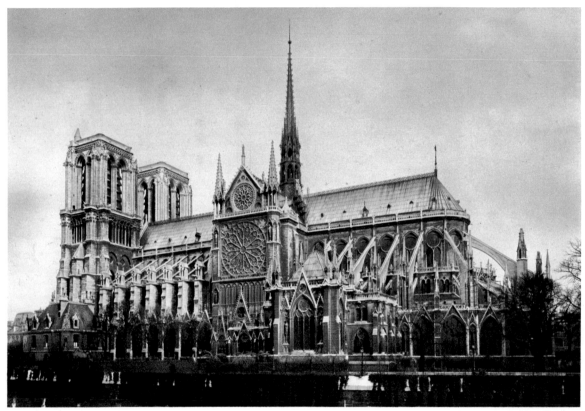

Further refinements were added to the ribbed vault and the pointed arch. Instead of being carried on the exterior walls of the cathedrals, the thrust of the vaults was diverted by means of connecting arches to large vertical piles of masonry beyond the sides of the building. This device was called a *flying buttress* (Fig. 517). It reduced the forces playing on the walls of the buildings and allowed the builders to achieve heights beyond their early dreams. It also permitted the side walls to be opened for the introduction of large glass windows.

The combination of these structural systems—the ribbed vault, the pointed arch, and the flying buttress—produced what is now called the "Gothic system" of construction (Fig. 518).

THE DOME

The dome was developed by the Romans after it had been invented in the Middle East. Essentially a hemispherical vault, the dome is subject to the same forces that work upon the arch and the vault, but the thrust of the dome is exerted around its rim for 360 degrees. It, too, must be buttressed so that its thrust is contained by heavy walls or by other, smaller, half-domes pressing back in on it (Fig. 519).

Because the plan of a dome is a circle, the dome most easily covers a cylindrical building. The builder who wishes to use a dome as the roof of a building with a square plan is faced with the problem of covering the corners of his building and, somehow, joining the round edge of the circle to the straight edges of the walls (Fig. 520). One way of solving this problem is to fill in the corners with triangular wedges that sit under the edge of the dome. These wedges are known as *squinches* (Figs. 521, 522). They help to make a transition from the rectangle to the circle by producing at the corners angles less acute than the usual 90 degrees and therefore easier to bridge.

A more elegant solution was developed in the Near East. It consists of erecting four arches above the sides of the building, each arch springing from the two corners of the wall on which it sits. The space between two adjacent arches is filled with stone to produce a curved triangular form with a point where it meets the corner of the square. The two rising edges of the triangle are formed by the sides of the arches and the upper edge curves below the base of the surmounting dome, forming one quarter of its support (Fig. 523).

519. Buttressing of a dome.

Square Building

Exposed Corners

520. Area of a dome
on a square plan,
showing corners to be bridged.

521. Squinch construction.

522. Squinch construction. St.-Hilaire, Poitiers. Consecrated 1049.

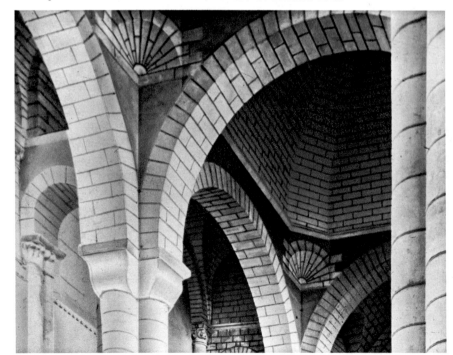

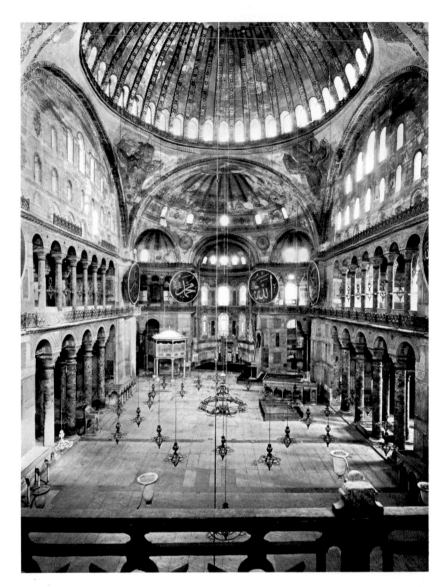

below: 523. Construction of pendentives.

right: 524. Interior, Hagia Sophia, Istanbul. 6th century.

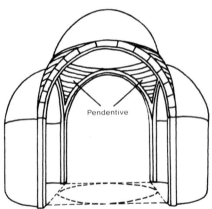

This device is called a *pendentive*, and it became an important structural feature in Byzantine architecture (Fig. 524).

THE TRUSS

A triangle is a geometric form which cannot be forced out of shape, once the sides are joined. This stability permits a designer to join pieces of wood, iron, or steel into triangular structures, or *trusses*, which can be used to span large spaces. Individual members in the truss design may be under compressive or tensile forces, and frequently their cross section is altered to suit the demands

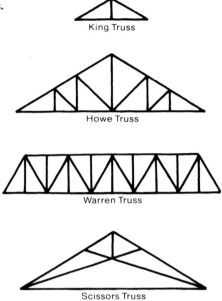

525. Examples of trusses.

King Truss

Howe Truss

Warren Truss

Scissors Truss

of their function. Many different kinds of trusses have been designed by combining triangles of different angles and dimensions (Fig. 525). The design of a truss frequently becomes the basis for interior or exterior architectural forms.

THE BALLOON FRAME

With the beginning of the nineteenth century a new chapter opened in the development of architecture. Out of the industrial revolution, which was born in England and spread throughout Europe and the United States, new building methods slowly developed, based on the use of iron and then steel, which were made available, and the concept of standardized mass-production techniques. The changes that occurred did not happen overnight, but by the end of the century it was plain from the appearance of many of the contemporary public and private structures that the revolution in architectural design was as significant as the social and economic changes preceding it. Building in wood had previously been based on the post-and-lintel system used in the earliest forms of construction. Heavy wood timbers were assembled with complicated joints and wooden pegs to produce a basic framework upon which the rest of the house depended for its strength (Fig. 498). The work was slow and tedious, requiring highly skilled joinery. Nails were used sparingly, for they were hand-wrought out of metal and therefore expensive.

With the improvement of sawmill machinery and the invention of machines which could manufacture quantities of inexpensive wire nails, a novel method of wood construction was made possible. About the middle of the nineteenth century a system was developed for nailing together pieces of wood only

2 inches wide, instead of the heavy timbers which before had been used for the erection of wooden buildings. Substituting many thin, easily handled pieces of wood for a single massive timber and nailing them together, rather than cutting into the wood to form joints, produced a structure that was strong and easy to raise. This is the method most commonly adopted for the construction of wooden buildings and interior partitions today (Figs. 526, 527). Though this technique is now universal, it was considered daring, even dangerous, at the time of its introduction. Old-time builders refused to believe that anything so frail in appearance would have the strength necessary for substantial walls and roofs. They called it *balloon* construction, a derisive term that has remained.

Although the method was used, in the main, to construct houses that were similar in exterior appearance to those built before its introduction, it is a significant example of the influence of technology on building.

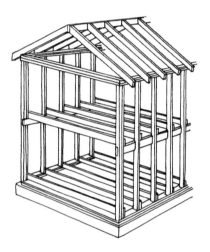

left: 526. Basic house framing in wood.

below: 527. Balloon construction.

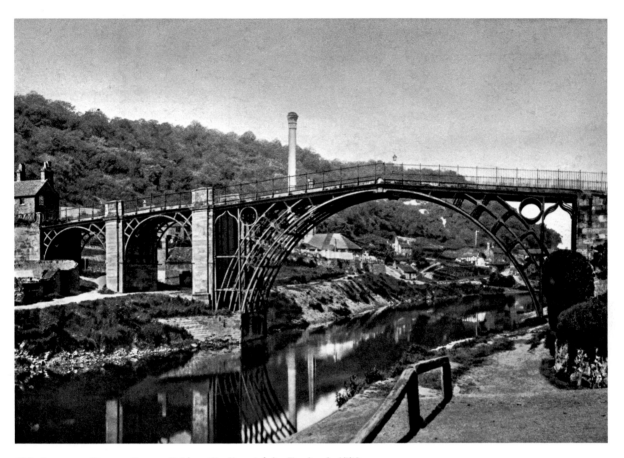

528. ABRAHAM DARBY. Severn Bridge, Coalbrookdale, England. 1779.

Prior to the industrial revolution, ferrous metals were employed only sparingly in the construction of buildings. Though iron was known to the Greeks and the Romans, and even to earlier peoples, it was not used by them in architecture. For durable products they preferred nonrusting bronze, which was cast and wrought in very limited quantities to serve primarily decorative purposes. Renaissance architects were equally reluctant to utilize iron as a structural substance. With the emergence of iron technology, this metal became the symbol of the nineteenth century. Used originally in railroad tracks, it was quickly introduced into the building trades. Cast iron actually predates the nineteenth century; for example, there is a cast-iron bridge in England that was erected in 1779 (Fig. 528).

Cast iron was adopted for architectural columns by those who realized that the great strength and the relative ease of its production made the material admirable for building. Many of the new buildings astounded the public with their light-filled interiors, designed with vast areas of glass and daring open arches and trusses of a cobweblike strength that seemed to deny the force of

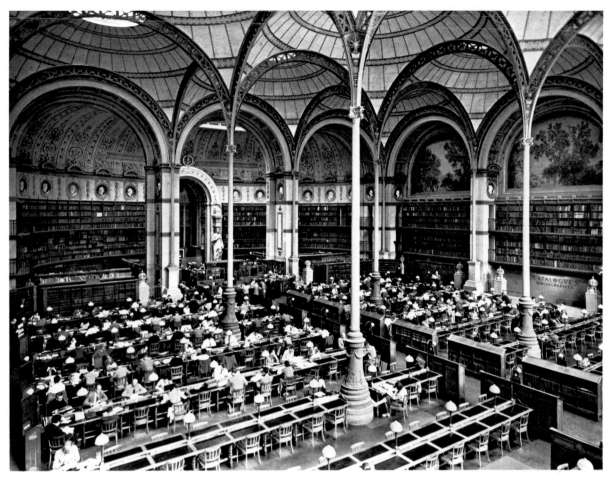

529. Henri Labrouste. Reading room in the Department of Prints,
Bibliothèque Nationale, Paris. 1858–68.

gravity. One of the most innovative examples of cast-iron construction was the
Bibliothèque Nationale in Paris, designed by Henri Labrouste and built be-
tween 1858 and 1868 (Fig. 529). Throughout this building, and particularly
in the reading room, the new potentials of cast iron were exploited.

STEEL-FRAME CONSTRUCTION

Until the late nineteenth century a building stood erect because its walls formed
part of the necessary structural system. The Gothic cathedral, whose vaults
and flying buttresses produced a system in which the wall was not a primary
structural element, is the major exception to this rule. In the post-and-lintel
system and the vaulted constructions of the Romans and the Renaissance, the
walls supported the roof or the floor of the next highest story. In multistoried
buildings all the weight of the upper floors was finally carried by the lower

walls. Windows were essentially holes cut through this operative construction, with the weight above the windows supported on lintels or arches (Fig. 530).

The Marshall Field Wholesale Store, built in Chicago in 1885–87, designed by H. H. Richardson, was one of the last important multistoried masonry buildings erected in this country (Fig. 531). The weight of the interior floors and the roof of the building was carried, for the most part, on cast-iron columns and wrought-iron beams, but the outer walls were self-supporting masonry construction, massive elements of granite and sandstone.

At the end of the nineteenth century the introduction of steel as a building material permitted the development of a structural system which freed the

right: 530. Masonry construction of a multistoried building. Bottom story carries the weight of all upper stories.

below: 531. H. H. RICHARDSON. Marshall Field Wholesale Store, Chicago. 1885–87.

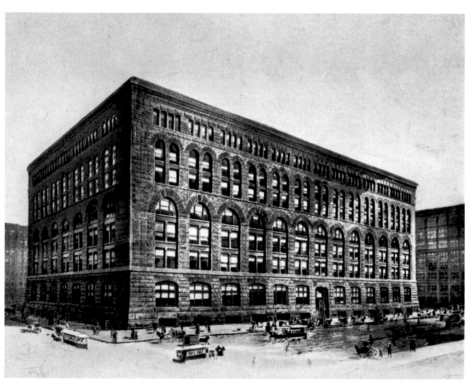

exterior walls from their load-bearing function. A skeleton steel-and-iron framework was erected prior to the construction of walls, floors, or interior partitions. This skeleton supported the walls. The strength and relatively light weight of the metal frame reduced the cost of multistoried office buildings and permitted an increase in the number of stories which could be erected on a single site (Fig. 532).

William Le Baron Jenney was one of the early innovators of the steel-frame building. His Home Insurance Company Building, constructed in Chicago

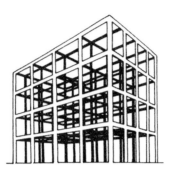

left: 532. Steel-frame construction of multistoried building. Steel frame is self-supporting and carries the weight of masonry and glass exterior walls, floors, and interior partitions.

below left: 533. WILLIAM LE BARON JENNEY. Home Insurance Company Building, Chicago. 1883–85.

below right: 534. SKIDMORE, OWINGS & MERRILL. Lever House, New York. 1952.

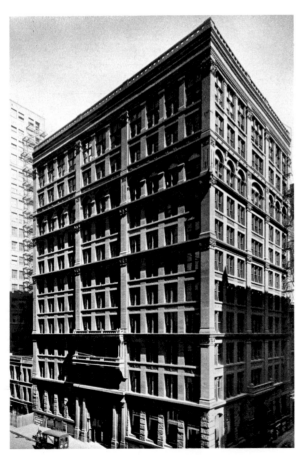

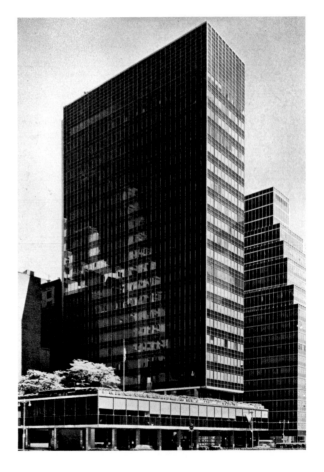

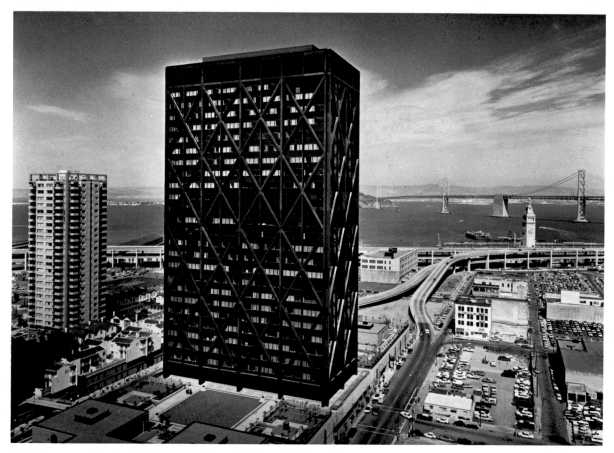

535. Skidmore, Owings & Merrill. Alcoa Building, San Francisco. 1967.

between 1883 and 1885, was the first major example of a structure that did not depend upon its outer walls for support (Fig. 533).

The façade of Jenney's building appears much lighter in weight than the Marshall Field Store, but it still seems quite heavy when compared to buildings such as New York's Lever House (Fig. 534), which is constructed on the same structural principles.

The esthetic need for a masonry wall remained an important factor in the design of steel-frame buildings for many years, even though the practical need no longer existed. At the end of the nineteenth century and into the twentieth the appearance of masonry on the exterior of a large building seemed to provide a sense of strength and stability that was expected in a major building, particularly a tall building. Only gradually did the function of the external wall find expression in the thin glass and metal skins that are so common today.

An interesting variant of the steel-cage construction system is to be found in the Alcoa Building designed by Skidmore, Owings & Merrill and erected in San Francisco (Fig. 535). The building combines an internal steel frame with

536. GUNNAR BIRKERTS and
ASSOCIATES.
Federal Reserve Bank Building,
Minneapolis. In construction.
Scale models. *above:* First stage.
right: Proposed second stage.

an aluminum-clad external steel trussing system that helps to support the floors but acts primarily as diagonal bracing to provide structural security in case of earthquake. In a sense this design returns to the use of the wall as a structural element. The powerful visual impact of the massive steel frame imparts a sense of strength to an inner, light-weight core in a city where the concern for protection against earthquake has restricted the construction of tall buildings.

A unique steel construction system has been employed in the Federal Reserve Bank Building in Minneapolis, Minnesota (Fig. 536). The dominant structural elements are two steel catenary members that hang from massive towers at the ends of the buildings. Like a suspension bridge, this building carries the floors on the catenaries, each floor supported in part by hanging vertical tension members and in part by light-weight vertical steel columns resting on the inverted arches. The design has two advantages in addition to the star-

tling visual effect produced by the dramatic elevation of the central part of the building between its two great terminal supports: floors are suspended between the outer walls without the necessity of inner columns; and the building can be expanded vertically by the addition of an arch that will support six more floors transferring the loads to the end towers already standing. Here, too, is a contemporary example of a structural design utilizing external walls as working elements in the construction.

In contemporary architecture the wall has been given a new meaning. Though it may still function structurally to support a roof or floors, there are instances in which the wall is nonstructural, when it functions to protect the interior areas from the weather or perhaps when it becomes a means of achieving visual or audio privacy. Specific wall materials may be selected to satisfy any of these three separate functions; glass, plastic, thin sheets of metal, even cloth, may serve best in any one instance. Materials may, but need not, have multiple functions. This flexibility offers the architect alternatives that were not possible before, and it increases his opportunity to suit his design to a functional and expressive purpose.

FERROCONCRETE CONSTRUCTION

Concrete is a mixture of small stones or gravel bound in a cement mortar. As it is mixed, this material has a heavy, fluid consistency. To be used in building, concrete is poured into molds which shape its final appearance. When the concrete has dried and the molds are removed, it keeps its shape and has structural properties similar to those of stone. This homogeneous material was known and used during the time of the Roman Empire. Forgotten until the end of the eighteenth century, concrete was rediscovered and employed for the first time in modern history in the construction of lighthouses (Fig. 537).

537. JOHN SMEATON. Eddystone Lighthouse, English Channel. Demolished 1882. Engraving by WILLIAM COOKE.

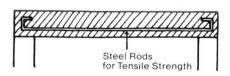
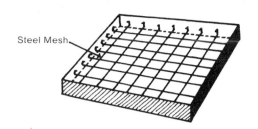

Steel Mesh

Steel Rods
for Tensile Strength

538. Reinforced concrete beam (*left*) and slab (*right*).

Like stone, concrete is extremely strong in compression but equally weak as a tensile material. By the end of the nineteenth century a building method had been developed in which metal rods were imbedded in the concrete, combining the tensile strength of the rods with the compressive strength of the concrete. This combination is called *ferroconcrete,* or *reinforced concrete* (Fig. 538). It is an extremely strong and versatile material.

Architects and engineers have been quick to adopt ferroconcrete and have learned to make use of its ability to take on the shape of whatever forms were

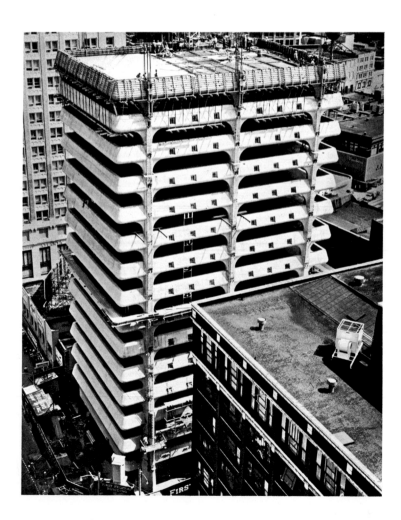

constructed to mold it (Fig. 539). This freedom of design has been expressed in recent years in dramatic, thin, concrete shells, which are being used in our most advanced structures. Vast spaces have been covered by domes and complex geometric surfaces with shells less than 1 inch in thickness. This latest development in building presages an entirely new landscape for city and suburb in the not too distant future.

Steel and concrete construction methods are combined in the Knights of Columbus Office Building in New Haven, Connecticut, designed by the firm of Kevin Roche, John Dinkeloo and Associates (Fig. 540). Four round towers constructed of concrete, like giant smoke stacks, are placed at the four corners of the building. These towers are sheathed in a dark brown tile, and they make a powerful silhouette against the sky. They house service areas, stairways, and ducting systems. Massive steel girders span the spaces between the towers, forming the major elements in the walls and supporting the floors with the help of diagonal girders that tie the walls to an inner elevator core. The structural system is the basis for an extremely clear and dramatic composition that has the logic and strength of a medieval fortress.

opposite: 539. Concrete construction with forms still in position and vertical steel reinforcements still showing in upper story.
First Federal Savings & Loan Building, Atlanta.

right: 540. KEVIN ROCHE,
JOHN DINKELOO and ASSOCIATES.
Knights of Columbus Office Building,
New Haven, Conn. 1969.

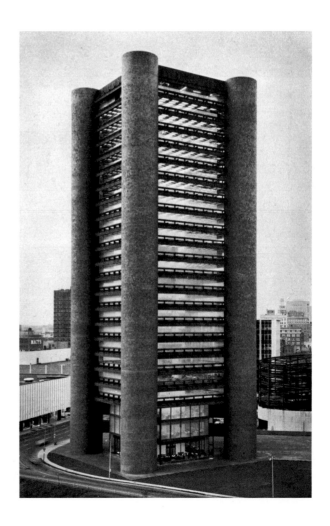

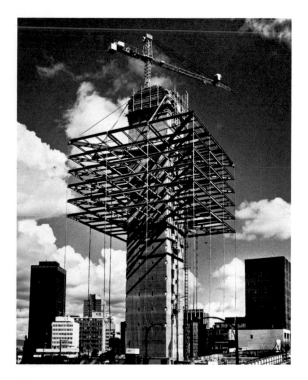

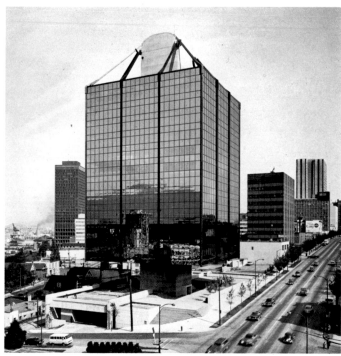

541. RHONE and IREDALE.
West Coast Transmission
Company Building,
Vancouver, B.C. 1969.
left: In construction.
right: Completed building.

The concrete core of the West Coast Transmission Company Building (Fig. 541) in Vancouver, B.C., was built with the same construction technique used for the towers in the Knights of Columbus Office Building. The method, called "slip forming," uses a sliding hollow form designed to elevate slowly during the period in which the concrete is poured. In this building the rate of elevation was 6 inches per hour. As the poured concrete hardens, the form rises, creating a continuous vertical space that is filled with concrete. Motorized hydraulic jacks lift the form until the full height of the tower is reached. The core of this seamless, continuous, monolithic tower houses elevators, washrooms, lobbies, utilities, service rooms, heating, and air conditioning. At the top, two crossed arches roof the tower. Over these arches and the four perimeter core walls, six sets of continuous cables are draped so that they hang down, supporting the outer edge of the floors that are suspended from them. Additional steel framing ties each floor to the central core, and the whole building is finally wrapped with a mirrored glass wall supported by the individual floors.

Among the most remarkable and esthetically satisfying examples of construction in ferroconcrete are the buildings of the Italian architect Pier Luigi Nervi. In 1957 Nervi designed an enclosed stadium for the 1960 Olympic games held in Rome (Figs. 542, 543). It is a concrete shell supported on Y-shaped columns, one of three major buildings designed by Nervi for the athletic events of the games. This building, like all Nervi's work, is an example of the esthetic potential inherent in the technological developments of recent years.

Nervi has said: "It is obvious that engineering and the mental make up produced by engineering do not suffice to create architecture. But it is just as obvious that without the realizing techniques of engineering any architectural conception is as non-existant as an unwritten poem in the mind of the poet."[1]

LIGHTWEIGHT STRUCTURAL SYSTEMS

The introduction of light-weight structural metals and plastics has encouraged the development of several unique construction systems that demonstrate the direct relationship between structure and design. Some of these are adaptations of technology developed in aircraft industries. Most often seen are the many house trailers used throughout the world. Some often seem to be the result of the designer's attempts to imitate buildings constructed in traditional materials,

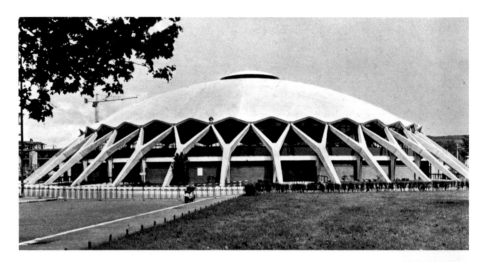

542. PIER LUIGI NERVI.
Palazzetto dello Sport, Rome.
1957.

543. Interior,
Palazzetto dello Sport (Fig. 542).

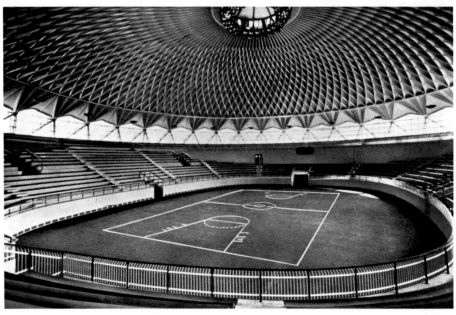

above: 544. Airstream trailer.

left: 545. Futuro II house.
Fiberglass; diameter 26′,
height 12′.

but trailers such as the Airstream (Fig. 544) are built by a thin-skinned *mono-coque* construction method. The outside shell serves both covering and structural functions. This form of construction is used in airplanes, and it is the basis of the natural structural system found in an eggshell.

Another variant of the monocoque building principle is found in the Futuro House (Fig. 545). Originally designed in Finland, this elliptical pod looks like something constructed for a science-fiction motion picture. It is actually a fiberglass shell insulated with polyurethane foam, 26 feet in diameter, with an internal ceiling height of 11 feet at the center. Available with complete heating, bathroom, and kitchen facilities, it is offered as a virtually maintenance-free housing unit that can be delivered to almost any site, including those reachable only by helicopter.

The extraordinary form of this building will demand from many observers the same reorientation as was required of earlier skeptical and tradition-bound

individuals who found it difficult to accept the direct visual expression of a steel-frame building. It could be hard to imagine a building so unfamiliar as this placed in the backyard or next door on a neighbor's building site. However, attitudes do change, and the need for low-cost housing may make the efficient use of new material imperative. Forms once considered bizarre may become more acceptable as their functions are better understood and the pressure to satisfy human needs affects esthetic responses.

World's fairs often provide designers with the opportunity to experiment with novel structural systems. Because most of the buildings are temporary and the atmosphere of a fair is innovative and light-hearted, the architects tend to seek original and relatively inexpensive solutions to pavilion design. The United States Pavilion at Expo 70 (Fig. 546), in Osaka, Japan, fulfills the need to provide a large, attractive, covered space at a limited cost. A shallow bowl was created by moving earth into perimeter embankments. This bowl was covered by a translucent air-tight bag of gigantic proportions. The interior of the bag was inflated by a system of blowers to keep the interior air pressure slightly higher than outside the bag. Inflatable structures of similar design, but somewhat reduced size, have been used as warehouses, bowling alleys, and banks.

The United States Pavilion at the Montreal World's Fair in 1967 was a sensational exploitation of R. Buckminster Fuller's *geodesic* principles (Fig. 547). A three-quarter sphere 250 feet in diameter, the pavilion interior was an airy, light-filled space that awed and delighted visitors (Fig. 548). After dark the transparent skin that covered the light metal structural elements allowed the interior illumination to brighten the night. The building was an ideal demonstration of a technological achievement that had an esthetic and expressive character consistent with the function of a temporary exhibition pavilion.

546. Davis, Brody & Associates.
United States Pavilion,
Expo 70, Osaka. 1970.

Fuller is a designer who for many years has experimented with new structural principles. His domes are based upon his own system of mathematics, which he calls "energetic-synergetic geometry." Essentially, these structures are based upon the combination of tetrahedrons, a figure constructed of four triangles. By joining tetrahedrons into more complex groups and extending them to form segments of spheres, Fuller and his associates have produced a large number of designs which combine extremely light weight with a seemingly infinite ability to cover huge volumes. These domes are constructed of small modular elements, which are joined together. The resulting web can then be covered with any of a number of materials to make the enclosed space weatherproof. Plastics, cloth, aluminum, and sheet steel have been used as skins for Fuller domes. Domes based on this structural system have been made of cardboard, waterproofed with plastic, and used by the United States Marines as temporary structures. A geodesic dome has been calculated which could span 2 miles and cover the area of midtown Manhattan.

Buckminster Fuller believes that structure and design are intimately wedded. He would extend this idea far beyond its application in architecture to include all aspects of human life.

> My experience is now world-around. During one third of a century of experimental work, I have been operating on the philosophic premise that all thoughts and all experiences can be translated much further than just into words and abstract thought patterns. I saw that they can be translated into patterns which may be realized in various *physical* projections—by which we can alter the physical environment itself and thereby induce other men to subconsciously alter their ecological patterning.[2]

part IV

EXPRESSION
AND RESPONSE

chapter 14

THE EXPRESSIVE IMAGE

A large body of representational art consists of detailed delineations of the human form seemingly devoid of movement or emotion. Many of these objects are products of social and ethnic groups who appear to have been interested in the generalized representations of human and animal characteristics, rather than the specific images that differentiate individuals. Some of the works in this category treat the subject as an abstract equivalent for Man, with little or no indication of the changes in position of the body's parts that result from the activity normal to living things.

Figures 549 through 551 are pieces of sculpture produced in ancient Egypt over a period of 2,000 years. For this great span of time the stylistic conventions of representation remained remarkably consistent in Egyptian art. With the exception of a short period during the reign of the Pharaoh Akhenaton, 1375–1358 B.C., when Egyptian art showed the personal preference of the monarch for a freer, more naturalistic style, the sculpture designed by Egyptian artists exhibits a frontality of immutable stiffness. In statues of standing figures the head, shoulders, and hips are placed in parallel lines, the left leg is positioned before the right, hands are most often at the sides (though there are some exceptions), and the eyes stare directly forward. The finished statue still retains the sense of the block of stone from which it was carved.

This description could apply to the two-figure group *King Mycerinus and His Queen* (Fig. 549), which dates from about 2525 B.C. It is also relevant for

left: 549. *King Mycerinus (Menkure) and His Queen.* 4th Dynasty, c. 2525 B.C.
Painted slate, height 4′ 8″. Museum of Fine Arts, Boston.

above left: 550. *Ramses II.* 19th Dynasty, c. 1250 B.C. Stone. Temple of Amon, Luxor.

above right: 551. *Taharqa,* from Gebel Barkal, Nubia. 25th Dynasty, 7th century B.C.
Stone, height 12′ 5″. Khartoum Museum.

the great figures from the court of Ramses II in Luxor (Fig. 550), which were
hewn from stone about 1250 B.C. Carved five or six hundred years later, in the
Twenty-fifth Dynasty, the statue of the Pharaoh Taharqa, from Gebel Barkal,
retains the early conventions of representation (Fig. 551).

When one considers the qualities that can be associated with a human
figure, the body movements, and the indication of personal feelings or emotion,
it is obvious that the conventional treatment of this subject in much of Egyptian

sculpture indicates a disregard for aspects that other artists, at another time, in another place, might have considered important.

Explanations for the consistent style of ancient Egyptian art often refer to the static society and to the emphasis on the eternal life after death that was a major factor in the religion of Egypt. This cultural climate would tend to reduce the possibility of stylistic changes in the art. Once adequate visual symbols had been developed for religious and social purposes, those emblems would prevail as long as the culture continued without major changes.

Across the Mediterranean from Egypt, the Greeks developed an art form starting with many of the static conventions of Egyptian sculpture, but within a period of five hundred years it evolved into an art concerned with movement and the expression of emotion. Compare the *Apollo* from Sounion (Fig. 552), dated about 600 B.C., with the central figure in *The Laocoön Group* (Fig. 553),

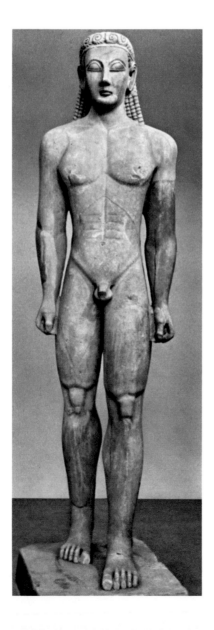

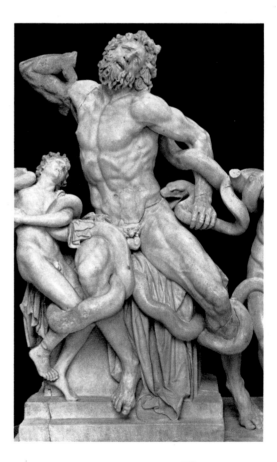

left: 552. *Apollo,* from Sounion. c. 600 B.C. Marble, height 11′. National Museum, Athens.

above: 553. Detail of Figure 350, *The Laocoön Group.*

The Expressive Image 435

which was completed in the first century B.C. The archaic *Apollo* has much in common with the Egyptian figures illustrated here. It is rigid, immobile, and frontal in its orientation. The sculpture shares these stylistic qualities with most of the figure pieces produced in Greece at this time. The central figure of *The Laocoön Group* is in sharp contrast to that of *Apollo*. It breaks from the frontal plane and twists the upper portion of the torso away from the direction of the legs. The head is bent back in an attempt to indicate action. This same concern for movement seems to account for the manner in which the feet touch the ground plane, not flat and solidly placed, but bent at the toes as though frozen in movement. The face is contorted in a grimace of pain; even the muscles of the figure are shown in the strain of an emotional experience. Surely for the sculptor who created this work the concept of man and the world he lived in was quite different from that of the artist working five hundred years before.

The changes which occurred in Greek art during the period between the sixth and first centuries B.C. reflected parallel cultural changes. Greece went from an aristocratic society, with its wealth and power concentrated in the possession of landowners who had deep roots in the past, men who desired the continuation of the ideals and the values of their fathers, to a materialistic society whose wealth was derived from trade. Greece of the second and first centuries B.C. was a country in which the old aristocracy gave way to a new one. Instead of maintaining the *status quo*, this new group broke down many of the old attitudes and values. Men were concerned with the present, with the transitory rather than the traditional. The art of this period presents a new concept of man and the world he makes for himself.

Early Greek art, like the art of Egypt, was an art of abstraction, though the images were based upon forms perceived in nature. The sculptors did not concern themselves with the representation of expression, but we cannot say that their work is devoid of expression. Looking at these idealized figures today, we can find them powerful, moving images. They can affect the emotions of the observer, though they do not represent emotions.

When we speak of *expressive* art, it is necessary to understand that the term can have several meanings. An expressive image in the visual arts may involve one or more of the following conditions: (1) a response to the representation of an emotional or atmospheric quality in the *subject* of the work; (2) a response to a visual equivalent for the artist's state of mind as he responded to a subject or an experience; (3) a response, on the part of the viewer, that is elicited by the plastic organization of the work without reference to representational subject matter.

At the outset, it should be noted that the third part of the definition may apply to the other two parts. That is, a viewer may have a subjective response to the faithful representation of a beautiful landscape, such as that by Jacob van Ruysdael (Pl. 70, p. 439). He may also respond to an artist's expressive representation of a landscape, such as the painting by Van Gogh (Pl. 71, p. 440). However, a viewer's response to the expressive image need not be tied to a representational form of art. In certain paintings and sculptural constructions

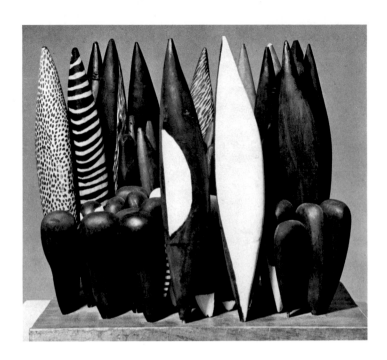

554. Louise Bourgeois. *One and Others*.
1955. Wood, height 18 ¹/₄″.
Whitney Museum of American Art,
New York.

the image that communicates strongly to an observer may not represent a specific physical object. The paintings of Mark Rothko (Pl. 49, p. 192) are evocative combinations of form and color which may suggest or create an environment or atmosphere that a sensitive viewer can feel as an expressive image. In Louise Bourgeois' sculpture *One and Others* (Fig. 554) the wooden forms are not figural, but their cramped placement on the space of their base has an implication of crowding which can produce the uncomfortable feeling of a claustrophobic society pressed together in a suffocating world.

THE EXPRESSIVE IMAGE IN REPRESENTATIONAL ART

As the shutter of a camera moves in a fraction of a second, it makes permanent a moment in time. The trapped images of human faces and bodies can be caught in externalized gestures that signify emotional states and attitudes, often too fleeting to be caught by the casual observer. Because it has this capacity to stop the movement of life, the camera is an effective medium for the representation of human beings as they react to experience. In the hands of a sensitive, skilled photographer such as Walker Evans, the camera can record the subtle differences in facial expression that register fatigue, boredom, or contemplative repose (Figs. 555–557). Intense feelings that contort the face and body are to be found reproduced in journalistic photography, where the camera has often replaced the typewriter as the most expressive instrument of communication (Fig. 558).

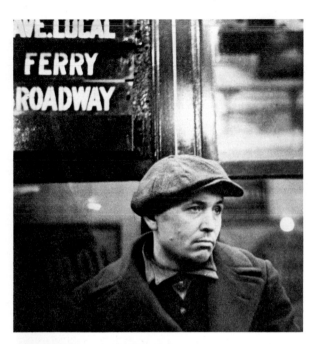

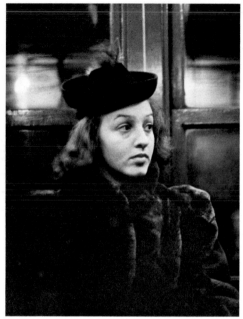

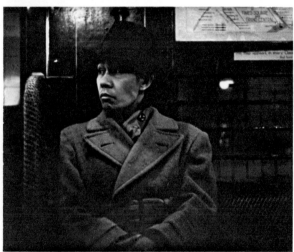

top, above, and right: 555–557. WALKER EVANS.
Subway Portraits. Photographs.

right: 558. DENNIS CONNOR. *Antiwar Protest
at the University of Wisconsin.* 1969. Photograph.

Plate 70. JACOB VAN RUYSDAEL. *Wheatfields.* c.1660.
Oil on canvas, 3′ 3³/₈″ × 4′ 3¹/₄″. Metropolitan Museum of Art, New York
(bequest of Benjamin Altman, 1913).

Plate 71. VINCENT VAN GOGH. *Crows over a Wheatfield.* 1890. Oil on canvas, 20 × 40³/₄″. Stedelijk Museum, Amsterdam (V. W. van Gogh Collection).

Plate 72. ERNST LUDWIG KIRCHNER.
Dodo and Her Brother. c.1908.
Oil on canvas, 5′ 7 1/8″ × 3′ 1 1/2″.
Smith College Museum of Art,
Northampton, Mass.

441

Plate 73. PAUL KLEE. *Ab Ovo*. 1917. Watercolor, 5½ × 10¼″.
Paul Klee Foundation, Museum of Fine Arts, Berne.

559. CHARLES-ANTOINE COYPEL.
Portrait of Mme de Bourbon Conti. 1731.
Oil on canvas, 4′ 6 1/8″ × 3′ 5 7/8″.
John and Mabel Ringling Museum of Art,
Sarasota, Fla.

Painters working within representational conventions that approximate
the photographic image have been able to suggest the moods of their subjects
by placing the figure in an expressive pose and portraying the features of the
face so as to typify the attitude of the inner man. The examples of Bronzino and
Ingres (Figs. 85, 87), discussed in Chapter 3, are relevant here too. The por-
traits by these artists are more than representations of the physical appearance
of the men they have portrayed. With intuitive sensitivity to human personality,
Bronzino and Ingres have been able to invest their sitters with an inner dimen-
sion that artists satisfied with a superficial likeness might have neglected. A
great many portraits fall into the category of technically satisfying representa-
tions of form and texture but fail to define those internal personal qualities so
important to the identity of unique men and women.

It is possible to enjoy conventionally representational paintings for reasons
other than their capacity to give a deep insight into the psychology of their
subjects. Some of these paintings may be examples of subtle and satisfying com-
positional relationships; others may be demonstrations of extraordinarily
refined skills like those of Charles-Antoine Coypel, whose *Portrait of Mme. de
Bourbon Conti* (Fig. 559), seems to say more about the sensuous quality of cloth
than it does about the sitter who has been sentimentalized into an image of
the ideal eighteenth-century beauty.

560. AUGUSTE RODIN. *The Burghers of Calais.* 1884–86. Bronze, 7′ 1″ × 8′ 2 1/8″ × 6′ 6″.
Joseph H. Hirshhorn Collection, New York.

Because the human expression of emotions is often a fleeting visual expe-
rience, it is difficult to represent the intensity of strong feelings in the static
forms of sculpture and painting without producing melodramatic, theatrical
images. *The Laocoön Group* (Fig. 553), with its display of tensed muscles and
agonized grimaces, is intended to communicate terror and fear in the bodies
and faces of the three figures struggling with an attacking serpent. Though to
its past admirers it was an effective expression of these emotions, contemporary
viewers who have seen photographic records of violence find it difficult to
respond to the expressive conventions in this sculpture. There is a conflict
here between the careful, studied treatment of the surfaces of the marble and
the overwrought, mercurial emotions that the Hellenistic sculptor attempted
to illustrate.

Many intense emotions find their visual expressions in actions, rather than
in fixed poses. Even a smile is a process, rather than a rigid position of a mouth.

In their concern for the representation of attitudes and feelings, many artists have recognized the dichotomy between the movement natural to life and the stasis common to sculpture and painting. The problem of representing *living* form was a continuing fascination for the French sculptor Auguste Rodin. In a conversation with Paul Gsell, Rodin described his approach to the creation of expressive form:

> "I obey Nature in everything, and I never pretend to command her. My only ambition is to be servilely faithful to her."
>
> "Nevertheless," [Gsell] answered with some malice, "it is not nature exactly as it is that you evoke in your work."
>
> [Rodin] stopped short, the damp cloth in his hands. "Yes, exactly as it is!" he replied, frowning.
>
> "You are obliged to alter...."
>
> "Not a jot!"
>
> "But after all, the proof that you do change it is this, that the cast would give not at all the same impression as your work."
>
> [Rodin] reflected an instant and said: "That is so! Because the cast is less true than my sculpture!
>
> "It would be impossible for any model to keep an animated pose during all the time that it would take to make a cast from it. But I keep in my mind the ensemble of the pose and I insist that the model shall conform to my memory of it. More than that the cast only reproduces the exterior; I reproduce, besides that, the spirit which is certainly also a part of nature.
>
> "I see all the truth, and not only that of the outside.
>
> "I accentuate the lines which best express the spiritual state that I interpret."[1]

Rodin's explanation describes the intuitive adjustment of the forms and surfaces of his sculpture to achieve an equivalent for animated form. Duplication of form alone could not satisfy the needs of expression. Rodin is perhaps best known for such monumental figurative work as *The Burghers of Calais* (Fig. 560), but it is in his small improvised sketches that his theories are most clearly demonstrated. The sculptor's figure of the dancer Nijinsky, only 6¾ inches high, presents an image of psychological intensity and coiled, controlled energy (Fig. 561). The surface of the work glistens with highlights that seem to shift and flicker throughout the form, refusing to be stilled; the head juts forward as the arms, all tension, are drawn back; the whole figure, tenuously balanced on one leg, suggests a transition from one position in space to another.

Rodin was not the first artist to depart from imitative proportions and surfaces for expressive purposes. Precedents are to be found throughout the history of art. One of the most famous examples of Haida Indian art is a small

561. AUGUSTE RODIN. *Nijinsky*. 1912. Bronze, height 6¾". Private collection, New York.

carving known as *Bear Mother* (Fig. 562). It is based upon the legend of a human mother who was wedded to a bear. Her child was half-bear, half-human. The nursing child is shown as a fierce creature, and the mother's pain as she is devoured by her offspring is expressed in her face and the contorted posture of her body.

The relief sculpture reproduced in Figure 563 was carved in the twelfth century on a capital inside the cathedral at Autun, France. The scene it narrates is the New Testament story of the Temptation of Christ. The representational conventions in this work are quite different from those revealed by the previous examples. The posture of Christ is fixed and stylized, as are the folds of the robe draped about the figure. The anonymous artist of this capital wished to indicate something other than physical appearance in the figure of the Devil. He did not use the more naturalistic proportions that appear in the Christ figure; instead, he modified the proportions to intensify the communication of a frightful expression. He distorted the representational method of forming the figure so as to express the *significance* of the Devil. As compared with the central figure in the *Laocoön Group*, the Devil in the Autun capital deviates from the conventions of direct representation for the purpose of greater expression. The forms corresponding to the mouth, the eyes, and the nose are similar to those used in the head of Christ, but they have been enlarged and shaped in a manner that abandons the conventions, and so are more expressive. Whenever a cultural period develops standard modes in styles of representation, artists are usually expected to work within those styles. When they depart from them to any significant degree, this departure can be used to indicate an expression of emotion within the subject or within the artist who produced the work.

above: 562. Skaows-Ke'ay. *Bear Mother.* c. 1883.
Argillite, length 5½".
Smithsonian Institution, Washington, D.C.

right: 563. *The Temptation of Christ,*
detail of a carved capital. 12th century.
Stone. Autun Cathedral, France.

Another use of the departure from a representational convention is to be found in the late paintings of El Greco. A study of his *Purification of the Temple* (Fig. 564), now in the Frick Collection, painted between 1596 and 1600, will reveal that the treatment of a number of the representational features in the painting do not conform to the conventions common at the turn of the seventeenth century. When this painting is compared with an earlier work by El Greco on the same subject (Fig. 565), in Minneapolis, significant contrasts

above: 564. EL GRECO.
The Purification of the Temple.
1596–1600. Oil on canvas, $16^1/_2 \times 20^5/_8''$.
Frick Collection, New York (copyright).

left: 565. EL GRECO.
*Christ Driving the Money Changers
from the Temple.*
1571–76. Oil on canvas, 3′ 10″ × 4′ 11″.
Minneapolis Institute of Arts
(William Hood Dunwoody Fund, 1924).

in the approach to representation are evident. The more youthful treatment of the representation of form and space in the subject matter corresponds, in the main, to that of late Italian Renaissance painting. Proportions of the figures in the painting are similar to those usually associated with the human body; shading from light to dark has been used to indicate three-dimensional form, with the source of light appearing to come from the upper right; linear perspective has been used to indicate spatial relationships; and the pattern of light-and-dark shadows and highlights seems directly related to the desire of the artist to represent human and architectural forms in a detailed and consistent manner.

Though the mode of representation in the Frick painting conforms, in general, to that of the earlier work, the figures in the later canvas are noticeably attenuated. The forms are defined by shading, but the source of light is not clearly indicated. The light-and-shadow pattern on the central figure of Christ is painted as though the source is at the right, yet there are unexplained shadows on the right side of the kneeling figure at the lower right. Other inconsistencies of lighting can be noted in the figure group at the upper right and the central group at the left. The illusion of three-dimensional space in the Frick painting is one of compressed volume. Figures seem forced together. Even the bit of landscape through the central arch has lost the deep spatial effect that is present in the earlier composition.

The effect of the Minneapolis painting is that of a tableau, a staged scene, in which the emotional expression depends upon the poses of the actors within the picture frame; but in the later work the light-and-dark pattern of flickering forms, the agitation of the contours defining the forms, and the attenuation of the forms themselves accentuate the drama and reinforce the communication of emotion.

The artist of the twentieth century had no single set of conventions for the representation of form and space. Unlike the artists of ancient Greece, the medieval sculptors working on the French Romanesque cathedrals, or El Greco in the late sixteenth century, the artist of the present has no single style to use as the standard form of representation. Enriched by the availability of examples and reproductions from the entire history of art in the West, aware of the great variety of representational approaches used throughout the world, the twentieth-century artist can choose from among them all the style best suited to his own expressive requirements. If he cannot find one that seems adequate, he is free to invent a new style, his only restrictions being those of his imagination, his skill, and his previous experience.

The two drawings (Figs. 25, 26) by Picasso discussed in Chapter 2 demonstrate one artist's ability to choose and utilize two distinctly different approaches to the problem of representation. The contrast is obvious; the choice of representational conventions—from the almost Renaissance approach of the nude figure to the Cubist system of analysis in the *Guernica* study—was apparently made to suit the artist's need. Obvious, also, is the contrasting use of the drawing line in each work—the smooth, flowing movement of the line in the figure

and the seemingly crude, scribbled, apparently uncontrolled use of the pencil in the head. As in the two examples by El Greco, the elements of the Picasso drawings have been controlled for expressive purposes.

Compare the *Kneeling Woman* by Wilhelm Lehmbruck with Gaston Lachaise's *Standing Woman* (Figs. 566, 567). Neither of these works pretends to be an accurate replica of the forms of a female figure. The work of Lachaise is composed of bulging, massive, spherical forms, which seem to burst with strength and vitality. The bronze glows as though under stress, appearing to be drawn taut under the effort of restraining the burgeoning energy within. This figure becomes a symbol of woman as the generative source of life, fertility, and power.

Lehmbruck elongates the forms of his figure from those which would be considered an accurately proportioned representation of a young woman. This attenuation and the restrained modeling of the forms produce a quiet image. The stone surface has a slightly flowing quality and a surface that is warm and free from active highlights. This figure is all that Lachaise's is not, and it, too,

left: 566. WILHELM LEHMBRUCK.
Kneeling Woman. 1911.
Cast stone, height 5′ 9¹/₂″.
Museum of Modern Art, New York
(Abby Aldrich Rockefeller Fund).

right: 567. GASTON LACHAISE.
Standing Woman. 1932.
Bronze, height 7′ 4″.
Museum of Modern Art, New York
(Mrs. Simon Guggenheim Fund).

becomes more than the portrait of an individual. The *Kneeling Woman* suggests grace, introspection, a sense of withdrawal from life.

To be sure, the stance of each figure is an important part of the image it projects, one aggressive and active, the other passive and reposed, but equally obvious is the arbitrary treatment of the forms and surfaces used by each sculptor, and this organization of elements speaks as clearly as does the representational statement.

EXPRESSIONISM

The word *expressionism* is used loosely by historians and critics of the visual arts to describe examples of painting, sculpture, and occasionally architecture which appear to have been shaped by the artist's desire to communicate a strong personal response to a subject or a state of mind. In this sense of the word the late work of El Greco, the paintings of Van Gogh, and the sculpture of Rodin, Lehmbruck, and Lachaise could be considered "expressionistic."

However, *Expressionism* in stricter usage refers to the work of a number of twentieth-century artists who considered the communication of emotion to be a primary essential in all works of art. They combined this esthetic with a consciously primitive approach to the use of their media, seeking spontaneity and a feeling of urgency in the images they produced. The early stages of Expressionism occurred at the end of the nineteenth century, appearing at several centers of artistic activity in Europe. By 1910 or 1911 the movement was well on its way as a major philosophical and stylistic force.

Among the early theorists of Expressionist concepts was the Swiss painter Ferdinand Hodler. In a lecture delivered at the University of Fribourg in 1897, Hodler described the purposes of the artist as he understood them:

568. FERDINAND HODLER.
The Chosen Vessel. 1893–94.
Oil on canvas, 7′ 1 3/8″ × 9′ 7 1/2″.
Kunstmuseum, Berne.

It is the mission of the artist to give expression to the eternal elements of nature, to unfold its inner beauty. The artist tells of nature in that he makes things visible; he sanctifies the forms of the human body. He shows us a greater, simpler nature—one free of all details that have no meaning. He gives us a work that is based upon the limits of his experience, his heart, and his spirit. . . . One paints what one loves; that is why one gives preference to *this* figure rather than *that* one. One reproduces that particular landscape in which one has been happy. For the painter, an emotion is one of the basic stimuli that cause him to create. He feels compelled to tell of the beauty of the landscape, or of the human figure, that is to say, of that particularly small part of truth which has "moved" him so profoundly.[2]

The paintings Hodler did about the time of his lecture (Fig. 568) seem closer to the flattened decorative qualities of the work of Paul Gauguin (Fig. 12) than they do to the artists who were to follow him. Even so, it is possible to find in his art a simplification of forms, an emphasis on strong, rhythmic linear repetitions, and the use of arbitrary areas of color that later were utilized in a freer, more direct manner by such Expressionists as Emil Nolde (Fig. 569) and Ernst Ludwig Kirchner (Pl. 72, p. 441).

Another important forerunner of Expressionism was the Norwegian painter Edvard Munch. In 1889 Munch traveled from Oslo to Paris, where he saw the work of Toulouse-Lautrec, Van Gogh, and Gauguin, who were then considered members of the avant-garde. The experience was crucial in Munch's development. He began to produce paintings and prints that applied the influences of the new art to his own work, using flat areas of color and linear arabesques. Munch sought to represent his response to a world he considered frightening and anguished. Often, he tried to find visual images for nonvisual emotional experiences. *The Cry* (Fig. 570) is typical of this period. In it the foreground

far right: 569. EMIL NOLDE. *Eve.* 1910. Oil on canvas, 41³/₈ × 16″. Städelsches Kunstinstitut, Frankfurt (Hagemann Collection).

right: 570. EDVARD MUNCH. *The Cry.* 1893. Oil on cardboard, 32³/₄ × 26¹/₈″. Oslo Kommunes Kunstsamlinger.

451

above: 571. ERICH HECKEL. *Convalescence of a Woman.*
1913. Oil on canvas, 3′ 2³/₄″ × 7′ 11³/₄″ (framed).
Busch-Reisinger Museum, Harvard University,
Cambridge, Mass. (purchase, Mrs. Greenough Fund).

left: 572. KARL SCHMIDT-ROTTLUFF.
Landscape with Young Elms. 1910.
Woodcut, 4¹/₂ × 6″.

figure becomes a part of a sweeping, undulating rhythm, and flattened forms
contrast against an indication of deep space. The gesture suggested in the skull-
like face is echoed in the forms about it. There is a free calligraphic application
of paint denoting a spontaneous reaction to inner forces felt by the artist.

Munch's paintings, including *The Cry,* were shown in Germany in an
exhibition that made a significant impact on many of the artists who later
became part of the Expressionist movement, among them Kirchner, Eric
Heckel (Fig. 571), and Karl Schmidt-Rottluff (Fig. 572), who together formed
an association known as *Die Brücke* (The Bridge).

573. José Clemente Orozco. *Civil War.* 1936–39. Fresco.
Government Palace, Guadalajara.

Expressionism continued as an important force in European art until the
end of World War I (Pl. 16, p. 84). After the war, the close ties between many
of the artists were broken, and the movement came to an end, though individ-
ual painters and sculptors continued to produce important work, influencing
younger artists throughout Europe and the Western Hemisphere (Fig. 573).

During the 1950s in the United States, and later throughout the world,
Expressionism found a new nonrepresentational form. Led by Willem de
Kooning and Hans Hofmann (Pl. 3, p. 17; Pl. 40, p. 162), many painters reaf-
firmed the philosophy of the earlier Expressionists with paintings motivated by
intense subjective experiences. By applying color in a spontaneous, vigorous
fashion to large canvases that demanded enormous physical effort to cover,
the artists sought to realize visual equivalents for their experience of the process
of painting. The Abstract Expressionist movement has lost much of the impor-
tance it had before 1960, but, like Expressionism, it continues to influence the
work of many contemporary artists.

REPRESENTATION AND EXPRESSION
OF THE "INNER WORLD"

The common man of the fifteenth century who wished to know himself had
only to look at his fellow men or look in the mirror. He understood men in

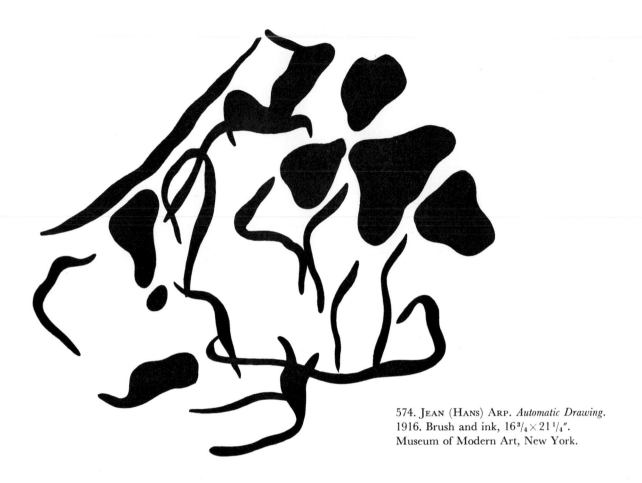

574. JEAN (HANS) ARP. *Automatic Drawing.*
1916. Brush and ink, $16^3/_4 \times 21^1/_4''$.
Museum of Modern Art, New York.

terms of their overt actions. The man of the twentieth century, even the un-
trained observer, has been made to realize that "understanding" is not that
simple. It has become usual to explain our actions by referring to the uncon-
scious and subconscious aspects of our behavior. Psychology and psychiatry
have taught us to consider whole areas of unseen, and in some cases unknow-
able, experience as a real and important part of our lives.

With the introduction of the idea of the unconscious into the realm of
human experience, artists found a new source of subject matter. This source
was themselves. They attempted to examine and represent those areas of
experience and personality which were kept behind the gates of their conscious
lives. These artists have been grouped, generally, into the category of Surreal-
ism. Their first attempts to touch their inner experience followed the paths of
current psychological techniques. Paint or ink was blotted without an attempt
to determine the final appearance of the forms. Bits of torn paper were allowed
to drop onto a surface, producing chance combinations or groups. The artists
hoped that these blots and bits of torn paper would suggest images that were
locked in the recesses of their minds (Fig. 574).

above: 575. MAX ERNST. *Alice in 1941.* Oil on canvas, 15³/₄ × 12¹/₂″. Museum of Modern Art, New York (collection James Thrall Soby).

right: 576. RENÉ MAGRITTE. *The Liberator.* 1947. Oil on canvas, 39 × 31″. Los Angeles County Museum of Art (gift of William N. Copley).

One of the early Surrealists, Max Ernst, wrote:

The investigations into the mechanism of inspiration which have been ardently pursued by the Surrealists, lead them to the discovery of certain techniques, poetic in essence, and devised to remove the work of art from the sway of the so-called conscious faculties. These techniques, which cast a spell over reason, over taste and the conscious will, have made possible a vigorous application of Surrealist principles to drawing, to painting and even, to an extent, to photography. These processes, some of which, especially collage, were employed before the advent of Surrealism, are now modified and systematized by Surrealism, making it possible for certain men to represent on paper or on canvas the dumbfounding photograph of their thoughts and of their desires.[3]

As Surrealism was developed, it changed its methods. Such artists as Ernst (Fig. 575), René Magritte (Fig. 576), and Salvador Dali attempted to

represent the world of their dreams through a technique of painting that approached the precision and clarity of a photograph. This approach was, technically, at the extreme pole from the spontaneous, uncontrolled images that resulted from the chance methods of the first Surrealist experimentalists. Nevertheless, these artists insisted that the images in their paintings were spontaneous and directly related to the unconscious experience of their inner world.

Salvador Dali describes his method of painting as follows:

After some time spent wholly in indulging in this kind of fancy summoned up out of childhood reminiscences, I finally decided to undertake a picture in which I would limit myself exclusively to reproducing each of these images as scrupulously as it was possible for me to do according to the order and the intensity of their impact, and following as a criterion and norm of their arrangement only the most automatic feelings that their sentimental proximity and linking would dictate. And it goes without saying there would be no intervention of my personal taste. I would follow only my pleasure, my most uncontrollably biological desire. This work was one of the most authentic and fundamental to which surrealism could rightly lay claim.

I would awake at sunrise, and without washing or dressing sit down before the easel which stood right beside my bed. Thus the first image I saw on awakening was the painting I had begun, as it was the last I saw in the evening when I retired. And I tried to go to sleep while looking at it fixedly, as though by endeavoring to link it to my sleep I could succeed in not separating myself from it.

577. SALVADOR DALI.
Apparition of a Face on the Seashore.
1938. Oil on canvas, 3′ 7 1/2″ × 4′ 9″.
Wadsworth Atheneum, Hartford.

456 *Expression and Response*

Sometimes I would awake in the middle of the night and turn on the light to see my painting again for a moment. At times again between slumbers I would observe it in the solitary gay light of the waxing moon. Thus I spent the whole day seated before my easel, my eyes staring fixedly, trying to "see," like a medium (very much so indeed) the images that would spring up in my imagination. Often I saw these images exactly situated in the painting. Then, at the point commanded by them I would paint, paint with the hot taste in my mouth that panting hunting dogs must have at the moment they fasten their teeth into the game killed that very instant by a well aimed shot.[4]

Dali's paintings and the works of others following this general approach have certain typical stylistic qualities (Figs. 577, 578). They usually provide the viewer with a meticulously drawn, ambiguous scene in which the realism suggested by the technique is in conflict with a representation of forms or events outside his experience. In some cases fantastic worlds are created, filled with frightening monsters or strange architectural structures. In other instances the

578. PIERRE ROY.
Electrification of the Country.
c. 1929. Oil on canvas, 29 × 20″.
Wadsworth Atheneum,
Hartford.

579. PAUL KLEE. *Swan Pond*. 1937.
Black gouache, 19½ × 16¾".
Vassar College Art Gallery, Poughkeepsie, N.Y.
(gift of Mrs. John D. Rockefeller, III).

artist will present a superficially conventional scene with some small detail
that cannot be logically explained or that suggests a series of connected images
extending beyond the limits of the canvas (Fig. 578)

THE EXPRESSIVE IMAGE
IN NONREPRESENTATIONAL ART

Somewhat apart from the movement of Surrealism but developing along more
or less parallel lines, the paintings and drawings of the Swiss artist Paul Klee
bridge the gap between representational and nonrepresentational images in the
visual arts. When Klee died in 1940 he left behind him an extraordinary body
of work, in which was traced the artist's extended involvement with the problems
of pure visual expression. Klee was a member of the Expressionist group *Der
Blaue Reiter* (The Blue Rider), and later taught at the Bauhaus, an experimental
institute for instruction in the arts, which was established first in Weimar and
then moved to Dessau, Germany. It was Klee who said in 1919 that art did not
exist to reproduce the visible but to render visible what lay beyond the visual
world. His work is a combination of a highly intellectual concern for plastic
organization and an intuitive search for expressive images (Pl. 73, p. 442;
Fig. 579). Klee's researches (and one may truly refer to his paintings in this

Plate 74. WASSILY KANDINSKY. *Panel (4)*.
1914. Oil on canvas, 5′ 4″ × 2′ 7¹/₂″.
Museum of Modern Art, New York
(Mrs. Simon Guggenheim Fund).

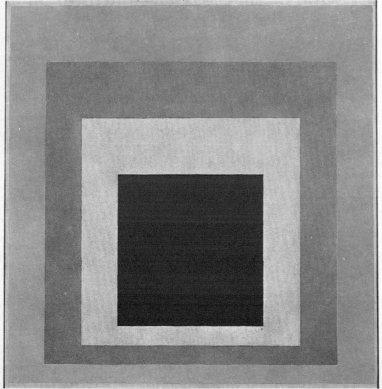

above: Plate 75. JOSEF ALBERS.
Study for an Early Diary. 1955.
Oil on canvas, 15″ square.
Sheldon Memorial Art Gallery,
University of Nebraska, Lincoln.

left: Plate 76. JOSEF ALBERS.
Homage to the Square: Ascending. 1955.
Oil on compositon board, 43 1/2″ square.
Whitney Museum of American Art,
New York.

Plate 77. AD REINHARDT. *Abstract Painting: Blue*.
1952. Oil on canvas, 6′ 3″ × 2′ 4″.
Museum of Art, Carnegie Institute, Pittsburgh
(gift of the Women's Committee).

Plate 78. JACKSON POLLOCK. *Mural on an Indian Red Ground.* 1950.
Oil, enamel, and aluminum paint on canvas, mounted on wood; 6×8′.
Collection William S. Rubin, New York.

way) resulted in some paintings that appear to be formal exercises, others that are imaginary landscapes and cityscapes, and still others that contain enigmatic calligraphy and childlike figurative symbols. Paul Klee's paintings were always highly personal, and yet they opened doors for many artists who followed him in searching for visual, nonliterary images.

In 1911 a Russian Expressionist painter and theorist, Wassily Kandinsky, who some years later was to be a colleague of Paul Klee at the Bauhaus, published a book in which he attempted to define his new concepts of art. In *On the Spiritual in Art* Kandinsky developed his belief in an art based on an inner conviction. He felt that art should be derived from actual experience but also that it should develop out of the personal, subjective reality of the individual artist, without any attempt to represent, pictorially, the appearance of the outer world. To do this he suggested the use of a "language of form and color." He ascribed expressive values to particular colors and forms and asserted that it was essential for the artist to paint with a primary concern for these values, because they represented the artist's subjective, that is, his "spiritual" response to experience.

> In reality, no picture can be considered "well painted" if it possesses only correct tone values [illusionistic use of color]. . . . One should call a picture well painted if it possesses the fullness of life. A "perfect drawing" is the one where nothing can be changed without destroying the essential inner life, quite irrespective of whether this drawing contradicts our conception of anatomy, botany, or other sciences. The question is not whether the coincidental outer form is violated, but only, if its quality depends on the artist's need of certain forms irrespective of reality's pattern. Likewise, colours should be used not because they are true to nature but only because the colour harmony is required by the paintings individually. The artist is not only justified in using any form necessary for his purpose, but it is his duty to do so.[5]

In *Point and Line to Plane*, published in 1926, Kandinsky continued his development of the idea of a visual language. He attempted to establish particular meanings for colors and forms and their combinations (Pl. 74, p. 459).

Kandinsky realized that his analysis of the expressive qualities of the elements of art could only brush the surface of the problem. He and other artists who have attempted to relate pure color, form, line, and texture to the expression of visual meaning have not come to any general agreement concerning the specific meanings of particular elements or the meanings of their possible combinations. To assume that one variety of line or a single color will express love, or hate, or happiness is simplifying the problem unrealistically, but it is possible to suggest certain general, and perhaps obvious, kinds of meaning that may be achieved by a selective use of line, form, and color.

For example, short, staccato lines will suggest more agitation than lines that have a flowing continuity. The line itself may be rough or smooth. It may be oriented on the diagonal or curve, placed with a vertical emphasis or a horizontal emphasis (Fig. 580).

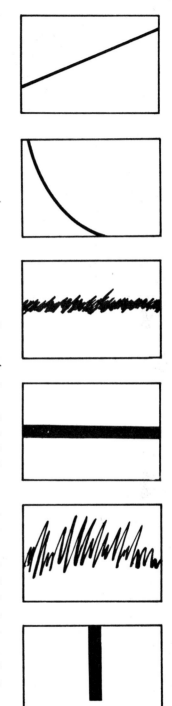

580. Variations of quality in line.

581. Contrasting values.

582. Closely related values.

Color can be selected to contrast sharply in value or hue, or color combinations can be harmonious and quietly unified, suggesting obvious expressive possibilities.

Even when the forms in a composition are restricted to identical squares and those squares are arranged in horizontal and vertical lines, variation in color can produce significant differences in the expressive content of the designs. The two examples shown here illustrate color changes in value. Figure 581 shows variations of value in contrast, and the quality produced is one of agitation, excitement, conflict. Figure 582 is composed of squares of closely related values, and the effect is quite different. Words such as "still," "quiet," "mysterious" might very well apply to this effect.

As long as the artist conformed to the conventions of his time in the construction and the production of works of art, his exploration of the expressive possibilities in the plastic elements had to be extremely limited. Under these conditions the painter or the sculptor conceived of his subject matter and executed his work within the patterns set by his traditions, but given the freedom of the present day, an artist may choose his visual language. Without concern for a particular form of representation, he may consider the expressive use of each element and the possible combinations of elements. What kind of line will best express anger? What combination of hues will communicate a feeling of gaiety? What type of space is required in a mural to convey a condemnation of aggression? Such questions have been answered by contemporary artists, who have found their own solutions to the creation of expressive visual symbols.

The possibility of a choice of expressive visual images exists today, but the artist does not always make a conscious selection of that style which is most relevant to his intentions. Often the choice is made without a logical predetermination of how a feeling or an idea can best be expressed. The artist may be affected by works of art he has seen before, without knowing that they are acting as an influence. The selection of a visual language is rarely an arbitrary

decision. A critic, or even the artist himself, may be able, after the work is completed, to analyze the reasons for the choices that inevitably produced the unique qualities of a particular art object, but in the process of creating that work a complex series of conscious and intuitive actions and interactions yields the visual language that satisfies the needs of the sculptor or painter.

Many present-day artists have forsaken a rational, conscious attitude toward art and instead depend upon spontaneous, intuitive responses to the emotional stimuli they feel. Their visual symbols develop in the very process of painting. Their methods and attitudes have much in common with those of the early Surrealists who experimented with automatic writing and accidental collages, and they have a familial connection with the work of Klee.

William Baziotes was a painter who belonged to this group (Fig. 583). He discussed his work in the following way:

> There is no particular system I follow when I begin a painting. Each painting has its own way of evolving. One may start with a few color areas on the canvas; another with a myriad of lines; and perhaps another with a profusion of colors. Each beginning suggests something. Once I sense the suggestion, I begin to paint intuitively. The suggestion then becomes a phantom that must be caught and made real. As I work, or when the painting is finished, the subject reveals itself.[6]

583. WILLIAM BAZIOTES. *The Beach*. 1955. Oil on canvas, $3 \times 4'$.
Whitney Museum of American Art, New York.

above: 584. JEAN DUBUFFET. *Beard of Uncertain Returns.* 1959. Oil on canvas, $45^3/_4 \times 35^1/_8$". Museum of Modern Art, New York (Mrs. Sam A. Lewisohn Fund).

right: 585. JACQUES LIPCHITZ. *Figure.* 1926–30. Bronze, height 7' 1 $^1/_4$". Museum of Modern Art, New York (Van Gogh Purchase Fund).

Artists such as Baziotes combine the use of a language of pure form and color in the tradition of Kandinsky and the automatic intuitive development of expressive images in the manner of the Surrealists. They do not represent emotion; they try to produce a visual equivalent for the emotional experience itself.

The phantom to which Baziotes refers in his statement may take the form of a nonrepresentational, chimerical image, which becomes a threatening or beneficent presence that a viewer may sense in the work of art. The painting *Beard of Uncertain Returns* (Fig. 584), by Jean Dubuffet, may be understood to represent the head of a bearded man, and yet it is more than that. The highly textured surface of the single large form dominates the center of the canvas. Here is a portrait of *something*, a nightmarish presence that is far more than an area of textured canvas. The central form becomes an image, rather than a part of an esthetic organization. It seems to have a life of its own, rather than a function as a color or textural area in a compositional scheme.

A similar nonrepresentational image appears in the bronze by Jacques Lipchitz called *Figure* (Fig. 585). This massive series of forms has elements of a figurative image in it, but its expressive content seems to derive from its scale (over 7 feet high), the simplicity of its forms, and a robotlike arrangement of the circular elements in the upper portion of the composition.

Kurt Schwitters, a German artist who died in 1948, produced collages which combine image and composition in a style quite different from that of Dubuffet. Schwitters organized bits of printed matter, commonplace scraps of paper, and cloth into meticulously arranged compositions (Fig. 110). The materials incorporated into these collages often carry with them some of the meaning associated with their original use. A part of a calendar, a ticket stub, the handwritten corner of a note—these become more than textural and color shapes combined to form a pleasant design. They are the residue of the lives of unknown men and women, formed into a mosaic that provides the viewer with a shadowy image of past events.

Frequently, the image in nonrepresentational subjects is an evocative atmosphere, rather than a disquieting specter. The paintings of Josef Albers can be described as compositions based upon overlapping squares of color, but when a group of them is seen together, each subtle combination of colors seems to suggest a quite different attitude (Pls. 75, 76, p. 460). In fact, Albers' titles often have reference to highly personal experience.

In some instances contemporary painters have increased the scale of their works so that they cover wall-size areas. These large canvases seem to create a personal world of form and color that functions as a man-made environment. They offer a viewer a universe set apart from nature, charged with the emotion that initially stimulated the artist who produced it.

An American painter, Ad Reinhardt, produced a number of works based upon simple, flat rectangular forms of very closely related colors (Pl. 77, p. 461). Large in scale, they appear at first to be painted in one color, but as the eyes of the observer accommodate to the subtleties of the contrasts, areas of the painting seem to appear and then fade, to be replaced by still other ghostly forms that

586. Frédéric-Auguste Bartholdi.
Statue of Liberty
(Liberty Enlightening the World).
1874–85. Copper and iron,
height of figure 151′.

enter and then leave the viewer's awareness. This quiet, intense perceptual experience induces in many observers a mood of contemplation and introspection.

Among the mature paintings by Jackson Pollock are several large oils which become expressive environments. His *Mural,* reproduced as Plate 78 (p. 462), was executed in a technique that the artist developed to bear the full weight of his expressive intent. The canvas was laid out flat on a floor. Pollock stood over it, using brushes, punctured cans, and sticks, which dripped paint, to produce the skeins of colored lines that cover the surface. The result is a complex screenlike web surrounding the viewer with a shimmering barrier through which there seem to be visible lights and forms of unknown origin.

The artist described his involvement in this painting process as follows:

When I am *in* my painting, I'm not aware of what I am doing. It is only after a sort of "get acquainted" period that I see what I have been about. I have no fears about making changes, destroying the image etc., because the painting has a life of its own. I try to let it come through. It is only when I lose contact with the painting that the result is a mess. Otherwise there is pure harmony, an easy give and take, and the painting comes out well.[7]

The scale of Pollock's paintings is an important element that affects those who stand before them. Many artists use size for expressive effect. One does not

587. Tony Smith. *Die*. 1962.
Steel, 6′ cube.
Collection Samuel Wagstaff, Jr., Detroit.

feel the same about a tiny illumination in a manuscript as about a mural that covers a great wall. But in sculpture, perhaps because the three-dimensional work exists as an actual mass in space, scale seems to have an even greater importance than it does in the two-dimensional media. A sculptural work that towers over the observer has an importance deriving from its height. The *Statue of Liberty* in the harbor of New York City (Fig. 586) is not a figure of great esthetic value; it takes its significance from the values it symbolizes, but its monumental proportions also have their effect. Reduced to the stature of a man, it would lose its impressive appearance and become far less than it now is.

An even more obvious example of the influence of scale on the expressive content of an object can be found in the massive 6-foot cube constructed by Tony Smith (Fig. 587). A 2-inch version of this geometric solid would have the interest of a child's building block. Enlarged to its present proportions, it becomes a powerful, enigmatic object. If it were given the dimensions of an Egyptian pyramid, it would be awe-inspiring.

Smith belongs to that group of contemporary artists who have been called "minimalists." The objects they create confront the observer with highly simplified forms whose impact seems to depend on their being inexplicably huge.

A variation on the enlargement of a commonplace object is Claes Oldenburg's *Giant Soft Fan* (Fig. 588), which combines outsize scale with a change in

the material characteristics and the rigid forms associated with the original subject. The organic folds and bulges of the fan, swollen and padded in its exaggerated proportions, give it a sensuality that requires a conceptual reorientation in the spectator.

To review, the expressive image may be a representation of the attitude of a subject in a work of art; it may be the expression of the artist's reaction to a subject, indicated by the representational conventions he has adopted, the way in which he has altered those conventions from the anticipated, *normal* modes, or, finally, in a nonrepresentational work the image may be an evocative symbol or atmosphere which, created by color, form, and the other plastic elements, evokes an emotion in the viewer. The expressive image is in part shaped by the subjective makeup of the observer, and because this is so, there cannot be a universal response to any particular expressive statement. So much of the response depends on the variable qualities in each artist and in each individual who looks at the result of the artist's work, that some images are inevitably ambiguous and "meaningless" to some persons. It is enough to say that, for each viewer, certain works of art will express some of the feelings and subjective attitudes which are an important part of the sense of life we all feel.

588. Claes Oldenburg. *Giant Soft Fan.* 1966–67. Vinyl, wood, and foam rubber; 10′ × 10′ 4″ × 6′ 4″. Museum of Modern Art, New York (gift of Sidney and Harriet Janis).

THE VISUAL DIALOGUE

I would venture to affirm that a man cannot attain excellence if he satisfies the ignorant and not those of his own craft, and if he be not "singular" or "distant," or whatever you like to call him.[1]

What I want to show in my work is the idea which hides itself behind so-called reality. I am seeking for the bridge which leads from the visible to the invisible.

. .

One of my problems is to find the ego, which has only one form, and is immortal —to find it in animals and men, in the heaven and in the hell which together form the world in which we live.[2]

The first of the two quotations above is attributed to Michelangelo, one of the titans of the Italian Renaissance. It is the expression of an artist who felt that he was important in his society which had slowly made the transition from the medieval world, in which individuality was severely limited. The second quotation is the statement of the twentieth-century German Expressionist painter Max Beckmann, completely immersed in his own personal search for those things and values which were meaningful to him. Though not in the same way, or to the same degree, both Michelangelo and Beckmann turned from those about them to look inward for the basis of their art, and this attitude is representative of the great majority of contemporary artists.

For the artist today, and for many others, there is no single meaningful, all-encompassing concept of man, his society, his ethics, and morality. Instead,

there is the recognition of a world fragmented into many separate, though often related, cells, divided by language, custom, religion, economic development, and geographical location. For any single individual in this conglomerate group, the significance of the events which occur from day to day, the nature and meaning of past events, and the expectation of what is yet to happen can differ so widely that it is not strange to think of one artist in one studio in one small part of the world focusing on only a small part of this immense fabric, attempting to express his singular involvement with it.

Today, each artist must isolate that which is important to him, and then he must find the visual equivalent for it. He is faced with a situation that never confronted his predecessors. He lives in a world for which the visual image is commonplace. The most inexperienced art student is conversant with visual art forms more varied and more numerous than those known to the master artist of the previous century. Each year the history of art grows larger, and access to the art of the past becomes easier. Museums and galleries in our cities have made possible a first-hand knowledge of major art objects from the very beginning of history to the present, and what the museums have been able to do for their visitors, mass magazines have done for their readers. Color reproductions of works of art seem to find their way to the pages before the paint is dry on the artist's canvas. This esthetic bounty has increased the interest in the visual arts, but at the same time it has driven the contemporary artist to a search for new forms of visual communication.

As the exposure of paintings, sculpture, and architecture has grown, the need for new forms of communication has grown with it. The characteristics of a painting style which seem to express a sincere and direct sensitivity to human experience at one time in history may become the basis for a stylistic cliché at another. Picasso used the Cubist treatment of a head in his paintings of the 1930s as a vital expressive device (Fig. 589). By showing composite views of the head, it was possible for him to intensify the emotional content of his figure symbols. This device has now become relatively common and has even made its way into advertising art, drained of its emotional impact, a clever stylistic treatment (Fig. 590).

The artist searching for the plastic means to say the things that are important to him cannot use forms, symbols, and symbolic structures that have been drained of their meaning through repeated use. He must find those combinations of the plastic vocabulary which will have the impact and the directness necessary for what he has to say. He needs a way to bypass the cliché, not to be ambiguous and incomprehensible, as many critics have charged, but for exactly the opposite reason—to be explicit and meaningful. He is an extension of the artistic tradition that preceded him, but he also tries to expand that tradition so that the aspects which are no longer effective for real communication are reinforced or superseded by more vital forms.

Many of the expressive forms of art have been conceived as a result of the demand for resolution of practical problems. This is particularly true in architecture, where the structural and operational considerations are crucial to the

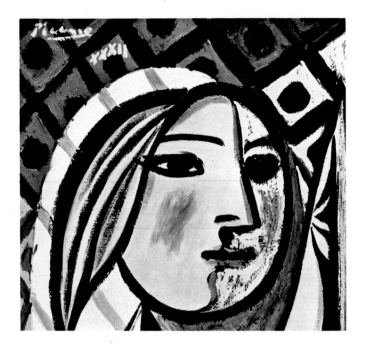

above: 589. Detail of Plate 2 (p. 16),
PICASSO's *Girl Before a Mirror.*

right: 590. Advertisement for
Croton Watch Co., Inc. February, 1962.

design, but there are frequently many possible solutions; a roof may be covered by a round vault, a pointed groin vault, or a flat plane. The choice of a structural method depends upon the supply of materials, cost, and the skill of the available craftsmen, but it also depends upon the esthetic response of the designer. Certain forms and spaces satisfy him more than others, apart from structural or operational necessity.

In painting and sculpture the need and the desire to represent important objects and experiences in the real world do not limit the style chosen.

Certain painters and sculptors working at the present time feel that their function is to comment on the social and moral condition of their world, using visual images that can be understood by a mass audience. For the most part, artists committed to this belief in the sociological function of art use the traditional forms of visual communication, the forms which have had the greatest exposure and so are most familiar to the public.

591. FRANCISCO GOYA. *Tampoco (Nor These)*, from *The Disasters of War*. c. 1820.
Intaglio, $5^3/_8 \times 7^1/_2$″. Metropolitan Museum of Art, New York (Schiff Fund, 1922).

In our own age the photograph dominates all other visual media in the dissemination of information. Several times in this book it has been stressed that the photograph gives only a part of the information that can be communicated about experience, but the widespread ability of peoples throughout the world to interpret photographic images and relate them to the real world makes the camera a potent instrument. Usually the photograph communicates a single, ephemeral experience. As it is used in newspapers and magazines, it becomes a journalistic tool. On occasion a photograph can represent an image of permanent value as an expression of the life and the condition of man, but the vast number of mass-reproduced photographs are seen and then relegated to the trash heap. Once they have served their purpose for the short-term audience, they are superseded on the next day by another set of consumable visual images.

. Like the photographer, the painter, the printmaker, and the sculptor are faced with concerns of relevance in dealing with social and political conditions. Socially conscious works can have an immediate and expressive impact, but often the power of their message declines as the character of life changes. Some exceptional examples seem to possess values untouched by time. The etchings by the Spanish painter Francisco Goya were a damning commentary on the bestiality of war when they were drawn about 1820, as a result of the Napoleonic invasion of Spain (Fig. 591). Today, perhaps because the images of rape, murder, and torture still cry out, these etchings continue to move a large

audience. On the other hand, when one looks at the work in Figure 592, by the American Ben Shahn, there is little comprehension of the message contained in this single composition from a series devoted to the trial and execution of Sacco and Vanzetti, which took place in the 1920s. At the time, the series of protests painted by Shahn was considered a powerful indictment of what many believed to be a grave miscarriage of justice. Today, without the aid of a written historical account of the event, what does this painting describe or express to the viewer who is unfamiliar with the story?

It is not possible simultaneously to extend the form of language and to appeal to a mass audience. With new forms of communication come difficulties of understanding, the problem of a confusion of symbolic meanings. New language forms may give the artist an opportunity to intensify the content of his message, but at the same time they restrict his audience, and he must choose

592. BEN SHAHN.
The Passion of Sacco and Vanzetti.
1931–32. Tempera on canvas,
$7'1/_2'' \times 4'$.
Whitney Museum of American Art,
New York (gift of
Edith and Milton Lowenthal
in Memory of Juliana Force).

593. Folk spindle *(rocca)*, from Calabria, Italy. 19th–20th century. Carved and incised wood with rattling seed pod, height 9³/₈″. Collection Mamie Harmon, New York.

between an expressive vocabulary and a large public. In times of crisis the choice has often been for the latter. Today, however, with photography serving as an active and efficient visual art for the communication of ideas to a mass public, the painter and the sculptor seem destined to concern themselves with the development of visual forms of expression which have limited audiences but, at the same time, extend the area of expression.

Why does the artist wish to paint, to carve stone, to organize steel and stone into architecture?

The most obvious answer is that it pleases him, it satisfies him. In manipulating the materials of his art he finds a pleasure akin to that of the games of children. The sensuous and kinesthetic release expressed in the scribble of the infant as he discovers the lines made by his crayons and the almost animal delight of squeezing clay between the fingers are still to be found in the mature artist. Of course, there is more. There is the act of discovery. There is the gratification of identifying in the work under the artist's hands the concrete expression of a reality he has sensed, half-formed, in his mind, of establishing order, of being able to control the material and organize the forms and colors to achieve the ends that inspired the undertaking. It is at this level that the artist needs to find that combination of the plastic vocabulary which will do for him what no other combination is capable of achieving.

Finally, the work of art functions for the artist as a form of communication. When he is through with it, after the last brush stroke has been placed and the last mark of the chisel has been ground from the surface of the stone, he offers his statement to those who are capable of reading his message.

Art seems to have a real value for the artist, but why should anyone else be concerned with it? The answer, of course, is obvious: no one *should necessarily* be concerned, but many people *are*.

For some, the involvement they feel comes from an awareness that certain products of the artist have given them pleasure, and they seek more. It is, perhaps, impossible to establish the basis for this feeling. It seems to have been present in man from his earliest days on earth. The ornamentation of simple tools, implements, and weapons testifies to its importance in almost every culture (Fig. 593).

At one time, when art alone fulfilled the function of visually recording and representing the physical world, accurate representation was the aspect of greatest significance to many viewers. Today, this function, in the main, has been assumed by photography, but there are still many persons who find pleasure in seeing a painting that is essentially representational. For the most part, the satisfaction offered by such work, as distinguished from the photograph, is similar to that found in the work of the craftsman, the identification of skilled labor, the sense of participation in the resolution of the technical problems posed by the work. When such a work gives the viewer a sense of reality surpassing that of the photograph, the pleasure to be realized is like that of discovering some new bit of information, some new insight, a revelation about a world one already knows.

The paintings of the American Andrew Wyeth have found wide public and critical acclaim. They combine photographic representation with an extraordinary skill in the application of paint, and, in addition, they often project or evoke an intimate awareness of a highly personal sensitivity to everyday experience beyond the perception of most people (Fig. 594).

The revelatory aspect of art and the satisfaction it can provide are not reserved to such readily recognized forms. An art form that is evocative, that seems to point to certain aspects of reality without rendering them in such a familiar guise, also has in it the potential for discovery. It permits an emphatic, subjective response. The reality it offers need not be pleasant in itself; the pleasure is derived from finding the meaning, whatever it may be. There is also the pleasurable sensation of being transported into a world apart, a world which has order and reason to a degree that one cannot often find in the complexity of his own, or which offers some respite from the realities of the immediate experience and permits the luxury of a temporary existence in an environment created by the artist.

Finally, there are the direct sensory pleasures to be had from the response to color or the touch of a smooth piece of marble, or perhaps the exhilaration that is felt when one stands in the center of a great architectural space.

There are, then, many effects of art on those who do not produce the works: satisfaction of the senses, stimulation of the imagination, isolation of

594. Andrew Wyeth. *Christina's World.* 1948. Tempera on gesso panel, 32 1/4 × 47 3/4". Museum of Modern Art, New York.

consciousness in a world of clarity or reverie. All these offer the observer an opportunity for experience he might otherwise not have, experience which adds to the riches of life in a way that cannot be duplicated by other means.

The public cannot, however, place the total responsibility for its response upon the artist. It is not enough to say that the artist *must* produce an object which makes the public respond, for the appreciation of art results from an *active* participation on the part of an observer. The work of art and the person who stands before it take part in a *dialogue*, in which each contributes a portion of the whole experience.

This dialogue has its counterpart in the studio, for the creation of the work of art frequently results from a process in which the artist acts upon his work and is in turn acted upon by it. The artist begins the process. In painting, a red mark placed upon the canvas will be followed by other marks. The initial impulse to make the marks may have been urged by a desire to represent a subject, to express a feeling, to fashion an object, or any combination of the three, but once the marks are there, outside the painter, they become a part of a process which continues until the painting is complete. Each spot of color on a canvas has at least some minutely accidental qualities in it. No matter how precisely he works, an artist cannot control every possible variable in each stroke of his brush, and for painters who work in a broad and vigorous manner the factor of accident may be very large, indeed. The painter learns, as do the practitioners of the other visual arts, to take advantage of the unexpected or unplanned effects that appear in the work in progress, to permit a dialogue to take place between the artist and the art object.

A continuing interaction can take place as the work progresses, but though the appearance of some portions may be traceable to accidental or unconscious factors in its creation, it is the artist who has the ultimate responsibility for the final result. It is he, having seen the accidental areas, who decides to retain or eliminate them.

It is true that an artist who believes he is carrying on a dialogue with his work as it progresses is, in reality, speaking to himself, but this does not alter the fact that communication does *appear* to take place between two *active* participants. The production of a work of art is a dynamic activity, in which the artist acts and then responds to what he has done as he proceeds to the next step in the sequence that eventually brings forth his finished work.

As noted, the interaction, or the dialogue, that occurs between artist and art object has a parallel in the relationship between the viewer and the art object. The work of art exists as a completed physical entity when it is presented to view, but it becomes an object of esthetic value only when it causes a response in the observer, and the nature of that response is dependent upon his active participation in the esthetic experience. The work of art has a statement to make, but it is the observer who shapes that statement into a personal communication by committing himself to the experience. The work can speak to those who are passively involved, but it speaks most eloquently and satisfyingly when it becomes a part of a visual dialogue.

Bibliography and Notes

The bibliography, topically arranged, is a selection of the sources the author has found responsive to the questions and issues he raised in the course of his own development in art. Far from exhaustive, these few published statements are recommended to the reader as an introduction to the rich store of ideas and commentary that the challenge of art has motivated artists and thinkers of every persuasion to formulate. The notes to the text, which follow the bibliography, cite certain specific sources that have contributed to the book's content. These are arranged by chapter.

BIBLIOGRAPHY

Architecture

Argan, Giulio C. *The Renaissance City*. N.Y.: Braziller, 1969.

Choay, Françoise. *The Modern City: Planning in the 19th Century*. N.Y.: Braziller, 1969.

Evenson, Norma. *Chandigarh: A Study of the City and Its Monuments*. Berkeley: U. of California Press, 1966.

Fletcher, Banister. *A History of Architecture on the Comparative Method*, 17th ed. N.Y.: Scribner, 1961.

Frigand, Sidney J. *The New City: Architecture and Urban Renewal*. N.Y.: Museum of Modern Art, 1967.

Giedion, Siegfried. *The Beginnings of Architecture*. Princeton U. Press, 1964.

———. *Space, Time and Architecture*. Cambridge: Harvard U. Press, 1963.

Gropius, W. *Scope of Total Architecture*. N.Y.: Collier, 1962.

Hamlin, Talbot F. *Architecture through the Ages*. N.Y.: Putnam, 1940–53,

———. *Forms and Functions of Twentieth Century Architecture*. N.Y.: Columbia U. Press, 1952.

Hilberseimer, Ludwig. *The Nature of Cities*. Chicago: Theobald, 1955.

Hiorns, Frederick R. *Town Buildings in History*. N.Y.: Criterion, 1958.

Hitchcock, Henry-Russell, Albert Fein, Winston Weisman, and Vincent Scully. *The Rise of an American Architecture* (ed. with intro. by Edgar Kaufmann, Jr.). N.Y.: Praeger, 1970.

Jacobs, Jane. *The Death and Life of Great American Cities*. N.Y.: Random, 1961.

———. *Economy of Cities*. N.Y.: Random, 1969.

Johnson-Marshall, Percy Edwin Alan. *Rebuilding Cities*. Chicago: Aldine, 1966.

Lampl, Paul. *Cities and Planning in the Ancient Near East* (ed. by George R. Collins). N.Y.: Braziller, 1968.

Lowe, Jeanne R. *Cities in a Race with Time: Progress and Poverty in America's Renewing Cities*. N.Y.: Random, 1967.

Lowry, Bates. *Renaissance Architecture*. N.Y.: Braziller, 1962.

MacDonald, William L. *The Architecture of the Roman Empire*. New Haven: Yale U. Press, 1965.

Millon, Henry A. *Baroque and Rococo Architecture*. N.Y.: Braziller, 1961.

———, and Alfred Frazer. *Key Monuments of the History of Architecture*. N.Y.: Abrams, n.d.

Moholy-Nagy, Sibyl. *Matrix of Man: An illustrated History of Urban Environment*. N.Y.: Praeger, 1968.

Mumford, Lewis. *The City in History*. N.Y.: Harcourt, 1961.

Neutra, Richard. *Survival Through Design*. N.Y.: Oxford U. Press, 1954.

Panofsky, Erwin. *Gothic Architecture and Scholasticism*. Cleveland: Meridan Books, World,1957.

Pevsner, Nikolaus. *An Outline of European Architecture*. Baltimore: Penguin, 1957.

Rasmussen, Steen Eiler. *Experiencing Architecture*. Cambridge: M.I.T. Press, 1962.

———. *Towns and Buildings*. Cambridge: M.I.T. Press, 1969.

Richards, J.M. *An Introduction to Modern Architecture*. Baltimore: Penguin, 1940.

Rudofsky, Bernard. *Streets for People: A Primer for Americans*. Garden City: Doubleday, 1969.

Safdie, Moshe. *Beyond Habitat*. Cambridge: M.I.T. Press, 1970.

Scully, Vincet J., Jr. *Earth, the Temple and the Gods: Greek Sacred Architecture*. New Haven: Yale U. Press, 1962.

Spreiregen, Paul D. *Urban Design: The Architecture of Towns and Cities*. N.Y.: McGraw-Hill, 1965.

Sullivan, Louis. *Kindergarten Chats and Other Writings*. N.Y.: Wittenborn, 1947.

Venturi, Robert. *Complexity and Contradiction in Architecture*. N.Y.: Museum of Modern Art, 1967.

Ware, Dora, and Betty Beatty. *A Short Dictionary of Architecture*. N.Y.: Philosophical Library, 1945.

Wright, Frank Lloyd. *The Future of Architecture*. N.Y.: Horizon, 1953.

Color

Albers, Josef. *Interaction of Color*. New Haven: Yale U. Press, 1963.

Birren, F. *The Story of Color*. Westport: Crimson Press, 1941.

Hickethier, Alfred. *Color Mixing by Numbers*. N.Y.: Van Nostrand-Reinhold, 1969.

Itten, Johannes. *The Art of Color*. N.Y.: Reinhold, 1961.

Munsell, Albert Henry. *A Color Notation*. Baltimore: Munsell Color Co., 1946.

Ostwald, Willhelm. *Color Science*. London: Winsor & Newton, 1931–33.

Seitz, William C. *The Responsive Eye*. N.Y.: Museum of Modern Art, 1965.

Wright, W.D. *The Measurement of Color*. London: Hilger & Watts, 1958.

Communication

Haber, Ralph N. *Information-Processing Approaches to Visual Perception*. N.Y.: Holt, Rinehart & Winston, 1969.

Hall, E.T. *The Silent Language*. Garden City: Doubleday, 1959.

McLuhan, Marshall, and Edmund Carpenter. *Explorations in Communication*. Boston: Beacon, 1960.

Ogden, C.K., and I.A. Richards. *The Meaning of Meaning*. N.Y.: Harcourt, 1930.

Ulman, Stephen. *Words and Their Use*. N.Y.: Philosophical Library, 1951.

Urban, Wilbur Marshal. *Language and Reality*. N.Y.: Macmillan, 1939.

Whorf, Benjamin Lee. *Language, Thought and Reality*. N.Y.: Technology Press and Wiley, 1956.

Drawing

Anderson, Donald M. *The Art of Written Forms: The Theory and Practice of Calligraphy*. N.Y.: Holt, Rinehart & Winston, 1969.

Bertram, A. *1000 Years of Drawing*. N.Y.: Dutton, 1966.

Blake, Vernon. *The Art and Craft of Drawing*. London: Oxford U. Press, 1927.

Chaet, Bernard. *The Art of Drawing*. N.Y.: Holt, Rinehart & Winston, 1970.

de Tolnay, Charles. *History and Technique of Old Master Drawings*. N.Y.: Bittner, 1943.

Hutter, Heribert. *Drawing: History and Technique*. N.Y.: McGraw-Hill, 1968.

Kampelis, R. *Learning to Draw*. N.Y.: Watson-Guptil, 1968.

Lindemann, Gottfried. *Prints and Drawings: A Pictorial History* (tr. by Gerald Onn). N.Y.: Praeger, 1970.

Mendelowitz, Daniel M. *Drawing*. N.Y.: Holt, Rinehart & Winston, 1967.

Moskowitz, Ira. *Great Drawings of All Time*. N.Y.: Shorewood, 1962.

Rawson, P. S. *Drawing*. London: Oxford U. Press, 1969.

Rosenberg, Jakob. *Great Draftsmen from Pisanello to Picasso*. Cambridge: Harvard U. Press, 1959.

Slive, S. (ed.). *Drawings of Rembrandt*. N.Y.: Dover, 1965.

History of Art Surveys

Arnason, H. Harvard. *History of Modern Art: Painting, Sculpture, and Architecture*. Englewood Cliffs: Prentice-Hall; N.Y.: Abrams, n.d.

Cuttler, Charles D. *Northern Painting: From Pucelle to Bruegel*. N.Y.: Holt, Rinehart & Winston, 1968.

de la Croix, Horst, and Richard G. Tansey. *Gardner's Art Through the Ages*, 5th ed. N.Y.: Harcourt, 1970.

Fleming, William. *Art & Ideas*, 3rd ed. N.Y.: Holt, Rinehart & Winston, 1968.

Focillon, Henri. *The Art of the West in the Middle Ages*, 2nd ed. (ed. by Jean Bony; trans. by Donald King). N.Y.: Phaidon, 1969.

Frankfort, Henri. *Art and Architecture of the Ancient Orient*. Baltimore: Penguin, 1959.

Gombrich, E.H. *The Story of Art*, 11th ed. N.Y.: Phaidon, 1966.

Hamilton, George Heard. *The 19th and 20th Centuries: Painting, Sculpture, and Architecture*. N.Y.: Abrams, 1970.

Hartt, Frederick. *History of Italian Renaissance Art: Painting, Sculpture, and Architecture*. Englewood Cliffs: Prentice-Hall; N.Y.: Abrams, 1969.

Hauser, Arnold. *The Social History of Art*, 4 vols. N.Y.: Vintage, 1957.

Janson, H.W. *History of Art*, rev. Englewood Cliffs: Prentice-Hall; N.Y.: Abrams, 1969.

Lange, Kurt, and Max Hirmer. *Egypt: Architecture, Sculpture and Painting in 3000 Years*, 4th ed. N.Y.: Phaidon, 1968.

Lee, Sherman. *A History of Far Eastern Art*. Englewood Cliffs: Prentice-Hall; N.Y.: Abrams, 1964.

Leroi-Gourhan, A. *Treasures of Prehistoric Art*. N.Y.: Abrams, 1967.

Mendelowitz, Daniel M. *A History of American Art*, 2nd ed. N.Y.: Holt, Rinehart & Winston, 1970.

Morey, Charles R. *Early Christian Art*. Princeton U. Press, 1942.

———, *Medieval Art*. N.Y.: Norton, 1942.

Murray, Peter and Linda. *The Art of the Renaissance*. N.Y.: Praeger, 1963.

Myers, Bernard. *Art and Civilization*, 2nd ed. N.Y.: McGraw-Hill, 1967.

Newton, Eric. *European Painting and Sculpture*. Baltimore: Penguin, 1964.

Rewald, John. *The History of Impressionism*, rev. N.Y.: Museum of Modern Art, 1961.

———. *Post-Impressionism, from van Gogh to Gauguin*. N.Y.: Museum of Modern Art, n.d.

Rice, David Talbot. *The Byzantine Era*. N.Y.: Praeger, 1963.

Richter, Gisela M.A. *A Handbook of Greek Art*, 5th ed. London: Phaidon, 1967.

Robb, David M., and J. J. Garrison. *Art in the Western World*. N.Y.: Harper, 1963.

Sewall, John Ives. *A History of Western Art*, rev. N.Y.: Holt, Rinehart & Winston, 1961.

Upjohn, Everard, Paul S. Wingert, and Jane Gaston Mahler. *History of World Art*. N.Y.: Oxford U. Press, 1958.

Wittkower, Rudolf. *Art and Architecture in Italy 1600–1750*. Baltimore: Penguin, 1958.

Painting

Canaday, John. *Mainstreams of Modern Art*. N.Y.: Holt, Rinehart & Winston, 1959.

Doerner, Max. *The Materials of the Artist and Their Use in Painting, with Notes on the Techniques of the Old Masters*. N.Y.: Harcourt, 1949.

Jensen, Lawrence N. *Synthetic Painting Media*. Englewood Cliffs: Prentice-Hall, 1964.

Levey, Michael. *A Concise History of Painting*. N.Y.: Praeger, 1962.

Lippard, Lucy R. *Pop Art*. N.Y.: Praeger, 1966.

Mayer, Ralph. *The Painter's Craft*. Princeton: Van Nostrand, 1948.

Robb, David M. *The Harper History of Painting*. N.Y.: Harper, 1951.

Perception and Vision

Ames, A., C.A. Proctor, and Blanche Amos. "Vision and the Technique of Art," *Proceedings of the American Academy of Arts and Sciences*, Vol. 58, No. 1, February, 1923.

Brandt, Herman F. *The Psychology of Seeing*. N.Y.: Philosophical Library, 1945.

Buswell, Guy Thomas. *How People Look at Pictures: A Study of the Psychology of Perception*. U. of Chicago Press, 1935.

Gibson, James J. *Perception of the Visual World*. Boston: Houghton Mifflin, 1950.

Gregory, R. L. *Eye and Brain: The Psychology of Seeing*. N.Y.: McGraw-Hill, 1966.

Vernon, M.D. *A Further Study of Visual Perception*. London: Cambridge U. Press, 1952.

Young, J.Z. *Doubt and Certainty in Science*. London: Oxford U. Press, 1951.

Philosophy of Art and Criticism

Berndtson, Arthur. *Art Expression and Beauty*. N.Y.: Holt, Rinehart & Winston, 1969.

Bird, Milton. *A Study of Aesthetics*. Cambridge: Harvard U. Press, 1932.

Bosanquet, B. *A History of Aesthetics*. N.Y.: Meridan, 1957.

Carritt, E.F. *Philosophies of Beauty*. N.Y.: Oxford U. Press, 1931.

Cassirer, Ernest. *An Essay on Man*. Garden City: Doubleday, 1956.

Chandler, Albert R. *Beauty and Human Nature*. N.Y.: Appleton, 1934.

Dewey, John. *Art as Experience*. N.Y.: Putnam, 1934.

Fiedler, Conrad. *On Judging Works of Art*. Berkeley: U. of California Press, 1949.

Jarritt, James L. *The Quest for Beauty*. Englewood Cliffs: Prentice-Hall, 1957.

Langer, Susanne K. *Problems of Art*. N.Y.: Scribner, 1957.

Munro, Thomas. *The Arts and Their Inter Relations.* N.Y.: Liberal Arts Press, 1949.

Osborne, Harold. *Aesthetic and Criticism.* N.Y.: Philosophical Library, 1955.

Pepper, Stephen C. *The Basis of Criticism in the Arts.* Cambridge: Harvard U. Press, 1941.

Rader, Melvin M. *A Modern Book of Esthetics.* N.Y.: Holt, Rinehart & Winston, 1951.

Read, H. *The Meaning of Art.* Baltimore: Penguin, 1964.

Prints and Printmaking

Arms, John Taylor. *Handbook of Printmaking and Printmakers.* N.Y.: Macmillan, 1935.

Bliss, Percy Douglas. *A History of Wood Engraving.* London: Dent, 1928.

————. *Rembrandt, Experimental Etcher.* Boston: Museum of Fine Arts, 1969.

Brown, B. *Lithography for Artists.* U. of Chicago Press, 1930.

Cirker, Blanche. *1800 Woodcuts by Thomas Bewick and His School.* N.Y.: Dover, 1962.

Hargrave, Catherine. *A History of Playing Cards.* N.Y.: Dover, 1966.

Heller, Jules. *Printmaking Today.* N.Y.: Holt, Rinehart & Winston, 1958.

Hind, Arthur M. *A Catalogue of Rembrandt's Etchings.* N.Y.: Da Capo Press, 1967.

————. *A History of Engraving and Etching from the 15th Century to the Year 1914.* N.Y.: Dover, 1963.

————. *An Introduction to the History of Woodcut.* London: Constable, 1935.

Ivins, William, Jr. *How Prints Look.* Boston: Beacon, 1943.

————. *Prints and Visual Communication.* Cambridge: Harvard U. Press, 1953.

Johnston, Meda Parker, and Glen Kaufman. *Design on Fabrics.* N.Y.: Reinhold, 1967.

Kurth, Willi (ed.). *The Complete Woodcuts of Albrecht Dürer.* N.Y.: Dover, 1963.

Lindemann, Gottfried. *Prints and Drawings: A Pictorial History* (trs. by Gerald Onn). N.Y.: Praeger, 1970.

Mackley, George E. *Wood Engraving.* London: National Magazine Co., 1948.

Man, Felix H. *150 Years of Artists' Lithographs.* London: Heinemann, 1953.

Mayor, A. Hyatt, Richard V. West, and Donald Karshan. *Language of the Print.* Brunswick: Bowdoin College Museum of Art, 1968.

Mueller, E. G. *The Art of the Print.* Dubuque: Brown, 1969.

Peterdi, Gabor. *Printmaking.* N.Y.: Macmillan, 1961.

Sachs, P. J. *Modern Prints and Drawings.* N.Y.: Knopf, 1954.

Sotriffer, Kristian. *Printmaking: History and Technique.* N.Y.: McGraw-Hill, 1968.

Stephenson, Jessie Bane. *From Old Stencils to Silk Screening.* N.Y.: Scribner, 1953.

Sternberg, H. *Silk Screen Printing.* N.Y.: McGraw-Hill, 1942.

Tilley, Roger. *Playing Cards.* N.Y.: Putnam, 1967.

Watrous, James. *The Craft of Old Master Drawings.* Madison: U. of Wisconsin Press, 1957.

Watson, E. W. *The Relief Print.* N.Y.: Watson-Guptil, 1945.

Wechsler, Herman J. *Great Prints and Printmakers.* N.Y.: Abrams, 1967.

Weddige, Emil. *Lithography.* Scranton: International Textbook, 1966.

Weekley, Montague. *Thomas Bewick.* London: Oxford U. Press, 1953.

Werner, Alfred. *The Graphic Works of Odilon Redon.* N.Y.: Dover, 1969.

Psychology of Art

Arnheim, Rudolph. *Art and Visual Perception.* Berkeley: U. of California Press, 1954.

Eng. Helga. *The Psychology of Children's Drawings.* London: Routledge, 1954.

Gombrich, E.H. *Art and Illusion.* N.Y.: Pantheon, 1960.

Lowenfeld, Viktor. *The Nature of Creative Activity.* N.Y.: Harcourt, 1939.

Ogden, R. *The Psychology of Art.* N.Y.: Macmillan, 1939.

Schaefer-Simmern, Henry. *The Unfolding of Artistic Activity.* Berkeley: U. of California Press, 1948.

Sculpture

Arnason, H. Harvard, and Pedro E. Guerrero. *Calder.* Princeton: Van Nostrand, 1966.

Battcock, Gregory (ed.). *Minimal Art: A Critical Anthology.* N.Y.: McGraw-Hill, 1966.

Burnham, Jack. *Beyond Modern Sculpture.* N.Y.: Braziller, 1968.

Carpenter, Rhys. *Greek Sculpture.* U. of Chicago Press, 1960.

Geist, Sidney. *Brancusi.* N.Y.: Grossman, 1968.

Giedeon-Welcker, Carola. *Contemporary Sculpture.* N.Y.: Wittenborn, 1955.

James, Philip (ed.). *Henry Moore on Sculpture.* London: Macdonald, 1966.

Kirby, Michael. *Happenings.* N.Y.: Dutton, 1965.

Ramsden, E.H. *Twentieth-Century Sculpture.* London: Pleides Books, 1949.

Read, Herbert. *The Art of Sculpture.* N.Y.: Pantheon, 1956.

————. *A Concise History of Modern Sculpture.* N.Y.: Praeger, 1965.

Rich, Jack C. *The Materials and Methods of Sculpture.* N.Y.: Oxford U. Press, 1947.

Richter, Gisela M.A. *Sculpture and Sculptors of the Greeks,* rev. New Haven: Yale U. Press, 1950.

Ritchie, Andrew C. *Sculpture of the Twentieth Century.* N.Y.: Museum of Modern Art, 1953.

Russell, John. *Henry Moore.* N.Y.: Putnam, 1968.

Seymour, Charles. *Tradition and Experiment in Modern Sculpture.* Washington, D.C.: American U. Press., 1949.

Struppeck, Jules. *The Creation of Sculpture.* N.Y.: Holt, Rinehart & Winston, 1952.

Valentiner, W.R. *Origins of Modern Sculpture.* N.Y.: Wittenborn, 1946.

Statements by Artists

Americans 1963. N.Y.: Museum of Modern Art, 1963.

Butler, Reg. *Creative Development.* N.Y.: Horizon, 1963.

Cellini, Benvenuto. *Autobiography of Benvenuto Cellini.* Garden City: Doubleday, 1960.

Dali, Salvador. *The Secret Life of Salvador Dali.* N.Y.: Dial, 1960.

Fifteen Americans. N.Y.: Museum of Modern Art, 1952.

Friedenthal, Richard (ed.). *Letters of the Great Artists* (tr., with certain exceptions, by Daphne Wood Ward). N.Y.: Random, 1963.

Goldwater, Robert, and Marco Treves. *Artists on Art.* N.Y.: Pantheon, 1945.

Henri, Robert. *The Art Spirit.* Philadelphia: Lippincott, 1923.

Herbert, Robert L. *Modern Artists on Art.* Englewood Cliffs: Prentice-Hall, 1964.

Holt, Elizabeth G. *A Documentary History of Art* (2 vols.). Garden City: Doubleday, 1957.

Kandinsky, Wassily. *On the Spiritual in Art.* N.Y.: Solomon R. Guggenheim Foundation, 1946.

Klee, Paul. *Paul Klee on Modern Art.* London: Faber & Faber, 1949.

John Marin on John Marin (ed. by Cleve Gray). N.Y.: Holt, Rinehart & Winston, 1970.

Mondrian, Piet. *Plastic Art and Pure Plastic Art.* N.Y.: Wittenborn, 1947.

The New Decade: 22 European Painters and Sculptors. N.Y.: Museum of Modern Art, 1955.

Protter, Eric. *Painters on Painting.* N.Y.: Grosset & Dunlap, 1963.

Richter, Sean Paul (ed.). *The Notebooks of Leonardo da Vinci* (2 vols.). N.Y.: Dover, 1970.

Shahn, Ben. *The Shape of Content.* N.Y.: Vintage, 1960.

David Smith on David Smith (ed. by Cleve Gray). N.Y.: Holt, Rinehart & Winston, 1968.

Williams, Hiram. *Notes for a Young Painter.* Englewood Cliffs: Prentice-Hall, 1964.

NOTES

Chapter 1

1. Albert R. Chandler, *Beauty and Human Nature* (copyright 1934, D. Appleton Century Co., Inc.), Appleton-Century-Crofts, Inc., New York, pp. 9, 10.
2. J. Z. Young, *Doubt and Certainty in Science*, Oxford University Press, London, 1951, p. 62.
3. R. L. Gregory, *Eye and Brain: The Psychology of Seeing*, World University Library, McGraw-Hill Book Co., Inc., New York, 1966, pp. 189–228.

Chapter 2

1. Clive Bell, "Art," 1913, in *A Modern Book of Esthetics*, ed. by Melvin M. Rader, Holt, Rinehart and Winston, Inc., New York, 1935, pp. 247, 252.
2. Henry Schaefer-Simmern, *The Unfolding of Artistic Activity*, University of California Press, Berkeley, Calif., 1948, p. 29.
3. Robert Henri, *The Art Spirit*, J. B. Lippincott Co., Philadelphia, 1923, p. 159.
4. Quoted in David L. Shirey, "Impossible Art—What It Is," *Art in America*, May–June, 1969, p. 34.
5. Quoted in Elizabeth G. Holt, *A Documentary History of Art*, Doubleday and Company, Inc., Garden City, N. Y., 1957, Vol. I, p. 230.

Chapter 3

1. Wilbur Marshal Urban, *Language and Reality*, The Macmillan Company, New York, 1939, p. 21.
2. J. Z. Young, *Doubt and Certainty in Science*, Oxford University Press, London, 1951, p. 92.

Chapter 5

1. Robert Woodworth and Donald Marquis, *Psychology*, 5th ed., Holt, Rinehart and Winston, Inc., New York, 1947, p. 323.

Chapter 6

1. *The Notebooks of Leonardo da Vinci*, ed. and trans. by Edward MacCurdy, Reynal & Hitchcock, New York, 1939, pp. 877, 878.

Chapter 10

1. Gyorgy Kepes, ed., *The Nature and Art of Motion*, Vision+Value series, George Braziller, New York, 1965.

Chapter 11

1. Norma Evenson, *Chandigarh*, University of California Press, Berkeley, Calif., 1966, p. 92.
2. Jane Jacobs, *The Death and Life of Great American Cities*, Random House, New York, 1961.

Chapter 12

1. John W. Griffiths, *Treatise on Marine and Naval Architecture*, 3d ed., D. Appleton and Company, New York, 1853, p. 384.
2. Louis H. Sullivan, "The Tall Office Building Artistically Considered," *Kindergarten Chats and Other Writings*, George Wittenborn, Inc., Publishers, New York, 1947, p. 203.
3. Richard Neutra, *Survival Through Design*, Oxford University Press, New York, 1954, p. 155.
4. *Ibid.*, p. 151.
5. Louis I. Kahn, "Structure and Form," Voices of America Forum Lectures, 1960, in Vincent Scully, Jr., *Louis I. Kahn*, George Braziller, Inc., New York, 1962, p. 118.
6. Robert Venturi, *Complexity and Contradiction in Architecture*, Museum of Modern Art, New York, 1967, p. 22.

Chapter 13

1. Pier Luigi Nervi, "Nervi's View on Architecture, Education and Structure," *Architectural Record*, December, 1958, p. 118.
2. R. Buckminster Fuller, *Education Automation*, Southern Illinois University Press, Carbondale, Ill., 1962, p. 8.

Chapter 14

1. Auguste Rodin, *On Art and Artists*, Philosophical Library, New York, 1957, p. 46.
2. Ferdinand Hodler, "The Mission of the Artist," in Eric Protter, ed., *Painters on Painting*, The University Library, Grosset & Dunlap, New York, 1963, p. 158.
3. Alfred H. Barr, Jr., *Fantastic Art, Dada, Surrealism*, Museum of Modern Art, New York, 1936, p. 37.
4. Reprinted from *The Secret Life of Salvador Dali*, p. 221. Copyright © 1942, 1960 by Salvador Dali. Used with the permission of the publishers, The Dial Press, Inc., New York.
5. Wassily Kandinsky, *On the Spiritual in Art*, Solomon R. Guggenheim Foundation, New York, 1946, p. 92.
6. *Fifteen Americans*, ed. by Dorothy Miller, Museum of Modern Art, New York, 1952, p. 12.
7. Jackson Pollock, "My Painting," *Possibilities*, Winter 1947–48, in Eric Protter, *Painters on Painting*, Grosset & Dunlap, Inc., New York, 1963, p. 249.

Chapter 15

1. *Artists on Art*, ed. by Robert Goldwater and Marco Treves, Pantheon Books, New York, 1945, p. 67.
2. *Ibid.*, p. 447.

Glossary

Italicized terms within the definitions are themselves defined in the glossary.

Abstract Expressionism. A style of painting and sculpture important as an esthetic force in the decade 1950–60. Characterized, generally, by large scale and evidence of spontaneous invention, suggesting the creative experience sought by the artist involved in the process of forming the image. Sometimes (inaccurately) referred to as Action Painting; also the New York School.

abstraction. In art, a translation into a *graphic* medium of a real life object or experience. Usually implies the isolation, emphasis, or exaggeration of some limited aspect of the artist's perception of reality. Not to be confused with *nonrepresentational* or "nonobjective" art, terms often, and incorrectly, used as synonyms for "abstract."

academy. The cultural and artistic establishment, formerly an elected group with teaching (academic) and standard-maintaining responsibilities. From the French Académie des Beaux-Arts, the term has often been applied to conservative and traditional forms. An "academy" is a nude study.

acrylic, or *acrylic resin.* A clear plastic used as a *vehicle* in paints and as a *casting* material in sculpture.

additive sculpture. Three-dimensional works of art made from a process of combining small pieces of material. Also objects gradually built up from plaster into forms, and those made of wood and metal fragments joined by adhesives or mechanical means. See *modeling.*

aerial perspective. A method of *representing* spatial depth in two-dimensional art. Color-forms representing objects in the foreground are painted with greater contrasts in *hue* and *value* than color-forms representing distant objects. In addition, forms intended to be seen as distant are painted with imprecise edges instead of the sharply delineated edges used in the representation of objects intended to be perceived as close to the observer.

altarpiece. A painting, sculptural group, or *bas relief* prepared for and placed above and behind an altar.

analogous colors. *Hues* adjacent to one another on the color wheel, usually centered about a *primary* or a *secondary* hue.

Analytical Cubism. A style of painting developed by Picasso and Braque (c. 1909–12), with compositions based upon still-life and figurative subjects observed or analyzed from a great many separate points of view instead of from the single viewpoint used in *linear perspective* representations. Fragmented sequences of lines or shaded planes, derived from the contours of the forms of the subject, are the basis for both the *picture-plane* organization and the expression of the real objects observed by the painter. Its compositional orientation is toward the frame, or shape, of the canvas rather than toward geometries built up *illusionistically* inside the composition. Analysis of form, line, and structure resulted in a wide range of *value* dynamics and the exclusion of rich color. See *Cubism.*

apse. A semicircular extension at the eastern end of a Christian church built on an elongated rectangular, or *basilican,* plan.

aquatint. A form of *intaglio* printmaking in which the artist uses *rosin* dust to *resist* the biting action of the *mordant* so that tonal areas can be produced when the plate has been printed.

arabesque. From Arabic Mohammedan design patterns, a stylized decorative or carved motif, based on organic, floral sources, whose lines flow in curved, intricate movements.

arcade. 1. A row of columns supporting a series of connected arches. 2. A roofed passageway.

arch. Any of a number of freestanding curved structural devices spanning a space.

architrave (ark′-i-trayv). The lowest portion of an *entablature.* That part of the bridging element in a *post-and-lintel* system that sits directly above the *capital* of a *column.*

armature. An internal metal or wooden support for clay, plaster, or wax being modeled into sculpture.

arricio (ah-ree′choh). The first rough coat of plaster applied to a wall in preparation for a *fresco* painting.

art. A product of man in which materials are skillfully ordered to communicate a human experience.

Art Nouveau (ahr noo-voh′). Literally "new art" in French, a decorative style dominant in Europe and America in the 1890s. Characteristic are flat patterns of attenuated and writhing tendril forms abstracted from a naturalistic conception of vegetable growth. Though most notable in architecture and the decorative arts, the long, sensuously curving line appeared also in much significant painting and sculpture of the period. Art Nouveau remains influential in the visual arts of the 1970s.

assemblage. A work of art composed of fragments of objects or materials originally intended for other purposes.

avant-garde (a-vahn-gard′). A French term meaning "advanced guard," used to designate innovators and their experimental art.

axis. 1. A centrally placed imaginary line indicating the major directional emphasis in one *plane* of a three-dimensional object. 2. In two-dimensional art, an imaginary line indicating the major directional compositional emphasis on the *picture plane;* or the illusion of an important directional emphasis between objects in the represented subject matter.

balance. The distribution of *visual weights* in a work of art achieving an interrelated, interdependent state of equilibrium.

balloon frame. A building construction system developed in the 19th century, and still in use, that employs lumber of relatively small cross sections nailed together to form a cagelike frame for the support of floors, roof, siding, windows, and doors. Balloon framing replaced the use of heavy, joined timbers as the basic structural system for the construction of small buildings.

Baroque. A period and style in European art generally corresponding to the 17th century. In the Baroque, often the arts of painting, sculpture, and architecture were united in a theatrically cunning way to fool the eye with soaring spatial illusions, exuberant, full-blown forms, and curvilinear designs, all intended to surround the spectator with color, movement, and light in an unabashed appeal for emotional involvement.

barrel vault. A method of covering rectangular architectural space by erecting in masonry a continuous round *arch* extending the full length of the supporting walls. Also called "tunnel vault."

basilica. A rectangular plan building, with an *apse* at one or both ends, originating in Roman secular architecture and found later in Gothic and Renaissance architecture.

bas (bah) *relief.* See *relief sculpture.*

bay. In architecture, a section of the interior or exterior of a building marked off by major vertical elements.

binder. The constituent of paint that causes pigment particles to adhere to one another and to the *support*. See *vehicle*.

block print. A form of *graphic art* in which an image is transferred to paper or cloth from the surface of a flat wooden or linoleum block that has been carved so that the printing surfaces stand in relief above the non-printing areas.

brilliance. A measure of the reflectivity of a *color*.

burin (byoor in). A tool employed by engravers to cut lines into a plate.

burr. A rough edge of metal thrown up by the cutting process in *drypoint* that holds ink and forms the soft, feathery lines typical of this printmaking medium.

buttress. A support, usually exterior, for a *wall, arch,* or *vault* that opposes the lateral forces of these structural elements. See *flying buttress*.

calligraphy. The art of beautiful writing. More broadly, any controlled, flowing, continuous use of line in painting, drawing, or sculpture.

camera obscura. A boxlike device for projecting an image of an object or a scene through a small orifice onto a surface so that it can be traced.

camera ottica. A *camera obscura* that uses a glass lens in the opening that projects and focuses the image.

campanile (kam-pah-neel′eh). A bell tower, usually next to but separate from a church building.

capital. The upper portion of a *column*, often carved or decorated.

caricature. A representation of a person or object that exaggerates one or more of the subject's salient characteristics to create a satirical or expressive image.

cartoon. 1. A full-scale preparatory drawing for a *mural* or tapestry. 2. A simplified humorous drawing.

carving. 1. A method of shaping wood or stone sculpture utilizing edged tools that are forced against the material by the pressure of the hand or the blow of a mallet. 2. A piece of sculpture produced by the carving process.

casting. 1. A process using plaster, clay, wax, or metal that, in a liquid form, is poured into a mold. When the liquid has solidified, the mold is removed, leaving a replica of the original work of art from which the mold was taken. 2. The molded replica made by the casting process. Also called a "cast." See *cire-perdue*.

catenary. The geometric curve taken by a hanging cable of uniform weight and density when supported only at its two ends.

centering. A temporary wooden scaffolding or support used to erect an *arch* or *vault*.

ceramics. 1. Objects made of clay that have been baked into a permanent form. Often, they are decorated with *glazes*, then returned to the *kilns* for additional firing to fuse the glazes to the clay body. 2. The art and technology of producing ceramic objects.

chiaroscuro (kee-ar′oh-skoor′oh). Literally, "light-dark." In painting and drawing the use of dark and light *value* areas to represent the effects of light and shadow in nature.

chroma. See *saturation*.

cire-perdue (seer-pair-dew′). A method of casting metal sculpture requiring a wax version of the original model. The wax form is encased in a heat-resistant molding material. Baking the mold causes the wax to melt and run out, leaving a cavity in its place. The cavity is filled with molten metal which solidifies to become the sculpture when the mold has been broken open.

cista. A primitive tomb made of stone slabs; a stone or metal chest or sarcophagus.

Classical. 1. The art of ancient Greece and Rome and subsequent stylistic imitations of Western antiquity. 2. With a lower case "c," the term indicates a style of art that is idealized, regular, and rational, based on a carefully controlled and orderly arrangement of *elements*. 4. Also with a small "c," classic can mean established excellence, whatever the period, style, or form. See *Neoclassicism*.

clerestory. A row of windows in the upper part of a wall. Also, in church architecture, the upper portion of the interior walls pierced by windows for the admission of light.

closure. The imaginary or psychological connection between units with a common characteristic.

collage (kohl-lahzh′). A two-dimensional work of art containing pieces of paper, cloth, or other materials. A form of *assemblage*.

colonnade. A series of regularly spaced columns.

color. A perceived quality in direct light or in objects reflecting light that varies with: 1. the wave length of the light energy; 2. the *brilliance* of the light source; 3. the degree to which objects reflect or absorb the light energy falling on them. In paint, the light-reflecting and absorbing characteristic, which is a function of the pigment giving the paint its primary visual identity.

color solid. One of a number of theoretical three-dimensional models of the variable characteristics of *color, hue, saturation,* and *value*.

column. A cylindrical post or support which often has three distinct parts: a base, a shaft, and a *capital*.

complementary colors. Two contrasting *hues* that are found opposite each other on a color wheel. Also two hues that neutralize each other when combined, i.e., red and green.

composition. In the arts, an ordered relationship between significant parts or *elements*.

compression. In architecture, a force that presses material together with a crushing action.

conceptual art. An art object or event that in its total or essential form is conceived in the mind of the artist before it is fabricated. For some conceptual artists the conception of the work of art obviates the necessity to produce it.

conceptual representation. A form of pictorial representation based upon the image of the subject in the mind of the artist.

concrete. A mixture of gravel or rubble, sand, cement, and water that forms a plastic mass easily shaped into architectural and structural forms. When solidified it is a homogeneous, strong building material. Originally developed and perfected for monumental forms by the Romans.

Conté crayon. A form of hard chalk used for drawings.

content. The subject matter of a work of art, plus all the intellectual, symbolic, emotional, narrative, thematic, and spiritual values, as opposed to considerations addressed purely to *form* and technique. See *subject* and *symbol*.

contour. A linear representation of the edge of a form or group of forms. Also the edge between juxtaposed areas of color in a painting or drawing.

contrast. The comparative relationship between two or more relatively opposed *elements* or forces.

cool color. A color generally in the blue, violet, or green section of the *spectrum*.

Glossary

Italicized terms within the definitions are themselves defined in the glossary.

Abstract Expressionism. A style of painting and sculpture important as an esthetic force in the decade 1950–60. Characterized, generally, by large scale and evidence of spontaneous invention, suggesting the creative experience sought by the artist involved in the process of forming the image. Sometimes (inaccurately) referred to as Action Painting; also the New York School.

abstraction. In art, a translation into a *graphic* medium of a real life object or experience. Usually implies the isolation, emphasis, or exaggeration of some limited aspect of the artist's perception of reality. Not to be confused with *nonrepresentational* or "nonobjective" art, terms often, and incorrectly, used as synonyms for "abstract."

academy. The cultural and artistic establishment, formerly an elected group with teaching (academic) and standard-maintaining responsibilities. From the French Académie des Beaux-Arts, the term has often been applied to conservative and traditional forms. An "academy" is a nude study.

acrylic, or *acrylic resin.* A clear plastic used as a *vehicle* in paints and as a *casting* material in sculpture.

additive sculpture. Three-dimensional works of art made from a process of combining small pieces of material. Also objects gradually built up from plaster into forms, and those made of wood and metal fragments joined by adhesives or mechanical means. See *modeling.*

aerial perspective. A method of *representing* spatial depth in two-dimensional art. Color-forms representing objects in the foreground are painted with greater contrasts in *hue* and *value* than color-forms representing distant objects. In addition, forms intended to be seen as distant are painted with imprecise edges instead of the sharply delineated edges used in the representation of objects intended to be perceived as close to the observer.

altarpiece. A painting, sculptural group, or *bas relief* prepared for and placed above and behind an altar.

analogous colors. *Hues* adjacent to one another on the color wheel, usually centered about a *primary* or a *secondary* hue.

Analytical Cubism. A style of painting developed by Picasso and Braque (c. 1909–12), with compositions based upon still-life and figurative subjects observed or analyzed from a great many separate points of view instead of from the single viewpoint used in *linear perspective* representations. Fragmented sequences of lines or shaded planes, derived from the contours of the forms of the subject, are the basis for both the *picture-plane* organization and the expression of the real objects observed by the painter. Its compositional orientation is toward the frame, or shape, of the canvas rather than toward geometries built up *illusionistically* inside the composition. Analysis of form, line, and structure resulted in a wide range of *value* dynamics and the exclusion of rich color. See *Cubism.*

apse. A semicircular extension at the eastern end of a Christian church built on an elongated rectangular, or *basilican*, plan.

aquatint. A form of *intaglio* printmaking in which the artist uses *rosin* dust to *resist* the biting action of the *mordant* so that tonal areas can be produced when the plate has been printed.

arabesque. From Arabic Mohammedan design patterns, a stylized decorative or carved motif, based on organic, floral sources, whose lines flow in curved, intricate movements.

arcade. 1. A row of columns supporting a series of connected arches. 2. A roofed passageway.

arch. Any of a number of freestanding curved structural devices spanning a space.

architrave (ark'-i-trayv). The lowest portion of an *entablature.* That part of the bridging element in a *post-and-lintel* system that sits directly above the *capital* of a column.

armature. An internal metal or wooden support for clay, plaster, or wax being modeled into sculpture.

arricio (ah-ree'choh). The first rough coat of plaster applied to a wall in preparation for a *fresco* painting.

art. A product of man in which materials are skillfully ordered to communicate a human experience.

Art Nouveau (ahr noo-voh'). Literally "new art" in French, a decorative style dominant in Europe and America in the 1890s. Characteristic are flat patterns of attenuated and writhing tendril forms abstracted from a naturalistic conception of vegetable growth. Though most notable in architecture and the decorative arts, the long, sensuously curving line appeared also in much significant painting and sculpture of the period. Art Nouveau remains influential in the visual arts of the 1970s.

assemblage. A work of art composed of fragments of objects or materials originally intended for other purposes.

avant-garde (a-vahn-gard'). A French term meaning "advanced guard," used to designate innovators and their experimental art.

axis. 1. A centrally placed imaginary line indicating the major directional emphasis in one *plane* of a three-dimensional object. 2. In two-dimensional art, an imaginary line indicating the major directional compositional emphasis on the *picture plane*; or the illusion of an important directional emphasis between objects in the represented subject matter.

balance. The distribution of *visual weights* in a work of art achieving an interrelated, interdependent state of equilibrium.

balloon frame. A building construction system developed in the 19th century, and still in use, that employs lumber of relatively small cross sections nailed together to form a cagelike frame for the support of floors, roof, siding, windows, and doors. Balloon framing replaced the use of heavy, joined timbers as the basic structural system for the construction of small buildings.

Baroque. A period and style in European art generally corresponding to the 17th century. In the Baroque, often the arts of painting, sculpture, and architecture were united in a theatrically cunning way to fool the eye with soaring spatial illusions, exuberant, full-blown forms, and curvilinear designs, all intended to surround the spectator with color, movement, and light in an unabashed appeal for emotional involvement.

barrel vault. A method of covering rectangular architectural space by erecting in masonry a continuous round *arch* extending the full length of the supporting walls. Also called "tunnel vault."

basilica. A rectangular plan building, with an *apse* at one or both ends, originating in Roman secular architecture and found later in Gothic and Renaissance architecture.

bas (bah) *relief.* See *relief sculpture.*

bay. In architecture, a section of the interior or exterior of a building marked off by major vertical elements.

binder. The constituent of paint that causes pigment particles to adhere to one another and to the *support.* See *vehicle.*

block print. A form of *graphic art* in which an image is transferred to paper or cloth from the surface of a flat wooden or linoleum block that has been carved so that the printing surfaces stand in relief above the non-printing areas.

brilliance. A measure of the reflectivity of a *color.*

burin (byoor in). A tool employed by engravers to cut lines into a plate.

burr. A rough edge of metal thrown up by the cutting process in *drypoint* that holds ink and forms the soft, feathery lines typical of this printmaking medium.

buttress. A support, usually exterior, for a *wall, arch,* or *vault* that opposes the lateral forces of these structural elements. See *flying buttress.*

calligraphy. The art of beautiful writing. More broadly, any controlled, flowing, continuous use of line in painting, drawing, or sculpture.

camera obscura. A boxlike device for projecting an image of an object or a scene through a small orifice onto a surface so that it can be traced.

camera ottica. A *camera obscura* that uses a glass lens in the opening that projects and focuses the image.

campanile (kam-pah-neel′eh). A bell tower, usually next to but separate from a church building.

capital. The upper portion of a *column,* often carved or decorated.

caricature. A representation of a person or object that exaggerates one or more of the subject's salient characteristics to create a satirical or expressive image.

cartoon. 1. A full-scale preparatory drawing for a *mural* or tapestry. 2. A simplified humorous drawing.

carving. 1. A method of shaping wood or stone sculpture utilizing edged tools that are forced against the material by the pressure of the hand or the blow of a mallet. 2. A piece of sculpture produced by the carving process.

casting. 1. A process using plaster, clay, wax, or metal that, in a liquid form, is poured into a mold. When the liquid has solidified, the mold is removed, leaving a replica of the original work of art from which the mold was taken. 2. The molded replica made by the casting process. Also called a "cast." See *cire-perdue.*

catenary. The geometric curve taken by a hanging cable of uniform weight and density when supported only at its two ends.

centering. A temporary wooden scaffolding or support used to erect an *arch* or *vault.*

ceramics. 1. Objects made of clay that have been baked into a permanent form. Often, they are decorated with *glazes,* then returned to the *kilns* for additional firing to fuse the glazes to the clay body. 2. The art and technology of producing ceramic objects.

chiaroscuro (kee-ar′oh-skoor′oh). Literally, "light-dark." In painting and drawing the use of dark and light *value* areas to represent the effects of light and shadow in nature.

chroma. See *saturation.*

cire-perdue (seer-pair-dew′). A method of casting metal sculpture requiring a wax version of the original model. The wax form is encased in a heat-resistant molding material. Baking the mold causes the wax to melt and run out, leaving a cavity in its place. The cavity is filled with molten metal which solidifies to become the sculpture when the mold has been broken open.

cista. A primitive tomb made of stone slabs; a stone or metal chest or sarcophagus.

Classical. 1. The art of ancient Greece and Rome and subsequent stylistic imitations of Western antiquity. 2. With a lower case "c," the term indicates a style of art that is idealized, regular, and rational, based on a carefully controlled and orderly arrangement of *elements.* 4. Also with a small "c," classic can mean established excellence, whatever the period, style, or form. See *Neoclassicism.*

clerestory. A row of windows in the upper part of a wall. Also, in church architecture, the upper portion of the interior walls pierced by windows for the admission of light.

closure. The imaginary or psychological connection between units with a common characteristic.

collage (kohl-lahzh′). A two-dimensional work of art containing pieces of paper, cloth, or other materials. A form of *assemblage.*

colonnade. A series of regularly spaced columns.

color. A perceived quality in direct light or in objects reflecting light that varies with: 1. the wave length of the light energy; 2. the *brilliance* of the light source; 3. the degree to which objects reflect or absorb the light energy falling on them. In paint, the light-reflecting and absorbing characteristic, which is a function of the pigment giving the paint its primary visual identity.

color solid. One of a number of theoretical three-dimensional models of the variable characteristics of *color, hue, saturation,* and *value.*

column. A cylindrical post or support which often has three distinct parts: a base, a shaft, and a *capital.*

complementary colors. Two contrasting *hues* that are found opposite each other on a color wheel. Also two hues that neutralize each other when combined, i.e., red and green.

composition. In the arts, an ordered relationship between significant parts or *elements.*

compression. In architecture, a force that presses material together with a crushing action.

conceptual art. An art object or event that in its total or essential form is conceived in the mind of the artist before it is fabricated. For some conceptual artists the conception of the work of art obviates the necessity to produce it.

conceptual representation. A form of pictorial representation based upon the image of the subject in the mind of the artist.

concrete. A mixture of gravel or rubble, sand, cement, and water that forms a plastic mass easily shaped into architectural and structural forms. When solidified it is a homogeneous, strong building material. Originally developed and perfected for monumental forms by the Romans.

Conté crayon. A form of hard chalk used for drawings.

content. The subject matter of a work of art, plus all the intellectual, symbolic, emotional, narrative, thematic, and spiritual values, as opposed to considerations addressed purely to *form* and technique. See *subject* and *symbol.*

contour. A linear representation of the edge of a form or group of forms. Also the edge between juxtaposed areas of color in a painting or drawing.

contrast. The comparative relationship between two or more relatively opposed *elements* or forces.

cool color. A color generally in the blue, violet, or green section of the *spectrum.*

corbel. A block of masonry that projects from a wall to support a beam. Also a method of bridging a space using courses of stone or brick that partially project over the course beneath them to form a stepped diagonal form slanting toward the center of the opening the as courses rise.

Corinthian. One of the *Classical* styles of temple architecture characterized by slender "channeled" *columns* topped by highly carved, ornate *capitals* that use decorative forms derived from the acanthus leaf.

cornice. The projecting *molding* at the top of the *entablature* in *Classical* architecture. Also any projecting molding.

cross-hatching. A system of lines drawn in close parallel order, crossed at an angle by another similar system. Used in drawing and printmaking to provide the effect of changes in tonality in works drawn with lines of uniform *value.*

crossing. The intersection of the *nave* and *transept* in a *cruciform* church.

cruciform. Arranged or shaped like a cross.

Cubism. One of the original "abstract" styles of the 20th century, Cubism was developed in Paris by Picasso and Braque, beginning in 1907, from Paul Cézanne's late-19th-century achievements in representational systems. Though based on physical phenomena, Cubism replaced a concern for the surface of objects and natural appearances with a more intellectual conception of the reality of forms and space and their interrelationships on the flat surface of a canvas. Seeking to express the totality of an object and in respect for the two-dimensionality of the picture surface, the Cubists represented several views of their subject in the same composition (simultaneity) and, in lieu of modeling in the round, superimposed one view over another in a dynamic spatial perception. *Analytical Cubism* (1909–12) emphasized the analysis of form, rigorously excluding the sensual elements of texture and color. From this emerged *Synthetic Cubism* (1912–14), a more decorative style utilizing flat, overlapping planes, the full spectral palette, tactile surfaces, and stylized patterns.

direct-metal sculpture. Sculpture formed by welding or otherwise joining sections of metal into three-dimensional constructions.

direct painting. A technique that requires the artist to apply each stroke of color directly to the canvas *support* rather than use successive layers of opaque and transparent paint to produce coloristic effects.

direct-plaster sculpture. Sculpture in which the forms are built up by successive applications of wet plaster.

dome. A roof or *vault* generally hemispheric in shape.

Doric. The oldest of the *Classical* styles of temple architecture, characterized by simple, sturdy *columns* that rise without a base to an unornamented, cushionlike *capital.*

dry brush. A method of painting or drawing that produces tonal areas. The ends of the bristles of a stiff brush are dipped in paint or ink and lightly drawn across a *support* leaving a pattern of fine parallel lines.

drypoint. An *intaglio* printmaking method that utilizes the *burr* thrown up when lines are cut into a metal plate to give the printed image a softened, atmospheric character.

Duco paint. Originally an industrial paint made with a lacquer *vehicle.* Duco has been used by some artists for easel and mural paintings.

earthworks. Large-scale sculptural projects involving the excavation or movement of earth for the purpose of shaping a site into an esthetically satisfying form.

eclectic. Choosing from earlier styles and combining them as opposed to originating new compositional or expressive forms.

ecology. The interrelationship of organisms and their environment.

element. The individual graphic and plastic devices with which an artist works—*color, value, line, form, texture,* etc. They are the constituent parts of which the physical work of art is composed.

elevation. In architectural plans a drawing of one of the exterior sides of a building.

encaustic. A form of paint in which the *vehicle* is wax.

engraving. 1. A form of *intaglio* printmaking in which grooves cut into a metal plate with a *burin* are filled with a viscous ink and the plate pressed against absorbent paper after its surface has been wiped clean. Also the finished print that results from this process. 2. Any form of decoration resulting from the use of *incised* line.

entablature. The portion of a building between the *capitals* of the *columns* and the roof. In *Classical* architecture the entablature includes the *architrave, frieze,* and *cornice.*

environment. The physical, social, and cultural conditions and processes that exist in a defined location. Also, an art form in which such conditions have been created and ordered.

esthetic response. A pleasurable reaction to the perception of an object or event which an individual would wish to repeat or sustain.

esthetics. The study of the nature of beauty and its relation to man.

etching. A form of *intaglio* printmaking requiring a metal plate coated with an acid-resistant wax which is scratched to expose the metal to the bite of the acid. Lines eaten into the plate by the acid are subsequently filled with ink and transferred to paper after the surface of the plate has been cleaned of excess ink. Also, the finished *print* that results from this process.

Expressionism. A form of art developed at the end of the 19th and the beginning of the 20th century that emphasized the expression of the artist's subjective or emotional response to experience through the use of color, the direct, vigorous exploitation of media, and the formation of evocative and symbolic representational imagery. See *Fauvism.*

façade. The exterior, usually front, wall surfaces of a building.

Fauvism (fohv′ism). A style of painting introduced in Paris in the early 20th century, which used seemingly arbitrary areas of brilliant contrasting color for structural and expressive purposes. Henri Matisse was the leading Fauve.

fenestration. The arrangement of windows in the walls of a building.

ferroconcrete. A building material composed of concrete with rods or webs of steel imbedded in it.

figure-ground. A phrase referring to an ambiguous, interdependent spatial relationship between some painted forms and the *grounds* on which they are placed. Under certain conditions a form, or figure, can be seen in front of a surrounding ground. Under other conditions the illusion can reverse.

fine art. Traditionally the nonapplied arts; in the visual arts, painting, drawing, printmaking, sculpture, and, in some estimates, architecture.

flying buttress. A *masonry* strut or segment of an *arch* that carries the thrust of a *vault* to a *buttress* positioned away from

the main portion of the building. An important structural element in the architecture of Gothic cathedrals.

focus. A point of convergence; also a center of attention.

foreshortening. The representation of forms on a two-dimensional surface which creates the illusion that the subject is projecting into, or out of, the frontal *plane* of the composition.

form. 1. *Composition* or organization, as in, "The form of the work is complex." 2. A three-dimensional solid. 3. An area on a two-dimensional surface. 4. The *illusionistic* representation of a three-dimensional form on a two-dimensional surface. 5. A mold into which concrete is poured. 6. A verb meaning to shape or order as in, "He formed the clay into a pot."

formal balance. A symmetrical arrangement of the *visual weights* in a work of art.

formalism. Adherence to a rigid set of rules or conventions in the conception and completion of a work of art.

fresco. A painting *medium* frequently employed for *murals* requiring the artist to paint on a freshly laid, damp lime-plaster wall with pigments mixed in lime water. When the plaster has dried the paint is an integral and permanent part of the wall surface. A medium favored during the *Renaissance* in Italy.

frieze. The central portion of the *entablature* between the *architrave* and the *cornice.* Also any horizontal decorative or sculptural band.

function. The work that can properly be done by a unique mechanism or individual.

Futurism. A style of painting originating in Italy during the first decade of the 20th century, which endeavored to represent a dynamic, modern, machine-powered world of moving subject matter.

geodesic. A form of geometry that is the basis for structures using short sections of lightweight material formed into interlocking polygons.

gesso. A mixture of chalk and glue used as a *ground* for *tempera* and other paints. Gesso has also served as surface for wooden *polychromed* sculpture.

glaze. 1. A transparent film of paint. 2. In *ceramics,* a pigmented or transparent liquid applied to a clay object that hardens and becomes glasslike when baked at high temperatures.

Gothic. A style in European art and architecture that prevailed from the 12th to the 15th century. The highest achievements of Gothic architecture are the great cathedrals of England and the Continent, with their *basilican* plans, *ribbed groin vaults,* and *flying buttresses.*

gouache (goo-ahsh'). A generic word for any opaque water-soluble paint.

graphics. Any form of drawn, painted, or printed *image.*

graphic arts. A term that includes the visual arts of drawing, printmaking, typographic design, advertising design, and the technology of printing.

graphite. A manufactured soft, dense, granular material that can be formed into sticks of gray or black color for use in "lead" pencils.

groin vault. A structural device constructed in the form of two intersecting *barrel vaults.*

ground. The prime or preparatory surface applied to the cloth, wooden, or metal *supports* used by artists for painting. Also, the general area of the *picture plane* on and against which *forms* are composed.

ground line. A stylized indication of the horizontal base or ground on which figures and elements of landscape are placed in some paintings, drawings, and reliefs.

happening. An event conceived and performed by artists utilizing light, sound, and human and mechanical movements.

hatching. A series of closely spaced parallel lines serving in a drawing or print to indicate a toned or shaded area.

horizon line. The division between the earth and the sky as seen by an observer. Also, in *linear perspective* the indicated eye level to which all points of convergence have been directed.

hue. The quality of color that differentiates one *spectrum* color from another; a function of the wavelength of light.

icon. An *image* or *representation,* usually of a religious personage. Often refers to a revered stylized image.

iconography. 1. The visual imagery selected to represent and convey the meaning and content of a work of art. 2. The study and knowledge of the various forms of meaning to be found in pictorial *representations* in the visual arts.

idealization. The *representation* of objects, individuals, and events according to a stylized, perfected, preconceived model.

illumination. A decorative illustration or design, used preeminently in the Middle Ages, to enhance *calligraphic* manuscripts or printed texts.

illusionistic. Descriptive works of art that seek to represent the natural world in a manner that causes an observer to believe he is seeing the actual subject rather than an artist's equivalent for it.

image. A *representation* of an object, an individual, or an event. An image may also be an evocation of a state of being in *representational* or *nonrepresentational* art.

impasto. The three-dimensional surface of thickly applied paint.

Impressionism. A style of painting developed in France during the second half of the 19th century and characterized by a concern for the fleeting effects of light as it played on forms in nature. Monet, Renoir, Pissarro, and their group employed discrete juxtaposed brush strokes of color to form a vibrating surface on the canvas, enhancing the representation of the natural luminosity of their subject matter.

incise. To cut into a surface with a sharp instrument.

informal balance. An asymmetrical arrangement of *visual weights* intended to form an equalized or stable pattern.

intaglio (in-tahl'yoh). A type of carving that cuts into a flat surface to shape forms lower than the level of the original plane. In printmaking a technique which requires that the lines and areas to be inked and transferred to paper be recessed beneath the surface of the printing plate.

intensity. See *saturation.*

intonaco (in-tohn-ah'coh). The smooth second coat of plaster in *fresco* painting which is applied over the primary rough coat.

Ionic. One of the Greek *Classical* styles of temple architecture, distinguished by slender, fluted *columns* and *capitals* decorated with volutes and scrolls.

keystone. The topmost stone or *voussoir* in an *arch*; the last stone to be placed in an arch.

kiln. An oven capable of controlled high temperatures in which clay objects are baked.

kinetic art. Art that incorporates articulated components moved by the action of air, gravity, or mechanical power. Kinetic art may also use changing light patterns controlled by electric or electronic switching.

kylix (kigh′lix). A two-handled shallow wine cup made by the ancient Greeks.

lacquer. A clear, transparent, resinous material used to coat metal and wood to give it a hard, shiny protective surface. Also used as a *vehicle* to form a quick-drying, brilliant paint.

lift-ground. A method of producing broad lines and areas in prints made by the process of *etching* and *aquatint.* The artist paints directly on the surface of an etching plate or on the *rosin* covering of a prepared aquatint plate with a syrup of sugar and water. When the drawing is dry the entire plate is covered with an acid-resistant *ground.* The plate is immersed in water; the water melts the syrup and causes the ground covering the sugar painting to lift away, leaving the plate exposed under the lifted portions. The plate is then etched and printed.

line. 1. A mark left by a moving point. 2. An implied axis through a form or group of forms. 3. A contour edge or the edge between juxtaposed forms. 4. A form so long in one dimension that the other dimension appears as a negligible characteristic.

linear perspective. A system of spatial representation on a two-dimensional surface whose success depends on the optical *illusion* that each group of parallel lines, as observed in nature, appear to converge at points on a line related to the height of the observer's eyes from the ground.

lintel. A structural member that spans an opening between *columns* or *walls.*

lithography. A printmaking medium based upon the antipathy of grease and water. With a grease crayon or waxy liquid, an image is drawn on a slab of grained limestone or on a grained aluminum plate. The drawing is treated chemically so that each grain of the plate touched by the drawing medium can accept a greasy ink and each untouched grain can accept water and repel the ink. When the plate has been wetted and charged with ink, an image in ink is retained which essentially replicates the drawing. The printmaker then covers the plate with a sheet of paper and runs them through a press, which offsets the image onto the sheet, thus producing the print.

local color. The identifying color of an object when it is perceived without shadows under a standard light source.

lost-wax casting. See *cire-perdue.*

Lumia. A form of art that employs moving projections of colored light on a translucent screen.

Mannerism. A style and period in the history of European art generally corresponding to the 16th century, notable for its deliberate reaction against the calm and balance of the High *Renaissance* (c. 1500–25). Presupposing a spectator educated in the "rules" of art, the exponents of this style took a "mannered," virtuosic approach to modeling, perspective, color, and composition. Characteristic of Mannerist art are subjective and emotional content, arbitrary and clotted compositions, concentration on the human figure, anatomical distortions, corner or side placement of the principal subject, figures cut by the picture frame, discrepancies in scale, harsh "shot" colors, and exaggerated perspective views. An aristocratic and complicated style developed during the Reformation years, much Mannerist art is strange, febrile, and alienated in a way that now seems remarkably modern.

masonry. Stone or brickwork.

mass. A discrete body of material, *form,* or group of forms. The physical bulk, weight, and density of a three-dimensional object occupying space.

mat, or **matte.** 1. A nonreflective or dull surface or applied finish. 2. In printing, a papier-mâché mold or matrix used to cast type. 3. A paper or cardboard frame surrounding and protecting a drawing, print, or photograph.

medium. 1. The technique, methodology, or technology used by an artist as the means for the production of a work of art. 2. The material used to dilute paint; i.e., turpentine is the medium for oil paint, water the medium for *watercolor.*

mezzotint. An *intaglio* printmaking technique that employs a manually produced, densely pitted surface on the plate to form tonal areas. Deeply pitted sections print black, sections that are smoothed by burnishing print lighter because the depth of the pits has been reduced.

Minimal Art. Usually refers to metal or wooden sculptural constructions employing linear and planar components in seemingly simple, geometric compositions. By extension, any *nonrepresentational* art form using severely restricted forms and colors.

mobile sculpture. Sculptural constructions using articulated components activated by motors or the force of the wind.

model. 1. A person or object used as a subject by an artist. 2. A scaled miniature representation of a proposed or extant sculpture or building.

modeling. 1. Arranging bits of clay, wax, or other pliable material into three-dimensional forms. A form of *additive sculpture.* 2. The effect of light falling on a three-dimensional object so that its forms are defined and dramatized by highlights and shadows. 3. Painting areas of varying tonalities to represent the effect of light falling on a three-dimensional object.

module. A standardized two- or three-dimensional unit that is intended for use in multiple groupings.

molding. A three-dimensional strip or edge used to define or decorate an architectural surface or frame a picture.

monochromatic color. *Color* formed by altering the *values* of a basic *hue.*

monochrome. A work executed entirely in a single *color* or in the *value* variations of a single *hue.*

monocoque. A form of construction that uses a continuous curved shell as both an external covering and a major part of the structural system.

monotype. A painting or drawing technique employing a smooth metal, glass, or stone plate on which the artist forms an image which is then transferred to a sheet of paper pressed against the plate.

montage (mohn-tahzh′). 1. A composition formed of pictures or portions of pictures previously photographed, painted, or drawn. 2. In motion pictures the sequence in which separate bits of film are combined to result in the continuous narrative or expressive cinematic statement.

monumental. 1. Having the quality of a symbol or memorial to a significant person, event, or idea. 2. A work of art grand, noble, timeless, and essentially simple in composition and execution, whatever its size.

mordant. The acid used to bite or etch metal, as in *intaglio* printmaking.

mosaic. An art medium that requires the use of small pieces of colored glass or stone *(tesserae)* fixed to or imbedded in a background material.

motif. See *subject.*

mural. A painting on a wall, usually large in size. See *fresco.*

naturalism. In the visual arts the attempt to create accurate equivalents for the perception of objects and experiences in the natural world.

nave. The central section of a church located in the *basilican* plan between the main entrance and the *crossing* or the *apse;* typically flanked by aisles.

Neoclassicism. Driven by ambitions as passionate as those motivating *Romanticism,* the exponents of Neoclassicism departed from the discoveries in 1748 of the lava-covered Roman cities of Herculaneum and Pompeii and, in reaction against the formal excesses and effete subject matter of late *Baroque* and *Rococo* art, consciously imitated antique models of painting, sculpture, and architecture so as to attain a rigorous and chastened esthetic, spare and selective in its treatment of line, form, color, space, and texture and intended to foster a secular, republican society, stern, selfless, and "Roman" in its public morality. Beginning as a radical movement that climaxed with the French Revolution, Neoclassicism became associated in the 19th century with the retardataire and reactionary academic establishment (see *academy*), the archenemy, in France as elsewhere in Europe and America, of such innovationary developments as *Realism, Impressionism,* etc.

neutral. A *color* not readily associated with any *hue;* also a color that has been formed by mixing complementary hues. Neutralized hues are low-*saturation* colors still retaining their spectral identities though lacking the *brilliance* of the pure hue.

niello (nee-el'o). Black pigment (an alloy of sulphur mixed with lead, silver, gold, or copper) forced into the lines of a pattern engraved decoratively on the surface of metal objects for the purpose of enhancing the contrast between the design and its background. A work made by this technique.

nonrepresentational. Works of visual art not based on physical subject matter.

odalisque (oh'da-lisk). A French word meaning a harem slave or concubine; more broadly, descriptive of any reclining female figure used as the subject of painting or sculpture.

œuvre (uhv). French for "work"; the whole of an artist's production, his lifework.

ogee (oh'jee). An S-shaped curve; also a molding with an S-shaped cross section.

Op. or optical, Art. A form of two-dimensional art that uses juxtaposed areas of contrasting color to generate optical vibrations and ambiguous or undulating spatial relationships.

order. 1. The organization or arrangement of the plastic elements in a work of art. 2. *Classical* architectural styles such as *Doric, Ionic,* and *Corinthian,* distinguishable by the proportions and decorative treatment given their *columns, capitals,* and *entablature.*

palette. 1. A tray or shaped planar surface on which a painter mixes his colors. 2. The characteristic range and combination of colors typically used by a painter or a school of painting.

papiers collés (pahp-yay' col-lay'). A form of two-dimensional art composed of pasted pieces of cut colored paper.

papier-mâché (pahp-yay' mah-shay'). A material made of paper strips or paper pulp combined with paste that can be molded or built up into three-dimensional objects.

papyrus. A plant found in Egypt and Mediterranean lands; also the matted paperlike material made from the split stems of the plant used as a *support* for some ancient manuscripts.

parchment. The treated skin of a lamb or goat processed to produce a smooth, flexible surface for manuscript writing and illumination.

pastel. 1. A combination of dry pigment and *binder* forming a colored chalk stick; also a work of art resulting from the use of pastels. 2. A light-*valued* chalky color.

patina (pa-teen'a). The surface of metal sculpture that results from natural oxidation or the careful application of heat, chemicals, and polishing agents.

pattern. 1. An arrangement or grouping of objects, forms, or ideas so that the parts appear to have an ordered relationship. 2. A preparatory design or matrix used to shape the final work.

pediment. In *Classical* architecture the triangular portion of the *entablature,* formed by the ends of the sloping roof and the *cornice.*

pendentive. In architecture a concave structural element used to support a circular *dome* above a square space formed by walls of equal measure. Essentially a curved triangular plane (a triangular section of a hemisphere) that has one point placed at a corner of the square base and an opposite edge supporting and contiguous with one-fourth of the circular rim of the *dome.*

photomontage (foh'toh mohn-tahzh'). A *montage* using only photographs.

picture plane. An imaginary vertical plane assumed to be at the front surface of a painting.

pier. A mass of *masonry* rising vertically to support an *arch, vault,* or other roofing member; also a *buttress.*

pigment. A dry powder that provides the coloring agent for paint, crayons, chalk, or ink.

pilaster. A decorative architectural element that looks like a vertical section of a *column* projecting from a *wall.*

plan. 1. The scaled symbolic equivalent, such as a line drawing, for the arrangement and appearance of the parts of a building as they are placed in a horizontal plane. 2. Any description—verbal, written, or pictorial —providing the essentials of a *composition* or of an informing concept.

plane. A surface that is defined and measurable in two dimensions.

planographic printing. See *lithography.*

plastic. 1. Descriptive of a material capable of being shaped or manipulated. A sculptural or three-dimensional quality in a work of art—roundness, apparent solidity. 2. The plastic elements are the basic components of works of art, such as line, form, and texture, capable of being shaped and arranged to result in the completed work. 3. The plastic arts are the visual arts. 4. Any of a number of synthetic materials with differing physical and manipulative characteristics.

plumbago (pluhm-bah'goh). The natural state of *graphite* used as a drawing material before the invention of pencils.

Pointillism. A late-19th-century *Postimpressionist* style of painting developed by the Frenchman Georges Seurat. Paint was applied systematically in small dots or areas of color producing a vibrant surface. Some Pointillist paintings seem a refinement of the representational intention and method of the *Impressionists;* other paintings are carefully constructed compositions in which abstract elements are given purposeful relationships.

pointing. A mechanical method of making three-dimensional measurements of a clay or plaster model and of transferring them to a stone block so that a sculptor can carve a replica or enlargement of the original.

polychrome. Referring to works of art, particularly sculpture and ceramic objects, finished with a painted or glazed surface employing many colors.

Pop Art. A style of painting and sculpture that, since the mid-1950s, uses popular, mass-media symbols as subject matter, treating them seriously or satirically.

post and lintel. A structural system that uses two uprights or posts supporting a member, the *lintel,* that spans the space between them.

poster. A form of *graphic art* combining a decoration or an illustration with type or lettering for the purpose of making a public announcement.

Postimpressionism. A vague and imprecise term applied to *avant-garde* styles of painting that developed from 1885 to 1900 in reaction against Impressionism (the Postimpressionists finding, for their purposes, the earlier style formless and indifferent to subject matter) or as an extension of Impressionism. From this period came the concerns for the significance of *form,* myth, *symbol,* expressiveness, and the psychological intensity that have been the constant preoccupations of modern art.

Pre-Columbian. The art produced in North and South America prior to the beginning of the 16th century.

primary. Basic and essential. When applied to *color,* designating those *hues* that can be mixed to derive all the other hues in the *spectrum.* The primary hues in paint are red, yellow, and blue; in light they are red, green, and blue.

primitive. 1. Descriptive of the art produced by untrained, naïve artists. 2. The native arts of Africa, the Americas, and the Pacific islands. 3. An anachronistic adjective for European painting of the 13th, 14th, and 15th centuries.

print. A multiple impression made from a master plate produced by an artist and printed by him, or under his supervision.

proof. The trial *prints* produced by the various printmaking processes before the artist approves the issuance of an edition. Distinguished from proofs are the impressions that are the prints comprising the edition.

proportion. The relationship of one part to another and of each part to a whole, measurable in mass, linear dimensions, weight, and color.

pylon. The major entrance to an Egyptian temple formed by paired truncated pyramids.

quoin (koin). 1. Blocks of stone placed at the corners of masonry buildings. 2. In printing, wedge-shaped devices used to lock type into the frames or chases of the press.

Realism. A mid-19th-century style of painting and sculpture based upon the belief that the *subject* matter of art and the methods of *representation* should be true to life without *stylization* or *idealization. Impressionism* emerged from the desire to achieve in art an absolute fidelity to man's perception of physical reality.

reinforced concrete. See *ferroconcrete.*

relief sculpture. A type of sculpture in which three-dimensional forms project forward or behind a defined plane. The degree of projection can vary, with some forms in high relief and totally disengaged from the rear plane, and low or *bas-relief* forms projecting only slightly from the surface.

Renaissance. From the time of Giotto (c. 1266–1337) to the sack of Rome (1527) there developed among Italians a keen sense of their *Classical* origins and of the merit and dignity of human endeavor. In the aftermath of the great religious faith and unworldly aspirations of the Middle Ages, the men of the Renaissance seemed indeed to believe themselves in a period of rebirth. Working both from antique models and from a close observation of nature, Italian artists achieved absolute mastery over the techniques of representing life with maximum fidelity in a style distinguished for its purity of *form,* simplicity and balance in *composition,* and a complete harmoniousness in mood, signifying a confident humanism at peace with God as well as with man. In the Renaissance was attained a truly *classic* equilibrium within the stuff of art—form and content, reason and inspiration, color and line, etc. Outside Italy, the term "Renaissance" is applied to European art and architecture as late as the 17th century.

representation. The methods or techniques for producing equivalents for perceptions of the real world.

reproduction. A mechanically processed and manufactured copy of an original two- or three-dimensional object.

resist. The acid-resistant coating that protects portions of an *etching* plate from the corrosive action of the *mordant.*

rib. In architecture a slender, arched structural element of a *vault,* a member of a skeletal system that is self-supporting and, forming a framework for the vault, carries the weight of the stone web that fills the space between the ribs.

ribbed vault. A *vault* constructed on a system of self-supporting *ribs* and a web of thinner material filling the spaces between the ribs. The ribbed vault differs from a regular vault, which uses stone of approximately the same weight throughout.

Rococo. From the French for "rock work." A late *Baroque* style (c. 1715–75) that domesticated and made private, pretty, and diminutive the monumental theatricality of 17th-century Counter-Reformation and absolutist art and architecture. Its subject matter was often, but not inevitably, erotic and effete.

Romanticism. A style of art whose period commenced about the middle of the 18th century and endured until well into the 19th century. A movement concurrent and closely interrelated with *Neoclassicism,* Romanticism emphasized the personal, the emotional, and the dramatic, often expressed through landscape and exotic, literary, and historical subject matter. The romantic and the classic, like the irrational and the reasoned, are dichotomies that have prevailed throughout the history of art in virtually every period and culture.

rosin (reh′zen). A resin derived from the sap of certain pine trees that is processed into a fine powder and dusted onto metal plates as a resist for tonal areas in *aquatint.*

rusticate. To define or emphasize the joints between blocks of stone used in the exterior walls of buildings.

sanguine (sang′wen). A reddish-brown color often found in chalks or crayons.

saturation. The measure of the *brilliance* or purity of a *color.* The saturation of a color decreases as the hue is neutralized. Also called *intensity.*

scale. 1. The relative size of an object, viewed in relation to other objects of its kind, to the environment or format it occupies, or to man himself. 2. The apparent size of an object, regardless of its actual dimensions. 3. In architectural drawings a ratio that relates a measurement on the drawing to a measurement on the full-size building.

sculpture in the round. An organization of three-dimensional forms capable of being seen from all sides.

secondary colors. Those *hues* located midway between the *primary* hues on a traditional color wheel: orange, green, and violet.

section. An architectural drawing representing a vertical slice through a building or structural member.

sepia (seep′yah). A warm dark-brown color often found in chalks, inks, and paint.

serigraphy. A form of printmaking utilizing *stencils* attached to porous screens that support delicate areas of the cut design. Also called "silk screen" printing.

sfumato (sfoo-mah′toh). A hazy, "smoky," atmospheric blending of tonalities in a painting; the softening of edges to create a sensual ambiguity of forms and spaces.

shade. A low-*value* color.

shading. Graduated variations in *value,* often employed in painting to represent the play of light on a form.

shape. 1. The configuration of a two- or three-dimensional *form.* Also a synonym for a two-dimensional form. 2. To form, build, or model a *medium* into an organized construct.

shaped canvas. A *support* for a painting, employed by some contemporary artists, that varies from the traditional rectangular shape. Shaped canvases may be found in many geometric planar forms; they have also been designed to bulge out or otherwise take on some of the characteristics of simple *relief* surfaces.

silk screen. See *serigraphy.*

silverpoint. A drawing medium employing a silver wire that leaves a deposit as it is drawn across the surface of a *support* prepared with sufficient "tooth" to hold the metal. After exposure to the air the silver in the line oxidizes, causing it to darken and change color.

sinopia (sigh-nohp′-yah). A preparatory drawing for a *fresco* made directly on the *arricio* coat of plaster and eventually covered by the *intonaco* and the finished painting.

sketch. A spontaneous, rapidly completed study of a subject or an idea.

slip. A thin mixture of clay and water used to *cast* pottery forms or to coat the surface of clay objects already shaped.

slip forming. *Casting* clay objects by pouring slip into *molds,* waiting until a shell of clay is formed adjacent to the walls of the mold, then pouring out the excess slip to leave a hollow *casting* when the mold is opened.

space. 1. The *volume* occupied by a *form.* 2. The measurable linear and angular relationships between forms. 3. The volume enclosed by limiting walls or boundaries. 4. The area of the two-dimensional *plane* on which a painter places forms. 5. The representation of three-dimensional spatial relationships on a two- dimensional surface. 6. The creation of a psychological or optical spatial effect by the interaction of colors and forms in a painting.

spectrum. Bands of colored light created when white light is passed through a prism. Also a range of *hues* in paint that approximates the spectral band.

squeegee. A tool consisting of a long flexible rubber blade attached to a supporting wooden strip and a handle that is used to force paint through a silk screen *stencil* in *serigraphy.*

squinch. A course, or courses, of *masonry* bridging the corner diagonally between adjacent walls of a square space to provide support for a circular *dome.* The squinch is often supported by a small arch under the horizontal stone courses.

steel-frame construction. A technique of raising buildings on a skeletal structure of steel in an interconnected *post-and-lintel* system that is self-supporting and that provides support for walls, floors, roof, and all the internal components of the building.

stencil. A method of producing repetitive images by cutting openings in a mask or matrix so that paint may be applied through the holes to a *support* underneath, in forms that are controlled by the shapes of the cutouts. See *serigraphy.*

still life. A group of inanimate, commonly found objects—bottles, fabrics, fruit, flowers, silver, and ceramic—arranged on a surface as the *subject* of a painting.

stress. An applied force or pressure placed on a structural member in a construction system.

string course. A horizontal band or molding used as a decorative element on a wall.

structure. 1. The *compositional* relationships in a work of art. 2. A building or other constructed architectural unit. 3. The operative framework that supports a building.

stucco. A plaster or cement coating applied to *masonry* walls.

style. 1. The characteristic manner or execution of a work of art, typical of a cultural group, a period of time, or the work of a single individual. 2. An aspect of individual taste suggesting the ability to make appropriate choices for the creation of a sophisticated and elegant solution to a problem.

stylization. The simplification or generalization of forms found in nature for the purpose of increasing the decorative relationships in a work of art.

subject. That which is *represented* in a work of art, as opposed to *form* and distinct from *content.* Sometimes called *motif.* See *iconography.*

subtractive sculpture. Sculpture formed by cutting into a block of stone and wood to remove the excess material; carving.

support. The physical material serving as a base for and sustaining a two-dimensional work of art, such as paper in the instance of drawings and prints, and canvas and board panels in painting. In architecture, a sustaining structural member.

Surrealism. Defined by its high priest André Breton as "pure psychic automatism, by which it is intended to express verbally, in writing or in any other way, the true process of thought. It is the dictation of thought, free from the exercise of reason, and every esthetic or moral preoccupation." Creating by the irrational dictates of their subconscious mind and vision, the Surrealists (c. 1917–45) produced works of pure dream-world fantasy, composed from automatic drawing, from "found" and unrelated objects, or with detailed renderings of objects in unexpected, hallucinatory juxtaposition, such as a sewing machine and an umbrella on an operating table.

symbol. A form, image, sign, or subject standing for something else. Often, a visible suggestion of something invisible.

symmetry. A composition in which identical forms and colors are placed equal distances from a central axis to form a mirror image; *formal balance.*

tempera. An aqueous paint whose *vehicle* is egg yolk. Some commercially made paints identified as tempera are actually *gouache.*

terra-cotta. Baked clay used in sculpture and architectural decoration; also a reddish-brown color similar to the color of baked clay.

terrazzo (tehr-ah′zoh). A mixture of cement and colored marble chips used as a decorative floor-paving material.

tesserae (tess′er-ee). The bits of colored glass and stone used in *mosaic.*

texture. The tactile quality of a surface or the representation of that surface.

thrust. A force moving out from a central point or axis.

tint. A high-*value* color.

tone. Used broadly, the general coloristic character or quality of a composition. More specifically, the *value* of a *color* or group of colors.

tracery. 1. A complicated, entwined linear *pattern* found in many decorative arts. 2. The ornamental stonework of linear design found in the upper portion of *Gothic* windows and, by extension, any interlaced, linear pattern of stonework.

transept. In a *cruciform* church the part of the building whose axis is set at right angles to the main axis of the *nave* and which intersects the nave at the *crossing.*

trompe-l'œil (trohmp luh'yuh). A type of representation in painting in which the *illusion* of form, space, light, and texture has been so cunningly contrived the observer may be convinced that what he percieves is the actual *subject* matter and not a two-dimensional equivalent for it.

truss. A structural unit built of wood or metal based upon a system of triangles joined at their apexes and used to span the space between walls or piers. Trusses are found in bridge design and in architecture where they serve to support roofs and floors.

type face. An alphabet style or design used as the basis for a font of type.

unity. The quality of similarity, shared identity, or consistency that can be recognized in the relationships between parts of a composition. A logical connection between separate elements in a work of art.

vacuum forming. A method of shaping thin sheets of plastic into sculptural *forms,* requiring the material to be softened with heat and then sucked tightly against a mold by a vacuum system. The plastic cools quickly, permanently shaped to the configuration of the matrix.

value. The measure of the lightness or darkness of a *color.*

vanishing point. In *linear perspective* the point at which lines or edges parallel in nature converge on a *horizon line.*

vault. A *masonry* or concrete roof constructed on the principles of an *arch.* See *barrel vault, groin vault,* and *dome.*

vehicle. In paint the binding agent that holds the grains of pigment together and forms a film that adheres to a *support.*

vellum. The treated skin of a calf processed to produce a smooth, flexible surface for manuscript writing. Also, an especially fine quality of *parchment.*

viewpoint. 1. The position from which an observer perceives a scene. 2. The assumed position of an observer in the construction of a *linear perspective representation* of a *space* filled with *forms.* The viewpoint affects the position of the *horizon line* and *vanishing points.*

visual weight. The psychological response to a *form* with regard to its importance in a *composition.* The weight is a function of the size, shape, texture, and color of the form, its position relative to the other components of the structure, and its metaphoric *content.*

volume 1. The measurable three-dimensional space enclosed by actual or visual boundaries. 2. The *representation* of a three-dimensional volume on a two-dimensional surface.

voussoirs (voo-swahr'). The wedge-shaped stone blocks used to construct an *arch.*

wainscot. A facing of paneled wood covering a wall. Often, the lower portion of the wall that has been finished with a wainscot.

wall. A vertical *plane* in architecture that functions in one or more of the following ways: as a structural *support* for the upper levels or the roof; as a protection from the weather; as a device to compartmentalize space and provide control of light and sound; and as a decorative *element.*

warm colors. Hues or variations of hues in the red or orange section of the *spectrum.*

wash. A thin, transparent layer of paint. Wash drawings combine thinly painted areas of color with linear *elements.*

watercolor. Broadly, any paint that requires water as a *medium.* In a narrower sense, paint that uses gum arabic as a *vehicle* and water as a medium.

web. The thin masonry surface between the *ribs* of a *vault.*

woodcut. A relief *print* made from a design cut into the flat surface of a wooden block. Also, the carved wooden block from which the print is made.

wood engraving. A relief *print* made from a design cut into the end grain of a laminated wooden block. Also, the block from which the print is taken.

Table of Painting Techniques, Media, and Characteristics

TECHNIQUE	VEHICLE	MEDIUM	CHARACTERISTICS
Transparent watercolor	Gum arabic	Water	Pigments slightly transparent.
Opaque watercolor	Casein or other opaque water-soluble glue binders	Water	Permits freedom in application. Because of opacity, repeated changes possible. Paint may be built up into thick layers.
Tempera	Egg yolk	Water	Fairly transparent, though less so than transparent watercolor. One of the oldest techniques.
Fresco	Lime plaster	Water or lime water	Combination of pigment and lime water applied on wall while lime plaster still damp. When plaster dries, pigment integrated with plaster. Used primarily for large murals.
Oil	Linseed oil Varnish (sometimes)	Turpentine	Probably the most versatile technique. May be applied opaque or transparent, thin or thick.
Encaustic	Beeswax	Turpentine or heat	Pigment combined with wax. Thinned for application by heat or turpentine.
Mosaic			Colored bits of stone or glass fitted together to form design and held in position by plaster or cement. Not generally considered a painting medium, but important in producing two-dimensional art.

Table of Printmaking Processes, Materials, and Characteristics

PROCESS	TYPE	MATERIALS	CHARACTERISTICS
Woodcut, or wood-block print	Relief	Wood block, side grain Cutting tools	Many different woods suitable. Strong black-and-white effects.
Linoleum-block print	Relief	Heavy-gauge linoleum Cutting tools	Similar to woodcut but less detailed in forms because of softness of material.
Wood engraving	Relief	Wood block, end grain Cutting tools	More difficult to cut than woodcut. Lines usually finer, more precise.
Etching	Intaglio	Metal plate Resist · Acid	No constraint of free use of line. Dark and light lines result from depth of acid bite.
Aquatint	Intaglio	Rosin-covered plate Resist · Acid	Permits graduated tones in large areas. Works from light to dark.
Engraving	Intaglio	Metal plate Burins	Difficult cutting produces more controlled designs than etching.
Drypoint	Intaglio	Metal plate · Needles	Burr on scratches holds ink to create soft line.
Mezzotint	Intaglio	Metal plate · Rockers Scrapers	Permits large areas of tone. Scrapers lighten tones by smoothing plate surface. Works from dark to light.
Lithography	Planographic	Stone · Wax crayons · Tusche Grained metal and paper plates	Based on mutual repulsion of oil and water. Wide range of techniques possible.
Serigraphy, or silk-screen print	Stencil	Stencils Silk, nylon, or metal mesh	Screen holds small stencil elements in position, permitting complex designs.

texture. The tactile quality of a surface or the representation of that surface.

thrust. A force moving out from a central point or axis.

tint. A high-*value* color.

tone. Used broadly, the general coloristic character or quality of a composition. More specifically, the *value* of a *color* or group of colors.

tracery. 1. A complicated, entwined linear *pattern* found in many decorative arts. 2. The ornamental stonework of linear design found in the upper portion of *Gothic* windows and, by extension, any interlaced, linear pattern of stonework.

transept. In a *cruciform* church the part of the building whose axis is set at right angles to the main axis of the *nave* and which intersects the nave at the *crossing.*

trompe-l'œil (trohmp luh'yuh). A type of representation in painting in which the *illusion* of form, space, light, and texture has been so cunningly contrived the observer may be convinced that what he perceives is the actual *subject* matter and not a two-dimensional equivalent for it.

truss. A structural unit built of wood or metal based upon a system of triangles joined at their apexes and used to span the space between walls or piers. Trusses are found in bridge design and in architecture where they serve to support roofs and floors.

type face. An alphabet style or design used as the basis for a font of type.

unity. The quality of similarity, shared identity, or consistency that can be recognized in the relationships between parts of a composition. A logical connection between separate elements in a work of art.

vacuum forming. A method of shaping thin sheets of plastic into sculptural *forms,* requiring the material to be softened with heat and then sucked tightly against a mold by a vacuum system. The plastic cools quickly, permanently shaped to the configuration of the matrix.

value. The measure of the lightness or darkness of a *color.*

vanishing point. In *linear perspective* the point at which lines or edges parallel in nature converge on a *horizon line.*

vault. A *masonry* or concrete roof constructed on the principles of an *arch.* See *barrel vault, groin vault,* and *dome.*

vehicle. In paint the binding agent that holds the grains of pigment together and forms a film that adheres to a *support.*

vellum. The treated skin of a calf processed to produce a smooth, flexible surface for manuscript writing. Also, an especially fine quality of *parchment.*

viewpoint. 1. The position from which an observer perceives a scene. 2. The assumed position of an observer in the construction of a *linear perspective representation* of a *space* filled with *forms.* The viewpoint affects the position of the *horizon line* and *vanishing points.*

visual weight. The psychological response to a *form* with regard to its importance in a *composition.* The weight is a function of the size, shape, texture, and color of the form, its position relative to the other components of the structure, and its metaphoric *content.*

volume 1. The measurable three-dimensional space enclosed by actual or visual boundaries. 2. The *representation* of a three-dimensional volume on a two-dimensional surface.

voussoirs (voo-swahr'). The wedge-shaped stone blocks used to construct an *arch.*

wainscot. A facing of paneled wood covering a wall. Often, the lower portion of the wall that has been finished with a wainscot.

wall. A vertical *plane* in architecture that functions in one or more of the following ways: as a structural *support* for the upper levels or the roof; as a protection from the weather; as a device to compartmentalize space and provide control of light and sound; and as a decorative *element.*

warm colors. *Hues* or variations of hues in the red or orange section of the *spectrum.*

wash. A thin, transparent layer of paint. Wash drawings combine thinly painted areas of color with linear *elements.*

watercolor. Broadly, any paint that requires water as a *medium.* In a narrower sense, paint that uses gum arabic as a *vehicle* and water as a medium.

web. The thin masonry surface between the *ribs* of a *vault.*

woodcut. A relief *print* made from a design cut into the flat surface of a wooden block. Also, the carved wooden block from which the print is made.

wood engraving. A relief *print* made from a design cut into the end grain of a laminated wooden block. Also, the block from which the print is taken.

Table of Painting Techniques, Media, and Characteristics

TECHNIQUE	VEHICLE	MEDIUM	CHARACTERISTICS
Transparent watercolor	Gum arabic	Water	Pigments slightly transparent.
Opaque watercolor	Casein or other opaque water-soluble glue binders	Water	Permits freedom in application. Because of opacity, repeated changes possible. Paint may be built up into thick layers.
Tempera	Egg yolk	Water	Fairly transparent, though less so than transparent watercolor. One of the oldest techniques.
Fresco	Lime plaster	Water or lime water	Combination of pigment and lime water applied on wall while lime plaster still damp. When plaster dries, pigment integrated with plaster. Used primarily for large murals.
Oil	Linseed oil Varnish (sometimes)	Turpentine	Probably the most versatile technique. May be applied opaque or transparent, thin or thick.
Encaustic	Beeswax	Turpentine or heat	Pigment combined with wax. Thinned for application by heat or turpentine.
Mosaic			Colored bits of stone or glass fitted together to form design and held in position by plaster or cement. Not generally considered a painting medium, but important in producing two-dimensional art.

Table of Printmaking Processes, Materials, and Characteristics

PROCESS	TYPE	MATERIALS	CHARACTERISTICS
Woodcut, or wood-block print	Relief	Wood block, side grain Cutting tools	Many different woods suitable. Strong black-and-white effects.
Linoleum-block print	Relief	Heavy-gauge linoleum Cutting tools	Similar to woodcut but less detailed in forms because of softness of material.
Wood engraving	Relief	Wood block, end grain Cutting tools	More difficult to cut than woodcut. Lines usually finer, more precise.
Etching	Intaglio	Metal plate Resist · Acid	No constraint of free use of line. Dark and light lines result from depth of acid bite.
Aquatint	Intaglio	Rosin-covered plate Resist · Acid	Permits graduated tones in large areas. Works from light to dark.
Engraving	Intaglio	Metal plate Burins	Difficult cutting produces more controlled designs than etching.
Drypoint	Intaglio	Metal plate · Needles	Burr on scratches holds ink to create soft line.
Mezzotint	Intaglio	Metal plate · Rockers Scrapers	Permits large areas of tone. Scrapers lighten tones by smoothing plate surface. Works from dark to light.
Lithography	Planographic	Stone · Wax crayons · Tusche Grained metal and paper plates	Based on mutual repulsion of oil and water. Wide range of techniques possible.
Serigraphy, or silk-screen print	Stencil	Stencils Silk, nylon, or metal mesh	Screen holds small stencil elements in position, permitting complex designs.

Index

References are to page numbers, except for color plates and black-and-white illustrations, which are identified by figure and plate numbers. See the Glossary, beginning on page 483, for a selection of terms and definitions. Because they are arranged in alphabetical order, the terms defined in the Glossary have not been cited in the Index.

Burri, Alberto, *Grande Nero Plastica-La*, 3, 112, 114, 115, Fig. 111
Bury, Pol, *Thirty-one Rods, Each with a Ball*, 297, 298, Fig. 349

Cadbury workers' village, England, 368, 369, Fig. 452
cadmium, 101
Calder, Alexander, *Hanging Mobile* (stroboscopic photograph), 296, 297, Fig. 347; *Lobster Trap and Fish Tail*, 296, 297, Fig. 346
Callahan, Harry, *Chicago c. 1950*, 152, 153, Fig. 163
calligraphy, 124, 213–215, 225, 230–232, Figs. 116–118
camera, 147, 148, 151, 153–155, 177
camera ottica, 142
Canaletto, *View of Venice, Piazza and Piazzetta San Marco*, 139–142, Figs. 140, 141
Carritt, Edgar, 42
Carola, Robert, graphic word play, 46, Fig. 35
cartoon, Osborn, 78, 79, Fig. 89
casting, metal, 314, 315, 321, 322, Figs. 383–385
cast-iron construction, 417, 418
cave drawings, 3; Spain, 272, Fig. 312
centering, in arch construction, 408, 409, Fig. 505
ceramics, Chinese, 41, Fig. 32; Greek, 3, 5, 163, 164, Figs. 3, 176
Cézanne, Paul, 183, 186, 197; *The Basket of Apples*, 183, 186, Pl. 41, p. 179
Chac-mool, Toltec figure, 304, Fig. 358
chalk, in drawing, 202, 206, 207
Champaigne, Phillipe de, *Anne of Austria Queen of France*, Morin engraving after, 261, 262, Figs. 298, 299
Chandigarh, India, Le Corbusier plan, 370–372, Figs. 456
Chandler, Albert R., 42; *Beauty and Human Nature*, 6; quoted, 374
chapbook illustration, *The History of the Two Children in the Wood*, 247, Fig. 275; *The Miracle of Miracles*, 247, Fig. 273; *The Wonder of Wonders*, 247, Fig. 274
charcoal, in drawing, 202, 206–208
Charivari, 78
Charlton, Mass. (Old Sturbridge, Mass.), Towne House, 338, 339, Figs. 408–410
Chartres Cathedral, jamb statues, 306, Fig. 363; *Notre Dame de la Belle Verrière*, 355, Pl. 69, p. 350
Chevreul, Michel Eugène, 190
Chicago, Civic Center, C. F. Murphy Associates, Skidmore, Owings & Merrill, and Loebel, Schlossman & Bennett, 394, 395, Figs. 483–485; Crown Hall, Illinois Institute of

Technology, Mies van der Rohe, 396–398, Figs. 486, 487; Home Insurance Company Building, Jenney, 420, 421, Fig. 333; Marshall Field Wholesale Store, Richardson, 419, 421, Fig. 531
children's drawings, 29, 30, Figs. 21–24; of the human being, 72, 73, Figs. 78–81
china painting, 74, 75, Fig. 83
Chinese art, 170; Chou food vessel, 304, Fig. 359; Han vase, 41, Fig. 32; Mu-Ch'i, 158, Fig. 172
cista, from Palestrina, 254, Fig. 288
city planning, *see* urban planning
Clague, John, *Overture in Black and White*, 294, 295, Fig. 342
Clark, William A., Wilmont Homes, Pa., 388, 389, Fig. 474
collage, 112, 113, 115, Figs. 108–110
"colonial" buildings, 388, 389, Figs. 470–474
colonial house, 338, Figs. 408–410
color, 99–103; change, 176, 177; hue, 100, 101; and light, 189, 190, 193; saturation, 102; solid, 102, 103, Fig. 98; value, 101, 102
color charts, 100–103, Pl. 21, p. 97, Figs. 98–101
color field, painted, diagram of canvas, 104, Fig. 101
color theory, 100, 101
compression, forces of, 401, Fig. 492
conceptual representation, 72, 73, Figs. 78–81
concrete construction, 425, Fig. 539
Condensation Box, Haake, 306, Fig. 364
Connor, Dennis, *Antiwar Protest at the University of Wisconsin*, 438, 443, Fig. 558
Constable, John, *Fir Trees at Hampstead*, 204, 205, Fig. 218
contour farming, Nottingham, Pa., 70, Fig. 76
Copley, John Singleton, 14; *Portrait of Mrs. Thomas Boylston*, 10–12, Fig. 9
Coppo, Pietro, *Portolano* (1528), map, 68, 69, Fig. 68
corbeled construction, 406, 407
Corinth, Lovis, *Dr. Rosen*, 211, Fig. 226
Corot, Jean-Baptiste-Camille, *Landscape (The Large Tree)*, 208, Fig. 224
Cortel, Jacques, map of New Amsterdam, 362, 363, Fig. 443
Coypel, Charles-Antoine, *Portrait of Mme de Bourbon Conti*, 443, 444, Fig. 559
Cozens, Alexander, blot from *A New Method of Assisting the Invention in Drawing Original Compositions of Landscape*, 266, 267, Fig. 304
Crane Memorial Library, Quincy, Mass., Richardson, 346, Fig. 424
crayon, Conté, 207; lithographic, 211; wax, 202, 211

Crippa, Roberto, *Composition*, 331, 332, Fig. 339
Crivelli, Carlo, *St. Pater*, detail of *The Demidoff Altarpiece*, Pl. 24, p. 108
cross vaulting, open, 410, Fig. 510
Croton Watch Co., advertisement, 472, 473, Fig. 590
Crown Hall, Illinois Institute of Technology, Chicago, Mies van der Rohe, 396–398, Figs. 486, 487
cube, photograph of, 145, Fig. 148; representation of, 143–145, Figs. 142–148; silhouette, 163, Fig. 173
Cubism, 21, 197, 331, 448, 472; Analytical, 187, Figs. 200–202
Cubists, 60, 61, 183, Fig. 62
Currier & Ives, *Midnight Race on the Mississippi*, 270, 271, Fig. 309
Cycladic statuette of a woman, 310, 311, Fig. 366
cylinders, 286, 287, Figs. 327–332

Dacca, Second Capital of Pakistan, Kahn, 342, 343, Fig. 418
Dali, Salvador, *Apparition of a Face on the Seashore*, 457, Fig. 577; quoted, 456
Darby, Abraham, Severn Bridge, England, 417, Fig. 528
Darwin, Charles, 177
Daumier, Honoré, *You Have the Floor, Explain Yourself*, 78, 79, Fig. 88
Davis, Brady & Associates, United States Pavilion, Expo 70, Osaka, 429, Fig. 546
da Vinci, Leonardo, *see* Leonardo
decorative writing, 82, Fig. 92
Degas, Edgar, 14; *Double Portrait: The Nieces of the Artist*, 12, Fig. 10; study for a portrait of Manet, 205, 206, Fig. 220; *Woman at Her Toilette*, 165, 167, 208, Pl. 34, p. 149
de Kooning, Willem, *Woman and Bicycle*, 13, 14, 116, 453, Pl. 3, p. 17
Demidoff Altarpiece, The, detail of St. Peter, Crivelli, Pl. 24, p. 108
Derain, André, *London Bridge*, 60, Pl. 16, p. 84
developing and printing (in photography), 155
Die Brücke (The Bridge), 452
direct-metal sculpture, 317, 319, 321, Figs. 375–378
Disasters of War, The, Goya, 474, Fig. 591
Dodge City, Hollywood set for *Gunsmoke*, 145, Fig. 149
dome, buttressing of, 413, Fig. 519; construction, 413, 414, Figs. 519–521, 523; geodesic, 429, 430, Figs. 547, 548; on square plan, 413, Figs. 520
Donatello, *David*, 302, Fig. 353; *Habakkuk* ("*Zuccone*"), 302, Fig. 352; *St. George*, 255, 278–280, 283, 284, Figs. 317, 319–321; *St. Mary Magdalene*, 302, Fig. 354

Savoye House, Poissy-sur-Seine, Le Corbusier, 351, Fig. 428
Schaefer-Simmern, Henry, *The Unfolding of Artistic Activity* (1948), quoted, 29
Schiaparelli, map of Mars, 70, Fig. 74
Schiller, Friedrich, 32
Schmidt-Rottluff, Karl, *Landscape with Young Elms*, 452, Fig. 572
Schwitters, Kurt, *Cherry Picture*, 112, 113, 467, Fig. 110
scroll painting, *Matsuzaki-tenjin engi*, 405, Fig. 499
sculpture, additive, 313–320; casting, 314, 315, 321, 322, Figs. 383–385; under construction, 321, Fig. 382; direct-metal, 317, 319, 321, Figs. 375–378; kinetic, 333–336, Figs. 346–349; plastic elements of, 313; relief, 327–333; subtractive, 322
Seagram Building, New York, Miës van der Rohe, 344, 353, 356, 395, 396, 398, Fig. 419
Seidler, Harry & Associates, Australia Square Office Centre, Sydney, plan, 356, Fig. 435
Self-portrait, Frasconi, 253, Fig. 286
Senefelder, Alois, 268
separation, hue, and value, diagram, 102, 103, Fig. 98
serigraphy, *see* silk screen
service systems, in architecture, 357, 358; plan of, 356, 357, Fig. 435
Seurat, Georges, *Café Concert*, 207, Fig. 222; *Entrance to the Harbor, Port-en-Bessin*, 60, Pl. 15, p. 84
Severn Bridge, Coalbrookdale, England, Darby, 417, Fig. 528
shading, 166, 167, Fig. 180
Shahn, Ben, *Miners' Wives*, 170, Fig. 186; *The Passion of Sacco and Vanzetti*, 475, Fig. 592
Sharaku, Toshusai, *Iwai Hanshiro IV*, 58, 189, 253, Pl. 42, p. 180
Shunshō, Katsukawa, *Woman in Red*, 164, Fig. 177
shutter (on camera), 147, 151, 155; speed, 151, Fig. 162
Siena, 359–362, 367; aerial view, 359–361, Fig. 440; history of settlement, 359; plan, 359–361, Fig. 439
silhouette, 167; of a cube, 163, Fig. 173; of a human figure, 163, Figs. 174, 175
silk screen, 237, 272–274; Indiana, 274, Fig. 316; Youngerman, 274, Pl. 59, p. 264; *see also* stencil
silverpoint, 202, 203; Leonardo, 202, Pl. 50, p. 209; Van Eyck, Figs. 215, 216
sinopia, 201, 224–226, Fig. 251
Sisley, Alfred, 190; *Flood at Port-Marly*, 190, Pl. 45, p. 182
Sistine Ceiling, studies, Michelangelo, 206, Pl. 51, p. 210
site-sculpture, Hueber, 34, 39, Fig. 29
Six Persimmons, Mu-Ch'i, 158, Fig. 172

Skaows-Ke'ay, *Bear Mother*, 445, 446, Figs. 562
Skidmore, Owings & Merrill, Alcoa Building, San Francisco, 421, 422, Fig. 535; Chicago Civic Center, 394, 395, Figs. 483–485; Lever House, New York, 420, Fig. 534
slip forming, 426
Smeaton, Joh, Eddystone Lighthouse, 423, Fig. 537
Smith, David, *Cubi XXIV*, 290, 291, Fig. 337; *History of Le Roy Barton*, 222, 223, Fig. 248; *Imaginary Glyphs*, 222, 223, Fig. 246; *Portrait of a Painter*, 222, 223, Fig. 248; *Sitting Printer*, 222, 223, Fig. 248; study for *Personages* and *Tank Totems*, 222, 223, Fig. 247
Smith, Tony, *Die*, 469, Fig. 587
Smithson, Robert, *Spiral Jetty*, 32, Pl. 8, p. 38
snake mound, Adams Co., Ohio, 33, 34, Fig. 28
Snelson, Kenneth, *Landing*, 337, 338, Fig. 407
Soleri, Paolo, "Arcosanti," 370, 371, Fig. 455; and urban planning, 370, 371, Fig. 455
sounds, and symbols, 45, Figs. 33, 34
Sounion, *Apollo* from, 435, Fig. 552
South Street, New York City, Bennett, 362, 363, Fig. 445
Soutine, Chaim, *Portrait of Moise Kisling*, 112, 118, Pl. 29, p. 120
Spencer, Herbert, 32
spindle, folk, 476, Fig. 593
Spinelli, Parri, *Christ on the Cross with the Virgin and St. John the Evangelist*, 224–226, Fig. 252
Spiral Jetty, Smithson, 32, Pl. 8, p. 38
squeegee, 273
squinch, 413, Figs. 521, 522
stained glass, Chartres Cathedral, 355, Pl. 69, p. 350
Stankiewicz, Richard, *Marionnette*, 318, 319, Fig. 378
Statue of Liberty (Liberty Enlightening the World), Bartholdi, 468, 469, Fig. 586
steel-frame construction, 419–423, Fig. 532
Stella, Frank, *De la nada Vida a la nada Muerte*, 175, 176, Pl. 37, pp. 160–161
stencil, Chinese, 272; hands (cave drawing), 272, Fig. 312; Japanese, 272, Fig. 313; wallpaper, 272, Fig. 314; *see also* silk screen
still life, photographs of, 184, 185, Figs. 197–199
Still Life with Fisches, Picasso, 139, 141, Pl. 22, p. 98
Still Life with Musical Instruments, Lipchitz, 330, 331, Fig. 398
Stone, Edward Durrell, United States Embassy, New Delhi, 353, Fig. 431
street drawings, 29, 30, Figs. 21–24

stroboscopic light, 153
Studio of the Painter Hans Makart, Alt, 8, Fig. 5
subjective reality, 75
subtractive sculpture, 322–323
Sugarman, George, *C Change*, 294, Pl. 63, p. 282
Sullivan, Louis, quoted, 381
Summers, Carol, *Choeps*, from *Nine Prints*, 254, Pl. 55, p. 245
Surrealism, 454–458, 465, 467
Swiss Pavilion, Expo 70, Osaka, Walter, 356, Fig. 434
symbols, written, 45, Figs. 33, 34

Taharqa, 434, Fig. 551
Takeyama, Minoru, 2-ban-kahn, Tokyo, 355, Pl. 68, p. 349
Taliesin West, Phoenix, Wright, 348, 351, 388, Figs. 426, 427
Tapestry, Nazca, 41, Fig. 31
Tea Kettle, Baiyu, 214, Fig. 231
Teatro Olympico, Vicenza, Italy, Palladio, 366, 367, Fig. 449
telescope, photograph, 69, Fig. 72
television set, *Gunsmoke*, 145, Fig. 149
Temple Emanu-El, Dallas, Tex., project drawings, Mendelsohn, 217, Fig. 236
Temple of Karnak, Hall of Amenhotep III, Luxor, 404, Fig. 495
Temptation of Christ, The, Autun Cathedral, 446, Fig. 563
tension, forces, of, 401, 402, Fig. 493
tepee, Plains Indians, 342, Fig. 417
Terence, *Eunuchus*, Dürer illustration for, 242, 243, Fig. 270
terra-cotta, 314
textile printed, 234, 238, 239, 272, Figs. 263, 264
Theseum (Hephaesteum), Athens, 404, Fig. 496
Thomas à Becket, reliquary with scenes of murder, 254, Fig. 289
Tiepolo, Giovanni Battista, *Hagar and Ishmael*, 213, Pl. 52, p. 227
time-space perception, 177, 183-188
Timgad, Algeria, plan, 360, 361, Fig. 441
Tinguely, Jean, *Homage to New York: A Self-constructing and Self-destroying Work of Art*, 297, Fig. 348
Tlaloc, Maya-Toltec head, 302, 303, Fig. 356
Tokyo, 2-ban-kahn, Takeyama, 355, Pl. 68, p. 349
Tolstoi, Lev, 29; *What Is Art?* (1896), quoted, 28
Toltec rain god Chac-mool, 304, Fig. 358
Toulouse-Lautrec, Henri de, 451; *At the Moulin-Rouge*, 232, Pl. 53, p. 228; *Le Divan Japonais*, 58, 269, 270, Pl. 14, p. 83; *Jane Avril*, 269, 270, Fig. 308; Japanese prints, 58
Towne House, Charlton, Mass. (Old Sturbridge), 338, Figs. 408–410

Photographic Sources

References are to figure numbers unless indicated Pl. (plate).

Aero–Photo, Paris (450); Alexander, Chalmer (540); Alinari–Art Reference Bureau, Ancram, N.Y. (8, 137, 193, 351–354, 390–391, 395–396, 432, 458–459, 488–489, 497); American Museum of Natural History, New York (74, 358, 417); Anderson–Art Reference Bureau, Ancram, N.Y. (430, 433); Andrews, Wayne, Grosse Pointe, Mich. (424); Arauz Lomelí, Juan Victor, Guadalajara (573); Archives of American Art, Washington, D.C., David Smith Papers (248); Archives Photographiques, Paris (44); Avery Architecture Library, Columbia University, New York (522); Baer, Morley, Los Angeles (535); Baker, Oliver, New York (377, 383, 554); Arnott Rogers Batten, Ltd., Montreal (454); Beaujard, B., Moret-sur-Loing, France (442); Bibliothèque Nationale, Paris (529); Blomstrom, Irving E., New Britain, Conn. (17, 19, 124); Boltin, Lee, Croton-on-Hudson, N.Y. (561); Bournville Village Trust, England (452); Brooks, Bob, New York (148, 160–162, 173–175); Burckhardt, Rudolph, New York (324, 380, 400); Burckhardt, Rudolph, New York, and Leo Castelli Gallery, New York (365); Burstein, Barney, Boston (258); CFL–Giraudon, Paris (Pl. 44); Carnegie Institute, Museum of Art, Pittsburgh (111); Leo Castelli Gallery, New York (112, 223, 315); Chicago Architectural Photographing Co. (533); Clements, Geoffrey, New York (306, 379); Cserna, George, New York (475); Curwen Gallery, London (302); Davis, Brody & Assocs., New York, and Arai, Masao, *The Japan Architect*, Tokyo (546); de Cusati, E., New Haven, Conn. (388); Deutsche Fotothek Dresden (216); Dwan Gallery, New York (27); Eastman Kodak Company, Rochester, N.Y. (70); Elisofon, Eliot, New York (494); William A. Farnsworth Library and Art Museum, Rockland, Me. (234–235); Fischbach Gallery, New York (Pl. 63); Fletcher, Mike T., Black Star, New York (469); Fondazione Giorgio Cini, Venice (449); Fotocielo, Rome (440); Fototeca Unione, Rome (507, 511); Frantz, Alison, Princeton, N.J. (18, 496, 500, 503); French Government Tourist Office, New York (2, 43, 448, 450); Allan Frumkin Gallery, Inc., New York (226); Futagawa, Y., Tokyo (425); Gahr, David, New York (348); General Electric Company, Cleveland (547); Georges, Alexandre, Pomona, N.Y. (411); Giraudon, Paris (217, 272, 423, 518, Pls. 12, 69); Giraudon–Art Reference Bureau, Ancram, N.Y. (87); Graubünden, Switzerland, Bau- und Forstdepartment (4); Green Studio Limited, Dublin (Pl. 18); Guerrero, Pedro E., New Canaan, Conn. (426–427); Solomon R. Guggenheim Foundation, New York (401–405); Harlow Development Corporation, England (453); Harmon, Mamie, New York (21–24, 593); Hedrich–Blessing, Inc., Chicago (429, 486, 490); Hirmer Fotoarchiv, Munich (495, 524, 550); Hubbard, Cortlandt V.D., Philadelphia (474); Institute of Art Research, Tokyo (172); Jennings, George, Jr., Norwich, Conn. (313); Joel, Yale, LIFE Magazine © Time Inc., New York (167); Peter A. Juley & Son, New York (178); King, John, New Canaan, Conn. (278–279, 338, Pls. 25, 58–59, 66, 78); Knobler, Nathan, Mansfield Center, Conn. (6, 195–199, 470–473); Lieberman, Alexander, New York (Pl. 4); Lichtbildwerkstätte "Alpenland," Vienna (271, 295); MAS, Barcelona (312); Marburg–Art Reference Bureau, Ancram, N.Y. (42, 563); Marlborough Gallery, New York (229, 398); Mates, Robert, and Katz, Paul, Solomon R. Guggenheim Museum, New York (Pl. 54); Matter, Herbert, New York, and Museum of Modern Art, New York (347, Pl. 60); Mendelsohn, Mrs. Eric, San Francisco (236); Money, Lynton, Welwyn Garden City, England (386–387); Morse, Ralph, LIFE Magazine © Time Inc., New York (1); Museum of Modern Art, New York (90, 237, 428, Pl. 19); NASA, Washington, D.C. (73, 75); National Parks Pictures, Washington, D.C., Branch of Still Pictures (467–468, 586); Old Sturbridge Village, Mass. (408–410); Orion Press/SCALA, New York (Pl. 68); Betty Parsons Gallery, New York (106); Partridge, Rondal, Berkeley, Calif. (431); Pennsylvania State University, University Park, Pa., Department of Physics (71); Piaget, St. Louis, Mo. (30); Pinney, Roy, Photo-Library, Inc., New York (438); Pollitzer, Eric, New York (Pl. 22); Pollitzer, Eric, New York, and Lawrence Rubin Gallery, New York (Pl. 31); Portland Cement Association, Chicago (539); Port of New York Authority (491); Radio Times Hulton Picture Library, London (537); Rand, Marvin, Los Angeles (436); Rapho-Guillumette Pictures, New York (166); Roger-Viollet, Paris (45, 47); Rudofsky, Bernard, New York (457); St. Patrick's Information Service, New York (422); Sandak, Inc., New York (Pl. 67); Savio, Oscar, Rome (Pl. 50); SCALA, Florence (317, 319–321); Schnellbacher, Elton, Pittsburgh (Pl. 77); Science Museum, London (528); Joseph E. Seagram and Sons, New York (419); Service de Documentation Photographique de la Réunion des Musées Nationaux, Paris (194, Pl. 45); Sherwin Greenberg, McGranahan & May, Inc., Buffalo, N.Y. (63); Shulman, Julius, Los Angeles (466); Smith, William Stevenson, Harvard University, Cambridge (551); Society for the Preservation of New England Antiquities, Boston (498); Soprintendenza alle Gallerie, Florence (251–252); Staempfli Gallery, New York (392); Steinkopf, Walter, Berlin (86, 290); Stevens, Lt. Col. Albert W., © 1948 National Geographic Society, Washington, D.C. (28); Stoedtner, Dr. Franz, Düsseldorf (509); © Ezra Stoller [ESTO], Mamaroneck, N.Y. (412, 414–416, 420, 476, 478–479); Sunami, Soichi, New York (282); Sutter, Werner, Osaka, Japan (434); Swedlund, Charles, Chicago (153–159); Uht, Charles, New York (53, 335, 355–356, 370–371); United Press International, New York (558); United States Department of Agriculture, Washington, D.C., Office of Information (76); United States Department of the Interior, Washington, D.C., Geological Survey (169–170); United States Information Agency, Washington, D.C. (548); Vatican Photoarchives, Rome (350); Vine, David, New York (150–152); Visual Direction, Massapequa, N.Y. (413); Wachtel, Dr. Allen W., Storrs, Conn. (69); Waddell Gallery, Inc., New York (342); Ward, Clarence, Oberlin, Ohio (46); Wehmeyer, Herman, Hildesheim (394); Wide World Photos, New York (149, 542–543); Wyatt, A. J., Philadelphia (Pls. 6, 29–30); Zimberg, George, Cambridge, Mass. (477); Zumbühl, St. Gall, Switzerland (265).

Figs. 439 and 441 from *Key Monuments of the History of Architecture*, edited by Henry A. Millon (Harry N. Abrams, Inc., New York, and Prentice-Hall, Inc., Englewood Cliffs, N.J., 1964). Figs. 385–387 from *The Technique of Casting for Sculpture*, by John W. Mills, © by John W. Mills 1965 (B.T. Batsford Ltd., London, and Reinhold Publishing Corporation, New York). Figs. 447 and 451 from *Towns and Buildings*, by Steen Eiler Rasmussen (M.I.T. Press, Cambridge, Mass., 1969). Fig. 454 from *Beyond Habitat*, by Moshe Safdie (M.I.T. Press, Cambridge, Mass., 1970). Fig. 92 reproduced by permission of Reinhold Publishing Corporation, from *The Universal Penman*, by Raymond A. Ballinger, copyright © 1965 by Litton Educational Publishing, Inc. Fig. 572 from *The Graphic Art of German Expressionism*, by Lothar-Günter Buchheim (Universe Books, Inc., New York, 1960). Fig. 456 from *Chandigarh*, by Norma Evenson (University of California Press, Berkeley, 1966).

Works by Arp, Bonnard, Brancusi, Braque, Derain, Dubuffet, Giacometti, Gris, Kandinsky, and Modigliani: Permission A.D.A.G.P. 1971 by French Reproduction Rights, Inc. Works by Degas, Hodler, Klee, Lepère, Matisse, Monet, Picasso, Renoir, Rodin, Soutine, and Vuillard: Permission S.P.A.D.E.M. 1971 by French Reproduction Rights, Inc.